CHARLES ROSS: Qui a mange le baboon?

 * * * * * * * * * * SUSAN KAUFMAN & CHARLES ROSS

Free Play

RUTH EMERSON: Sense

CAROLEE SCHNEEMANN: Lateral Splay

ALEX HAY: Prairie

CARLA BLANK: Turnover

YVONNE RAINER & CHARLES ROSS: Room Service

 teams:

 * * * * * * * * * * * Ross, Aeppli, Emerson

 Hay, Holder, Hansen

 Rainer, Gross, Blank

 Childs, Greenbaum,

 Farnsworth.

PHILIP CORNER: I N T E R M I S S I O N

DEBORAH HAY: Would They or Wouldn't They?

 * * * * * * * * * * * * * Alex Hay, David Lee,

 Yvonne Rainer, Deborah Hay

 * * * * * * * * * music by AL HANSEN

Free Play

ARLENE ROTHLEIN: Enceinte for Isadora Duncan

YVONNE RAINER: Shorter End of a Small Piece

(pgm. con't. next page......

JOAN BAKER: Ritual

CAROLEE SCHNEEMAN: Lateral Splay

LUCINDA CHILDS: Egg Deal

 * * * * * Judith Dunn, Ruth Emerson, Tony Holder,

 Lucinda Childs.

 * * * * * * * * * * * *

LIGHTING: Alex Hay & Carol Summers

SOUND: Lanny Powers

STAGE MANAGER: David Lee,
 assisted by Janet Castle.

Galumpf Squad: Al Hansen (Captain),
 assisted by Mac Benford,
 Arthur Cohen, Michael Pass.

Chair Sculpture: Charles Ross,
 assisted by Felix Aeppli

PROGRAM COMMITTEE: Alex Hay, Yvonne Rainer.

Flyer Designed by Alex Hay.

 * * * * * * * * * * * * *

A CONCERT OF DANCE #3
Judson Memorial Church
55 Washington Square South
Tuesday, January 29, 1963, 8:30 P.M.

Contributions may be made at the door, and are welcomed
toward the continuance of this series of concerts. Those
desiring to add their names to the mailing list may do so
at the end of the program.

1. Yvonne Rainer: WE SHALL RUN
 (performers: Trisha Brown, Lucinda Childs, Philip
 Corner, June Ekman, Malcolm Goldstein,
 Sally Gross, Alex Hay, Deborah Hay,
 Tony Holder, Carol Scothorn, John
 Worden)
 (music: Hector Berlioz)

2. Ruth Emerson: GIRAFFE
 (music: John Herbert McDowell)

3. Steve Paxton (with Yvonne Rainer): WORD WORDS
 (music: from 'Music for Word Words')

4. Elaine Summers: SUITE
 (improvised on a choreographic score)
 a) Galliard
 (performers: Rudy Perez, Elaine Summers, John
 Worden)
 b) Sarabande
 (performed by Ruth Emerson)
 c) Twist
 (performers: Trisha Brown, Philip Corner, Ruth
 Emerson, Malcolm Goldstein, John
 Herbert McDowell, Gretchen MacLane,
 Rudy Perez, Arlene Rothlein, Carolee
 Schneemann, Carol Summers, Elaine
 Summers, Jennifer Tipton, John Worden)
 (music: John Herbert McDowell)

5. Carol Scothorn: THE LAZARITE

INTERMISSION

J U D S O N D A N C E T H E A T R E

presents

C O N C E R T O F D A N C E # 1 3 * * * * * * * * * * * * * * * * * *

A COLLABORATIVE EVENT

with ENVIRONMENT by Charles Ross

Judson Memorial Church

November 19-20, 1963.

PERFORMERS:

 Felix Aeppli
 Joan Baker
 Carla Blank
 Lucinda Childs
 Philip Corner
 Judith Dunn
 June Ekman
 Ruth Emerson
 Lulu Farnsworth
 Marty Greenbaum
 Sally Gross
 Al Hansen
 Alex Hay
Deborah Hay
 Tony Holder
 Jerry Howard
 Susan Kaufman
 David Lee
 Deborah Lee
 Elizabeth Munro
 Rudy Perez
 John Quinn
 Yvonne Rainer
 Charles Ross
 Arlene Rothlein
 Carolee Schneemann
 Larry Segal
 Elaine Summers
 James Tenney
 John Worden

```
================J=u=d=s=o=n===D=a=n=c=e===T=h=e=a=t=r=e=====================
==========================,==========presents================================
= = = = = = = =        M=O=T=O=R=C=Y=C=L=E              = = = =  == = = = = = = = =
============================by==Judith=Dunn==================================
===============Lighting==by==Robert==Rauchenberg============================
```

```
=========================================  Judson==Memorial==Church=====
=========================================  55==Washington==Square==South
=========================================  Friday==December==6,==1963==■=
=========================================  ====================8:30pm.
=========================================  Saturday=December=7,==1963===
=========================================  ===================8:30pm.
==Contributions=may=be=made=at=the=door=,=and==  ===========================
==are=welcomed=toward=the=continuance=of=this==  ===========================
==series=of==concerts.=====Those=desiring=to===  ===========================
==add==their==names==to==the==mailing==list====  ===========================
==may==do==so==at==the==end==of==the==program.=  ===========================
```

```
==============
```

1. MOTORCYCLE

> Judith Dunn, with Arlen Rothlein, voice,
> John Worden, trumpet, and:
> FRI.-Lucinda Childs, Ruth Emerson, Debroah
> Hay, Yvonne Rainer.
> SAT.-Ruth Emerson, Yvonne Rainer.

```
        ==================================================================
```

2. ACAPULCO

> Lucinda Childs, Deborah Hay, Alex Hay,
> Yvonne Rainer.

```
===============
```

3. Fri. - SPEEDLIMIT
> Judith Dunn, Robert Morris.

 Sat. - INDEX I
> Judith Dunn, Steve Paxton.

> Robert Dunn: DOUBLES FOR 4 (1959)
> Alex Hay, Yvonne Rainer, Arlene Rothlein,
> John Worden.

> WITNESS I
> Steve Paxton, John Worden

```
        ==================================================================
```

```
=========================INTERMISSION=======================================
```

```
        ==================================================================
```

THE JUDSON DANCE THEATRE presents

A C O N C E R T O F D A N C E # 1 4

MONDAY, APRIL 27, 196

a p r o g r a m o f i m p r o v i s a t i o n s

1ST HALF:

 30 minutes.
 Choreographers whose improvisations will take place at any time
 within this 30 minute period:

CHOREOGRAPHERS:

CARLA BLANK - SALLY GROSS IMPROVISATIONS:

 "Pearls Down Pat"

LUCINDA CHILDS "Improvisation"

JUDITH DUNN "The Other Side"

ALEX HAY - ROBERT RAUSCHENBERG "Dredge"

STEVE PAXTON "Rialto"

YVONNE RAINER "Thoughts On Improvisation"
 (for the painter Carl Byer)
 James Byars

ELAINE SUMMERS "Execution is Simply Not"

i n t e r m i s s i o n - - - members of the audience are requested to
 take their hats, coats, etc. with them a
 this time as seating will be changed aft
 intermission.

2ND HALF:
PERFORMERS: DEBORAH HAY 25 minute improvisation
 CAROLYN BROWN
 LUCINDA CHILDS
 WILLIAM DAVIS
 JUDITH DUNN
 DAVID GORDEN
 ALEX HAY
 DEBORAH HAY
 TONY HOLDER
 BARBARA LLOYD
 STEVE PAXTON
 YVONNE RAINER
 ROBERT RAUSCHENBERG
 ALBERT REID
 CAROLEE SCHNEEMAN
 JOANNA VISCHER

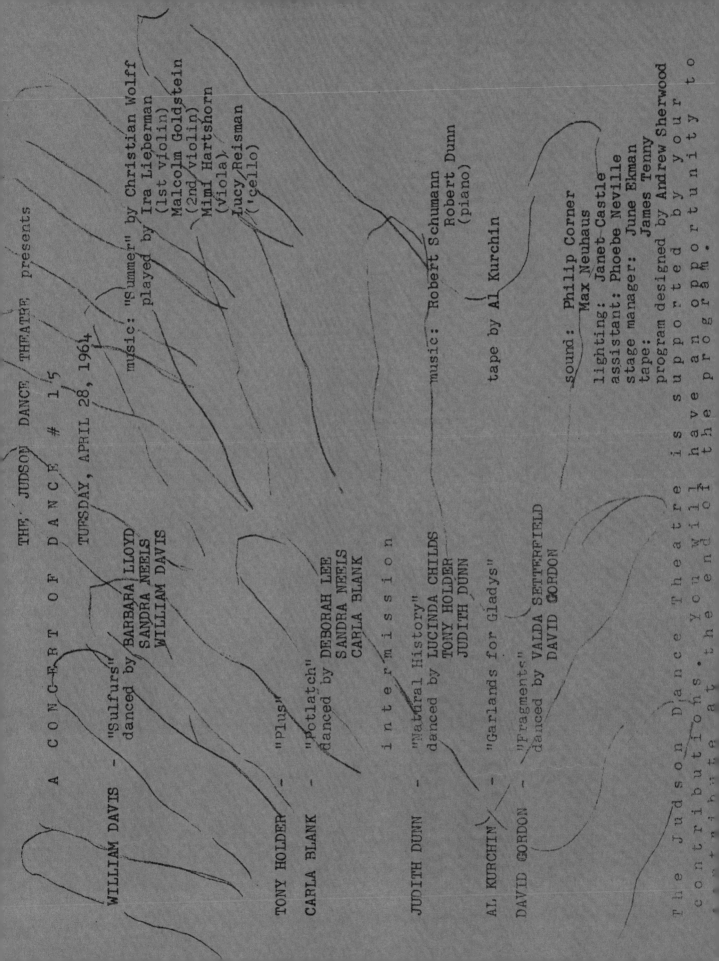

THE JUDSON DANCE THEATRE presents

A CONCERT OF DANCE # 15

TUESDAY, APRIL 28, 1964

WILLIAM DAVIS - "Sulfurs"
 danced by BARBARA LLOYD
 SANDRA NEELS
 WILLIAM DAVIS

 music: "Summer" by Christian Wolff
 played by Ira Lieberman
 (1st violin)
 Malcolm Goldstein
 (2nd violin)
 Mimi Hartshorn
 (viola)
 Lucy Reisman
 ('cello)

TONY HOLDER - "Plus"

CARLA BLANK - "Potlatch"
 danced by DEBORAH LEE
 SANDRA NEELS
 CARLA BLANK

 i n t e r m i s s i o n

JUDITH DUNN - "Natural History"
 danced by LUCINDA CHILDS
 TONY HOLDER
 JUDITH DUNN

 music: Robert Schumann
 Robert Dunn
 (piano)

AL KURCHIN - "Garlands for Gladys"

 tape by Al Kurchin

DAVID GORDON - "Fragments"
 danced by VALDA SETTERFIELD
 DAVID GORDON

 sound: Philip Corner
 Max Neuhaus

 lighting: Janet Castle
 assistant: Phoebe Neville
 stage manager: June Ekman
 tape: James Tenny
 program designed by Andrew Sherwood

The Judson Dance Theatre is supported by your contributions. You will have an opportunity to contribute at the end of the program.

THE JUDSON DANCE THEATRE presents

A CONCERT OF DANCE # 16

WEDNESDAY, APRIL 29, 1964

FRED HERKO - "Villanelle"
 danced by CARLA BLANK music: "Nuits d'ete"
 ABIGAIL EWERT Hector Berlio
 DEBORAH LEE
 SANDRA NEELS
 FRED HERKO

ALBERT REID - "A Brief Glossary of Personal Movements"

LUCINDA CHILDS - "Carnation"

DEBORAH HAY - "Three Here"
 danced by JUDITH DUNN music: "Williams Mix
 TONY HOLDER # 5"
 DEBORAH HAY John Cage

 i n t e r m i s s i o n

SALLY GROSS - "Conjunctions" music: tape by
 Sally Gross

BOB MORRIS - "Site"
 CAROLEE SCHNEEMANN music: tape by
 BOB MORRIS Bob Morris

DEBORAH LEE - "Dance in a Black Dress" music: James Waring
 by: Philip Corner
 (trombone)
 Malcolm Goldstein
 (violin)

SALLY GROSS - "In Their Own Time" music: Philip Corner

PHILIP CORNER - "from keyboard dances"

 lighting: Janet Castle
 assistant: Phoebe Neville
 stage manager: Yvonne Rainer
 tape: James Tenny
 program designed by
 Andrew Sherwood

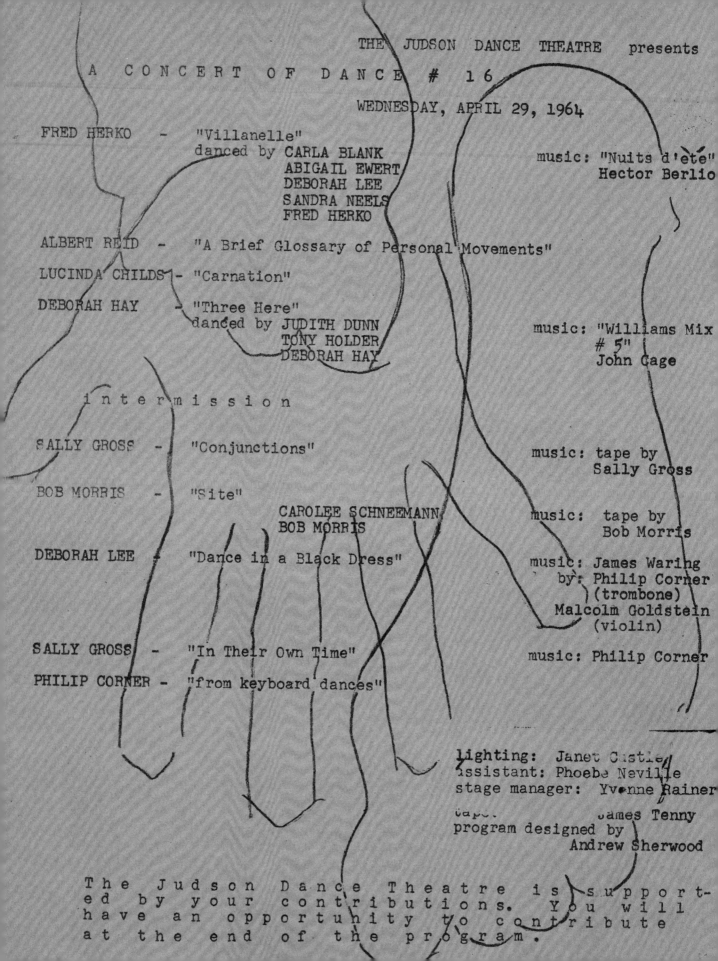

JUDSON DANCE THEATER · THE WORK IS NEVER DONE ·

ANA JANEVSKI & THOMAS J. LAX
THE MUSEUM OF MODERN ART

⌐ Hyundai Card ⌐

Hyundai Card is proud to sponsor *Judson Dance Theater: The Work Is Never Done* at The Museum of Modern Art, New York. The exhibition features the work of pioneering artists who explored genres as diverse as sculpture, performance, film, and photography. These artists confronted hierarchical distinctions between materials and produced unsettling but thoroughly dynamic experiences. Committing itself to the creative disciplines with such intensity, Hyundai Card not only seeks to identify important movements in culture, society, and technology, but also to stimulate meaningful and inspiring experiences in everyday life. Whether Hyundai Card is hosting tomorrow's cultural pioneers at our stages and art spaces; building libraries of design, travel, music, and cooking for our members; or designing credit cards and digital services that are as beautiful as they are functional, the company's most inventive endeavors all draw from the creative well that the arts provide.

As a ten-year sponsor of The Museum of Modern Art, Hyundai Card is delighted to make *Judson Dance Theater: The Work Is Never Done* possible.

12 Foreword
 Glenn D. Lowry

INTRODUCTIONS

14 Allow me to begin again
 Thomas J. Lax

26 Judson Dance Theater: The Work Is Never Done—
 Sanctuary Always Needed
 Ana Janevski

MEETING POINTS

36 Before Judson & Some Other Things
 Adrian Heathfield

44 "The Nerve of a Dancer's Life": Cunningham Class
 and Judson Dance Theater
 Danielle Goldman

52 From Snapshots to Physical Things
 Julia Robinson

JUDSON IN OUR TIME

60 Real People
 Malik Gaines

68 On and Off the Grid: Music for and around
 Judson Dance Theater
 Benjamin Piekut

76 Handling Judson's Objects
 Kristin Poor

82 Elaine Summers's Intermedia
 Gloria Sutton

CONCERTS OF DANCE: PORTFOLIOS

89 Concert of Dance #3: Selection of Photographs
 by Al Giese
 Introduction by Vivian A. Crockett

100 Concert of Dance #13: Selection of Photographs
 by Peter Moore
 Introduction by Vivian A. Crockett

112 Lines of Flight
 Sharon Hayes

A JUDSON HANDBOOK

114 Sites of Collaboration
 *With entries by Harry C. H. Choi, Elizabeth Gollnick,
 and Victor "Viv" Liu*

118 Selection of Annotated Works
 *With entries by Giampaolo Bianconi, Vivian A.
 Crockett, Elizabeth Gollnick, Jennifer Harris,
 Ana Janevski, Martha Joseph, and Thomas J. Lax*

186 Judson Dance Theater Participants

188 List of Works
194 Acknowledgments
198 Photograph Credits
200 Trustees of The Museum of Modern Art

Foreword

Judson Dance Theater marks a crucial flash point in the history of downtown New York City, a charged moment at the beginning of the 1960s in which a group of choreographers, visual artists, composers, and filmmakers came together and changed the trajectory of performance. They transformed Judson Memorial Church in Greenwich Village into a space for experimentation, incorporating into their work ordinary gestures such as running, walking, or even eating a sandwich. They were asking fundamental questions: *What is dance? And what is its place in the world?*

The landmark projects that resulted traversed disciplinary boundaries and championed a collective model rooted in collaboration. *Judson Dance Theater: The Work Is Never Done*, one of the most ambitious performance exhibitions yet staged at The Museum of Modern Art, attempts to spotlight this moment. The exhibition situates Judson in its historical context using photographic documentation, films, sculptural objects, scores, music, poetry, architectural drawings, posters, and archival materials from the period and features a robust performance program in the Donald B. and Catherine C. Marron Atrium. The program shines a light on key protagonists from the Judson era, as well as on contemporary makers whose work engages corresponding concerns. The Judson group's interventions into modern dance's norms—by staging performances in a church, for example, or infusing their work with a sense of spontaneity—stripped the discipline of its theatrical conventions. The ideas they introduced and the questions they posed continue to resonate within dance, art, and performance today.

The Work Is Never Done builds on commitments MoMA has made to a group of artists, including Lucinda Childs, Simone Forti, Deborah Hay, Robert Morris, Steve Paxton, Yvonne Rainer, Robert Rauschenberg, and Carolee Schneemann, and reflects the Museum's broader engagement with dance and performance—an engagement that has been amplified since 2009, when the Department of Media and Performance Art was founded by Klaus Biesenbach. Today the Department, led by Stuart Comer, upholds this responsibility with its rich and dynamic programs of performance and dance and its consideration of the ways the Museum can extend its core commitments—collecting, preserving, and documenting art—to performance and time-based work. One example is Forti's Dance Constructions, a series of influential sculpture and dance works from 1960 and 1961. The Museum acquired them in 2015, and since then the Dance Constructions have become the most loaned works from the Department's holdings. We are thrilled to feature them in the exhibition—the first time they will appear at MoMA since entering the collection.

While newly reignited, MoMA's engagement with dance and performance is long-standing, stretching back to the institution's earliest days; this engagement is central not only to the Museum's history but also to the development of modernism in the United States. In 1939, MoMA established the Dance Archives, providing a specialized research collection for the study of dance; in the mid-1940s, the Dance Archives became the short-lived Department of Dance and Theater Design. In the 1960s and 1970s, the Museum presented

works of dance and performance by Forti, Paxton, Elaine Summers, and many others in the Sculpture Garden as part of Summergarden. Today the Museum is making an institution-wide effort to recognize artistic influences across disciplinary boundaries, including dance and performance; a major expansion will include a space dedicated to performance, and exhibition galleries will be arranged to better accommodate multiple mediums simultaneously. *The Work Is Never Done*, insofar as it highlights the cross-disciplinary origins of New York's experimental downtown scene in the 1960s, is a harbinger of the Museum's future.

We are indebted to Ana Janevski, Curator, Thomas J. Lax, Associate Curator, and Martha Joseph, Curatorial Assistant, in the Department of Media and Performance Art. Led by Judson's spirit of collaboration, they have crafted the exhibition, the performance program, and the volume you now hold, encouraging new readings of this fascinating moment.

We are especially grateful to the generous supporters of this project: Hyundai Card, Monique M. Schoen Warshaw, The Jill and Peter Kraus Endowed Fund for Contemporary Exhibitions, MoMA's Wallis Annenberg Fund for Innovation in Contemporary Art through the Annenberg Foundation, The Contemporary Arts Council of The Museum of Modern Art, The Harkness Foundation for Dance, and The Annual Exhibition Fund, including major contributions from the Estate of Ralph L. Riehle, Alice and Tom Tisch, The Marella and Giovanni Agnelli Fund for Exhibitions, Mimi and Peter Haas Fund, Brett and Daniel Sundheim, Franz Wassmer, Karen and Gary Winnick, and Oya and Bülent Eczacıbaşı. MoMA Audio is supported by Bloomberg Philanthropies.

On behalf of the Trustees and staff, we would like to thank all the lenders to the exhibition. We would also like to recognize the various local institutions that have historically supported artists making work in dance and performance, including Judson Memorial Church, which remains a socially engaged religious and cultural site; Movement Research; Danspace Project; and the Department of Performance Studies at New York University.

Finally, I would like to extend my gratitude to all the artists involved for their generosity and collaboration on this project. Their work is proof that a group of people can incorporate their everyday experiences into their art and, in the process, change the world around them.

Glenn D. Lowry
Director
The Museum of Modern Art

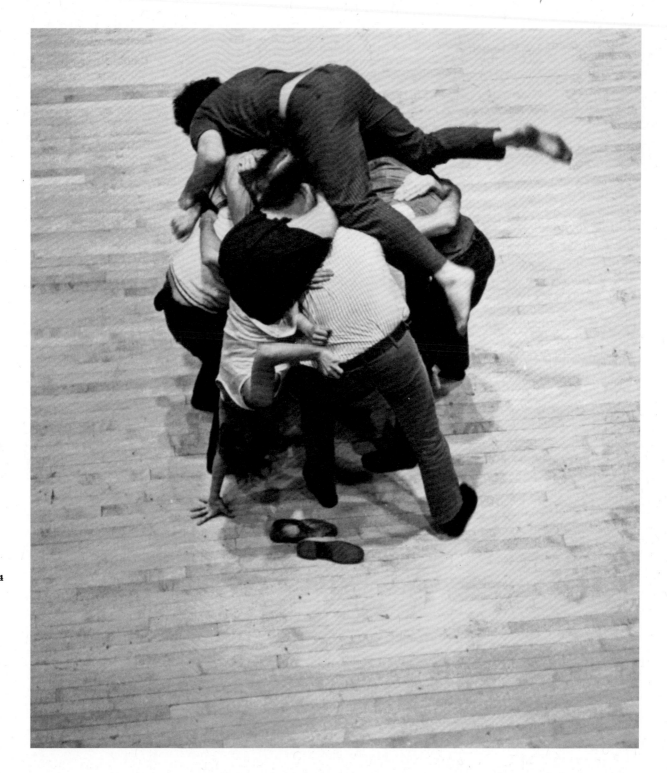

Much has been written about Judson Dance Theater;[1] yet the choreographers, composers, filmmakers, and artists who came together in the early 1960s at Judson Memorial Church on Washington Square Park never wrote a definitive statement declaring their collective intentions. Unlike earlier groups of artists associated with Europe's early-twentieth-century avant-gardes, the various makers who performed at the first Concert of Dance on July 6, 1962, had neither a unified aesthetic nor a political program, functioning without a designated leader. Their story is one of mutual refusal.

After being turned down from the annual Young Choreographer Concert at the 92nd Street YM-YWHA,[2] three choreographers—Ruth Emerson, Steve Paxton, Yvonne Rainer—and their teacher, Robert Ellis Dunn, auditioned late one afternoon for Al Carmines, a Protestant minister who had been recently appointed head of cultural programming at Judson Church. Carmines approved, and their first public performance was attended by more than three hundred people. Dance critic Jill Johnston, writing in the *Village Voice*, celebrated the fourteen choreographers and seventeen performers who participated in the "democratic evening of dance" and suggested that the "young talents . . . could make the present of modern dance more exciting than it's been for twenty years."[3]

Despite the historical terms in which Judson was heralded by critics, its protagonists were more self-effacing. In a press release issued several months after the July concert, an unsigned statement matter-of-factly telegraphed the group's ambitions: "These concerts [were] initiated at the church . . . with the aim of periodically presenting the work of dancers, composers, and various non-dancers working with ideas related to dance. It is hoped that the contents of this series will not so much reflect a single point of view as convey a spirit of inquiry into the nature of new possibilities."[4] To collaborate, to inquire rather than take a position—such was the spirit of this interdisciplinary group of trained and amateur dancers who came together to experiment and show their work.

However, it was not long before the participants began to signal the group's impending end.[5] A consistent chronicler of the group's work, Rainer wrote that following some "splinter concerts," Judson participants began "to drop out . . . a natural outgrowth of particular aesthetic and social alignments that were both complicated and schism-making."[6] Robert Morris—a sculptor and performer, as well as Rainer's partner at the time—reviewed a February 1966 concert featuring David Gordon, Paxton, and Rainer, noting that they were already re-presenting their own work. He self-consciously linked this recurrence to historic avant-gardes: "Every movement in art in this century has been characteristically brief. . . . In each of these movements . . . 'open' positions were very early closed out. What follows after the primary positions have been filled is, of course, tradition."[7] For Morris, Judson's moment in the early 1960s was of historic consequence precisely because of its brevity.

Finitude is a funny kind of distinction, mostly because Judson never really ended. It never formally disbanded because it had never codified itself as an organization or described itself as a collective to begin with. Today the term *Judson* acts as a stand-in for some of the hallmarks of postmodern dance: the use of so-called ordinary movement, those gestures more common to everyday life than to dance studios, as well as composition strategies thought to favor spontaneity, such as allowing a situation, an environment, or a dancer's interpretation of a set of instructions to determine a work's structure and content. These tenets continue to inform much of contemporary dance as well as contemporary art. However, Judson is but one origin story for the belief in contemporary art and performance that mundane, everyday action and speech are meaningful and that art is made as much at the places where people gather as in the isolated space of a studio; that assembly and the disagreements that ensue are as much art's means as its ends. And, like all origin stories, Judson's legacy is hazy and contestable, despite the real effects it has had for artists and choreographers working in its wake.

If what today we call "Judson" began as a short-lived moment of creative inspiration in the early 1960s, what were the conditions that allowed this historical moment to emerge? Johnston—who, in addition to reviewing Judson concerts for the *Voice*, organized several events with the Judson artists and made lecture-performances—rallied against the force of origin narratives in a 1965 article aptly called "Untitled": "There's only one genealogy. It takes place in our dreams. Every specific genealogy

15

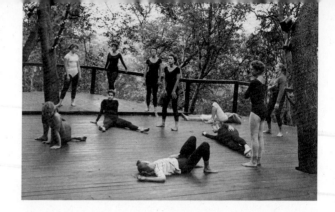

is a fiction."[8] The essay you are reading, an introduction to the exhibition *Judson Dance Theater: The Work Is Never Done*, is one such fiction; it traces the workshops in which the ideas that would lead to Judson were developed and accounts for those forms of aesthetic and social experimentation that occurred simultaneously and in close proximity. This fiction, unlike earlier art-historical considerations, does not emphasize how the group influenced a generation of male Minimalist sculptors concerned with, for example, drawing analogies between the mass and gravitational pull of an art object and those of a human body.[9] Rather, this introduction, much like the exhibition it accompanies, situates Judson in the late 1950s and early 1960s—in the workshop model that was part of the traveling culture that migrated from Europe to the United States during and after World War II; in the experiments in cross-medium collaboration that were reemerging in the visual arts, music, and poetry; and, finally, in the antagonisms and attachments that formed between a group of artists who would work together over a period of some years. Later, in the mid-1960s and '70s, many of these figures would associate themselves with the second-wave feminist, anti–Vietnam War, gay and lesbian pride, and Black Power movements—aspirational efforts that differently claimed the intimacy of everyday life as a contestable political space, and which are still being struggled over in our time. (#MeToo and Black Lives Matter, to name just two of today's most vibrant forms of contemporary political organizing, have demonstrated the ways that collective actions can respond to violations that occur behind closed doors or on the street.) By situating my genealogy in the period immediately before these broad social changes, I mean to ask: how did a subset of cultural practices, which would become formative for an overlapping group of artists, offer an opportunity to experiment with this fraught question of personal and collective identification that has so fueled the political gestures of subsequent social and artistic movements?

The workshop . . . was really a sort of utopian thing that had to fall apart. —Robert Ellis Dunn

By using a rehearsal format for their weekly meetings, the Judson members implicitly recalled another set of workshops led by choreographer, dancer, and teacher Anna Halprin (then Ann) at her home in northern California. Halprin had trained as a dancer in Madison at the University of Wisconsin with Margaret H'Doubler, a former gym teacher, whose pedagogy focused on how

the skeletal structure affects the body's movement rather than on formal dance technique. Anna's students, some of whom would go on to join Judson, gathered on the Dance Deck (fig. 2) built by her husband, Lawrence, a landscape architect and former student of Bauhaus founding director Walter Gropius. The Halprins borrowed the workshop idea from Gropius, who as a teacher found workshops a valuable way to bring together artistic practices across disciplines.

Anna began teaching two-week workshops on her Dance Deck in the summer of 1954; in August 1960, eighteen participants, including Trisha Brown, Ruth Emerson, Forti, and Rainer, arrived for what would be a historically influential exchange (fig. 3). Anna used improvisation to explore each person's capability for movement invention; she did not teach specific techniques or movement patterns.[10] The workshops linked improvisation to observation, borrowing prompts from the immediate surroundings: ants scurrying along an anthill; water running in a creek; trees swaying or standing stalwart.[11] Ecological phenomena were considered both social and aesthetic forms that could be witnessed and then imitated. Anna also used improvisation to repattern habitual bodily responses to choreographic input. She might, for example, show her students a limb on the model skeleton in her studio and then ask them to move as they paid attention to the effect of gravity on that part of the body.[12] The simple tasks she assigned, such as running in a circle with a branch, encouraged her students to observe the particular kinesthetic shifts that transpired while handling various objects from nature.[13]

Anna's workshops also hosted poets and musicians so that language and sound began to play an increasingly important role in their explorations. "We began to allow the voice to become an integral part of movement," Halprin recalls, "where breathing became sound or some heightened feeling stimulated certain associative responses and a word came, or a sound, or a shout. Free-association became an important part of the work. We began to deal with ourselves as people, not dancers."[14]

Forti, Rainer, and others who attended the workshop used their voice as an instrument, externalizing internal bodily functions like breathing or associative thinking by making them audible. They spoke aloud text plucked from dialogue they had overheard or had themselves participated in, leaving behind its narrative context. They vocalized emotion with nonlinguistic noises—sound fragments borrowed from animals or technological devices.

Composers La Monte Young and Terry Riley served as musical directors for Anna's workshops from 1959 through 1960. As her collaborators, they became important channels for the dispersal of her ideas. On the first day of the 1960 workshop, Young presented his "Lecture 1960" on the Dance Deck over a three-hour period. The lecture consisted of reflections on the activities of his artist friends and their use of sounds like clapping and chatter to make music, which he presented in a randomized order. He also premiered new text-based work, including the first of his Compositions 1960. These scores—or notations for performances—ask the performer to accomplish tasks at once mundane and whimsical, such as building a fire in front of an audience without standing between fire and audience, or turning a butterfly loose in the performance area and allowing it to fly away. The first example emphasizes that the performer is herself an observer, nearly indistinct from the audience; the second underscores the permeable boundary between the stage and the reality it constructs and by which it, too, is constructed. That summer, Young continued developing these works, combining instruction-based, quasi-conceptual exercises while engaging with the natural world, a reformulation of Anna's ethos.

Young's presence pushed Anna's workshops toward composer John Cage's interest in chance operations, juxtaposing material drawn from wildly different parts of the observable world. When, back on the East Coast in fall 1960, Dunn—accompanist to Merce Cunningham, who was Cage's artistic and life partner—announced a composition class in Cunningham's dance studio (fig. 4, page 18), five students signed up,

including Forti, Paxton, and Rainer;[15] it was Cage, Dunn's former teacher at the New School in New York, who had urged him to teach the course. Although Dunn was not a choreographer, he had taught percussion composition for dance accompaniment at Boston Conservatory under choreographer Mary Wigman. At the time, Robert was married to Judith Dunn, a Cunningham dancer who assisted and subsequently taught the class with her husband. The Dunns offered four courses between 1960 and 1962 and a fifth in 1964, each of which included ten to twelve sessions roughly two and a half hours in length. They charged twelve to fifteen dollars for the entire course, a fee that could be waived.

The Dunns' class was informed by Cage's interest in structure—the successive parts of a composition—and his emphasis on observation and discussion over evaluation. Robert often borrowed theologian Thomas Aquinas's remark that "each angel is one of a species" to encourage students to focus on watching and describing their peers' work rather than simply approving or disapproving of it.[16] He brought in musical scores as prompts for various assignments, including the gnomic "Trois gymnopédies" by early-twentieth-century composer Erik Satie. Students were asked to make dances that corresponded to the number of measures in the music—its "time-structure" or "number structure"—without taking the melody or its affective qualities into account, ideas then associated with modern dance choreographers like Martha Graham and José Limón. The Dunns gave other assignments that used time-based structures, sometimes inscrutably: Make a five-minute dance in half an hour.[17] Do something that's nothing special.[18] These koanlike instructions were part of Robert's intention to make his class "a clearing," or a "space of nothing," and reflected the effect of Zen Buddhism on his teaching method, introduced to the Dunns, Cage, and others in their downtown cohort through the writings of teacher and monk Shunryū Suzuki.[19]

Indeterminacy, or the ability of a composition to be performed in substantially different ways, was likewise

important in the Dunns' workshops—again, due to the influence of Cage.[20] The chance-based composition strategies Cage advocated generated incongruities deserving of slapstick antics—imagine, for example, juxtaposing "percussive" with "ankle," as did one assignment that randomly combined movement qualities and body parts. Chance-based practices also encouraged the performers to de-emphasize artistic intent—a form of self-abnegation drawn from Zen Buddhism—eliciting unexpected forms of collaboration. For example, the Dunns sometimes asked the participants to score a movement sequence and pass the score to a partner, who would interpret both her own score and the one she was given, yielding four distinct phrases. These phrases would be further adapted by other members of the workshop.[21] The variability in how a dance was interpreted suggested that the contribution of the interpreter was on a par with that of the author.

While the workshops encouraged participants to examine their preconceived notions of taste and to give up some authorial control, stylistic tendencies nevertheless emerged. Robert recalled a division between what he identified as two antagonistic traditions: architecture and camp.[22] While Dunn himself aligned with the former, James Waring, who taught many of the same students in his composition classes at the Living Theatre in 1959 and 1960, was associated with camp—a coded, know-it-when-you-exhibit-it term that cultural critic Susan Sontag used in her influential 1964 essay to describe a "sensibility . . . of artifice and exaggeration . . . of failed seriousness."[23] Unlike Dunn, Waring spent years formally training as a dancer. He studied ballet at both San Francisco Ballet School and the School of American Ballet in New York and took classes with Anna Halprin at the Halprin-Lathrop studio in San Francisco with choreographer and teacher Welland Lathrop. "Everything changes all the time,"[24] Waring frequently told his students. His theatrical compositions encompassed this sense of flux by juxtaposing various incongruous genres with one another, including vaudeville and classical ballet. They featured simultaneous, idiosyncratic

events moving independently of each other. In a *Village Voice* review, Beat poet Allen Ginsberg described Waring's 1958 *Dances before the Wall* as "rather like the parts of a snake or scorpion cut in pieces scattering in different directions, but all pieces of one life: uncanny."[25] Waring's works were all-inclusive, combining costumes, music, and flyers he designed into his theatrical collages. Waring also included non-dancers in his work. As Rainer observed, "His company was full of misfits—they were too short or too fat or too uncoordinated or too mannered or too inexperienced by any other standards."[26]

Waring's classes at the Living Theatre, located at Fourteenth Street and Sixth Avenue, in the same building as Dunn's, were fonts of interdisciplinary exchange (fig. 5).[27] The group spent no small amount of time talking. Gordon, who regularly attended the classes, recalls how Waring's evening classes "always began or ended with Jimmy sitting in a chair wearing a too big sweater, sniffling comments on what was going on around town."[28] The classes spilled over into his life and work. He invited several of his students to be in his work or to present their own at the Living Theatre, including Gordon, Gordon's wife and Cunningham dancer Valda Setterfield, Rainer, Childs, Hay, and Fred Herko.[29] This model of support was an extension of Dance Associates, the member organization he cofounded in 1951 (dubbing it "Dance Eclectics") with dancer and archivist David Vaughan for their friends, including Edward Denby, Aileen Passloff, and Paul Taylor, to provide them with an annual performance venue. If Halprin offered improvisation as a tool to repattern trained bodily responses, and the Dunns—via Cage—offered scores and chance composition as alternative modes of authorship, Waring offered a form of mutual aid that brought dancers, theater folk, visual artists, and ordinary people into close proximity. In the classroom, students given the same assignments responded in unique ways. Both organizing and disorienting, these composition classes foregrounded environment and sensory experience as the primary source of artistic identity and collective attachment.

Left: (4) Robert Rauschenberg's photograph of Merce Cunningham Dance Company prior to its world tour, Cunningham Studio, 1964. Pictured, from left: Barbara Dilley, John Cage, Sandra Neels, Shareen Blair, and Robert Rauschenberg (seated); Merce Cunningham, Carolyn Brown, Steve Paxton (hidden), William Davis, and Viola Farber (standing). Opposite: (5) Edward Oleksak's photograph of James Waring teaching with Fred Herko at the Living Theatre, n.d.

By summer 1962, the Dunns' classes had grown so large that the end-of-semester performance was too big to fit in Cunningham's loft. After the group was refused by the Young Choreographers Concert, Carmines agreed to host the group at Judson Memorial Church. Robert created a program for the first concert, encouraging the choreographers and dancers to adopt the same casual, unselfconscious sensibility in the church as they had in the loft: "The early concerts that we had at Judson had this wonderful feeling of space and of involvement with the audience because the dancers were not trying to mock up a . . . stage in a church. It was the area it was."[30]

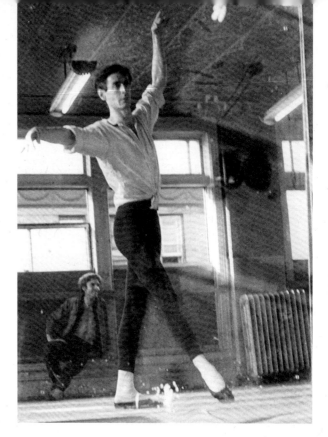

The ensemble: the social situation in which we find ourselves. —Al Carmines

When Robert Dunn described the early concerts at Judson Memorial Church as having treated the church as the "area it was," what did he mean by this? The church had long committed itself to nonreligious forms of support for congregants and community members alike through the Judson Clinic, founded in 1920 to serve Italian American immigrants in the tenements south of Washington Square, as well as the Student Co-op, which housed students from small towns in the South and Midwest.[31] After World War II, the church's leadership continued their engagement with the surrounding community: Robert (Bob) Spike, who became the church's senior minister in 1949, opened up the building's basketball court to public use and established Judson House, an interracial dormitory.[32] Howard Moody, who became reverend in 1957, oversaw the Village Aid and Service Center, one of the first drug-treatment facilities that offered counseling and services to narcotics users in 1960. He defended folk singers, who had played informally at the church during Sunday gatherings since the 1940s, when they were banned from Washington Square Park by the parks commissioner in 1961. And, in 1967, he established the Clergy Consultation Service on Abortion, a network of ministers and rabbis to counsel and refer pregnant women to safe, low-cost abortion providers before the procedure was legalized. At Moody's ordainment, his professor at Yale Divinity School Kenneth Underwood had summarized this social approach to theology when he invited his students "to remember that the fundamental symbol of Protestantism is not the pulpit, where ideas are delivered by a pastor . . . [but] a communion table."[33]

As the church expanded its engagement with its constituency, its commitment to local artists grew too.

In 1959, an associate minister, Bernard "Bud" Scott, invited several artists, including Marcus Ratliff (who was living at Judson House at the time), Tom Wesselmann, and Jim Dine, to turn the basement of Judson House into a one-thousand-square-foot studio and exhibition space—what would become the Judson Gallery. Artist Claes Oldenburg organized exhibitions and Happenings in the space from 1959 to 1960, while Allan Kaprow did the same from 1960 to 1962.[34] When Carmines replaced Scott as the head of cultural programming in 1961, he founded Judson Poets' Theater, an alternative to off-Broadway performance spaces, before welcoming Dunn's workshop into the church. Carmines, who had studied at Union Theological Seminary in New York, was also a composer, actor, singer, and director and understood the parallels between the new arts and new theology. Acknowledging what the church had learned from Judson, he affirmed their mutual commitment to "the ensemble: the social situation in which we find ourselves."[35] For Carmines, it was the importance of the group that linked new dance to new theology.

If for new theology the emphasis on the ensemble was sited in worship, for the new dance the interest in the ensemble can be traced—at least as one example—to Forti and her 1960–61 Dance Constructions. On May 26 and 27, 1961, Forti presented Five Dance Constructions and Some Other Things at Yoko Ono's

The front page of the Village Voice, September 5, 1963.

Above: (6) The front page of the
Village Voice, September 5, 1963.
Opposite: (7) The cover of the
Floating Bear no. 29, March 1964.
Edited by Diane di Prima and
LeRoi Jones

loft at 112 Chambers Street in New York. The evenings were organized by Young and included Paxton, Rainer, and Morris, who manufactured the first sculptures used in the performances.[36] Young, who had seen Forti perform a suite of dances the previous year as part of one of Kaprow's Happenings at Reuben Gallery, asked Forti to expand on these dances for the concerts.[37] The movements in each of Forti's nine works were generated by manipulating and moving objects or by following a set of rules that frequently pushed the performers to their physical limits.[38] Each work was shown in a distinct area of Ono's loft, often more than one at a time, much like a group of sculptures that the audience could move around to view from all sides. Forti's choice of materials—unadorned planks and hanging ropes—provided a material trace of the loft in which they were shown. And by titling her works Dance Constructions, Forti further joined movement with sculpture, a signal to her public that she was working across different mediums and that what she made should be interpreted according to the logic of this blurring.[39]

Forti's concert made forceful, sometimes paradoxical claims about the heterogeneous character of social interaction. Rainer recalls, "The evening began with *Herding*. All of us performers herded the audience from one end of the huge loft to the other several times. This unusual relation to spectators seemed whimsical and good-natured in its unassuming demonstration of limited power. . . . No one protested."[40] While the performers entered the space as audience members dressed in street clothes, Forti quickly established who was in control. *See Saw* created a more intimate display of power and play. Morris and Rainer stood on opposite sides of a seesaw that they had assembled in real time by placing a long wooden plank on top of a sawhorse. When the work is restaged today, Forti asks that the two performers be selected in such a way that their pairing can "reflect domestic life."[41] As the performers stand on the plywood and try to maintain equilibrium, they inevitably shift up and down: a physical manifestation of the oscillations that occur between two friends, artistic collaborators, or lovers. *Huddle*, another work shown that night, bears its own social implications (fig. 1, page 14). The only "construction" that doesn't exist in a solid sense, but that can be reconstituted at any time, *Huddle* consists of a group of six to nine people who bond together in a tight mass while standing, then take turns climbing over the top of their self-made structure. The work lasted ten minutes. Art historian Julia Bryan-Wilson has said *Huddle* calls to mind "a slow-motion depiction of teeming

insects, like swarming bees, a fulminating energy knot that has been decelerated as if for the viewer to inspect it."[42] Like a herd, Forti's *Huddle* evidenced the various ways people act when assembled into a group: cooperative, recalcitrant, animalistic.

<p style="text-align:center">*</p>

While Forti's Dance Constructions implied that social interactions are marked by power, activist and writer Jane Jacobs simultaneously developed a language to describe the tensions in the burgeoning and contested notion of "downtown" in US cities. In prose that unintentionally echoed the Judson artists' juxtaposition of traditional form with pedestrian movement, Jacobs described what she called an "intricate sidewalk ballet" in her 1961 *The Death and Life of Great American Cities*. Calling sidewalks the art form of the city, she likened their use to a "dance—not to a simple-minded precision dance with everyone kicking up at the same time, twirling in unison and bowing off en masse, but to an intricate ballet in which the individual dancers and ensembles all have distinctive parts which miraculously reinforce each other and compose an orderly whole."[43] This vibrant celebration of Jacobs's Hudson Street in the West Village was a poetic protest against contemporaneous forms of "progressive" city planning, most notoriously embodied by public official Robert Moses. Known as "the Highwayman," Moses sought to turn the city into a dense web of highways. In the early 1950s, he proposed a plan to build a forty-eight-foot, four-lane road or tunnel through Washington Square Park directly in front of Judson Memorial Church.[44] The plan would have made the sidewalks associated with the street culture of the city's working poor and people of color inaccessible. Sidewalks were also, according to Jacobs, what made the city both creative and safe.[45] In response to Moses's proposal, Jacobs cofounded the Joint Emergency Committee to Close Washington Square Park to Traffic, an alliance of community groups and local families, to thwart Moses's efforts. The group found success in 1963 when public buses were rerouted away from the park and pedestrians were given free reign over it (fig. 6).[46] This decade-plus fight for public space occurred immediately in front of Judson Church; in their use of "pedestrian" techniques like walking and running, Judson choreographers were unwittingly inverting Jacob's articulation of everyday movement as dance, turning a contested physical gesture into aesthetic form.

The forces of racial segregation that were gathering immediately outside of Judson Church and throughout the city informed the terms of social inclusion at Judson Dance Theater. Judson was predominantly made up of white artists, but black culture nevertheless persisted in its sanctuary. Reflecting on the early years of his collaboration with Judith Dunn at Judson and elsewhere, trumpet player and jazz composer Bill Dixon noted that although he was never treated rudely by the postmodern dance scene in New York, he did experience subliminal racism: "Something wasn't right," he reflected to scholar and dancer Danielle Goldman on his time at Judson. "Judson Church was a long five miles away from the work I was doing up at 91st street," the site of his 1964 October Revolution in Jazz at the Cellar Café.[47] While Dixon was one of the few figures of African descent in the milieu, black dance and music were not absent from Judson. Rainer, Forti, and Nancy Meehan—who had met at Martha Graham's school—made improvisations together in 1960 while playing a solo piano record by Thelonious Monk and music by Miles Davis in a rented rehearsal space at Dance Players on Sixth Avenue.[48] In addition to her reviews of downtown performances, Johnston celebrated choreographer Alvin Ailey's masterpiece *Revelations* when it was performed in 1961.[49] Closer to the Judson sphere, the *Floating Bear* (fig. 7)—a mimeographed semimonthly "newsletter" of new poetry, art reviews, and gossip established in 1961 and sent by mail to a designated readership—was edited by the poets

Diane di Prima and LeRoi Jones (who would change his name to Amiri Baraka in 1965, after Malcolm X's assassination). Produced every other Sunday at Jones's family's Fourth Street apartment, it was an all-out collaboration: Waring typed, jazz composer Cecil Taylor ran the mimeograph machine, and Herko and di Prima collated the pages, with everyone pitching in to address the envelopes.[50] Even if at the Judson Concerts of Dance there were few performers of color onstage, the behind-the-scenes work at adjacent sites of collective publication like the *Floating Bear* included a broader chorus of "everyday people."[51] Black people— or at least black men—participated in these new forms of communing and criticizing, but perhaps in such a way that elicited Dixon's sense of estrangement.

The interracial, sexually frank writing published in *Floating Bear* made it both an object of state repression— in 1961, Jones was arrested by two postal inspectors and a federal agent for sending obscene materials through the mail—and a rag for some of the earliest and freshest critical writing around Judson Dance Theater. In di Prima's review of the first Concert of Dance, she described Herko's *Like Most People*, in which Herko performed inside a Mexican hammock with brightly colored stripes to Taylor's "exciting playing on piano."[52] Two years later, Warhol star Gerard Malanga's memorial poem to Herko would appear following the dancer's suicide.[53] In one particularly trenchant repartee between Waring and poet and essayist Diane Wakoski, he responded to her criticism that Rainer lacked originality because of the influence of Forti and Halprin on her work: "The idea of 'originality' as a criterion of value is a relatively modern one, and one which inevitably is doomed to fade again from fashion."[54] Waring understood that it was precisely Rainer's continuous relation to her teachers and peers—their shared interest in compositions made from incommensurable associations and their mutual interest in rendering repetition as a value in itself—that made her dances vital and worthy of love. Social bonds induced gossip and shade; but they also were the font of the work.

The editors of the *Floating Bear* would extend the same discerning frankness to the writing they published elsewhere. Jones, for example, wrote about the work of his *Floating Bear* colleague Taylor among his various considerations of black avant-garde music, later collected in his volume *Black Music* (1967). In Taylor's music, Jones found much to be supportive of. In his review of the 1962 album *Into the Hot*, Jones wrote that Taylor's contributions "redemonstrate that the gifted jazz soloist, even the innovator, can function on a highly creative level

in the context of formal composition."[55] He painted the musician as innovative improviser and constructivist composer, virtuoso soloist, and band leader, who was capable of building "a whole, integrated structure," in which cacophony and dissonance proliferated. (Taylor's social experiments in music extended beyond human sound to what he called "other musics": the grass and trees, for example, on the other side of Boston's railroad tracks where he studied at the New England Conservatory.[56]) And yet these affirmations were offset by Jones's marked ambivalence, what poet and critic Fred Moten has described as "veiled and submerged distancings, critiques, outings."[57] Indeed, some of Jones's prose included coded stereotypes about queer black men. He described Taylor's use of the waltz "This Nearly Was Mine," sung by a wealthy French planter living in Polynesia in the musical *South Pacific* by Rodgers and Hammerstein—who were consistently interested in portraying cross-racial sexual encounters—as "under ordinary circumstances . . . one of the most terrifyingly maudlin pop tunes of our time."[58] Jones's description suggests that Taylor had managed to redeem himself from what in other circumstances was "mere" sentimentality. Elsewhere he celebrated Taylor as "always *hotter, sassier* and newer than" Third Stream music—a backhanded compliment, as this other synthesis of jazz and classical music had fallen out of Jones's favor.[59] (The sassy italics are Jones's.) Sexuality, like race, was a coded key for inclusion.

Taylor and Jones are just two figures peripherally associated with Judson; but Jones's criticism, while built out of mutual respect, is nevertheless symptomatic of conflicts that undergirded Judson's overall reception— sexual identity among them. Art historian Michael Fried, in his disparaging assessment of Minimalist art, "Art and Objecthood," expressed his own distance from queerness in his take on the larger Judson group. In the essay, Fried argues feverishly against Minimalist art's theatricality—its emphasis on the spectator's encounter—as well as what he calls its "literal biomorphism," by which he means the way these art objects remind of him of real humans. Yet Fried makes his own slippery conflations between objects and people when he criticizes artworks of a "general and perversive condition" as "artificial," "superfluous," "hidden," "degenerate," "aggressive," "corrupted or perverted by theater"— adjectives used to stereotype people who might have also been pejoratively called "queer" at the time.[60] Fried ended up on the wrong side of art history, and while his essay is today something of a punching bag for art historians and critics, one can still trace the soul-shaking

effects of the work he witnessed: repulsion is a lasting archive. Fried was a frequent visitor to Judson Dance Theater, which informed his take on the Minimalist art he wrote about; in his repressed discourse, he expressed his latent fear of the queer sexualities he first sensed in the makers and then projected onto their artworks.

In recoiling from the personal, extra-aesthetic dimensions of the work they were describing, both Jones and Fried were alluding to what Jill Johnston once referred to, in her description of the work of Lucinda Childs, her romantic partner in the mid-1960s, as "something outside the closed and completed work as a component within the work"—or, to put it another way, *process*.[61] For the artists at Judson, process often pointed to the sweaty, knotted labor that making art necessitates. We see this in Morris's *Site*, of 1964, in which the artist, wearing a white painter's uniform and work gloves, a soundtrack of jackhammers in the background, reveals a nude Carolee Schneemann standing in for the sex worker Édouard Manet presented in his painting *Olympia* (1863). And we see it in Yvonne Rainer's 1965 "Corridor Solo," which would be recycled the same year in her *Parts of Some Sextets*, a dance about sleeping, in which ten dancers variously stack, unstack, and carry twelve store-bought mattresses as Rainer reads from her journals: "Those familiar beds. Those unfamiliar beds. Those one night beds. Those beds on the way somewhere in the night. How many sleepings like that?"[62] In placing the middle-of-the-night work it took to make art center stage, these artists were not only self-reflexively shoring up the material conditions of artistic production and aestheticizing a variety of kinds of labor; they were also putting the intimate flotsam and jetsam of their daily lives onstage as part of what it meant to make art. When Paxton and Rauschenberg, who were living together, tumbled in tandem and touched and carried each other in both Paxton's 1964 *Jag vil gärna telefonera (I Would Like to Make a Phone Call)* and Rauschenberg's 1965 *Spring Training*, weren't they also presenting a pared-down summation of the common actions that occur between two lovers? When Andy Warhol filmed Johnston and Herko smoking cigarettes, drinking beer, and vamping for the camera on a rooftop in *Jill and Freddy Dancing* (1963), wasn't he also capturing the boredom and excess that the workaday city can produce for two romantic friends? These works were not autobiographical, but they did implicate the specific people that made them. In doing so, these artists suggested that art and writing mattered outside of the history of a specific, rarefied discipline. It could mean something within the context of a neighborhood block (Hudson Street, in the case of Jacobs); or the place where a work was made (a bathtub, for David Gordon's *Mannequin Dance*, of 1962). Art making leaves traces. Attention to self-reflexivity and an unconscious manifestation of the substructural relations of production were not only modernist and Marxist holdovers concurrently being played out on the national and world stages; they were also realities being framed and worked through by an entangled group of individuals in a changing city. The context that made up the city's domestic spaces—that two men could live with one another; that a married couple could easily get divorced; that former industrial spaces could be used for groups of people to live and work; that a woman could live with another woman or live alone—were transmuted into the art language these artists made together.

In an exhibition catalogue this museum published in 1959, Rauschenberg famously said that he tried to "act in the gap between [art and life]";[63] but what is often unacknowledged in this formulation is the way that art, like life, is processual, alienating, or half-grasped. Across various overlapping circles downtown, sites of collaboration shaped the content and structure of the work being produced. For many artists, and the communities in which they lived, ensembles sustained their work, offering creative support and blurring distinctions between artist and participant. Group dynamics also brought out forms of racial and sexual exclusion, reflecting rather than transcending the shape of New York's social map at the time. Choreographers, poets, musicians, theater producers, and filmmakers working in the early 1960s not only made work together; they also pictured the steadfast and divisive social relations that informed their work *as the work itself*.

Whether at a performance or out on the street, being alone could become an occasion for becoming part of an integrated structure, even if its totality remained unseen. There is something inchoately queer in the primacy of physical proximity and the simultaneously connective and disorienting experience of touch, if we understand queerness to be "a matter of a world you inhabit, not something you simply are," as art historian Douglas Crimp has described it.[64] Whatever the nonnormative practices of its individual members, many of whom would not identify their artistic self with a sexual identity either then, or ever, it was the world out into which Judson emerged that we might today call queer—contingent, emergent, able to be named only in retrospect. Judson was but one group of young and lithe dancers and non-dancers who aimed to reuse ordinary gestures, but in its attention to engaging the erotics of the everyday, it underscored the immediate world as a locus of the artistic imaginary. This

idea that the stuff of daily life could be the raw material for art would prove indispensable not only for subsequent political formations, particularly those under the influence of feminism, but also for cultural organizations that formed under new names: Grand Union, Lesbian Nation, Contact Improvisation, and the Collective for Living Cinema were some of the ways those who appeared in the Concerts of Dance would reorganize themselves. This same notion was also important for artworks such as Carolee Schneemann's *Meat Joy* (1964) or Cecil Taylor's album *Unit Structures* (1966). Judson thus contributed to making a language for ongoing experiments with dismantling male-dominated capitalist institutions, as well as for experiments supporting the black radical aesthetic tradition and human interactions with the natural world that we might call the domesticated sublime—creative traditions whose vibrancy calls to us today.[65] The legacy of those who gathered for a brief period in the early 1960s at Judson Memorial Church lives in the recurrence and incompleteness of their dissonant ensemble.

NOTES

1. These works include, among others, Don McDonagh, *The Rise and Fall and Rise of Modern Dance* (New York: Outerbridge & Dienstfrey, 1970), Jill Johnston, *Marmalade Me* (New York: E. P. Dutton & Co., 1971); *Judson Dance Theater (1962–1966)*, eds. Wendy Perron and Daniel J. Cameron (Bennington: Bennington College, 1982), exh. cat.; Sally Banes, *Democracy's Body: Judson Dance Theater, 1962–1964* (Ann Arbor, MI: UMI Research Press, 1983); Ramsay Burt, *Judson Dance Theater: Performative Traces* (New York: Routledge, 2006); and Judy Hussie-Taylor, *Judson Now* (New York: Danspace Project, 2012).
2. At a later date they learned that a jury member had complained they all "look alike." See Steve Paxton and Yvonne Rainer quoted in Banes, *Democracy's Body*, 88–89.
3. Johnston, "I Dance: Democracy," *Village Voice*, August 23, 1962.
4. Press release for "A Concert of Dance #3," January 30, 1963, Judson Memorial Church Archive, MSS 094, 3;32, Fales Library & Special Collections, New York University Libraries.
5. After the first two years of concerts, the workshop ceased and Carmines took on the responsibility of choosing the choreographers and dates. Al Carmines, "In the Congregation of Art" [1967–68], *Movement Research Performance Journal* 14 (Spring 1997): 7.
6. Yvonne Rainer, *Work 1961–73* (Halifax: Press of the Nova Scotia College of Art and Design, 1974), 9.
7. Robert Morris, "I Dance," *Village Voice*, February 3, 1966.
8. Johnston, "Untitled," in *Marmalade Me*, 18.
9. Rosalind Krauss, *Passages in Modern Sculpture* (1977; repr., Cambridge, MA: MIT Press, 1998).
10. Janice Ross, *Anna Halprin: Experience as Dance* (Berkeley: University of California Press, 2007).
11. Simone Forti, *Handbook in Motion* (Halifax: Press of the Nova Scotia College of Art and Design, 1974).
12. Janice Ross, "Atomizing Cause and Effect: Ann Halprin's 1960s Summer Dance Workshops," *Art Journal* 68, no. 2 (Summer 2009): 66.
13. Rainer and Ann Halprin, "Yvonne Rainer Interviews Ann Halprin," *Tulane Drama Review* 10, no. 2 (Winter 1965): 142–67.
14. Ibid., 144.
15. The other two students were Paulus Berensohn, who would go onto live in the mountains of North Carolina working as a self-described amateur craft artist and passionate deep ecologist, and Marni Mahaffay. Perron, "Introduction," *Movement Research Performance Journal* 14 (Spring 1997): 2.
16. Cate Deicher, [no title], *Movement Research Performance Journal* 14 (Spring 1997): 2.
17. Anita Feldman, "Robert Dunn: His Background and His Developing Teachings" (unpublished paper, 1979, 3–4, Vita, 1980), as cited in Banes, *Democracy's Body*, 7.
18. Yvonne Rainer, [no title], *Movement Research Performance Journal* 14 (Spring 1997): 10.
19. Steve Paxton similarly recalls that "he allowed us to ramble, argue and turn the class away from his direction. He proposed, and waited. He wanted us to fill in the blanks—and looking back, I suspect we were those blanks." Paxton, "RE Dunn," *Movement Research Performance Journal* 14 (Spring 1997): 15.
20. James Pritchett, *The Music of John Cage* (Cambridge, UK: Cambridge University Press, 1993).
21. Nancy Zendora, "A Magician in the Classroom," *Movement Research Performance Journal* 14 (Spring 1997): 3.
22. McDonagh, *The Rise and Fall*, 51. The epigraph on page 16 is also from this volume. See Dunn quoted on page 59.
23. Susan Sontag, "Notes on 'Camp,'" in *Against Interpretation* (New York: Farrar, Straus and Giroux, 1966).
24. Aileen Passloff, oral history interview conducted by Ana Janevski and Thomas J. Lax, Department of Media and Performance Art, The Museum of Modern Art, New York, February 22, 2018.
25. Allen Ginsberg, "James Waring & Co.," *Village Voice*, December 17, 1958.
26. Rainer, *Work*, 6.
27. The Living Theatre was the experimental theater named after the living room in which its husband-and-wife founders, painter Julian Beck and actress Judith Malina, began producing their plays in 1947.
28. David Gordon, [no title], *Movement Research Performance Journal* 14 (Spring 1997): 19.
29. Waring drew on a variety of movement styles from Japanese Noh theater to camp and baroque genres found in vaudeville, commedia dell'arte, and silent films.
30. Robert Dunn quoted in McDonagh, *The Rise and Fall*, 52.
31. Conceived by Dr. Edward Judson in 1888 to honor his father, Reverend Adoniram Judson, the church was envisioned to provide religious instruction and a variety of social services to the neighborhood's growing population of Italian immigrants.
32. Spike left Judson Church to become the executive director of the National Council of Churches' Commission on Religion and Race, which played an important role in the Civil Rights movement. He was brutally killed in 1966, targeted, many believe, for his bisexuality.

33. Howard Moody, *A Voice in the Village: A Journey of a Pastor and a People* (self-published with Xlibris, 2009), 15.

34. These include Claes Oldenburg's *The Street* (1960), a three-dimensional mural in the shape of a city block made of found objects including cardboard, paper, newspaper, and wood and outlined in black paint.

35. Al Carmines, "The Judson Dance Theater, and the Avant-Garde Dance," lecture given at the Lincoln Center Library and Museum of the Performing Arts, New York, 1968, Dance Audio Archive, MGZTL 4-4, reel 1, Jerome Robbins Dance Division, New York Public Library for the Performing Arts. Carmines affirmed that these seemingly disparate disciplines shared much in common, including their devotion to the immediate, everyday stuff of life. He also pointed to their shared emphasis on groups over individuals, a move away from psychological preoccupations such as individual morality, whether in relation to an individual worshipper or to a character in a play. The epigraph on page 19 is from this source.

36. These include Ruth Allphon and Marni Mahaffay. In 1960, Forti had performed with Patty Mucha.

37. Kaprow's *18 Happenings in 6 Parts* in 1959 at Reuben Gallery in New York has been recognized for juxtaposing artistic activities, like playing violin and painting, with domestic actions, like sweeping the floor or squeezing oranges. These activities took place in separate spaces simultaneously, so that viewers were able to grasp the work only as a partial, mediated experience.

38. These were *Roller Boxes* (formerly *Rollers*), *See Saw*, *Huddle*, *Slant Board*, *Hangers*, *Platforms*, *Accompaniment for La Monte's "2 sounds"* and *La Monte's "2 sounds,"* *Censor*, and *From Instructions*.

39. Forti's inspiration and process were similarly task oriented. She first conceptualized the works as drawings, which she used as directions for Morris.

40. Forti in *Simone Forti: Thinking with the Body*, ed. Sabine Breitwieser (Salzburg: Museum der Moderne, 2015), 71.

41. Forti's Dance Constructions acquisition papers, Department of Media and Performance Art, The Museum of Modern Art, New York.

42. Julia Bryan-Wilson, "Simone Forti Goes to the Zoo," *October* 152 (Spring 2015): 38.

43. Jane Jacobs, *The Death and Life of Great American Cities* (New York: Random House, 1961), 50.

44. Robert Moses, "Statement of Robert Moses Regarding Washington Square," *Village Voice*, January 1, 1958.

45. Jacobs, *The Death and Life*, 50.

46. Embracing the post-World War II consumerism that set automobile assembly-line production into high gear, Moses proposed the widening or construction of no less than two hundred miles of roads at a time when two-thirds of New Yorkers did not own cars. His various proposed projects also included the Lower Manhattan Expressway, a ten-line elevated highway along the island's southeast, which was protested in and near Greenwich Village and ultimately defeated. See Robert Caro, *The Power Broker: Robert Moses and the Fall of New York* (New York: Alfred A. Knopf, 1974).

47. Bill Dixon quoted in Danielle Goldman, *I Want to Be Ready: Improvised Dance as a Practice of Freedom* (Ann Arbor: University of Michigan Press, 2010), 62.

48. Handwritten account of dance improvisation sessions, dated May 23, 1960, in Yvonne Rainer's notebooks c. 1960–62, Yvonne Rainer Papers, 2006.M.24., 1;2, Getty Research Institute, Los Angeles. Accessed online in an audiorecording read by Rainer at http://www.getty.edu/research/exhibitions_events/exhibitions/rainer/

49. In Johnston's review of *Revelations* performed at the West Side YMCA, she wrote, "If that kind of thing were available every Sunday in the neighborhood, I could be a holy roller, definitely." Johnston, "Mr. Ailey," *Village Voice*, December 21, 1961.

50. Banes, *Democracy's Body*, 55.

51. Thanks to choreographer, artist, and writer Will Rawls for this reflection.

52. Diane di Prima, "A Concert of Dance: Judson Memorial Church, Friday, 6 July 1962," *Floating Bear*, no. 21 (August 1962): 239.

53. Gerard Malanga, "Rollerskate," *Floating Bear*, no. 29 (March 1964): 358.

54. James Waring, "To the Floating Bear," *Floating Bear*, no. 23 (September 1962): 263.

55. LeRoi Jones, "Present Perfect (Cecil Taylor)" [1962], in *Black Music* (New York: William Morrow & Company, 1968), 97.

56. *Les grandes répétitions*, "Cecil Taylor à Paris," dir. Gérard Patris, featuring Cecil Taylor, Andrew Cyrille, Jimmy Lyons, and Alan Silva (Paris: Office national de radiodiffusion télévision française, 1968). Accessed online at https://www.youtube.com/watch?v=Rh0MUuHJRcQ.

57. Fred Moten, *In the Break: The Aesthetics of the Black Radical Tradition* (Minneapolis: University of Minnesota Press, 2003), 161. Jones and Taylor had been close in the late 1950s and early 1960s, until Jones brought poet Allen Ginsberg to Taylor's East Village apartment. Ginsberg asked Taylor to write music for a reading of his poem *Howl*; Taylor—feeling loyal to the black Beat poet Bob Kaufman and thinking him unfairly overshadowed by Ginsberg—declined. As they were leaving, Jones disapproved with a remark he knew would have been cutting for Taylor: "The problem with our jazz musicians is that they're not literate." See Adam Shatz, "The World of Cecil Taylor," *New York Review of Books*, May 16, 2018, http://www.nybooks.com/daily/2018/05/16/the-world-of-cecil-taylor.

58. Jones, "The World of Cecil Taylor" [1962], in *Black Music*, 101.

59. Jones, "The Changing Same (R&B and New Black Music)" [1966], in *Black Music*, 174.

60. Michael Fried, "Art and Objecthood," *Artforum* 5, no. 10 (June 1967): 12–23.

61. Johnston, *Marmalade Me*, 69.

62. Rainer, Work, 318.

63. Robert Rauschenberg quoted in *Sixteen Americans*, ed. Dorothy C. Miller, with statements by the artists and others (New York: The Museum of Modern Art, 1959), 58.

64. Douglas Crimp, *Before Pictures* (Chicago: University of Chicago Press, 2016), 11.

65. William Cronon, "The Trouble with Wilderness: Or, Getting Back to the Wrong Nature," *Environmental History* 1, no. 1 (January 1996): 7–28. Thanks to Myles Lennon for this reflection.

* Here as everywhere, my critical syntax is indebted to Saidiya Hartman and Fred Moten. Thanks also to Sarah Resnick for sharpening my prose.

26

A CONCERT

OF DANCE

BILL DAVIS, JUDITH DUNN, ROBERT DUNN, RUTH EMERSON, SALLY GROSS, ALEX HAY,
DEBORAH HAY, FRED HERKO, DAVID GORDON, GRETCHEN MACLANE, JOHN HERBERT MCDOWELL,
STEVE PAXTON, RUDY PEREZ, YVONNE RAINER, CHARLES ROTMIL, CAROL SCOTHORN,
ELAINE SUMMERS, JENNIFER TIPTON

JUDSON MEMORIAL CHURCH
55 WASHINGTON SQUARE SOUTH
FRIDAY, 6 JULY 1962, 8:30 P.M.

Between 1962 and 1964, the various dancers, choreographers, painters, filmmakers, sculptors, and composers who made up the group known as Judson Dance Theater organized sixteen numbered concerts, each with events in a range of mediums. The group comprised dancers Trisha Brown, Lucinda Childs, Ruth Emerson, David Gordon, Deborah Hay, Steve Paxton, Rudy Perez, and Yvonne Rainer; composers Philip Corner and John Herbert McDowell; visual artists Robert Morris, Robert Rauschenberg, and Carolee Schneemann; filmmakers Gene Friedman and Elaine Summers; and many others, all of whom shared a fidelity to experimentation and a commitment to vigorous debate, a means through which to advance their ideas. Most of the concerts took place at Judson Memorial Church, the group's de facto headquarters; the basement gym, linoleum-floored sanctuary (the pews were moved out), and choir loft were all fair game. The others took place at equally unconventional sites: an opera house in upstate New York, the America on Wheels roller-skating rink in Washington, DC, and theaters around New York. The concerts were free to the public—although donations were encouraged—and occurred at intervals ranging from a few days to a few months (fig. 2).

The Judson artists proposed new thematic, aesthetic, and production paradigms outside the conventions of modern dance. They eschewed the traditional company structure, its titular choreographer venerated as a kind of demigod or hero, instead adopting a group-based approach in which the role of the "artist" was distributed across all of the participants. They programmed their concerts using the Quaker model of consensus, which requires unanimous agreement among the voting parties. They introduced into dance ordinary movements, forgoing leaps and spins for running, walking, catching, falling, and climbing. They interacted with mundane objects and wore everyday clothes. They abandoned narrative, expression, and formal stylization; they abandoned everything that marked the dancer's body as extraordinary, ideal, or ethereal. They explored stillness and repetition, akin to John Cage's investigation of silence,

Opposite: (1) Poster for Concert of Dance #1, 1962. Designed by Steve Paxton. Above: (2) Fred W. McDarrah's photograph of unidentified dancers. Performed at Concert of Dance #1, Judson Memorial Church, July 6, 1962

calling attention to ambient movement and temporal elasticity. They experimented with group dynamics. They privileged improvisation and score-based movements and performed in nonconventional spaces. They executed task-based actions, foregrounding the experience of a task undertaken, start to finish, in real time. They took risks—and sometimes they failed.

"In retrospect it was a beautiful mess," Jill Johnston, dance critic for the *Village Voice* and chronicler, supporter, and adjunct member of Judson, wrote in 1968. "For some centuries now," she observed, "the art world of the West has been involved in cyclic patterns of subversion, overthrow, and replacement of one sort of Establishment with another." The dance world, by contrast, has always been reluctant to accept this inevitability—or its necessity. But Judson Dance Theater was different, according to Johnston. "Within a positive assertion of old creative values," she contended, "was the negative idea of the annihilation of all preconceived notions about dance."[1] It may not have been an organized movement with a declared manifesto; it may not have been catalyzed by political ideals—Judson's participants routinely deny having been ideologically motivated.[2] All the same, insofar as they adopted a critical stance toward modern dance and classical ballet and preferred group assembly to "single-minded master[s]" or "bosses,"[3] Judson Dance Theater was something of a revolution.

The characteristics of this revolution were present even from the first Concert of Dance in 1962 (fig. 1). For her *Daily Wake* (also known as *Newspaper Dance*), Summers scored the dance's three sections using a copy of the *Daily News*: she laid out the newspapers on the floor of the church, and the five performers, cued by the paper's arrangement of images and text, moved through a series of still postures, sometimes as individuals and

sometimes as a group.[4] The dance's larger ensemble cast, meanwhile, directed audience attention away from any one performer and toward the mass of bodies—no performer stood out; no hierarchy distinguished background from foreground. In *Daily Wake*, the crowded stage was itself a kind of achievement, the mobilization and organization of autonomous bodies in a cooperative situation a sign of those values that would soon emerge as central to the Judson ethos.

For her solo performance *Ordinary Dance*, which also premiered at Concert of Dance #1, Rainer likewise explored quotidian events, but of a different scale—not world or national or local events, but personal ones. Rainer strung together simple movements, like squatting, falling, and bending, to create, in her own words, "unrelated, unthematic phrases, with some repetitions."[5] While performing these phrases, she recited a kind of autobiography in poetic fragments that included the names of her grade-school teachers as well as of the streets she had lived on as a child—one of the first examples of dance incorporating the spoken word. Writing in the *Floating Bear*, Diane di Prima likened *Ordinary Dance* to "a system of Dante's hell in dance, personal as any hell, but terrifyingly clear to the observer."[6] These broken movements and asynchronous spoken phrases amounted to an expression of alienation and anticipated the feminist position that would emerge only a few years later—*the personal is political*—drawing connections between personal experience and larger social and political structures. This, too, would reveal itself to be part of the Judson ethos, even if it went unstated at the time. As Schneemann recently observed, Judson was effectively a group of women working together, subverting the dominant authority of their male colleagues.[7] Judson's female protagonists were practicing a form of collective antipatriarchal politics within their personal daily lives.

We tend to think of revolutions as sudden or violent ruptures to a system that is subsequently replaced by a new one, but this is not always the case. Johnston's characterization—that Judson "annihilat[ed] all preconceived notions about dance," which is to say, all preconceived notions about traditional American and Western European concert dance—may be something of an overstatement. After all, the group's negation of previous ideas about dance was in no way total. Most of the Judson dancers were formally trained. They had studied ballet and/or one of the classical modern dance techniques laid out by Martha Graham or José Limón or Doris Humphrey. The majority were also students of

Merce Cunningham, who, despite his departures from classical modern dance, retained a specialized, technical vocabulary and choreographed dances for the proscenium stage. Rainer likewise observed that, inasmuch as breaking with the past is part of the avant-garde's historical legacy—a legacy that includes conceptual artist Marcel Duchamp and the Bauhaus—Judson's departure from what came before them situated the group in this lineage.[8] Thus, while the Judson artists moved beyond the dance techniques taught to them by their forebearers, they were at the same time the inheritors of them—techniques they adapted and transformed as much as they rejected. It was this process of transformation that was essential to their particular revolution.

I WANT TO GO BACK FROM 1961 TO 1965

In an essay reflecting on Judson Dance Theater some twenty-five years after Judson's final concert, Robert Ellis Dunn advised that before attempting to write a history of dance, one should first read Friedrich Nietzsche's "On the Use and Abuse of History for Life" (1874) and "make clear at least for oneself, what effect the work is meant to have on the present and on the future."[9] Dunn was a choreographer and musician, who, after studying with Cage, organized a series of choreography workshops that proved formative for many in the Judson group. Dunn was writing at a time when several important events had resurrected the group, among them Bennington College's Judson Project (1980–82)—a multipart project that included a dance program, an exhibition, and a series of workshops[10]—and the publication of Sally Banes's book *Democracy's Body: Judson Dance Theater, 1962–1964* (1983). Both projects studied Judson's past performances, reconstructed them, and evaluated the group's legacy by describing its influence within an art historical context. Both also questioned how the unreliability of memory must be accounted for in the writing of such a history. In his essay, Dunn

Opposite: (3) Al Giese's photograph of Ruth Emerson in Carolee Schneemann's *Newspaper Event*, 1963. Performed at Concert of Dance #3, Judson Memorial Church, January 29, 1963

wasn't refusing these projects out of hand as misguided; rather he was asking how best to reconstruct and recover the group's ephemeral past. He wondered how to reassess Judson in a way that would render it relevant to present audiences and also to future ones; that would not leave it cordoned off to a "posthumous existence."[11]

Paxton likewise expressed the difficulties inherent in projects reliant on memory, albeit a little differently. "I am forty-one years old. I want to go back from 1961 to 1965," he said with his eyes closed during a 1983 phone interview with dancer Nancy Stark Smith.[12] Paxton, who was being interviewed by Smith for Bennington's Judson Project, was ostensibly under hypnosis to help him recall his experiences with Judson. This extreme gesture of seeking out psychic intervention to aid in the recovery of past events evokes the nonviability—even the downright absurdity—of retrieving work that was sometimes improvised and always ephemeral.

As curators of *Judson Dance Theater: The Work Is Never Done* and editors of this companion volume, Thomas J. Lax and I have been confronted with these same questions—and, moreover, how to answer them in the context of an art museum, no less The Museum of Modern Art. In 1974, a decade after the last Judson concert, art critic Annette Michelson observed of dance that "underground films and dances existed in proximity to the art world but were not part of that economy. New dance and new film have been, in part and whole, unassimilable to commodity form."[13] Michelson's remark is germane insofar as exhibiting time-based, ephemeral works performed more than fifty years past raises questions that the display of material objects would not. As curators, we were confronted with how to build an exhibition when the very subject of this exhibition exists only in traces that are necessarily mediated or translated into other forms, including films, photographs, scores, and oral histories. We were confronted with how to acknowledge the intimate connection between the artist and the manifestation of the work, when it resides initially, if momentarily, within the body of its maker. Yet, in the decades since Michelson made her observation, museums have indeed found means to integrate underground films and ephemeral works into their collections, as well as what she defined as "new dance"; MoMA's recent acquisition of Simone Forti's Dance Constructions is but one example. Our task as curators was thus further complicated: how might exhibiting Judson Dance Theater in a museum context in 2018 risk reifying or fixing in place and in time a constellation of works that bore no such risk at the moment of their making?

For *The Work Is Never Done*, we began by nego-
tiating information gleaned from photographs, films,
administrative files, programs, posters, performer biog-
raphies, contemporaneous reviews, gossip, and artist
and audience accounts, and attempting to reconstruct a
narrative from it. Three types of documentation—the
films made by artists working in proximity to Judson,
the scores generated by the choreographers, and the
photographs taken by contemporaneous journalists
and enthusiasts—struck us as particularly compelling
because they share with dance the same qualities of
reproduction, circulation, reiteration, and ephemerality.

In preparation for this exhibition, we watched
several films, many of which document Judson perfor-
mances or include Judson participants as performers;
others screened at Judson concerts. These films are
revealing because they show the particularities of the
dancers' movements, the spaces they performed in, and
the audience members in attendance—which is to say,
they reveal both the work and its context. Billy Klüver's
8mm home movies of Rainer and Brown dancing on the
roof of a chicken coop or of Paxton's outdoor perfor-
mance *Afternoon (a forest concert)*, both in 1963, were new
discoveries, important records capturing these ephem-
eral moments in a straightforward manner. But many of
the films we viewed can be said to exceed direct docu-
mentation, their precise combinations of content, form,
and structure articulating ideas central to the Judson
ethos. The films of Summers, for example, eschewed
any linear reconstruction of events or semblance of
narrative employing the chance methods first champi-
oned by Cage—the same methods often used by Judson
choreographers to make their dances. To enter Concert
of Dance #1, the audience was forced to walk through
the projection of Summers's *Overture*, an assemblage of
footage that included children playing, parked trucks,
and clips from the films of W. C. Fields, in order to
take their seats in the sanctuary.[14] As the movie was
nearing the end, some of the dancers came out and the
screening slowly transitioned into a live performance.
Due to its content and the circumstances of its initial
presentation, *Overture* foregrounds how still and moving
images, sculptural objects, and recorded sound were
integral to Judson concerts. *Judson Fragments*, another of
Summers's films that she assembled using chance oper-
ations, features James Waring teaching a class as well as
Hay, Paxton, and Rainer performing. These films offer
a kind of testimony about the period but within a formal
structure—chance-based assembly—that parallels how
many Judson dances were made.

In his film *3 Dances* (1964), Gene Friedman, who
participated in the second Dunn workshop, showcased
various forms of movement that can be considered
dance. The film's three sections, "Public," "Party,"
and "Private," show, for example, people milling about
MoMA's Sculpture Garden; Robert Rauschenberg
doing the twist and other social dances in the basement
of Judson Church; and Judith Dunn rehearsing in the
Cunningham studio. By drawing equivalencies between
these scenarios, Friedman asserts that all three are
equally worthy of the name *dance*. This expanded under-
standing of what dance consists of proved particularly
galvanizing for the Judson group. Moreover, *3 Dances*,
with its overlying multiple exposures, calibrated fram-
ing, and juxtaposition of distinct actions, captured the
experimental spirit of Judson.

Andy Warhol's *Jill and Freddy Dancing* (1963) is
an intimate portrayal of Johnston and performer Fred
Herko dancing on a rooftop with New York's skyline
behind them in lieu of the proscenium arch. Warhol
includes in the film the small moments the two danc-
ers shared between dancing—smoking cigarettes, for
instance, and drinking beer. His use of in-camera editing
to create multiple exposures generates dynamism, and
his preferred projection speed of sixteen frames per
second, which renders the interaction in slow motion,
emphasizes the quality of their gestures. Experimental
filmmaker Stan VanDerBeek's film *Site* (1965) docu-
ments artist Robert Morris's performance of the same
title, in which Morris, wearing gloves and a mask of his
own face, disassembles a structure of plywood boards to
reveal Schneemann, nude and posing as Édouard Manet's
Olympia (1863). Morris's newly discovered *Dances/
Robert Rauschenberg* (1965) features events from the First
New York Theater Rally. For both films, VanDerBeek
recorded the moving bodies using wide shots and long
takes then cut the performances into smaller segments,
highlighting particular gestures or movement phrases.
The films never show a frontal view of the dancers at
work—a convention of live performance, particularly
at the time. The films' cumulative effect is to reveal
variation and repetition as essential components of per-
formance, much as VanDerBeek believes them essen-
tial to film. It is clear that innovations similar to those
introduced by the Judson group were taking place across
various mediums, not only dance.

Thomas and I also sorted through any number of
photographs, all the while considering how each still
image might contribute to the story of Judson Dance
Theater. These photographs are the primary means

by which contemporary audiences can access Judson dances, and although on the whole there is no shortage of these images, their number begins to swell only with Concert of Dance #3: for Concert of Dance #1, we discovered very few photographs; for Concert of Dance #2, we found none at all, forcing us to contend with this lacuna in visual documentation. We agreed that arranging the exhibition chronologically was no longer an option, and this prompted us to think through various alternatives. Eventually, we arrived at the thematic structure on view in the galleries.

From the third concert on, we owe thanks mainly to photographer Peter Moore, a Judson enthusiast who attended and documented nearly every event, for the abundance of images. Moore's photographs tend to capture in their frames a wide view of the performances and their surroundings. He often took pictures from the balcony of the sanctuary, for example, as is apparent in his images of Concert of Dance #13 in 1963. The centerpiece of the concert was an enormous sculpture by Charles Ross set in the middle of the sanctuary; all of the performances that night engaged the metal trapezoid in some way. Moore's images document the whole of the scene—the sculpture, the tires dispersed on the floor, the cross and chandelier in the background, the performers in relation to the installation, and the audience positioned along the perimeter of the room (fig. 5, page 33). A picture of Childs performing her *Egg Deal* (1963) shows her alone, interacting with an empty cardboard box suspended on a rope, the audience in the background. Here Childs is clearly the focus of the performance, but Moore made a point of also documenting how performer and spectator existed in relationship to one another. He also often seized on performers in motion, his images blurry, as in his pictures of Schneemann's *Lateral Splay* from 1963. As theater scholar Ronald Argelander observed, Moore's photographs captured "as much of the total visual experience of an actual performance as possible and . . . from the point of view of the audience."[15] The exhibition's audience can assume a similar point of view.

The photographers Al Giese, another Judson enthusiast, and Fred W. McDarrah, who worked for the *Village Voice*, also documented the performances. The hand of the artist features more prominently in their images than in those of Moore. In a photograph by Giese of Schneemann's *Newspaper Event* (1963), the work's seven performers stand in front of the church gym's basketball net, surrounded by newspapers; one of the female performers has been caught mid-jump, as if

she were levitating (fig. 3, page 29). In the lower-right corner of the frame, a leg whose body has been cropped out suggests the presence of the audience. For one of the rare images from Concert of Dance #1, taken by McDarrah, the camera was positioned over the heads of the audience members, who are visible in the frame, confirming that the photographer, too, was seated among them. Despite apparent fixity, these photographs contain a distinct point of view that can inform our perception and interpretation of the represented event.

We also pored over various scores, effectively sets of instructions for how to perform a work. Many Judson artists had first become acquainted with scoring during Dunn's workshops and, following Cage, developed scores made up of text, images, or graphics, each proposing one or more actions. Corner's score for "Flares" (1963) consisted of abstract calligraphic drawings; performers were free to interpret these drawings into sound and movement. Rainer used colored lines, numbers, and written instructions to represent the different movements in her score for *Terrain* (1963). Paxton relied on photographs of people playing sports to prompt the movements in *Proxy* (1961) and *Jag vill gärna telefonera (I Would Like to Make a Phone Call)* (1964), though each performer was empowered to carry out these actions as they pleased. On the one hand, these scores are historical documents: they describe the movements or movement sequences that made up a particular work. But a score is also a set of instructions; more than a passive document, it is meant to be activated. The very existence of these scores suggests that the choreographers intended for their works to be repeated and gives us insight into their approaches. The space between score and performance, between gestures past and present, is a space of interpretation, at once displacing and dilating the site of dance, while enabling new thematic and formal associations. One might even claim that a choreographic work can come to life through a shared collective imagination.

The questions raised by the presentation of this historical dance group at an art museum thus transcend the ephemerality-versus-permanence dichotomy to include how variation and repetition were important strategies for these artists across mediums. Taken together, these documents have prompted us as curators to consider how dance, and more precisely choreography, is more than a matter of embodiment—choreography exists equally in an expanded field. The image-based material related to Judson Dance Theater is crucial for reconstructing and visualizing the performances but also for understanding the ways these

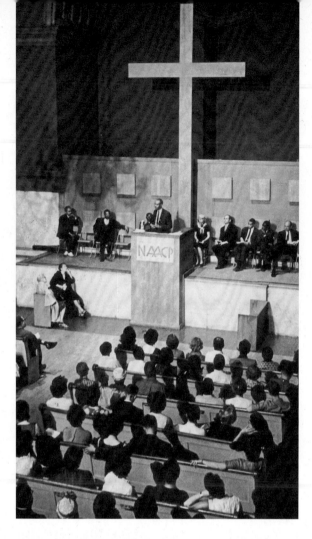

performances transpired at the threshold of image and action. Forti, who took part in the early workshops that would lead to Judson, and whose work proved deeply influential to the group, has often mentioned her fascination with nineteenth-century English photographer Eadweard Muybridge's serial photographs "of a man chopping wood," finding she was "moved by the image of a body doing an unadorned action."[16] Dance scholar Carrie Lambert-Beatty has described how the Judson artists were enamored of photography and photographic effects—how their use of repetition and slowness contests interpretations that suggest their performances were committed wholly to immediacy, instantaneousness, and presence.[17] *The Work Is Never Done* attempts to account for the ways that Judson performers negotiated motion and stillness, immediacy and the passage of time. Muybridge's innovation was to show multiple images of one action from start to completion, each frame observing a small advance in time and thus in movement, his photo series a kind of proto-filmstrip. Borrowing from his insights, we have included multiple images of each performance rather than letting one stand in for the whole. We have likewise borrowed from Moore, whose eloquent observation that the slideshow operates "between still camera technology and motion picture technology"[18] prompted us to present Concerts of Dance #3 and #13 in this format. These are two of the concerts with the most documentation, and by arranging the images in sequence, dance by dance, in a slideshow format, we aim to evoke the space between stillness and motion that seems to have captured the fascination of Judson's dancers.

THE WORK IS NEVER DONE

> *Judson Reconstruction is the beginning of a new form of documentation, a ritual to be performed every twenty years.*[19] —Paula Clements

A church, an institution in many ways synonymous with tradition, may seem like an unlikely home for a revolution (fig. 6, page 34). Yet it's no coincidence that Judson Memorial Church came to host this particular group of artists. Affiliated with the Baptist and United Church denominations, Judson Memorial Church has defined itself as "a sanctuary for progressive activism and artistic expression," pioneering in the 1950s several programs in support of women's health, including an abortion consultation service, a clinic for sex workers, and a center

Above: (4) Fred W. McDarrah's photograph of American Civil Rights activist Roy Wilkins speaking at Judson Memorial Church, June 14, 1963. Opposite: (5) Peter Moore's photograph of unidentified performers in Carla Blank's *Turnover*, 1963. Performed at Concert of Dance #13, Judson Memorial Church, November 20, 1963

for counseling.[20] It ran support programs for young people coping with harmful drug use and a program for runaway youths. It put its weight behind the Civil Rights movement, hosting, for example, Roy Wilkins under the sanctuary's wooden cross right before he became the executive director of the National Association for the Advancement of Colored People (fig. 4). This particular event transpired June 14, 1963—close in date to the sixth Concert of Dance (June 23) as well as to the March on Washington (August 28), which Wilkins helped to organize.[21] "Somehow if the church is going to be faithful in this age," Al Carmines, Judson's associate pastor wrote in a letter in 1965, "it must cut its way under through the sticky glutinous syrup known as religion and deal with real people in real situations who have real feelings—and real bodies."[22] A church committed to supporting the most fragile and marginalized of bodies was ideally suited to host a group of dancers and artists who made ordinary bodies and gestures the focus of their work.

The history of Judson Dance Theater has been mythologized as a story about artistic experimentation, community, and participatory democracy. The community the Judson group nourished and the self-organization they championed were exceptional, not least because the collectivity they fostered was otherwise unusual within the discipline of dance. Judson's revolution was in some ways undergirded by politics, even if its members did not recognize it at the time. But time and distance can illuminate ideas previously in silhouette. In the mid-1980s, for example, Rainer remarked in an interview: "In principle I still cling to the somewhat romantic ideas of avant-garde . . . ideas about marginality, intervention and adversarial subculture, a confrontation with the complacent past, the art of resistance, etc. Of course these ideas must be constantly reassessed in terms of class, gender, and race. On a personal level I could describe my development as a gradual discovery of the subtleties of my own privilege, which I took for granted when I began as a dancer."[23] What might be perceptible now that another thirty years has passed?

The title of both the show and of my essay is lifted from an email Paxton wrote to Danspace artistic director and chief curator Judy Hussie-Taylor. In 2012, Hussie-Taylor organized Judson Now, a three-month series commemorating the fiftieth anniversary of Judson Dance Theater. In an email following his

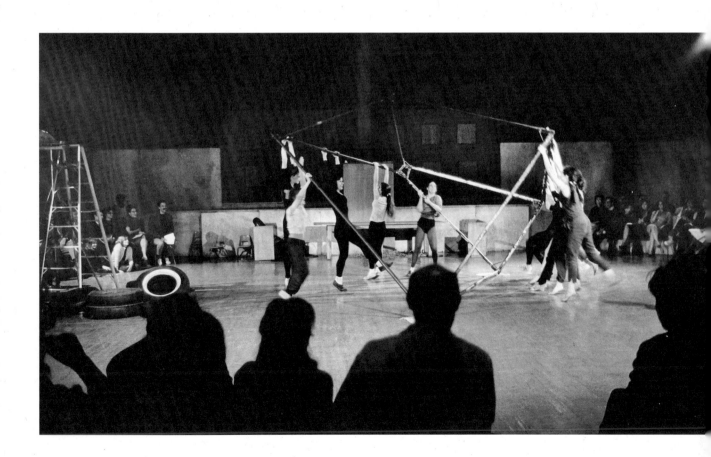

(6) Steve Paxton. Drawing of the Judson Memorial Church sanctuary for *Contact Quarterly* 14, no. 1, 1989

participation in an event, Paxton thanks Hussie-Taylor and reflects on the stance Judson took: "It seems to me it should be fuel for these times," he wrote. "The work is never done. Sanctuary always needed."[24] Here Paxton seems to be recognizing, much as Dunn did before him, that revisiting this moment so long after the fact asks that we consider the effect of the work on the present and on the future.

Describing the aftermath of Judson Dance Theater would require another essay: in the 1970s, Grand Union gathered many Judson participants into a group of dancers working with improvisation; in 1970, the Judson Gallery, run by Faith Ringgold, Jon Hendricks, and Jean Toche, organized visionary exhibitions and events such as *The People's Flag Show*, whose roster of artists included Judson protagonists Rainer, Gordon, and Paxton; in 1978, Movement Research emerged as a collective to support workshops in experimental movement, many of which take place at Judson Memorial Church even today; the European dance scene that in the 1990s and early aughts was so profoundly affected by their discovery of Judson (and is in part responsible for dance's emergence in museum spaces);[25] the many manifestations that have celebrated various Judson anniversaries over the years;[26] and the extensive writing and research on dance undertaken in the field.

Judson Dance Theater: The Work Is Never Done examines how the disciplines of art and dance have received Judson and transmitted its performances across history, while also attempting to add complexity to these extant narratives. We detail particularities of the group's past as well as its contemporary "afterlives," to borrow a term from dance scholars Adrian Heathfield and André Lepecki.[27] The exhibition's performance program, to take place in the Donald B. and Catherine C. Marron Atrium, addresses some of these questions head on. The program is organized in two-week segments, one for each artist. On display alongside the live program are videos of historical material edited by artist Charles Atlas. This structure, by calling attention to the artists as individual choreographers, brings into relief some of the tensions inherent in their shared name—Judson Dance Theater—and situates Judson less as a movement or organized collective than a moment in time. We opted to work mainly with the choreographers who took part in this moment: Brown via her dance company, Childs, Gordon, Hay, Paxton, and Rainer; with the exception of Brown, these former members still teach, make dances, and perform today. Many of the dances included in the exhibition originated in the Judson era; others were made later under the influence of Judson. Since most of the choreographers no longer perform in these pieces,

questions around transmission, mediation, and variation were central to our shared conversations.

In the final two weeks of the exhibition, the Atrium will be taken over by Movement Research, one such "contemporary afterlife," for a presentation of classes and workshops, including programs that integrate Movement Research's house journal of the same name. Recently, museums with dance in their programming have sought out original work privileging entertainment and spectacle above all else—precisely the style of performance that the Judson artists were working against. Our exhibition attempts to buck these trends. We aim to make space for openness and process, for research and experimentation, ideas so foundational to the Judson spirit. The work never is done; perhaps, then, the Museum can offer, if only for a short time, that sanctuary always needed, and provide space for what artists can do now: look, listen, and interpret with precision; imagine without compromise or fear.

NOTES

1. This and the preceding two quotations are from Jill Johnston, "Which Way the Avant-Garde?" [1968], in *Marmalade Me* (New York: E. P. Dutton & Co., 1971), 94.
2. See *The Judson Project: Trisha Brown, Alex Hay and Robert Rauschenberg*, video interview by Sally Banes, taped at Robert Rauschenberg's loft, New York, 1981 (New York: Bennington College, 1983), U-matic, two videocassettes. In this interview, Rauschenberg, Brown, and Alex Hay deny that their work contained any political content.
3. Banes, *Democracy's Body: Judson Dance Theater, 1962–1964* (1983; repr., Durham, NC: Duke University Press, 1993), 53–54.
4. Carolee Schneemann's first dance for Judson, *Newspaper Event* (1963), performed at Concert of Dance #3, also featured newspapers, although they were not used to score the dance.
5. Banes, *Democracy's Body*, 66.
6. Ibid., 68.
7. Schneemann, oral history interview conducted by Ana Janevski and Thomas J. Lax, Department of Media and Performance Art, The Museum of Modern Art, New York, March 6, 2018.
8. Yvonne Rainer, oral history interview by Janevski and Lax, Department of Media and Performance Art, The Museum of Modern Art, New York, February 22, 2018.
9. Robert Ellis Dunn, "Judson Days: Notes on Judson Dance Theater" *Contact Quarterly* 14, no. 1 (Winter 1989): 91.
10. The Bennington College Judson Project was organized by Wendy Perron, Tony Carruthers, and Daniel J. Cameron. Its dance program, Judson Reconstructions, featuring the first restaging of historical performances, took place at Danspace Project, St. Mark's Church, April 15–18, 1982. *Judson Dance Theater 1962–1966*, the related exhibition, was on view at New York University's Grey Art Gallery and Study Center.
11. Dunn, "Judson Days," 91.
12. Steve Paxton quoted in *The Judson Project: Steve Paxton*, video interview by Nancy Stark Smith (New York: Bennington College, 1983), U-matic videocassette.
13. Annette Michelson, "Yvonne Rainer, Part One: The Dancer and the Dance," *Artforum* 12, no. 5 (January 1974): 58.
14. Banes, *Democracy's Body*, 41.
15. Ronald Argelander, "Photo-Documentation (and an Interview with Peter Moore)," *Drama Review: TDR* 18, no. 3 (September 1974): 51.
16. Simone Forti, oral history interview conducted by Ana Janevski and Thomas J. Lax, Department of Media and Performance Art, The Museum of Modern Art, New York, March 7, 2018.
17. Carrie Lambert-Beatty, *Being Watched: Yvonne Rainer and the 1960s* (Cambridge, MA: MIT Press, 2008), 51.
18. Argelander, "Photo-Documentation," 53.
19. Paula Clements, "It's Impossible to Repossess . . . ," *Contact Quarterly* 7, no. 3/4 (Spring/Summer, 1982): 54.
20. "About," Judson Memorial Church, http://judson.org/about, accessed June 11, 2016. The website was redesigned in 2017 and the "About" page no longer exists. It is still accessible by searching the Wayback Machine at http://web.archive.org.
21. Lax, "Every Genealogy Is a Fiction," lecture (Carpenter Center for the Visual Arts, Cambridge, MA, April 20, 2017).
22. Al Carmines, "Response to Religious Protests Against 'Nude Dance' at Judson," n.d., Judson Memorial Church Archive, MSS 094, 3;71, Fales Library & Special Collections, New York University Libraries, http://dlib.nyu.edu/findingaids/html/fales/judson/dscaspace_ref15.html#aspace_ref376.
23. Jayamanne Laleen with Rainer and Geeta Kapur, "Discussing Modernity, Third World and *The Man Who Envied Women*" [1987], in *Modernism/Postmodernism*, ed. Peter Brooker (London: Longman, 1992), 46–47.
24. Paxton, quoted in Judy Hussie-Taylor, "Sanctuary," in *Danspace Project Platform 2012: Judson Now* (New York: Danspace Project, 2012), 14.
25. Between 1993 and 2002, the French group Quatuor Albrecht Knust, composed of dancers Dominique Brun, Anne Collod, Simon Hecquet, and Christophe Wavelet, recreated works by Judson artists, including *Continuous Project Altered Daily* (1970) by Rainer and *Satisfyin' Lover* (1967) by Paxton.
26. Retrospective celebrations of Judson Dance Theater include Past Forward, organized by Mikhail Baryshnikov and White Oak Dance Project in 2000; Judson @ 50, organized by Movement Research in 2012; and Judson Now, organized by Danspace in 2012.
27. In 2015, Adrian Heathfield and André Lepecki organized "Afterlives: The Persistence of Performance," a suite of three talks addressing the ways in which ephemeral art persists over time. The series took place in part at MoMA (September 25–27) as part of the Alliance Française's Crossing the Line festival.

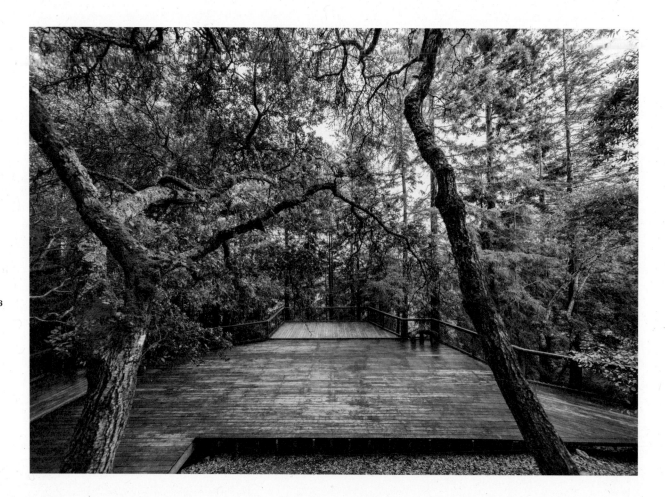

In collisions of action, objects, movement, spoken language, music, and sculpture, the events that constituted Judson Dance Theater challenged art borders and dance traditions. The Judson artists' choreographic experimentation with structured improvisation, anti-virtuosity, and a quality of performance known as *task* emerged from egalitarian collaborative processes that marked out new ways of making art and of being an artist. I want to follow and think through one previously peripheral aesthetic trajectory presented in this exhibition's curation and reassembly of Judson, with a distinctly West Coast and counter-urban ethos. I'll trace some lines of affinity from the work of choreographer and community activist Anna Halprin to the aesthetics of Judson, through its engagement with task and improvisation, to the works of Simone Forti, all within this period of the early and mid-1960s. To do so means to leave behind notions of originary scenes and identities altogether and instead to sketch a genealogy, as Michel Foucault described it.[1] While genealogy is historical work in the sense that it "operates on a field of entangled and confused parchments that have been scratched over and recopied many times," it seeks out phenomena that do not feel "properly historical," the felt undercurrents and lived realities of times, "sentiments, love, conscience, instincts," as they come in and out of cultural and historical presence and visibility.[2] In particular, I'll be concerned with certain ecological desires and feelings that underpin the communitarian and noted "democratic" principles of Judson. Along the way, I want to reconsider how architecture—such as that of a theater or a church—relates to its environment, how it informs and is itself shaped by the aesthetic sensibility of activities. I start in the recent experience of working beside and within the architecture of Anna's outdoor Dance Deck (fig. 1), in Kentfield, California, to examine how the ecological ethos of Anna and her husband, Lawrence Halprin, was an incipient force in the evolution of performance sensibilities and aesthetics, later translated and mutated in the East Coast scene.

(1) Hugo Glendinning's photograph of Anna and Lawrence Halprin's Dance Deck (1954), Kentfield, California, 2015

Preparing for improvisation work with Anna, I sweep the fallen leaves from the boards of the weathered deck onto the surrounding forest floor.[3] The task of clearing the ground is simple, repetitive. I speculate on the bodies that have moved through this space and the acts that have been witnessed here in the sixty or so years that have passed since its construction. Perhaps places do remember. Every action, however mundane, feels carried by this virtual accompaniment. I recall the many photographs I have seen of dancing on the deck; Merce Cunningham in 1955, firmly tilting on a single leg planted in the center, looking like a crane or part of the wooden architecture; unnamed community participants in a workshop in the 1970s, I'd guess, bending out of some fleeting ecstatic embrace; and an iconic photograph of the participants of the summer workshop of 1960, larking about while waiting to be captured on the auditorium's steps, Trisha Brown, Yvonne Rainer, Forti, and Anna among the group. Composer La Monte Young and artist Robert Morris were also present that year, and I wonder what it would have been like to be a participant in that particular historical confluence of nascent sensibilities and energies. A light breeze plays through the surrounding trees, and the faint drone of a far-off plane fringes my activity for a time. Wooded quiet. The space is a secluded opening, a clearing, and a private window that lets all manner of others in.

In the earliest photographs of the deck, three madrone trees pierce its surface, creating the sense that the architectural plane had found space within the forest, worked around its existent structures to find its shape and anchorage. Such accommodations were part of landscape architect Lawrence Halprin's ethos, in which responsiveness to natural forms was prized and human imposition eschewed. For Lawrence, intervention in an environment was an acknowledgment and hopefully a generative transformation of the intrinsic violence of human construction. In a lecture from a workshop in 1970, he put it bluntly: "Your first statement for creation or change is a violation."[4] Much of Lawrence's celebrated public work was aimed at an ecological harmony in which human subjects would better attune to (rather than ignore or dominate) the prodigious and ultimately ungovernable natural forces of which they are a part.

The jutting trees are gone now and the plane of the deck is uninterrupted, though no less accommodating of its living companions. Natural growth of the wood has also curtained the deck's back line, partially obscuring the vista beyond Mount Tamalpais across the San Francisco Bay. The forest and the deck are still learning to be with

each other in their own durations. For Lawrence and his collaborator on the project, theater architect and designer Arch Lauterer, architectural form was a negotiation with shifting environmental facts and a conciliation between potential antagonisms. One such clash at the time, as Janice Ross makes clear in her comprehensive book on Anna, was the insistent social conflict for women between mothering and working.[5] For the Halprins, the deck was a way to sidestep a normative cut between life and art that would have traditionally accompanied Anna's raising of a family. As Lawrence put it, his intervention on the land was a means to "enrich the living environment of my family," a phrasing that assumes an ecological under-standing of family itself.[6] His family was his environment. Such holistic perspectives, in which human subjects are inseparable from nature, were part of Lawrence's design ethos: an ecosystem was an elaborate set of shifting com-munity relations between plants and animals (including humans). The dialogue between Anna and Lawrence, between dance and architecture, was an animating axis in the postwar Bay Area arts scene, and within a decade of its construction the deck had become a locus of creative community energies and interdisciplinary exchanges that drew participants from afar (fig. 2). The Dance Deck is not an originary scene of this ecoaesthetic practice, but it is the locale of its singular historical intensifica-tion. Tracing the genealogies of this ethos is beyond the scope of this essay. As makers of theater—the space of the melding of forms *par excellence*—the Halprins were synthesizing many discourses and practices from diverse sources: relations to nature, the cosmos and the aleatory found in Zen Buddhism, and the aesthetics of John Cage; Artaudian theatrical impulses toward material life forces; ecological strains within emergent countercultural poli-tics; aspects of indigenous cultures and religions and their relations to the earth as home; and, from Lawrence's early experiences of the kibbutz, communitarian princi-ples and collectivities of the land.

To act in this open space is to be with the elements. There is something natal about the deck. Perhaps it arises

from the deck's infrastructural demand for the coexis-tence of entities, for symbiosis. As theater architecture, all four of its walls are transparent (not just the "fourth wall"), and so the usual strict boundary between on and off, micro- and macroworld, one and another, becomes highly porous.[7] The horizontal plane must be with the mountain's fall, and bodies must be with trees and sky. The trapezoid of the main space is extended to the back and left by slightly elevated wings giving the plane an irregular, many-sided shape suggesting the possibility of multiple places from which to look, the reorientation of the gaze. Lawrence, thinking beside Anna's dance experiments, understood the deck as a nonobject that was becoming landscape: it moved around.[8] But it was Anna who most acutely identified a relational dimension of this architectural intervention that, unbeknownst to her, was to become definitional of the art, dance, and performance of the era: "Since there is ever changing form and texture and light around you, a certain drive develops toward constant experimentation and change in dance itself. In a sense one becomes less introverted, less dependent on sheer invention, and more outgoing and receptive to environmental change. There develops a certain sense of exchange between oneself and one's environment and movement develops which must be organic or it seems false . . . space explodes and becomes mobile. Movement within a moving space, I have found, is different than movement within a static cube."[9] In language marked by emergence, Halprin notes that the environmental opening of the deck is simultaneously an opening of the performing body and of performance aesthetics to the complex restlessness of nature. An imperative, a kinetic demand, is transmitted in this meeting: to move with the outside in conditions of continuous differentiation. An experimental ethos and the practice of improvisation are inherently linked to a recognition of and attunement to the kinetic and autopoietic dimensions of nature. But improvisation was not the only consequence of ecological kinesthetic attunement. Drawing on the kinesiology of her dance training with pioneering pedagogue Margaret

Opposite top: (2) Lawrence Halprin's photograph of his and Anna Halprin's Dance Deck (1954) under construction, Kentfield, California, n.d. Opposite bottom: (3) Ernest Braun's photograph of the Halprin house and garden, Kentfield, California, n.d. Right: (4) Nicholas Peckham's photograph of unidentified performers in "Paper Dance" from Anna Halprin's *Parades and Changes*, c. 1965. Performed at San Francisco Dancers' Workshop, 1967

H'Doubler, Anna was inventing in an environment of undivided space, audience intimacy, sonic dissipation, and elemental physical exposure (fig. 3). This led her toward forms of movement without pretense that engaged with the materiality of flesh and bones. In a sense, flesh was simply one of the elements in an environmental theater. "Since we are concerned with the real world of things and beings in contact and not with the stage world of stage believability," Halprin later wrote, "we do not fabricate anything special for the stage that does not already exist for a real purpose in the everyday workaday world."[10]

An unadorned quality of movement and its attendant sensual exteriorization were intimately linked to the development of an aesthetics of task, where the performer was not taken up by self-consciousness, introspection, or expressivity in movement, but rather by the bare simplicity of a functional nonmimetic act. The epitome of this approach can be found in Anna's later influential theatrical work *Parades and Changes* (c. 1965), which treats the theater building as a site, breaching its spatial divisions through combinations of action, dance, sound, work with objects, and scenographic materials (fig. 4). The temporal structure of the work was divided into cells, reordered from occasion to occasion. One cell was a passage in which a group of performers of mixed ages slowly but matter-of-factly peeled off their clothes before laying out numerous large sheets of brown paper. Quietly lifting, touching, tearing, and enfolding themselves into the material, they formed an animate, rustling, skinny, cloudlike assemblage. The theater of material attunement and engagement that these acts made manifest was infused with an understated collective sensuousness, though one that was not easily

accommodated at the time of its showing in New York, where the city's police department sought to arrest Anna in response.[11] At the time she made *Parades and Changes*, Anna's radical interdisciplinary and environmental approach was already leading her to question whether what she was making could be contained within the current definition of dance. In an interview with Rainer published in 1965, Anna remarked, "I don't even identify with dance." Then she quickly moved to reincorporate her work within an expanded understanding of the field: "If you can think of dance as the rhythmic phenomena of the human being reacting to the environment. If the audience accepted this definition, then I'd say, yes, it's dance."[12]

My sweeping work is done. As Anna comes to take her place beside me on the bleachers, to sit where she has sat for over sixty years watching people perform, it is clear to me that she too is part of the environmental architecture. What if these ghostings of bodies, acts, and lives long past were not counterposed with the material here and now, but seen as constitutive of them? Spirited matter thus becomes a principle of ecological relations. What if these present natal relations between the immaterial and the substantive, between the organic and the inorganic, were understood as vital infrastructures of art making? I realize that the Dance Deck is one "ghost architecture" for Judson Memorial Church; the spaces of invention that the Halprins opened in the woods of Mount Tamalpais were carried within its halls.

Brown and Rainer have both spoken about the rich influence that Anna's work and ethos had on their aesthetic investments in the early 1960s, particularly through their participation in the summer workshop of 1960.[13]

39

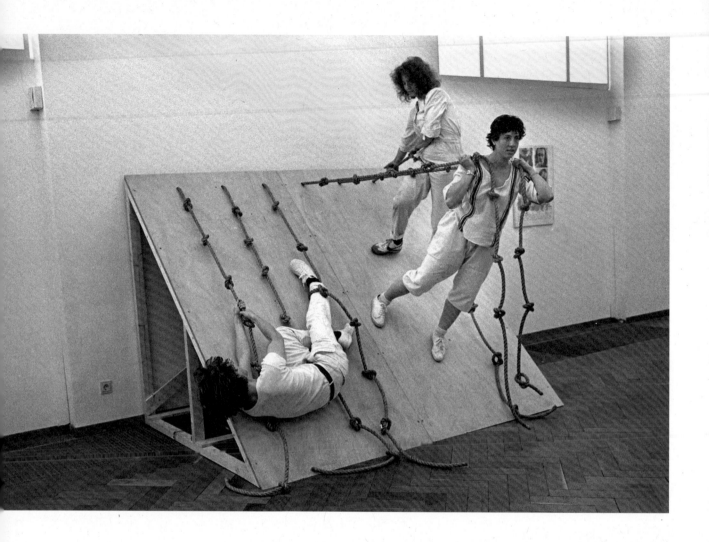

But Forti had been working with Halprin since 1956, dedicating herself to the accumulation of improvisational capacities through the environmental kinesthetic attunement that arose on the deck. Soon after Forti and her husband, Robert Morris, moved to New York in 1959, Forti became a participant in Robert Ellis Dunn's composition classes at Merce Cunningham's dance studio, commonly seen as the crucible of the Judson group. But in late May 1961, before the Judson Concerts of Dance between 1962 and 1964, at the invitation of Young (who had contributed to Halprin's 1960 workshop), Forti realized a two-evening performance "concert," Five Dance Constructions and Some Other Things, with Rainer, Steve Paxton, and Morris as performers, among others. The event took place in Yoko Ono's loft at 112 Chambers Street in New York and would have wide-ranging ramifications for all of the artists involved. But as Rainer recounts this period, there was little immediate art-world recognition or capitalization on this event, and so "a vacuum sealed that

evening for over a year until [Forti's] performers could get the Judson Dance Theater up and running. Simone was its inspiration and fountainhead. We all owe her."[14]

The functional and nonexpressive action so central to the Judson group has often been discussed as a formal dehierarchization of dance—its toppling as a high-culture coded activity founded on systemic training and exceptional physiological accomplishment—and as a (potentially) progressive democratization.[15] Like the late-nineteenth-century photographic motion studies of Eadweard Muybridge that Forti found so enchanting, the enrichment of the quotidian through its aesthetic anatomization at least gave new value to the over-seen.[16] As sociologist Rudi Laermans has argued, this making complex of the ostensibly banal deepens the sensuous and critical relation to what Anna phrased the "workaday."[17] In this regard, task aesthetics presaged the use of durational action in performance art to interrogate the notion of performance as labor under capitalism. Significantly,

despite the Judson group's use of some untrained non-dancers, many of its protagonists were movement trained, but not in the uniform classical regime that this term once implied. Another aspect of "democratization" in these events, the notion that spectators became performers, is also somewhat questionable in the way it fantasizes roles as instantly interchangeable and social space as free. Judson was certainly schooled and schooling. To dehabituate and destylize movement requires practice and skill, one might say performance training: an unlearning that is more the territory of a "professional amateur" than an amateur as such.[18] The emergence of this style of action with "neutral execution depersonalized intention, cool tone and quotidian content," as dance scholar Meredith Morse points out, is wrapped up with longstanding notions of the natural body in dance history.[19] Anna's redefinition (and destylization) of this natural body gave it particular physiological and material determinants that carried over in relay into Judson aesthetics. Most importantly, the performer did not simply arrive at this movement quality individually or internally (though that would be the more H'Doublerian part of Halprin's method) but rather through repeated immersive experiences of attunement to environmental and material relations and energetics. How these dynamics played out in Forti's profoundly influential New York works of the early 1960s, when she had tired of the infinite expanse of improvisational possibilities, is revelatory to trace. For the moment, though, it should be noted that a practiced sensuous ecological reattunement founds whatever affects of "democracy's body" the spectators encountered here.[20]

In Five Dance Constructions and Some Other Things, Forti arrayed a series of sparse functional objects with a minimal sculptural presence across the loft space, each animated by collaborative actions. No photographs or films of these events have yet emerged, leaving us reliant on the participating artists' descriptions and Forti's documentary accounts and initial sketch of the space. The concert took place as a sequential movement between these discrete but counterpointed acts and things, with

some actions repeated. The telling paradox of Forti's term for the majority of these works—Dance Constructions—is founded on tensions between the animate and the still, the fluid and the solid, the fleeting and the lasting—tensions that the works also play out.[21] The deliberate confusion between dance, sculpture, and architecture announced here echoes an entangled relational dimension between bodies and material structures so evident in Forti's work with Halprin on the deck. These are not dances *and* or *with* constructions, but acts in which the determination of a material construction as object is in question. One of the constructions performed those nights and on many since—*Huddle* (1961)—is simply an embodied communal activity, but it makes a substantive amorphous object or living sculpture. In this concatenation of human activity and the human made, relational agency and the relative animacy of bodies and things become the subject. Forti later narrated the actions constituting the works without named performers, lending them an instructional quality: they are separable, portable, and repeatable. But I want to speculate on a certain affective force resident in the singular combination of these acts.

Slant Board, a communal action for three or four performers climbing around knotted ropes, took place on a large plyboard plane fixed at a forty-five-degree angle between floor and wall (fig. 5). Although the performers could rest in situ they did not leave this precarious perch for the ten-minute duration of the work. A game structure without competition, winners, losers, or an evident goal, the piece invoked strenuous play in which human balance, reflexes, the negotiation with gravity and other bodies, effort, tiredness, and incapacity all came to the fore of attention. Reading the work retrospectively, Paxton remarked that the constraint of human potential for movement inherent in these conditions perhaps evoked our "arboreal prehistory."[22] In *Slant Board*, movement forms and choreographic relations are generated as much by the material conditions of the object as they are by performer decision. The same could also be said of *Huddle*, which was performed twice within the concert in different locations. Forti describes *Huddle* as "an object that doesn't exist in a solid sense, and yet it can be reconstituted at any time."[23] Six to nine people grasped each other, forming "a tight mass"; from time to time, participants of the huddle emerged from it, carefully climbed up over the group, and then reintegrated themselves on landing. Again, the work's duration is roughly ten minutes, and the movement quality unadorned. Here, the material conditions are other bodies in a form of collective labor, communion, and sensuous manyness. As

(5) Unidentified performers in *Slant Board*, 1961. Photographer unknown. Performed at Stedelijk Museum, Amsterdam, May 16, 1982

41

Paxton, one of the huddlers on those nights, noted, "Its members individuate, aspire, achieve, and then return to the mass. . . . It resembles a swarm of bees."[24] Animal qualities were also ascribed to the audience in the concert, through one of Forti's "Other Things," called *Herding*, a gentle act of pointlessly shepherding spectators from one place to another. Animal behavior and movement patterns would later become a specific choreographic interest of Forti's oeuvre. In combination, the Dance Constructions' evocation of group activity certainly signaled a return to an inherent precondition of nature, a more-than-oneness that the human animal is prone to forget. *Slant Board* and *Huddle* invoke the labor of climbing, but they are also three-dimensional landscapes: they echo the forms of mountains. In both, alongside a game metaphor, a certain purposelessness is pervasive: what emerges is the physical effort of a body's attempt to act as a communal and material negotiation. Both works are about conditions of coexistence in which a human subject, however it perceives or distinguishes itself, is dependent on the many.

Another Dance Construction, *Platforms*, in mutual resonance with these works, further delineates this human-as-less-than-human dynamic within the concert (the performers becoming animal or object). In *Platforms*, two distinct robust wooden boxes sat in the space and were lifted individually by a male and female performer, who disappeared beneath them: an exposed illusion. Each whistled gently to the other for a duration of fifteen minutes, after which they simply extracted themselves and departed. Julia Robinson has noted how material function is perturbed here: the boxes change "from object to conduit," but the inverse is also true as bodies become whistling but static containers.[25] This kind of thinglyness is an affective quality of material objects that perturbs definition and naming. Some associate thinglyess with an object's dysfunction, others with its instability, ambiguity, uncanny animation, or vitality.[26] My tendency would be to see the thingly as a rupture of objecthood that discloses an anterior amorphous state within the physical world: an emergence of formlessness in form.[27] In this regard, *Five Dance Constructions and Some Other Things* returns the human subject to conditions of movement and shared existence (with all things) where it is constantly becoming something other than itself.

Viewed from outside or above—or in retrospect, as historians say—human lives look like meandering rivers. The once-interlaced streams of creative energy of these collaborating artists took their courses elsewhere. Forti did not participate in the later Concerts of Dance at Judson Church. The "sentiments, love, conscience, instincts" informing this disentanglement are not part of this genealogy, but they will doubtless be written in another place. Forti has often described this period of her life in New York as a time of sadness. In her *Handbook in Motion*, she evokes one part of this sorrow: the experience of alienation from the cityscape, the "depressing" skybound "maze of concrete and mirrors."[28] In the felt movements between the personal and the impersonal that constitute a life, Forti found consolation in the fact that "gravity was still gravity" and turned to her "own weight and bulk as a kind of prayer."[29] The Dance Constructions in part would seem to be one such weighted turning to the flesh as elemental prayer, a negotiation with the ground from which we come and to which we will return. In later years Forti acknowledged that *Huddle* was for her an attempt to relive the emotional and physical conditions of communion with nature that she was missing from her Halprin-inflected Marin County, California, days (fig. 6). When working on the piece in Europe, where the word *huddle* stumbles in translation, she refers to it simply as *The Mountain*.[30]

In a recent consideration of Forti's work, Morris commented that many of the key shifts of twentieth-century art involve some form of "Agency Reduction," an analysis that seems particularly apt in relation to the withdrawal from expressionism into Minimalism.[31] Of course, the tactic of agency reduction signifies something very different for those whose structural position (whether through gender, class, race, or a number of other factors) means that they have little social, political, or economic agency. For Morris, this common tactic is

42

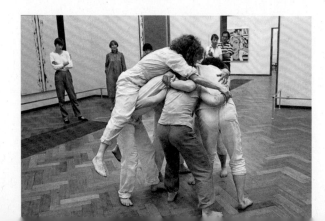

(6) Unidentified performers in *Huddle*, 1961. Photographer unknown. Performed at Stedelijk Museum, Amsterdam, May 16, 1982

part of a wider "discourse of negativity in art of the last century."[32] We might question the extent to which this idea of a power held but withdrawn necessarily pertains to Forti's movement aesthetics, as a female artist working in a male-dominated environment. I would argue that her shift from improvisation to task and instruction, and in the Dance Constructions her use of simple, unadorned action in resonance with constraining objects, while reducing expressive agency, allows the human body to be seen in its materiality; to be seen, that is, as part of a field of expressivity belonging to all things. Things whistle to each other, bodies wrestle against their fall, mingle, emerge, and reintegrate into an amorphous mass. Another kind of agency is found there; not the agency of man over nature, but the agency of one existence, attuned to and being with the many existents. This is the ecological undertow of the de- and re-naturing that takes place before Judson, and it is carried forward and elsewhere by the Judson artists' choreographic reductions, their use of task aesthetics. The democratic body disclosed here—one living species responsive and responsible among many—comes in and out of visibility and presence in the performances of the late twentieth century, but its cultural forgetting will later become an altogether different question of survival.

NOTES

1. Michel Foucault, "Nietzsche, Genealogy, History," in *Language, Counter-Memory, Practice: Selected Essays and Interviews*, ed. Donald F. Bouchard (Ithaca, NY: Cornell University Press, 1977), 139–64.
2. Ibid., 139.
3. On this occasion I was working as a dramaturge and independent curator on the performance *Paper Dance*, a collaboration between Janine Antoni and Anna Halprin, later shown at the Fabric Workshop and Museum, Philadelphia, in 2016.
4. Lawrence Halprin, "Concepts of Space," lecture from a workshop in 1970, Lawrence Halprin Collection, 014, I.A.6127, the Architectural Archives, University of Pennsylvania.
5. See Janice Ross, *Anna Halprin: Experience as Dance* (Berkeley: University of California Press, 2007), 119–22.
6. Lawrence Halprin, "Structure and Garden Spaces Related in Sequence," Progressive Architecture 39, no. 5 (May 1958): 96–104.
7. Arch Lauterer, quoted in Ross, *Anna Halprin*, 105.
8. Lawrence Halprin, quoted in Ross, *Anna Halprin*, 104.
9. Anna Halprin, "Dance Deck in the Woods," *Impulse: Annual of Contemporary Dance* (1956): 24.
10. Ann Halprin, "Film and the New Dance," *Bolex Reporter* 16, no. 1 (1966): n.p.
11. See Ross, *Anna Halprin*, 193.
12. "Yvonne Rainer Interviews Ann Halprin," in *Moving toward Life: Five Decades of Transformational Dance*, ed. Rachel Kaplan (Middletown, CT: Wesleyan University Press, 1995), 100.
13. "Conversation with Trisha Brown and Klaus Kertess," disc 2 of *Trisha Brown: Early Works 1966–1979* (Artpix: 2004), DVD. Accessed online at Ubuweb, http://www.ubu.com/dance/brown_kertess.html; and *Talking Dance: Yvonne Rainer and Sally Banes* (lecture, Walker Arts Center, Minneapolis, 2011). Accessed online at https://www.youtube.com/watch?v=cn6HtsbThKc.
14. Yvonne Rainer, "On Simone Forti," in *Simone Forti: Thinking with the Body*, ed. Sabine Breitwieser (Salzburg: Museum der Moderne, 2014), 72.
15. See for instance Thomas Crow, *The Rise of the Sixties: American and European Art in the Era of Dissent* (London: Laurence King, 1996), 126.
16. Simone Forti in conversation with Breitwieser, "The Workshop Process," in *Simone Forti*, ed. Breitwieser (Salzburg: Museum der Moderne, 2014), 26. Muybridge's images were often of "low class" subjects: laborers, children, and animals.
17. Rudi Laermans, "Re-Visiting Judson," *Moving Together: Theorizing and Making Contemporary Dance* (Amsterdam: Valiz, 2015), 63.
18. The phrase belongs to Bernard Stiegler in the film *Technologies of Spirit: A Conversation with Bernard Stiegler*, dir. Hugo Glendinning and Adrian Heathfield (London: Performance Matters, 2014). Accessed online at https://vimeo.com/ondemand/technologiesofspirit. Stiegler is parsing the position of filmmaker Jean-Luc Godard: "Our problem is to work like an amateur but in a professional way," in *Jean-Luc Godard Interviews*, ed. David Sterritt (Jackson: University of Mississippi, 1998), 81.
19. Meredith Morse, *Soft Is Fast: Simone Forti in the 1960s and After* (Cambridge, MA: MIT Press, 2016), 17.
20. The phrase is the title of Sally Banes's important second book on Judson: *Democracy's Body: Judson Dance Theater, 1962–1964* (1983; repr. Durham, NC: Duke University Press, 1993).
21. See Julia Robinson, "Prime Media," in *± 1961: Founding the Expanded Arts*, eds. Robinson and Christian Xatrec (Madrid: Museo Nacional Centro de Arte Reina Sofía, 2013), 29.
22. Steve Paxton, "The Emergence of Simone Forti," in *Simone Forti*, 61.
23. Simone Forti, "*Huddle*: Artist's Statement," in *Simone Forti*, ed. Breitwieser, 96.
24. Steve Paxton, "The Emergence of Simone Forti," in *Simone Forti*, ed. Breitwieser, 60.
25. Robinson, "Prime Media," 29.
26. See Jane Bennett, "The Force of Things," in her *Vibrant Matter: A Political Ecology of Things* (Durham, NC: Duke University Press, 2010), 1–19.
27. See Bill Brown, "Thing Theory," *Critical Inquiry* 28 (Autumn 2001): 1–16.
28. Forti, *Handbook in Motion* (Halifax: Press of the Nova Scotia College of Art and Design, 1974), 34.
29. Ibid.
30. Forti, "Simone Forti," interview with Samara Davis, Artforum.com, November 7, 2012, https://www.artforum.com/interview/Judson-at-50-Simone-Forti-36991.
31. Robert Morris, "Notes on Simone Forti," in *Simone Forti*, ed. Breitwieser, 47.
32. Ibid.

"The Nerve of a Dancer's Life": Cunningham Class and Judson Dance Theater

Danielle Goldman

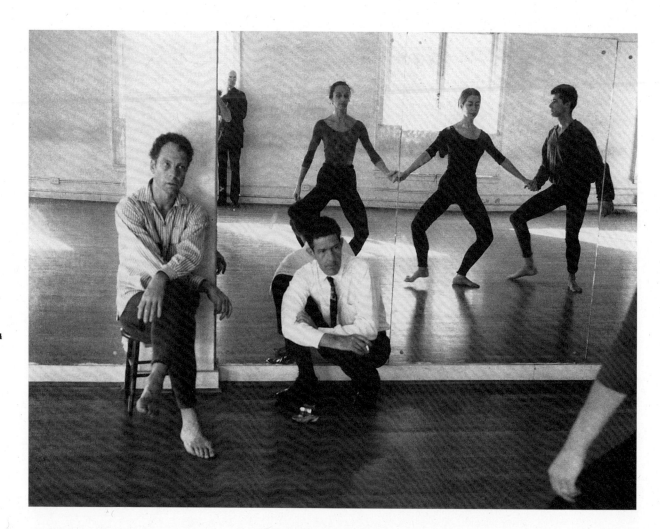

WE SHALL RUN

On January 29, 1963, Yvonne Rainer presented *We Shall Run* as the opening work in Judson Dance Theater's Concert of Dance #3 (fig. 2).[1] The piece began with twelve dancers and non-dancers standing in a line at the side of the Judson Memorial Church gymnasium with what dance writer Jill Johnston described as "impassive attention."[2] Then the performers began to run. Dressed in sundry everyday clothes, they embarked on a series of shifting patterns, gathering and dispersing. Occasionally, one or two people splintered off from the group, but eventually they all joined to form a swirling mass. Although the movements were simple, the spatial patterns were not. Lucinda Childs, one of the performers that day, recalls, "The piece was very complex. You had to go over here and make a little circle, and come back here and make a big circle. It was hard to keep it in my head."[3] Throughout the seven-minute dance, the running was juxtaposed with a recording of the bombastic Tuba Mirum section of Hector Berlioz's Requiem, scored for trombones, tubas, and a choir with hundreds of performers.

Of her participation in Judson Dance Theater, Rainer has frequently joked that she invented running and Steve Paxton invented walking. The line gets a laugh, but there's a substantive element to it as well. Both Paxton and Rainer, along with many artists affiliated with Judson, took seriously composer John Cage's notion that any sound could be considered music. When applied to dance, this meant that any movement, even the most ordinary, could be choreographic material. One sees this approach to action in works by Paxton such as *Proxy* (1961), *Transit* (1962), *English* (1963), and, especially, *Satisfyin' Lover* (1967), in which forty-two people walked from one side of the stage to the other according to a rudimentary score that indicated pacing and occasional pauses. Whereas *We Shall Run*'s robust sound score and complicated spatial patterns offset its quotidian movements, *Satisfyin' Lover* stripped the act of walking bare. As Paxton has explained, this radically unadorned dance "was about looking at what the body does without trying to trot it up into dance or art or whatever. We call it 'quotidian movement,' but they are ancient forms, and they're very complex."[4]

The embrace of quotidian movement in dance was radical in the 1960s, and it posed a challenge to modern dance orthodoxies that continues to resonate with today's dance makers. But the Judson artists' interest in pedestrian movement did not mean an outright rejection of technique and virtuosity, as is commonly assumed. In reality, Judson comprised numerous artists with varied attachments to style, technique, and theatricality, and many of the dances that embraced pedestrian activity also incorporated more established modes of dancing. As Rainer noted in a conversation with dance critic Gia Kourlas about Judson's fiftieth anniversary, "I hope it will disabuse a lot of people who think that Judson was all about minimalism and pedestrian movement. It was not! . . . All kinds of people were engaged in movement that required training, and although pedestrian movement was the innovation, I would say it was on an equal footing with movement and dances that required some degree of training."[5]

As important, many of the Judson dancers who have become known for "rejecting technique," Rainer and Paxton among them, were committed to taking daily technique classes during the early 1960s, often for several hours each day. This apparent paradox is worth examining. Rather than being a separate activity or preoccupation, or a conservative holdover from the era's modern dance, technique class functioned as a deep engine for much of the experimentation that unfolded under the auspices of Judson Dance Theater.

CUNNINGHAM CLASS: A LIVELY DOING

Dancers involved in Judson studied with a number of different choreographers. Anna Halprin was an important

Opposite: (1) Robert Rauschenberg. *Untitled [Cunningham Dance Company Rehearsal (II)]*, 1964. Above: (2) Peter Moore's photograph of Yvonne Rainer's *We Shall Run*, 1963. Performed at Two Evenings of Dances by Yvonne Rainer, Wadsworth Atheneum, Hartford, Connecticut, March 7, 1965. Pictured, from left: Yvonne Rainer, Deborah Hay, Robert Rauschenberg, and Robert Morris (back); Joseph Schlichter and Tony Holder (middle); and Sally Gross and Alex Hay (front)

teacher on the West Coast, and many dancers, including Trisha Brown, Simone Forti, Ruth Emerson, and Yvonne Rainer, attended Halprin's 1960 summer workshop in her outdoor studio near Mount Tamalpais in California. In New York, several Judson dancers took ballet classes at Joffrey Ballet School or studied with James Waring, but Merce Cunningham's classes were particularly influential. This is interesting given scholars' tendency to analyze the Judson group's embrace of quotidian movement as a pointed rejection of Cunningham technique.

At the time, Cunningham's studio, located on the top floor of the Living Theatre building on Fourteenth Street and Sixth Avenue, was a hotbed for contemporary ideas about dance (fig. 1, page 44). The composition workshop (1960–62) that led to the formation of Judson Dance Theater took place in Cunningham's studio and was taught by Robert Ellis Dunn. There was also significant overlap between dancers who performed and choreographed works for Judson concerts and those who were part of Merce Cunningham Dance Company, including William Davis (1963–64), Judith Dunn (1959–63), Deborah Hay (1964), Steve Paxton (1961–64), and Albert Reid (1964–68). Other Cunningham dancers, such as Carolyn Brown (1953–72), Remy Charlip (1950–61), Viola Farber (1953–65, 1970), Barbara Dilley (1963–68), Valda Setterfield (1961, 1965–75), and Marilyn Wood (1958–63), all performed at Judson. And although Childs, Emerson, Elaine Summers, and Rainer never performed with the Cunningham company, they assiduously took Cunningham's technique classes throughout the Judson years.

Cunningham began his career in Martha Graham Dance Company, where he performed from 1939 to 1944. He was a remarkable dancer, and critics lauded his quickness, buoyancy, and capacity for both humor and intensity. In addition to rehearsing with Graham, Cunningham also studied at the School of American Ballet in New York, founded by Lincoln Kirstein and George Balanchine. Soon after leaving the Graham company, Cunningham embarked on a lifelong collaboration with Cage, who would become a famed proponent of indeterminacy and chance operations in musical composition. In 1944, they presented their first joint concert in New York. During this time, Cunningham taught to make money and to provide continuity for the dancers with whom he worked, not because he particularly enjoyed teaching.[6] Still, he became a deft instructor who challenged his students both physically and mentally. In 1953, Cunningham founded his company. Reflecting on his early years as a teacher, when he primarily worked

with a handful of students in small, rented New York City studios as well as at Black Mountain College in North Carolina, Cunningham notes, "My point always was to make people strong and resilient in the head rather than giving the same class every day, to give them some kind of elasticity about technique."[7]

Despite his early training, Cunningham's classes departed from both Graham's technique and classical ballet in significant ways. Over time, he developed a class that began with dancers standing in the center of the studio—neither sitting on the floor, as was standard in a Graham class, nor using the support of a barre, as was customary in ballet training. He also prioritized the spine, asking his students to mobilize their backs and torsos with a series of twists, bends, and tilts. Once finished, he would move to the legs, ultimately linking the legs and the spine together in quick and rhythmically complex combinations.[8] He borrowed much from classical ballet technique, particularly the legwork. But rather than twisting the shoulders in classical épaulements, a holdover from court dancing, where it was unthinkable to turn one's back on the king or queen, Cunningham sought mobility initiated deeper in the trunk (fig. 3).[9]

Although these innovations are important to consider, there was more to Cunningham's work in the late 1950s and early 1960s than can be conveyed in a discussion of form, and there are reasons why Judson dancers were driven to study with Cunningham even as they were pushing the limits of choreography and challenging him on several counts. At the time, Cunningham's technique was not yet thoroughly codified; his studio was a place where dance was being interrogated and where *dancing* was prized. According to Judson dancer Reid, who took his first class with Cunningham in 1959, Cunningham would come out of his dressing room in slippers, put them in a corner, and start teaching. Reid recalls that Cunningham had a formal reserve, but that to watch him was riveting: "He would enter a room, and everyone would be taken aback."[10] Perhaps more notably, Cunningham would give very few criticisms. "Mostly

Opposite: (3) Clemens Kalischer's photograph of Merce Cunningham teaching at Black Mountain College, Asheville, North Carolina, 1948

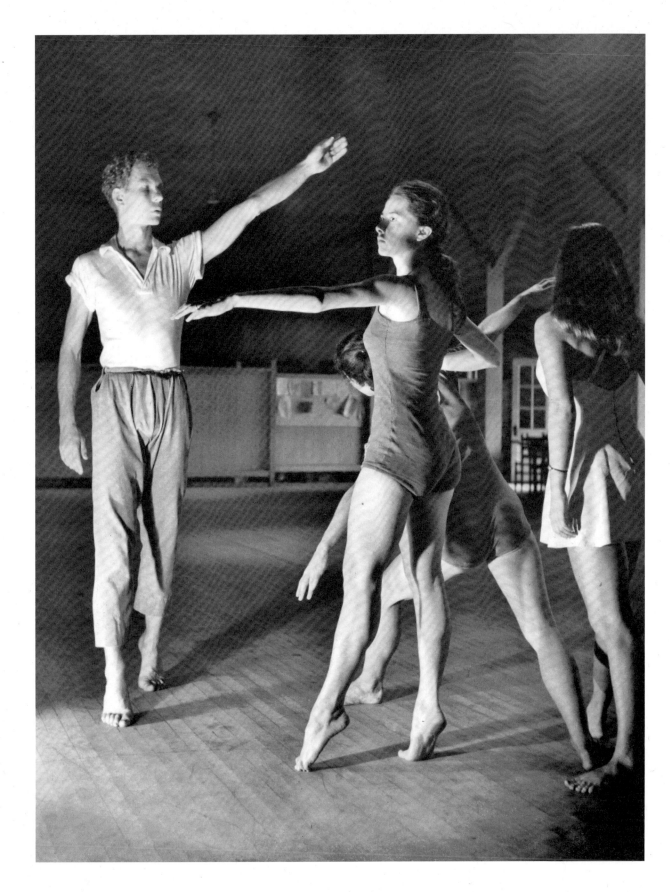

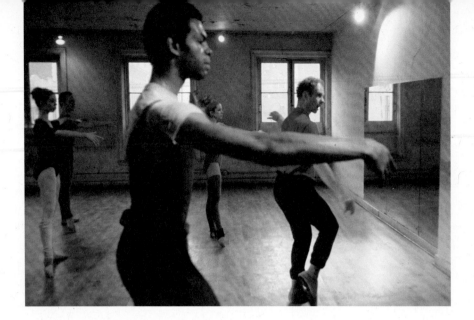

he would leave us alone," noted Reid. "It was fun to do these difficult things. Rigor was appealing."[11] By all accounts, Cunningham was interested in how dancers brought themselves to the daily work of dancing. "Class," he explained, "is the moment where you have to struggle to make the movement pass completely into and through the body."[12]

Cunningham's approach to technique classes corresponded with his concerns as a dance maker (fig. 4). He had a daring curiosity and an interest in movement of all sorts. Reflecting on his early choreographic explorations, Cunningham has noted, "When you find something you don't know about or don't know how to do, you have to find a way to do it, like a child stumbling and trying to walk, or a little colt getting up. You find that you have this awkward thing which is often interesting, and I would think, 'Oh, I must practice that. There's something there I don't know about, some kind of life.'"[13] The same philosophy activated his teaching. To the twists and tilts he delivered in class, Cunningham added rhythmic complexity and unpredictable coordination. This was a means to get at the deeper work of dancing—not in the limited sense of executing vocabulary, but in the fuller sense of bringing movement to fruition. There was to be none of the emotional expression, personal inflections, or attempts at storytelling that dominated modern dance. Like the colt or the child, dance was to be a lively doing, with minimal self-regard.

For many Judson dancers, Cunningham's attention to the *doing* of movement rather than the movement itself was most significant. Judson participant Hay first encountered Cunningham's work at Connecticut College in New London in 1961. "I used to sneak into

the auditorium at night and watch the rehearsals lying on my stomach in the balcony. I had never before experienced the magic that he still has. What I learned from watching him was something about performance: When he's dancing he looks like he's listening with his entire body."[14] Hay studied with Cunningham that summer in Connecticut and then continued until 1964. Having danced since childhood, she explains that her first encounters with Cunningham's work were "alarming to her system."[15] As any dancer knows, technique instills habits, and the adult dancers who worked with Cunningham in the beginning already had distinct movement histories in their bodies as well as ideas about performance, which Cunningham largely rejected. As Hay recalls, "There was no way to read or to follow what was going on in his work. There was no logic to what I was looking at. It was such a surprise. I had no history for looking at that."[16] She was shocked, but also thrilled and deeply challenged by the alternative sense of what her body could do. Through working with Cunningham, Hay discerned that other relationships to her body and to learning were possible: "I would say some part of my learning process was being challenged to the core, through his choreographing and his teaching. It was the first time I felt like I wasn't being a good girl. I was really and truly being challenged."[17]

A RHIZOME IN THE HEART OF A TREE

If one focused on form alone, it might seem as though Judson dancers' embrace of pedestrian movement was a repudiation of Cunningham's technique. Indeed, this

is what many historians say. As dance scholar Carrie Lambert-Beatty notes in "Moving Still: Mediating Yvonne Rainer's *Trio A*," much has been written regarding the "lines of influence and opposition" between Judson choreographers and the work of Cage and Cunningham. According to these accounts, "Cunningham's virtuosity became a model against which they worked in dances that incorporated found motion: walking, running, speaking."[18] Even David Vaughan, the long-time archivist for Merce Cunningham Dance Company, argued, "The Judson group, in the true tradition of the modern dance, consciously repudiated the aesthetic of the previous generation—that is, of Cunningham himself."[19]

But another story unfolds once one reckons with the *doing* that Cunningham prioritized. As Paxton recalled recently, "[Cunningham] wanted us to be *doing* his movement. This simple injunction was for me a stringent psycho-spiritual situation. How to motivate my body within Merce's movement without adding one iota of imagination, license, even thought."[20] Reflecting on how his own early explorations of pedestrian movement related to Cunningham's demands, Paxton elaborated: "If the stage is a sort of laboratory on which aspects of movement can be assessed, focused upon, then I was trying to see 'natural' movement under that scrutiny but without the self-regard of the performer being evident. This attempt is psychologically vexed for the performer. It is very much the problem I experienced with the Cunningham *doing*."[21] With a work like *Satisfyin' Lover*, Paxton explored whether it was possible for performers to walk, sit, and stand as they might under ordinary circumstances, but within the heightened frame of performance (fig. 5). Paxton was surprised to find that most of the performers were capable and recalls only two over the years who could not complete the task "without exhibiting excruciating self-consciousness."[22]

Rainer too was affected by Cunningham's emphasis on the doing of action. In those early years, Rainer thought it unlikely that she would dance in an "official" company because, according to her writings, she lacked technical proficiency and the "litheness" that was expected of most female dancers.[23] Instead, she performed in Waring's work, while increasing her commitment to choreography. All the while, throughout the Judson workshops and performances, and even for several years beyond that, Rainer continued to study with Cunningham. Notably, she concludes her book *Work 1961–73* with an epilogue dedicated to Cunningham.

Although she objected to the "tyranny of his discipline" and its attendant exclusions, Rainer recognized that Cunningham's teaching nevertheless moved her "ever nearer to her own body ease."[24] Recalling the exhilaration she experienced in dances such as *We Shall Run*, she specifically credits Cunningham "for the part he played in that running."[25]

Cunningham, of course, was by no means the only influence on Judson dancers. Artists involved in Judson drew from the aforementioned Halprin and Waring, as well as from visual artists such as Robert Rauschenberg and composers such as Cage. But even these tropes of influence and genealogy are too simple to account for the daily work that was happening across multiple bodies in the studio. There were, after all, many dancers in the room. Paxton, who at the time questioned why Cunningham's dances were balletic and organized if the operating principle was chance, nevertheless recognized that Cunningham offered "vigorous, precise, unusual classes . . . a daily dose of movement-heightening to which I became addicted." Paxton further explained, "My mental struggle with Cunningham's aesthetics gradually dissolved into this immersion."[26] This immersion matters, as does the work of company dancers such as Brown and Farber, who, according to Paxton, "gave exquisite renditions of the exercises" at the front of the class."[27] So do the contributions of those dancers working diligently in the back. Together these elements complicate the scene and put pressure on tired, painful tropes of lone (male) genius and artistic genealogy. As Paxton told me, "Rigor didn't begin and end with Cunningham."[28]

When in 1983, during an interview conducted for the Judson Project at Bennington College in Vermont, dancer Nancy Stark Smith asked Paxton whether any particular pieces or people changed his way of looking at things during the Judson days, Paxton recalled how, as dancers trickled out after one particularly intense Cunningham class, Forti crawled on the floor. "I'm sure she was sort of re-establishing some kind of contact

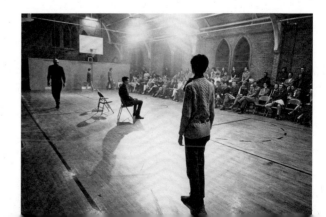

with the earth and basic movement after the high-flown technique that she'd been attempting. But it was shocking to see in that studio somebody crawl after all this flitting around on half-toe and balancing and high legs. . . . Her hair hanging over her head and hiding her face, and her body just lumping along, you know, no effort at grace, or 'grace'" (fig. 6).[29]

Forti is a remarkable improviser, and anyone who has followed her work over the years would be able to picture this scene. She studied extensively with Halprin, and in the spring of 1961 performed her series of Dance Constructions in Yoko Ono's loft in New York. These constructions involved a set of simple rules that generated activity but without arranged phrases or drama. *Huddle*, for example, involved a group of people who took turns climbing over each other. These works made a significant impression on many Judson artists, who either saw or heard about them. As Paxton recalls, "If in the Judson pantheon Merce was one pole, Simone was the other. . . . The contrast with Cunningham choreography could not have been more provocative."[30] Nevertheless, the cross-fade that Paxton renders with such precision complicates any simple dichotomy or separation between Forti's crawling and Cunningham's doing. One could view Forti's contact with the ground as being at odds with the material of the technique class. But it's more compelling to think about the extent to which it was animated by it, oscillating out to others in turn.

In their noted work of "anti-genealogy," *A Thousand Plateaus*, theorists Gilles Deleuze and Félix Guattari argue that "evolutionary schemas may be forced to abandon the old model of the tree and descent."[31] According to Deleuze and Guattari, the tree is a dominant metaphor in Western accounts of genealogy, where new branches are tied in an essential way back to a single trunk. Instead of the tree, a hierarchical model where lineage and authority are centralized, they suggest the rhizome as an alternate metaphor, a tangled underground root, without beginning, end, or precise center. "We're tired of trees," they write, "They've made us suffer too much."[32] There were certainly treelike aspects to Cunningham's class. Dancers organized themselves into a "front" and a "back," and many dancers have spoken of their intense desires to be "chosen" by Cunningham for his company. There was power at play, and, as Rainer has noted, the empathy in the room ought not be confused with equality.[33] Nevertheless,

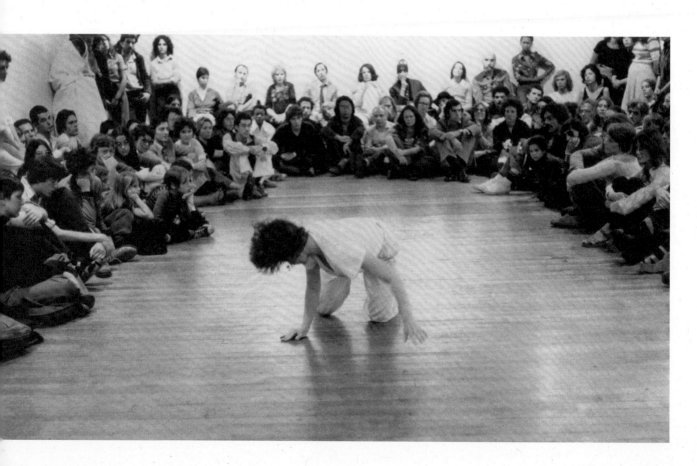

as Deleuze and Guattari also point out, "A new rhizome may form in the heart of a tree, the hollow of a root, the crook of a branch."[34]

With this in mind—a rhizome in the heart of a tree—perhaps we might reconsider relations between Judson artists and Cunningham and dispense with the simple notion that dancers affiliated with Judson embraced Cagean principles of chance and indeterminacy and explored pedestrian movement but rejected Cunningham technique. This long-told story misunderstands Judson and Cunningham's shared daily work. The "immersion" that Paxton mentions in his discussion of technique class ought to be taken seriously, along with his reminder that the rigor of class was not Cunningham's alone. Let us reckon, then, with the spaces between Cunningham's body and Forti's, and also Paxton's and Rainer's and Hay's—the rhizomatic weave of a Cunningham class—generated by the integrity of their attempts at unfettered doing. This *doing*, after all, was the daily work—what Cunningham called the "nerve of a dancer's life."[35]

NOTES

1. Sincere thanks to Pat Catterson, Deborah Hay, Sarah Michelson, Steve Paxton, and Albert Reid for taking the time to speak with me for this essay.
2. Sally Banes, *Democracy's Body: Judson Dance Theater, 1962–1964* (1983; repr. Durham, NC: Duke University Press, 1993), 87.
3. Ibid., 87.
4. Paxton, "Steve Paxton," interview by David Velasco, Artforum.com, July 24, 2012, https://www.artforum.com/words/id=31419.
5. Yvonne Rainer, "Yvonne Rainer Talks about Her Newest Dance and Judson," *Timeout: New York*, October 30, 2012, https://www.timeout.com/newyork/dance/yvonne-rainer-talks-about-her-newest-dance-and-judson.
6. Jacqueline Lesschaeve, *The Dancer and the Dance: Merce Cunningham in Conversation with Jacqueline Lesschaeve* (London: Marion Boyars, 2000), 56.
7. Ibid., 54.
8. Ibid., 60.
9. Ibid., 62.
10. Reid, conversation with the author, November 7, 2017.
11. Ibid.
12. Lesschaeve, *The Dancer and the Dance*, 64.
13. Lesschaeve, *The Dancer and the Dance*, 39–40.
14. Banes, *Democracy's Body*, 50.
15. Hay, phone conversation with the author, January 30, 2018.
16. Ibid.
17. Ibid.
18. Carrie Lambert-Beatty, "Moving Still: Mediating Yvonne Rainer's *Trio A*," *October* 89 (Summer 1999): 91.
19. David Vaughan, quoted in Roger Copeland, *Merce Cunningham: The Modernizing of Modern Dance* (New York: Routledge, 2004), 210.
20. Paxton, email to the author, February 2, 2018.
21. Ibid.
22. Paxton, email to the author, February 5, 2018.
23. Yvonne Rainer, *Work 1961–73* (New York: New York University Press, 1974), 5.
24. Ibid., 328.
25. Ibid., 329.
26. Ibid.
27. Ibid.
28. Paxton, email to the author, February 5, 2018.
29. "Trance Script: Judson Project Interview with Steve Paxton," *Contact Quarterly* 14, no. 1 (Winter 1989): 14–21.
30. Paxton, email with the author, February 2, 2018.
31. Gilles Deleuze and Félix Guattari, *A Thousand Plateaus* (Minneapolis: University of Minnesota Press, 1987), 10.
32. Ibid., 15.
33. Rainer, *Work*, 329.
34. Deleuze and Guattari, *A Thousand Plateaus*, 15.
35. Lesschaeve, *The Dancer and the Dance*, 67.

Opposite: (6) Babette Mangolte's photograph of Simone Forti in *Solo No. 1*, 1974. Performed at Sonnabend Gallery, New York, 1974

THREE DANCES

1.
Saliva

2.
Pause.
Urination.
Pause.

3.
Perspiration.

Summer, 1961
G. Brecht

Judson Dance Theater has become the kind of legend whose reality is lost in a mist of nostalgia and imperfect remembrances. The people who were involved in the group nearly twenty years ago remember only fragments and each one, of course, has a particular perspective on that past. . . . Dance historians and critics invoke Judson for all sorts of reasons, many of them inaccurate. And meanwhile, no one can agree on what, exactly, the Judson Dance Theater was.[1]

These opening lines, from a review of Judson Dance Theater's first retrospective in 1982, were penned not by an overtaxed journalist but by the reigning expert, Sally Banes. Since then, a wealth of scholarship has filled this vacuum: from dance history to increasingly wide-ranging theorizations of an inordinately experimental decade. With all we have learned about the 1960s—about diverse artistic attempts to break into actual space and real time, about the several post-Cagean cohorts in the same generation, about multiple *minimalisms*—the frame around Judson is as fragile as ever, perhaps productively so. In the progressive mediation of Banes's "lost" reality, photographs have gained outsized status as evidence, shaping memory and history alike. Revisiting this ephemeral chapter of a famously dematerialized decade, we are ever pressured by the fragments—by the difficulty of bridging the gap from snapshots to physical things.

What follows here is an attempt to illuminate briefly a convergence of different artistic competencies that anticipates Judson and directly informs it. I will touch on two figures—artist George Brecht and dancer Simone Forti—whose stories necessarily implicate others. After working through Cage's example (in his classes at the New School in New York, 1958–59), Brecht looked to dance, collaborating with choreographer James Waring to develop the perceptual field of his "events." After four years with choreographer Anna Halprin (1955–59), Forti involved herself with a new model of art, collaborating with artist Robert Whitman,

and then honed her Dance Constructions. Amid much experimentation at the turn of the 1960s, Brecht and Forti stand out for the focus with which they applied another art as research for their own. Their approaches and results then became models for others.

1. PRELUDE: INDETERMINACY AND WALKING

Given the centrality in the Judson story of Robert Ellis Dunn's composition class for dancers at Merce Cunningham's studio in New York—driven by Cage's indeterminate scores—it is worth briefly revisiting that foundation. As a Cage student at the New School in New York in 1958, Dunn witnessed the composer at a pivotal moment: developing his use of chance, originally confined to composition, as indeterminacy in the realm of performance. That year, Cage defined a series of radically formatted scores—*Variations I, Music Walk,* and *Fontana Mix* (all 1958)—comprised of loose transparencies whose differentiated graphic markings were to be assigned auditory, qualitative, or temporal values, and constellated by the performer at each realization. Cage marked his transgression of the limits of music in several performances introducing an antithetical act: *walking. Fontana Mix,* applied in Dunn's classes, was the most intricate and generalizable to date. Cage showed its scope by using it to make a piece for television: *Water Walk* (1959; fig. 2, page 54). Announcing a new virtuosity, he finessed the chance-based sounding of multiple water-related "instruments"—e.g., a pressure cooker, watering can, soda syphon, bathtub, and water gong—inside of three minutes. In 1960, when the CBS host queried his title, Cage responded, simply and provocatively: "Because it contains water, and because I walk during its performance."[2] This display, and his extension of *Music Walk* in 1960, as *Music Walk with Dancers,* are the precursors of the infamous Judson cliché concerning their invention of "walking."[3]

Cage's new indeterminate scores were the precipitate of his summer 1959 class, after which two students finalized the first applications in art. Allan Kaprow's *18 Happenings in 6 Parts* (October 4, 6–10) and Brecht's *Toward Events: An Arrangement* (October 16–November 5) were presented at Reuben Gallery in New York. Bracketing Brecht for now, what is notable about Kaprow's piece is its structure. Indeed, his distinctly Cagean, parts-to-whole ratio of 3:6:18—the piece was physically partitioned into three areas, with six actions in each and three moves of the audience—is closer to Judson

(1) George Brecht. *Three Dances,* 1961. From his box of cards, *Water Yam,* 1963. Offset card, 4⅜ × 2⅝", from cardboard box with offset label, containing 69 offset cards. Designed and produced by George Maciunas. The Gilbert and Lila Silverman Fluxus Collection Gift, The Museum of Modern Art, New York

choreography than to the theater/art models that began to appear in 1960. The resemblance of Kaprow's title, *18 Happenings in 6 Parts*, to Yvonne Rainer's *Dance for Three People and Six Arms* (1962) is no coincidence. More surprisingly, the same can be said of the movement vocabulary Kaprow parsed out—pendulum arms/elbows, discrete bends, squats, and leg swings—to drop into the structure.[4]

When Cage quit teaching in 1960, it was not just Dunn who continued his methods. There were two workshops: one for dancers, the other—led by composer Richard Maxfield—for a new cohort, as diverse as Cage's had been, at the New School.[5]

2. SNAPSHOTS 1960

The experimental scene was still fairly quiet in 1959 but the Reuben Gallery activities soon spilled over to Judson Memorial Church. In January 1960, Happenings artist Claes Oldenburg retooled the Judson Gallery as a site of collective performance. His own project radically bridged the two functions, transforming the architectural support with a "construction" called *The Street*. Seen in two distinct phases, this aggressively scaled, three-dimensional "drawing" was open to the public as it was being built. In phase two, the site became a set for *Snapshots from the City*. Through a doorway, two figures were seen running, writhing, and falling, as changing light/darkness calibrated the experience of time. Amid much staging of indeterminacy—in art and by Cage himself (*Theater Piece*, March 1960)—one should not underestimate the value of Oldenburg's starkly different orientation. Whitman would adopt the term "theater piece," but he was no

Cagean either. As a student of Kaprow's when the latter was taking Cage's class, Whitman's decision to reject that chance/structure in favor of a more Oldenburgian model was a knowing one.

On June 11, 1960, Whitman presented *E.G. (An Opera)* in a group program at Reuben Gallery. The set was a floor-scape of rags and wood, variously piled and scattered, extending to the feet of the audience on two sides. The piece was internally articulated with concrete and recorded sound—dropping bricks, voices—and slow- to fast-paced action. Significantly, the two main testimonies on this un-notated piece are from observers steeped in dance: dance writer Jill Johnston (future champion of Judson) and Forti. "The first work . . . in New York that I felt an immediate kinship with was . . . Bob Whitman['s] *E.G.*," Forti wrote. "Part way through it, [he] took a flying leap over the heads of the audience. . . . It was hard to take everything in because the room was overcrowded. [I] told Whitman . . . I'd been doing things in California I felt were similar to his piece, and that I'd like to work with him."[6]

American Moon honed Whitman's strategy of building an image through time. Staged at Reuben Gallery

(November–December 1960) with Forti as a performer, it is remembered now for certain emblematic moments, as when a vast volume of plastic inflated by vacuum cleaners materialized in the space before an audience clustered in "tunnels." In lieu of a score, a drawing, *The Heap* (fig. 3), established the morphological mandate; one thing, bristling with potential, it was indeterminate in that its instantiations always differed. *The Heap*'s first three-dimensional appearance was as rounded piles of rags, which, once grasped, began to move. The audience then saw projections of the same forms out in nature. Later, Forti and Whitman bounced in at floor-level from opposite sides of the space in what we might now call a moving plank pose. Based on slightly odd instructions, they transformed noun into verb. "What did he call it? *Heaping*," Whitman's coperformer recalled. "He said, 'you heap around.' And I'd heap around; and he'd heap around."[7] The relationship of object and action as determinants of the form would prove important for Forti. Her description confirms this as a world away from any existing model of dance: "My actions were done not in order that the movement be seen, but so that the particular task could be accomplished."[8]

3. BEYOND HALPRIN AND CAGE: SEEING THROUGH WHITMAN

Forti's encounter with Whitman's work came in 1960 when she was taking classes with Cunningham, whose formalist isolation of body parts she found alienating and arbitrary. The same summer saw her returning to Halprin's workshop in California—one last time—with her new peer Yvonne Rainer. From this moment on, Forti broke away from her mentor's approach as well. We have to wonder, then, what she meant, regarding Whitman's *E.G.*, that she had been doing "similar things" in California. Halprin's hours-long improvisation sessions—whose epiphanies of anatomical discovery blended into the polished choreographies—seem unrelated to the New York artist's scrappy presentation and planned chaos.[9] Forti takes an interest in Whitman's work precisely because she is grappling with the core elements in her practice. Consider the details of the scene at the Great Jones Street studio that Forti shared with Robert Morris and Rainer, which the latter has placed on record as radically affecting her conception of dance: "She scattered bits and pieces of rags and wood around the floor, landscape-like. Then . . . sat in one place for a while, occasionally changed her position or moved to another place."[10] One might now recognize this as notes on *E.G.*—Forti's effort to reconstruct the situation she found hard to take in. By extension— and given the witnesses involved—we may identify a post-Whitman dimension in certain Judson staples, from concretely flung bodies to scatter-piece sets, their reappearance or application—not pro-art/theater but contra dance—partaking of the "solution" they had represented for Forti.

Forti was unusually skeptical about the Cage scores being avidly applied in Dunn's classes from fall 1960 onward. Acknowledging their value as a spur for dancers who were not yet choreographers, she was apparently under no illusion about the freedom on offer. "It did not seem . . . that Cage had relinquished any control," she has noted. "His hand could still be strongly felt in the original structuring procedure, and in the resulting quality of space containing autonomous events."[11] Given the heavy spatial intervention of *American Moon*, one might say the same of Whitman. But, for the dancer, the operations the latter piece drew her into were more urgent and productive. Indeed, "the heap" made an unlikely return—as a corrective to skill—in the rehearsal of *See Saw* (December 1960), the first of two pieces Forti was to present at Reuben Gallery two weeks after *American Moon*. Watching her performers (Rainer and Morris) getting acquainted with the physical demands of the seesaw, Forti made spontaneous use of a piled-up coat. As if trying to shake Rainer out of a default to dance, which would have overly embellished this work, Forti threw the coat on the floor "ordering me to 'Perform that!'"[12] *See Saw* brought a new focus to the nominal-verbal catalyst (of the heap/heaping)—evoking a visual grasp structured in the now/not-now.

See Saw and the second work Forti presented at Reuben Gallery, later titled *Roller Boxes*, amounted to a rather uncompromising statement on deskilling. Stripped-down performance imperatives were established through a few obdurate objects: a plank on a sawhorse and two open boxes on wheels. These frames managed to elicit some of the all-or-nothing/nowhere-to-go/cause-effect momentum that had interested Forti for its radical rupture of trained movement. If *See Saw* restricted the action, *Roller Boxes* engendered another extreme, releasing control and engaging the space, wall to wall. In handing over the ropes attached to the boxes (containing performers) to be pulled around, Forti exceeded all openings to the audience to date. That this turned wild—with the pullers

55

Left: (4) Robert McElroy's photograph of Simone Forti and Patti Mucha in *Roller Boxes*, 1960 (then titled *Rollers*). Performed at Reuben Gallery, New York, December 16–18, 1960. Opposite: (5) George Brecht. *Comb Music (Comb Event)*, 1959–62. From his box of cards *Water Yam*, 1963. Offset card, 5¼ x 4¾", from cardboard box with offset label, containing 69 offset cards. Designed and produced by George Maciunas. The Gilbert and Lila Silverman Fluxus Collection Gift, The Museum of Modern Art, New York

becoming "maniacs"—has overwhelmed her original idea of creating a changing spatial situation and letting the piece develop.[13] Apart from all it anticipates concerning minimal objects and the presence of perceivers completing the work, *Roller Boxes'* simultaneous use of indeterminacy *and* improvisation broke the Halprin-Cage bind (fig 4).

Forti tuned the energy distribution she now understood into a single form/action, with a new, propless piece based on a mound of people, akin to a slow rugby scrum. After a five-minute test of the work in the Dunn class, she doubled its duration. There is no clearer evidence of the break this made from her mentor's work than Forti's need to explain to Halprin that this was "a form in itself and not part of a composition."[14] Beyond her Dunn class peers, Forti sought non-dancers to work with, from La Monte Young to Henry Flynt. The concept of the Dance Constructions came before the examples were finalized, even before she gave the title *Huddle* to the aforementioned mound. *Platforms*, *Hangers*, and *Slant Board* (all 1961) consolidated her aim of efficacy: an organization of weight and energy transparent to participants and audience alike. Five Dance Constructions and Some Other Things debuted on May 26 and 27, 1961, with Rainer, Steve Paxton, and Morris joining Forti as performers. This was one of ten "concerts"—of poetry, music, dance, and art—that Young curated at 112 Chambers Street in New York. His exacting standards drew the best from the diverse competency base around him. Young opted for Chambers Street after thinking to take over curating Judson Church. We can only speculate as to how this would have altered the history.[15]

4. DANCE: BETWEEN MUSIC AND EVENT

Toward Events, Brecht's first exhibition after the Cage class, had extended his efforts to score readymades (in/as music). Obviously, the context of art had no recourse to performers; the proposition—conveyed in objects and instructions—thus had to engage the viewer directly. But as everyone was learning the hard way, audiences—whether at exhibitions or concerts—were not ready to adjust their expectations. Imagining that for simple, everyday experiences to be given the kind of attention reserved for art, some skillful mediation could be of use, Brecht looked to dance. In early 1960, he laid out some distinctly Judson-like propositions:

> dance elements in a natural structure (eating
> at table)
> natural elements in a dance structure (walking
> in pattern)
> natural and dance elements opposed in space
> [natural and dance elements opposed in] time
> dance movement which is almost natural
> nat[ura]l [movement which is almost] dance.[16]

Waring, to whom Brecht expressed these ideas at the time, was unique in his openness toward the next generation. Waring had for some years been inviting artists (Jasper Johns, Ray Johnson, Kaprow, and Whitman) to create his sets. This division of labor changed in his collaboration with Brecht. The two assumed fluid roles, both creating lists of unconventional props and proposing how they might enter a given performance. In January 1960, Brecht's notes show him hashing out details—and

conferring with the choreographer—on a yet-to-be scheduled "Waring piece." Within a few months, this was recast as Brecht's *Gossoon*, the piece that preceded Whitman's *E.G.* on the Reuben Gallery's June 11 program. Scaled precisely to the room, three kinds of score were superimposed: movement (by Waring), sound (by Maxfield and Brecht), and light (by Brecht). Dancers were enlisted to do things like taking a glass from a wall cabinet to drink from, reading newspapers, or using flashlights to catalogue parts of their bodies. In his effort to amp up the ordinary, Brecht recognized that anything "too dance-like" may appear as parody. If Waring's style, tending toward the latter, raised the issue, it also revealed the solution: "to allow everyday movement to move just into significance."[17] This began a period of regular collaboration between the two that continued through 1963.

In late 1960 and early 1961, Brecht consolidated his concept of the event, building its scope by envisaging everyday contexts and modeling occurrences as a subtle form of dance. *Subway Event* (1960) situated choreography on a Sixth Avenue subway platform. *Three Social Pieces* (1960) put dancers on escalators at the Port Authority bus terminal, almost blending into the crowd. A certain conceptual resolution is evident by early 1961, when Brecht began recasting his Cage class scores as more general propositions; *Time-Table Music* and *Comb Music* (both 1959) became *Time-Table Event* and *Comb Event* (fig. 5). At this point he had finalized the concise text form of the event score—subsequently taken up in Fluxus—creating an extensive set of examples, which he printed and circulated by mail. Departing from simple objects and relationships, Brecht created occasions for attentiveness: *Three Lamp Events* and *Three Telephone Events* (both 1961) were based on the eponymous readymades and their familiar functions; *3 Piano Pieces* (1963) proposed the accompaniment of "standing, sitting, walking." Several scores explicitly referenced dance. *Three Dances* (1961) focused on minute events set off by the dancer's body, including saliva and perspiration (fig. 1, page 52). Its pendant, *Two Dances* (1961), simply consisted of the two words/prompts: *left* and *right*.

Brecht presented a pivotal articulation of his score *Three Chair Events* in the Martha Jackson Gallery show *Environments, Situations, Spaces* of May 1961 (the same month as Forti's Dance Constructions). The landmark show focused on the conception of context driving current artistic practice. Next to exuberant works like Oldenburg's *The Store* (1961) and Kaprow's wall-to-wall tire piece, *Yard* (1961), Brecht's empty room with a single white chair (and copies of the score) was the image of reticence. The two

other chairs mentioned—one yellow and one black—were put in more neutral spaces: near the gallery entrance and in the bathroom, respectively. Reviewing the show, Johnston revealed the tendency to see only the white chair.[18] As an artist dealing with similar concerns, Morris sensed the limit condition Brecht had defined: "Sitting on Brecht's white chairs one can forget about them. . . . Was the glass of water I drank at Brecht's Brecht's glass of water? . . . When I creaked . . . in the chair was that Brecht's Sound? Closing the door to leave, did I make a Brecht action?"[19]

Although Brecht's work has not been addressed in the context of Judson dance, one senses his ideas there, mediating the Cage model, entering the mix of new thinking by the emerging generation. Far from unknown, his events belong to that "reality" Banes described as "lost in . . . imperfect remembrances" in the quote with which we began. We do know that Cage and composer David Tudor were receiving and sending feedback on Brecht's scores while touring with Paxton in 1961; and that Rainer and dancer Fred Herko performed in Waring pieces in 1962 for which Brecht conceived events/sets. Indeed, Herko's performance of *Comb Music/Comb Event* is the one on the photographic record (fig. 6, page 58). A week before the event we know as the inaugural Concert of Dance, Waring wrote: "George. Would like to see you. . . . Come to Bob Dunn's class program Friday night 6 July at Judson Church."[20]

COMB MUSIC (COMB EVENT)

For single or multiple performance.

A comb is held by its spine in one hand, either free or resting on an object.

The thumb or a finger of the other hand is held with its tip against an end prong of the comb, with the edge of the nail overlapping the end of the prong.

The finger is now slowly and uniformly moved so that the prong is inevitably released, and the nail engages the next prong.

This action is repeated until each prong has been used.

Second version: Sounding comb-prong.

Third version: Comb-prong.

Fourth version: Comb. Fourth version: Prong.

G. Brecht
(1959–62)

(6) Peter Moore's photograph of Fred Herko in George Brecht's *Comb Music*, 1963. Performed at Concert of Contemporary American Music, the Pocket Theater, New York, August 19, 1963

5. CODA: PHYSICAL THINGS

The term *physical things* (opposed to *snapshots*) in this essay's title refers not only to the "reality" that pressures scholars of a precariously documented period; it also alludes to a work by Paxton to tie off this oblique contextualization of Judson Dance. Still underexamined in dance, and especially art history, Paxton's project adds an important chapter to the foregoing account. His early forays as choreographer (1962–63) through the post-Judson work of 1966–67 exhibit striking alignments with the examples I have laid out, from iconoclastic walking, eating and drinking, to arbitrary physical (plastic) form defying Cage/Cunningham, to the strategic placement of chairs.[21] Applied in dance these acts assume new implications; questions of skill/deskilling are only the beginning. *9 Evenings: Theatre & Engineering* (1966) is often seen as the swansong of Judson Dance; Paxton's *Physical Things* was its opening act. Its epic polyethylene "set"—staging a spectacle of perceivers—entered uncharted territory, but it did so by building upon at least two remarkable models: Paxton's own *Music for Word Words* (1963) and Whitman's *American Moon* (1960). This constellation encourages the kind of revision of historical frameworks for which this essay has argued. In this case, Whitman, credited by Paxton himself, inflects a Judson perspective like Dunn's, calling Paxton's work so "unencompassable . . . you just had to undergo [it]," which itself reorients one from classical Minimalism: "There is no way you can frame it, you just have to experience it."[22] Keeping all of this in play conveys the sense of this laboratory moment, galvanized by a kaleidoscopic convergence of ideas and their diverse application.

NOTES

1. Sally Banes, "Judson Rides Again!," *Village Voice*, April 20, 1982. Italics in original.
2. John Cage, guest appearance on *I've Got a Secret*, hosted by Garry Moore, dir. Franklin Heller, aired February 24, 1960, on CBS.
3. "Yvonne Rainer likes to joke that she invented running and Paxton invented walking," quips David Velasco (in one version of this). Steve Paxton, "Steve Paxton," interview with David Velasco, Artforum.com, July 24, 2012, https://www.artforum.com/interviews/judson-at-50-steve-paxton-31419.
4. For Kaprow's sketches, see *Allan Kaprow: Art as Life*, eds. Eva Meyer-Hermann, Andrew Perchuk, and Stephanie Rosenthal (Los Angeles: Getty Research Institute, 2008), 124–25; see also Yvonne Rainer's notebooks, Yvonne Rainer Papers 1971–2013, 2006.M.24, 1;1-4, Getty Research Institute, Los Angeles.
5. Richard Maxfield's students in 1960 included composer La Monte Young and Fluxus founder George Maciunas.
6. Forti, *Handbook in Motion*, eds. Kasper Koenig and Emmett Williams (Halifax: Press of Nova Scotia College of Art and Design, 1974), 35; Jill Johnston, "Dance," *Village Voice*, June 18, 1960.
7. Simone Forti, interview with Julie Martin, in *Robert Whitman: Performances from the 1960s*, dir. Julie Martin (Houston: Artpix, 2003), Tate Britain, DVD.
8. Forti, *Handbook in Motion*, 35.
9. Forti recently reminded me that Whitman's work is not at all improvised. Forti, conversation with the author, New York, January 2018.
10. Rainer, *Work 1961–73* (Halifax: Press of the Nova Scotia College of Art and Design, 1974), 5.
11. Forti, *Handbook in Motion*, 36.
12. Rainer, *Feelings Are Facts: A Life* (Cambridge, MA: MIT Press, 2006), 196.
13. Forti reports to Halprin on the details of her new works and discoveries through their performance. See "Letters from Forti to Halprin, 1960–1961," in *Radical Bodies: Anna Halprin, Simone Forti, and Yvonne Rainer in California and New York, 1955–1972*, eds. Ninotchka Bennahum, Wendy Perron, and Bruce Robertson (Berkeley: University of California Press, 2017), exh. cat., 150–57, esp. 154–56.
14. Ibid.," 153.
15. La Monte Young, letter to Halprin, fall 1960, Anna Halprin Papers, 1;76, Museum of Performance + Design, San Francisco.
16. *George Brecht Notebook IV: September 1959–March 1960*, ed. Hermann Braun (Cologne: Walther König Verlag, 1998), 224.
17. Ibid., 225.
18. Johnston, "Dance," *Village Voice*, July 6, 1961. Brecht gave her another chance to ponder the proposition, including three chairs in a collaboration he and Johnston did at Judson, *Dance–Lecture–Event*, c. 1962. See Wendy Perron and Daniel J. Cameron, *Judson Dance Theater: 1962–1966* (Bennington, VT: Bennington College, 1981), 46.
19. Robert Morris to Brecht, February 18, 1962, in *George Brecht Notebook VII: June 1961–September 1962*, ed. Hermann Braun (Cologne: Walter König Verlag), 202–3A.
20. Letter from James Waring to Brecht, June 28, 1962, in *Brecht Notebook VII*, 223–24B.
21. Other relevant works by Paxton are: *Proxy* (1961), *Transit* (1962), *Flat* (1964), and *Satisfyin' Lover* (1967).
22. Robert Dunn in Don McDonagh, *The Rise and Fall and Rise of Modern Dance* (New York: E. P. Dutton & Co., 1970), 88. Michael Fried citing Tony Smith in "Art and Objecthood" [1967], in *Art and Objecthood: Essays and Reviews* (Chicago: University of Chicago Press, 1998), 158.

* I would like to thank those who have contributed to this text: Andreas Petrossiants, for his tireless support on the research; Simone Forti, for her willingness to be interviewed again on this subject; the special collections staff at the Getty Research Institute in Los Angeles, and at Fales Library & Special Collections, New York University Libraries; Yvonne Rainer and Steve Paxton for answering questions; Christian Xatrec for his patient readings; Ana Janevski and Thomas J. Lax for their commitment; and Sarah Resnick for her efforts in the editing process.

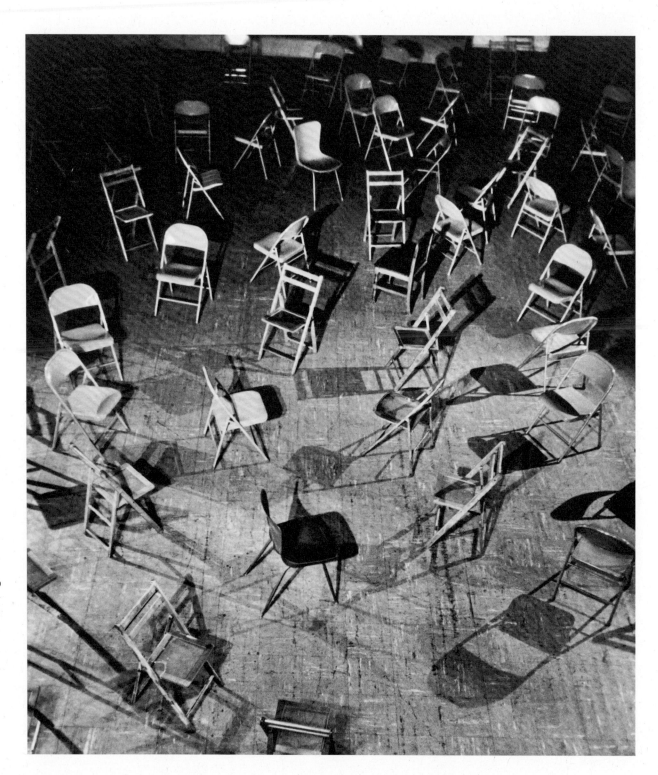

*In the arena of the Judson Dance Theatre the
audience is sometimes the Christian, sometimes the
Lion.*[1] —Jacqueline Maskey

Judson Dance Theater has a lot of potential. Its radical
possibility—to radiate in archives, to fill spaces between
disciplines, to endure in the ongoing works of its dynamic
participants—underlines the unguarded sociability of
the work, an exquisite production of being together.
Judson dances reside in a powerful set of affiliations,
reverberating throughout New York's creative world and
beyond, and long past the official Concerts of Dance at
Judson Memorial Church. Key figures and their circle of
friends, including Trisha Brown, Lucinda Childs, Simone
Forti, Deborah Hay, Fred Herko, Robert Morris, Steve
Paxton, Yvonne Rainer, and Robert Rauschenberg, tell a
resounding set of stories, some contradictory, about dance
and its contexts. While a refined minimalist aesthetic has
since attached itself to the black-and-white photos and
typewritten programs that remain of the original Judson
dances, what's clear in both the archive and the legend
is that the places of Judson's articulation were places of
unpredictable cooperation. A particular weekend pro-
gram presented by Rainer and Morris in March 1965
conveys the group's porous distinction between artist
and audience, soloist and company, history and presence,
art and life, person and object. Each of the weekend's
four works serves as a metonym for tendencies in their
context, offering a partial catalogue of Judson's modernist
expansiveness and its expanding aftermath.

The first of the weekend's performances was Robert
Morris's *Check*. The program lists forty-six participants,
including Morris and Rainer. A photograph taken by
Peter Moore reveals two types of common folding chairs,
wooden and steel, facing in all directions on the church's
heavily worn floor. Other photographs show the perform-
ers around the room, lined up, or with limbs extended
in a single direction, or seated in the chairs, or trailing
leaders who hold flags aloft. The array of chairs mock up
the potential found in Morris's monumental sculptures of
the same period, such as *Untitled (L-Beams)* (1965), which
draw attention to the movements of viewers around
them, as well as to the viewing position, what some have
disparaged as the "theatricality" inherent in Minimalism.[2]
The chairs in *Check*, usable and used, point to human
life, which is sometimes theatrical, but also often has to
do simply with butts pressed against small platforms in
institutionally resolved postures (fig. 1). The sculptures
suggest interaction; the chairs demand it, while giving
social, physical, and historical cues, plus the extra possi-
bility of misuse. In neither case is there a frontal view or a
way to evade being viewed by others.

Judson's artists reimagined bodily affiliations.
Works such as *Check* reset conventional arrangements
by which groups of people are ordered, conveying a
democratizing effect (fig. 2). This is not to ignore the
individuals or the specific forms and techniques that
constituted Judson Dance Theater. But attention to
these individuals leads to their contexts: the workshops
of Merce Cunningham, Robert Ellis Dunn, Anna
Halprin, and James Waring, in which Judson artists par-
ticipated; communication with other overlapping experi-
mental scenes; and the church itself, which was actively
engaged with the art and politics of the day. This was a
world alive with experimentation, conversation, influ-
ence across disciplines and generations, and new energy.

"We were put into four groups," remembers artist
Eleanor Antin of *Check*. "We had different mappings of
where we were supposed to go. We moved very quickly.
Not rushing, but we moved with determination, as if
we knew where we were going, though we didn't. Each
of our groups had a leader with a different colored flag
leading us in the different directions (probably follow-
ing a geometric pattern that Bob chose or invented).
We were following the leader you might say, and he or
she saw to it that if we followed, we would have smooth
sailing. An ironic and amusing idea."[3] Antin's description
offers a sense of what it felt like to be in *Check*, but also
of the ways the work filled time. Antin, who is known
for performance works from the 1970s on, participated

61

Opposite: (1) Peter Moore's photograph of the sanctuary
at Judson Memorial Church following the performance
of Robert Morris's *Check*, 1964. Performed at Judson
Dance Theater Presents Yvonne Rainer and Robert
Morris, March 24, 1965. Above: (2) Peter Moore's
photograph of Robert Morris's *Check*, 1964. Performed
at Judson Dance Theater Presents Yvonne Rainer and
Robert Morris, Judson Memorial Church, March 24, 1965

in *Check* along with her husband, writer David Antin. The pair, acquaintances of Morris and Rainer's, frequented their performances. Other familiar artists' names listed on the program include Joan Jonas, Christo, and Dorothea Rockburne, along with members of the Judson sphere, such as Childs, Hay, Paxton, Rainer, and Rauschenberg, who also designed the lighting for the evening. What a scene! Weirdly, art logic diminishes value as artists accumulate and consecrates the solid over the ephemeral. An inverted standard, one that values collaboration among artists and action over property, might elevate the art historical status of *Check*, given the meaningful assembly of persons and its unfolding process. Disciplinary standards aside, the performance of *Check* certainly activated an indistinction among artist, performer, audience, and downtown denizen.[4]

In a 1965 essay, Rainer describes the decentralized space and "undistinctive activities" of an earlier staging of *Check*.[5] These she relays as influences on her *Parts of Some Sextets*, also presented in the March program. Critic Jacqueline Maskey described *Sextets* in *Dance Magazine*: "The chief action . . . was the worrying of a pile of mattresses by ten sneaker-clad people, conducted to a taped reading from an 18th century diary. The mattresses were carted from floor left to floor right and everyone took turns flinging himself or someone else atop the pile. When not mattress mauling, individuals performed fragments of dance movement, and very well, too. In conclusion, the group climbed one by one atop their mattress pile, looked the audience in the eye and smiled. The audience smiled back and broke into amiable applause."[6] The review suggests a simplification in the reviewer's perception of what the score contained. While the moment of eye contact provided a charming culmination, Rainer described preferring to limit "cheap tricks"[7] of audience engagement and outlined an elaborate preparation process taking eight weeks of rehearsal and in which she composed a range of organized behaviors, many vernacular but some "dancey,"[8] that shifted in space and intensity according to a predetermined set of intervals.

Sextets offers what art historian Carrie Lambert-Beatty calls "the emergence of the ordinary."[9] This ordinariness appears not only in the mundane stage images and antivirtuoso movement, but also in the work's tape accompaniment. The eighteenth-century diary, a holding at New York Public Library, belonged to a minister who "kept careful stock of the local goings-on" over a forty-year period.[10] This choice reveals a deeply Protestant genealogy for a reduced and restrained body. While the daily journal references an interest in the quotidian, in choreography Rainer sought to move beyond the clichés of the everyday and the dramatic intensities we bring to moving through daily life: "I wanted it to remain undynamic movement, no rhythm, no emphasis, no tension, no relaxation," Rainer explains.[11] Forti, Rainer's contemporary, has attributed to the moment an antidramatic impulse: "For me, a drier conceptual approach was a physical need. I remember toward the end of my four years with Anna Halprin, feeling drunk with improvisation, running and twisting, falling, reaching, jumping. . . . At night I'd be dancing in my sleep, thrashing around on the mattress that was on the floor, 'til one night I awoke to the sound of my fist pounding on the floor."[12] This drier mode settled on the body's basic potential, as in the collaborative tasks called for in Forti's well-known Dance Constructions of 1961, finding a place in dance for regular activity. *Sextets* contained choreography for both trained and untrained dancers, but its reductions and repetitions separated the quotidian from its more expressive moments.

While the everyday can be anodyne, the Judson group's everyday included sex, in keeping with the bohemian sexiness of the milieu. There were personal relationships among Judson participants, sources of physical investment in the sociality of the scene. If the memoir of poet Diane di Prima can be taken as an indication of local attitudes, a liberated sexual permissiveness was possible.[13] Di Prima, who was a close friend of Herko's as well as a frequent reviewer of the performances, narrates diverse intimate entanglements as part

Left: (3) Peter Moore's photograph of Yvonne Rainer's *Parts of Some Sextets*, 1965. Performed at Judson Dance Theater Presents Yvonne Rainer and Robert Morris, Judson Memorial Church, March 24, 1965. Pictured, from left: Steve Paxton and Robert Rauschenberg (standing); Lucinda Childs, Deborah Hay, Robert Morris, Yvonne Rainer, and Joseph Schlichter (seated, second row); Tony Holder, Sally Gross, and Judith Dunn (seated, front row). Opposite: (4) Van Williams's photograph of Fred Herko, Charlotte Bellamy, and Al Carmines (from left) in Rosalyn Drexler's *Home Movies*, location unknown, 1964

of her Greenwich Village experience. "Material for a man and woman, mildly gymnastic, explicitly sexual" is how Rainer described the first pieces of movement she developed for *Sextets*, which retained the homonymic enumeration even after the cast grew to ten (and almost more, when Trisha Brown discussed participating in an advanced state of pregnancy).[14] The mattresses, which Rainer described as having been so cumbersome to move that they minimized stylization, offered a challenging form, a soft monumentality; but they were also suggestive of platforms for sexuality. Some of Moore's photographs show intimate entanglements: Morris bent over a mattress with Paxton embracing him from behind; Paxton pressing Rauschenberg against a stack of mattresses, holding his arms at his sides. It doesn't take too much imagination to see these as sexy scenes (fig. 3).

A retrospective gaze adds interest to the genders and sexualities of these participants, many of them women—notably before feminist criticism had been established—and gay men, whom, for the most part, did not talk about themselves that way. Of course, dance in modernity has held space for women, and this helps account for their prominence in Judson—a prominence that is not evident in the histories of visual art or new music where comparable aesthetic developments took place. Gay men, it turns out, were everywhere.

Attention to various differences also alerts us to the fact that Judson Dance Theater was an overwhelmingly white affair. Rainer emphasized this in her solo piece in the March 1965 program, *New Untitled Partially Improvised Solo with Bach's Toccata and Fugue in D Minor*, in which she danced alone with her face painted black. Rainer's white skin/black mask act may not have been an intentional comment on blackface minstrelsy. More generally, the black makeup references a history of masking and creates a stark formal contrast. The contrast between the black face and the white face it hides, between the black face and the white body that dances, sets off whiteness, substantiating a white ground upon which all other appearances must masquerade. This follows an avant-garde convention of using non-European forms, such as masks, to reanimate moribund classics. While race is not the subject of *New Untitled Partially Improvised Solo*, its irrelation to race was an act of canonical entanglement, as much as Rainer's pointed toe or the grandiose strains of Bach to which she pranced.

A queerer analog might be found in Fred Herko's "African-style" mask, which he wore in the Concert of Dance in 1962.[15] Herko danced to music by Erik Satie, repeating a Suzy Q–like movement in a grand circle, accented with an occasional arm gesture. He wore what writer Jill Johnston called a "tassel-veil head-dress,"[16] elsewhere described as having been decorated "with strings of beads ending with small shells that hung down over his forehead."[17] In another performance he donned a "Mexican hammock" around his body while musician Cecil Taylor played energetic jazz piano.[18] These decorations echo the primitivist and orientalist fantasies that shaped modernist aesthetics, including Igor Stravinsky's Rite of Spring, Dada, Surrealism, Cubism, the theaters of Antonin Artaud and Bertolt Brecht, and on into the modern dance and queer theater of New York City. Although such appropriations cannot be read uniformly, they often reenact the colonizing mode, ironically in order to unfix European centrality. Herko's theatrical style came off as different than Rainer's (fig. 4). But while Minimalism's allergy to representation purportedly kept it out of the trap of cultural reference, its strategies routinely substantiated whiteness nonetheless. Differences such as these are sometimes downplayed in reflections on the Judson movement. The group shared neither a unanimous style nor a set of agreed-upon priorities. Paxton, for one, dismissed Herko's dance as "campy and self-conscious."[19] Signaling this variability, dance historian Sally Banes has described three kinds of production within the concerts: the reductive, the baroque, and the multimedia. While acknowledging diversity, Banes was quick to assert that the reductive pieces did the most ambitious work.[20] Yet even Rainer's dances included music that is literally baroque and choreography that used or reformed classical technique. Such engagement with canonicity produces odd remainders around these works. Judson performers both revised their modernist antecedents and recycled them. Original tape scores were also common,

63

enlisting new media formats that were not proper to dance. Other extraneous materials add detail to the environment. The symmetrical image of Forti's *See Saw* that can be seen in photographs, for example, occludes the fact that Forti herself sang an Italian folksong on the periphery of the 1961 performance. A combinatory historical approach can be seen even in Herko's memorial service, held at the church following his death in 1964. Music by Henry Purcell as well as by Judson's pastor, Al Carmines, was played. Di Prima, LeRoi Jones, and Frank O'Hara read poems. New dances were performed along with versions of Herko's own work, including an unfinished dance to Mozart's *Eine kleine Nachtmusik* (1787). On the memorial program cover is a scratchy representational drawing of a bird in ascent. The diversity of output that is both modernist and not disrupts a primarily reductive narrative surrounding the Judson members' activities.

Herko died after concluding a dance in a friend's apartment by leaping out of a window, naked, in a perfect *jeté*. Performance theorist José Muñoz describes this act as a queer utopian performance, rejecting the demands of a naturalizing order and "reproductive straight time."[21] Herko's nude leap into and out of the canon also returns us to the site where seeing meets bodies, and the place of nudity in performance at this time (fig. 6, page 66). The final piece in Rainer and Morris's March 1965 program, *Waterman Switch*, reached an unanticipated audience beyond downtown, opening messy passages to other lives. In the previous year, Morris had performed *Site* (1964), in which he dismantles a large rectangular structure board by board to reveal artist Carolee Schneemann posed nude as Edouard Manet's 1863 *Olympia* sans maid, four times, including at the church in Concert of Dance #16. While nudity intensified the presence of Schneemann's body in a revelatory violation of taboo, the artist was representing a representation, complicating the sense of true-self to which nudity may attempt to lay claim in performance. In *Waterman Switch*, Morris and Rainer face off naked, while Childs, dressed in a man's suit, monitors and coaches (fig. 5). The duet appears to have revealed even less than *Site* in the way of nudity and, moreover, the sequence was only one part of the piece; much of the rest of it concerned the movement of stones, what Lambert-Beatty has described as a "geological ode."[22] Nevertheless, the nude bodies were what attracted the most attention.

The *New York Times* reported cheekily: "Nudity may be banned from the Broadway stage, but it found sanctuary last night in a dance program at the Judson Memorial Church. Robert Morris and Yvonne Rainer, seemed almost intent on showing that nudity on stage can be nearly as prim and proper as a church social."[23] Amplifying the duet's unsexy quality, *Dance Magazine* described the piece: "Chaste as a handshake was Mr. Morris' *Waterman Switch*, in which he and Miss Rainer (totally nude) clasped one another face-to-face and made a slow round trip on the floor, chaperoned by Lucinda Childs (totally dressed). Unsensational and unsuggestive, its attempt to shock seemed, oddly enough, only touching."[24] The *Times* added: "Among those present was the artist Marcel Duchamp, who with a young woman appeared similarly unclad 41 years ago in the Paris in a ballet called *Relâche*. 'We were only on for two seconds, because the director was afraid the police would come,' Mr. Duchamp recalled. 'But they didn't.'"[25]

The police didn't come to *Waterman Switch* either but a response was felt. An article in the magazine *Christianity Today* reported that, scandalously, nude dances had taken place at Judson Memorial Church, a report that was apparently amplified in sermons and radio broadcasts, eliciting many letters of protest from clergy, religious organizations, governing boards, and angry individuals all over the nation. Most of these were letters of pious condemnation, while some asked for an explanation. Mrs. Guy L. Podratz of Phoenix, Arizona, hazards: "I can see how people dealing with Greenwich Village and the artists, the existentialists, the beatniks, the surrealist thinkers, the bohemians, the rebels, etc. would have to revise their approach from the one used in the usual churches."[26] The president of the American Baptist Convention weighed in, confirming that the church's presiding minister was indeed trying to reach the avant-garde of Greenwich Village: "I'm not sure how I would go about ministering to this strange segment of our population," he wrote.[27]

Judson Church was a radical opening onto the strange world. Its history was one of political action and community engagement, first with the neighborhood's poor immigrant and African American communities and later with its bohemians. The church played a central role in protesting the city's proposed eradication of live folk music from Washington

(5) Ralph Crane's photograph of Robert Morris and Yvonne Rainer in *Waterman Switch*, 1965. Performed at Buffalo Arts Festival, the Albright-Knox Gallery, 1965

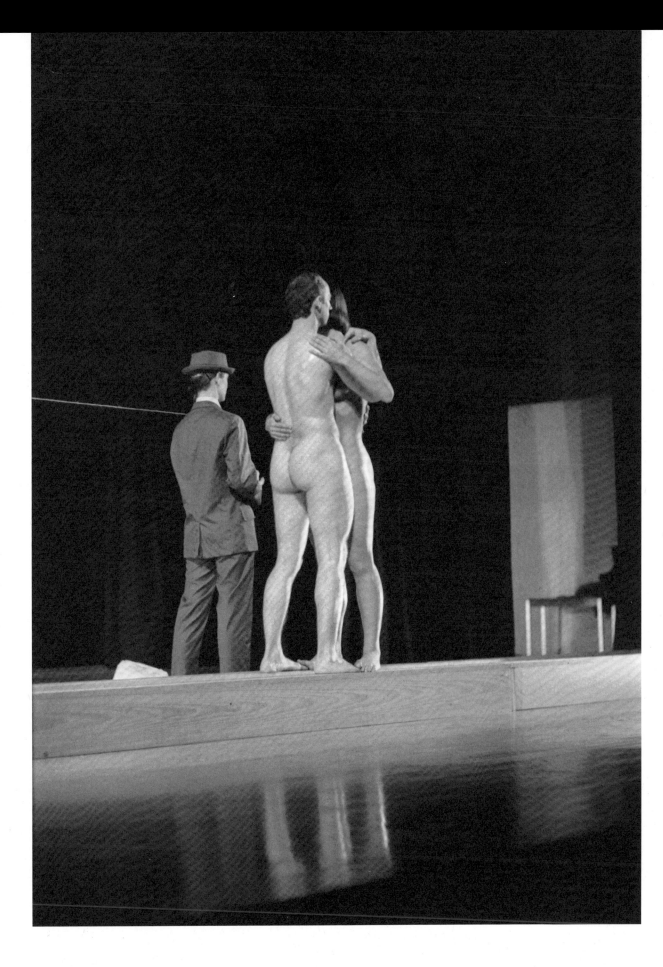

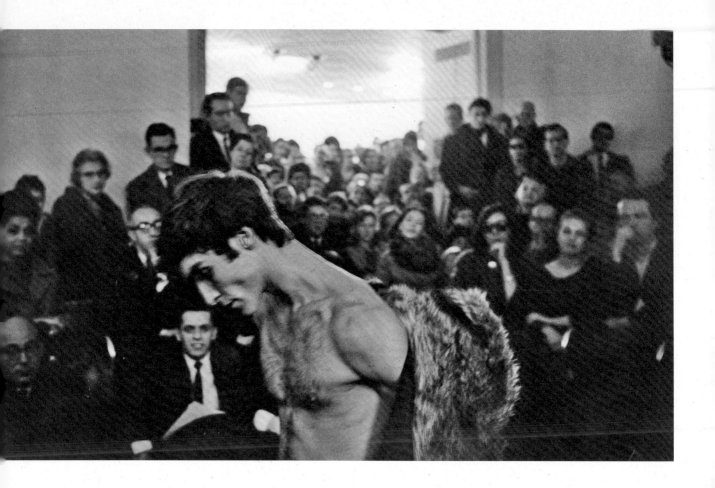

Square Park. Its remarkable pastor, Al Carmines, was involved in civil rights activities and founded theater and poetry projects in the church to connect to artists and others: the first play they produced was Guillaume Apollinaire's surrealist farce, *The Breasts of Tiresias* (1903), in 1961. When the young dancers showed up asking for space, their project was of a piece with the church's existing outreach.

Following the outcry spawned by *Waterman Switch*, Carmines's elegant six-page response to the article's author, the scandal, and the question of bodies includes these passages:

> Throughout the years the church has produced several off-beat plays, had sent out a call for clothes and money for the civil rights drive in Alabama and Mississippi, had participated in picketing to end the *de facto* school segregation in New York City—this gentleman had responded to none of these events or pleas for help. But nude dancing in a church—that was

something else—or was it? This is what the church has been asking itself since the evening when Yvonne Rainer and Bob Morris—to strains of Verdi arias—waltzed across the room in apparent nudity. . . . Because somehow if the church is going to be faithful in this age it must cut its way through the sticky glutinous syrup known as religion and deal with real people in real situations who have real feelings—and and real bodies. . . . We are living in an age when men are denied their humanity because of their color, when all of us live under the shadow of sudden extinction, when poverty spreads its cancer over all our country. It is strange indeed when the body fashioned by the love of man and woman and the mystery of God is seen inherently as the utmost harbinger of evil and is to be looked upon with fear, dismay, indignation, and self-righteousness rather than the laughter or sorrow or beauty that it deserves.[28]

Such a defense of dance and its bodies, grounded in love, is a politicization of Judson Dance Theater that is possible when the work is put in its historical context. The group's practical sociality, aesthetics of regularity, negotiations of modernity, and the unassuming radicality this all produced suggest ways we may continue to manage our own overwhelming subjectivity while, following Pastor Carmines's lead, building the affiliations of cooperative subjecthood that people need, not only to dance, but to survive.

NOTES
1. Jacqueline Maskey, "Reviews: Yvonne Rainer and Robert Morris," *Dance Magazine* (May 1965), clipping in the Judson Memorial Church Archive, MSS 094, 3;69, Fales Library and Special Collections, New York University Libraries, http://dlib.nyu.edu/findingaids/html/fales/judson/dscaspace_ref15.html#aspace_ref376.
2. See Michael Fried, "Art and Objecthood" [1967], in *Art and Objecthood* (Chicago: University of Chicago Press, 1998).
3. Eleanor Antin, interview with the author, February 2018.
4. For a description of this term, see My Barbarian, *The Audience Is Always Right: The Post-Living Ante-Action Theater Manual* (Austin, TX: Pastelegram, 2015).
5. Yvonne Rainer, "Some Retrospective Notes on a Dance for 10 People and 12 Mattresses Called 'Parts of Some Sextets,' Performed at the Wadsworth Atheneum, Hartford, Connecticut, and Judson Memorial Church, New York, in March, 1965," *Tulane Drama Review* 10, no. 2 (Winter 1965): 170.
6. Maskey, "Reviews: Yvonne Rainer and Robert Morris."
7. Rainer, "Some Retrospective Notes," 172.
8. Ibid.
9. Carrie Lambert-Beatty, *Being Watched: Yvonne Rainer and the 1960s* (Cambridge, MA: MIT Press, 2008), 80.
10. Rainer, "Some Retrospective Notes," 173.
11. Ibid., 170.
12. "Simone Forti and Malik Gaines," interview in *JUDSONOW* (New York: Danspace, 2012), 72.
13. Diane di Prima, *Memoirs of a Beatnik* (New York: Penguin Books, 1998).
14. Rainer, "Some Retrospective Notes," 169.
15. Sally Banes, *Democracy's Body: Judson Dance Theater, 1962–64* (Ann Arbor, MI: UMI Research Press, 1983), 44.
16. Ibid.
17. Ibid., 43.
18. Ibid., 58.
19. Ibid., 44.
20. Ibid., xviii.
21. José Esteban Muñoz, *Cruising Utopia: The Then and There of Queer Futurity* (New York: New York University Press, 2009).
22. Lambert-Beatty, *Being Watched*, 114.
23. Grace Glueck, "Dance Program Offers 2 Nudes," *New York Times*, March 26, 1965.
24. Maskey, "Reviews: Yvonne Rainer and Robert Morris."
25. Glueck, "Dance Program Offers 2 Nudes."
26. Letter from Mrs. Guy L. Podratz to Rev. Howard Moody, May 15, 1965, Judson Memorial Church Archive, MSS 094, 3;70, Fales Library & Special Collections, New York University Libraries, accessed online at http://dlib.nyu.edu/findingaids/html/fales/judson/dscaspace_ref15.html#aspace_ref376.
27. Letter from J. Lester Harnish to Southwestern Association, Colorado Baptist Convention, May 10, 1965, Judson Memorial Church Archive; MSS 094; 3; 70; Fales Library & Special Collections, New York University Libraries, accessed online at http://dlib.nyu.edu/findingaids/html/fales/judson/dscaspace_ref15.html#aspace_ref376.
28. Al Carmines, "Response to Religious Protests against 'Nude Dance' at Judson," n.d., Judson Memorial Church Archive, MSS 094, 3;71, Fales Library & Special Collections, New York University Libraries, accessed online at http://dlib.nyu.edu/findingaids/html/fales/judson/dscaspace_rcf15.html#aspace_ref376. Emphasis in original.

(6) Peter Moore's photograph of Fred Herko in Herko's *Dervish*. Performed at Cordier & Ekstrom Gallery Concert, Cordier & Ekstrom Gallery, January 18, 1964

Judson Dance Theater forged a heterogeneous relationship with music.[1] The diversity of the dance—austere and camp, conceptual and practical—found its match in sound. Judson dancers performed to classical music; conventionally notated new music; newly composed indeterminate works using texts, tasks, or graphics; new electronic music and collages; Fluxus-like musical theater; jazz; speech, song, and vocalizations from the dancers themselves; pop music; and free improvisations. Some of these soundtracks were performed live, while many were played on tape. As far as I can tell, a plurality of the works presented at the sixteen Concerts of Dance (1962–1964) took place with no music at all. But its spirit suffused even the silent dances, given the provenance of Robert Ellis Dunn's workshops in John Cage's experimental music courses at the New School in New York and the charismatic iconoclasm of composer La Monte Young (fig. 2), which had wafted into New York with the migrants from Anna Halprin's California digs.

Composer Philip Corner, who joined the workshop in autumn 1962, observed that the Judson dancers used "the physical equivalent of [Cagean] noise."[2] Corner would eventually respond to Cage's formalized chance operations with what he called "nonsystematic chance," one that would include desire, expression, and the choices of others. (It's no surprise that Carolee Schneemann would find him a productive collaborator in *Glass Environment for Sound and Motion*, of 1962.[3]) He had already been on the scene for some years—writing music for choreographers James Waring and Beverly Schmidt Blossom—when the dancers asked him to provide music if needed (he had worked as a class pianist for the Merce Cunningham Dance Company in autumn 1962). Corner served as music director, alone or with fellow composers Malcolm Goldstein and John Herbert McDowell, for many of the concerts.

Corner's Pitt Street loft in New York hosted a number of events during the Judson years, contributing to the city's welter of experimental activity that also included concerts at the Living Theatre and the Bridge,

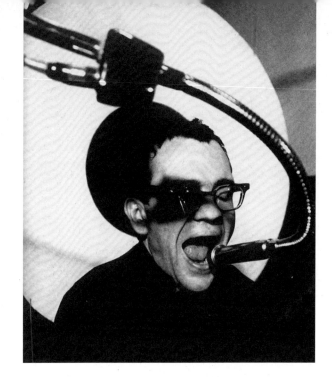

Charlotte Moorman's Avant Garde Festivals, the October Revolution in Jazz, historic stands at the Five Spot, Yoko Ono and Young's Chamber Street concerts, "Vexations" and other events at the Pocket Theatre, the factions of Fluxus, and composer Lucia Dlugoszewski's work for the Erick Hawkins Dance Company. For a musician like Corner, all this stuff ran together. His own contribution to the mix, with Goldstein and fellow composer James Tenney (the spouse of Schneemann), was Tone Roads, a chamber ensemble that programmed older works by the likes of Charles Ives, Carl Ruggles, Henry Cowell, and Edgard Varèse. Recital concerts of older notated music might have seemed old-fashioned to many downtown denizens, and Corner recalls very few of his Judson colleagues attending Tone Roads shows. In light of this testimony, and of the reaction to his trombone and tape piece "Big Trombone" at Concert of Dance #9 in 1963—somebody yelled, "Get off the stage!"—one wonders how comfortably the music-only numbers by Corner, Goldstein, and Tenney were received by Judson audiences.[4]

*

In the 1950s, Cage invited Corner to take his New School course. Corner, no longer interested in being a student, declined. Had he accepted, Corner would have participated in early conversations about the task structure that would prove so energizing for artists like George Brecht, Alison Knowles, and Dick Higgins. Their experiments with these bits of behavioral found forms, written up as

Opposite: (1) Philip Corner. Score for "Certain Distilling Processes," 1962. Above: (2) Steven Schapiro's photograph of La Monte Young on stage, New York, 1966

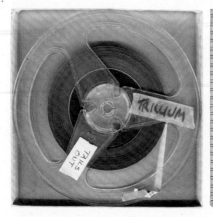

text instructions, would eventually influence their teacher: Cage wrote his own task piece, "0'00"," in 1962.

The task structure found its way into music as well as dance at Judson Church. Corner's "Intermission" took place during the entr'acte of Concert of Dance #13 in 1963, when artist Charles Ross's environmental sculpture was disassembled. Corner contact-miked up the metal structure and piped the sounds of disassembly into the lobby, but the mics didn't amplify well, and, in Corner's memory, "it was so ambient nobody paid any attention to it at all."[5] "Intermission" eventually morphed into Corner's well-known piece "Everything Max Has: As an 'Afterward,'" written for the percussionist Max Neuhaus. The piece, which premiered at the ONCE Festival in Ann Arbor in 1965, consisted of Neuhaus packing up his instruments and equipment in front of the audience.

The task format offered one point of articulation between the two settings that produced Judson dance: the workshops of Halprin in California and of Dunn in New York. As an alum of Cage's New School course, Dunn would have concentrated, as Cage did, on materials (everyday sounds/movements), method (chance), and structure (alternatives to forms like theme and variation), and he would have described indeterminacy as a way of creating variable, open-ended notations. By all indications, Dunn inherited Cage's reluctance to develop a discourse of improvisation, which he did not consider to be a suitable approach to his learning exercises.[6] "Improvisation was not on the grid in New York," Trisha Brown later explained.[7]

If the task was a kind of everyday material for Dunn, Halprin liked it because it provided a means of escape from imitation as well as an opportunity to discover new forms of movement. Stringing a few tasks together diminished the importance of transitions and created a clear, impersonal structure, a kind of easy

container for whatever small improvisations might be required to get from A to B. In other words, the fragmentation that was so important to someone like Rainer in these years implied and necessitated a kind of nonexpressive, immanent improvisational awareness. In my view, Rainer, Halprin, Brown, and Simone Forti found possibilities in improvisation that had escaped the attention of Cage and Dunn while also extending the practice of indeterminacy.

The task structure outlined a field of action traversed by both indeterminacy and improvisation; the relationship between them requires investigation. Improvisation is not a consistent or unitary practice, and it usually exceeds whatever single function it is thought to perform.[8] One might highlight its extemporaneity, problem-solving, bricolage, or ephemerality and wildness, preserved by the recording apparatus or the durative structure of choreography (even the spare structure given in the task format—sit, stand, lie down—in a work like Brown's *Trillium* of 1962).

To this list of improvisation's possible qualities, I add two that were significant for the historical milieu that produced Judson dance: interdisciplinarity and shared authorship. Improvisation does not entirely resist concepts, but its home base is found in practice, or thinking in action, which lends it a certain methodological fluidity across the durational arts. Halprin invited Young and compoer Terry Riley to improvise music for her summer workshop at just the moment when Young was primed to conceive of his process, as she did hers, across disciplinary borders. Some years later he explained, "[An] important point was that a person should listen to what [she] ordinarily just looks at, or look at things [she] would ordinarily just hear."[9]

In the weeklong course on music that Young taught in August 1960, not only did he and Riley "actually

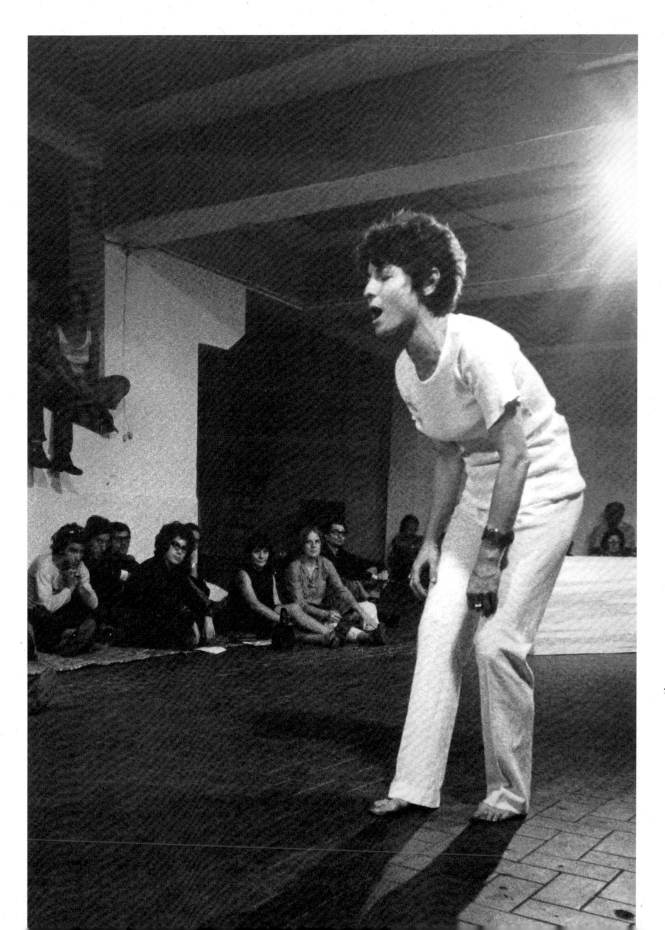

write on the spot" (also known as improvising), but the students investigated sound as it interacted with non-musical modalities like object manipulation, improvised movement, and visual observation.[10] Among the sounds presented by dancers were the chance squeaks of a tree branch held while improvising, the uncrumpling of a compressed plastic bag, and the imagined sounds of stationary trees spotted in the woods. These exercises illustrate art historian Branden W. Joseph's observation that "continually questioning the notion of medium or disciplinary specificity was . . . a primary condition of being 'advanced' after Cage."[11]

Forti was especially enterprising in her cross-disciplinary projects, all of which stemmed from the cultivation of embodied awareness (fig. 4, page 71).[12] The music she recorded in 1962 for *Trillium* (Concert of Dance #5) testified to the importance of Young's tape piece "2 sounds," which she would have heard at Halprin's workshop in 1960 (and which she set to dance in 1962). Relentlessly abrasive, Young's tape work addressed the body directly and continuously, without narrative, concept, or representation. The piece pulls the listener inside the sound—you hear it with your body because there's nothing in it for your mind. Likewise, Forti's improvisations were firmly rooted in the mechanics of vocal production (fig. 3).[13] The *Trillium* performance consists of an exploration of the constricted throat above the vocal folds, producing very high squeaks and scrapes of vocal fry that ring out over the ambient sounds of a reverberant loft and occasional traffic noises. These investigations did not lend themselves to notation: the whole point was to discover the unrepeatable, a practical grit that resisted conceptual extension or generalization. Guided by this principle, Forti let her body improvise across disciplinary borders between dance and sound.

Like Forti, Corner experimented with improvisational works that bridged the gaps between disciplines. His 1962 event "Flares" (Concert of Dance #8) unified sound, movement, and light in the simultaneous interpretation of a series of drawings that were danced, sounded, and projected collaboratively in real time, like flares shot into the darkness. An earlier work, "Certain Distilling Processes" (Concert of Dance #4), concentrated more closely on the remediation and transmission of instructions set down in notation (fig. 1, page 68). Corner gave four dancers sequences of numbers on large pieces of paper—laid flat on the floor—that specified measures of a certain number of beats. The dancers articulated these time structures with improvised movement. Meanwhile, the musicians—any number of them, singing or playing instruments, junk, or toys—took the temporal directions of the dancers and rerouted them through musical and graphic notations. Although these notations were open, mixing conventional musical signs with text instructions and spatial gestures, vertical lines throughout the parts were to correspond to the beats articulated by the dancing conductors. The result was a kind of continuous circulation of impulses from notation to movement and sound.

*

With these examples, I intend to highlight one layer in the tight fusion of the post-Cagean arts after 1959—not only Minimalism, indeterminacy, and daily life, but also improvisation as a cross-disciplinary method that made fluid the passage from sound to movement to light. I wish to turn now to improvisation's tendency to spread out authorship to a greater extent than "composed" or "choreographed" works customarily do. I suspect that Halprin's deeply developed improvisation practice included some allegiance to emergent group dynamics over the ideological patterns of single authorship and the work: a restless Brown would ask her every night of the workshops, "When do we get to make dances?"[14] Halprin replied that she didn't think the group was ready. Did her response reveal a reluctance to move into the space already defined—or closed down—by the great works of the great choreographers?

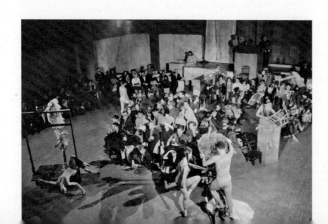

Left: (5) Al Giese's photograph of Deborah Hay's *Improvisations*, 1964. Performed at Concert of Dance #14, Judson Memorial Church, New York, April 27, 1964. Opposite: (6) Robert McElroy's photograph of Steve Paxton in *Music for Word Words*, 1963. Performed at Concert of Dance #4, Judson Memorial Church, January 30, 1963

In their music for Halprin's workshop, Young and Riley conducted themselves like a band. Through collaborative improvisation and rehearsal, they developed a shared sound in practice. The working familiarity of both in African American musical forms—Young on jazz saxophone, Riley on boogie-woogie piano—might not have manifested sonically in their work, but it certainly did so methodologically. In the black vernaculars, originality and authorship manifest in *how* an individual or group creates distinctive treatments of shared forms like the blues progression or the Tin Pan Alley standard. Finding a shared sound is one of the foremost goals of any band working in these traditions. I would never suggest that (European) composerly authorship gets eliminated in these contexts—jazz trumpeter Miles Davis expressed his status as an author in numerous ways, and his is the name on the spine of the records. But when saxophonist John Coltrane constructed his solo on Davis's "All Blues," some distinct and separate kind of distributed creativity was at work.

Riley and Young, with their experience in these traditions, would have been more comfortable in this relaxed arrangement than, say, Cage and David Tudor, who had no experience with vernacular music making and—no matter how improvisatory, distributed, and coequal their collaboration would become—retained the author-performer-work structure that had defined so much of the Western art music tradition. (By the early 1970s, they seem to have sorted it out: Tudor no longer performed music by Cage. They both played their "own" pieces simultaneously.[15]) In the Theatre of Eternal Music, founded in 1962, Young and his colleagues would advance this redefinition of composition into a shared, "real-time physicalized (and directly specified) process," as artist Tony Conrad put it, although Young would eventually retreat from this radical position into a more traditional assertion of unitary authorship.[16]

I don't detect much evidence of such shared, real-time, physicalized processes of coauthorship among the dance works presented by Judson Dance Theater. The improvised first half of Concert of Dance #14 in 1964 was an anomaly and consisted of individual solos presented at once, rather than a collectively authored piece. (As dance scholar Susan Leigh Foster perceptively notes, Schneemann's early 1960s performance works anticipated the shared, interactional format of contact improvisation in practice, but it left the single author apparatus firmly intact.[17]) Paxton (fig. 6) called *Word Words*, performed at Concert of Dance #3, "definitely a

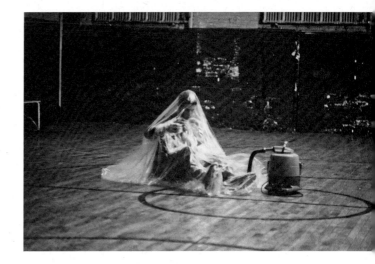

collaboration as opposed to later working with Yvonne where she was definitely the leader."[18] When Liza Béar suggested that Paxton and Rainer had written the score together, his correction emphasized improvisation and practice: "No, we rehearsed it. We worked it out together figured out what the movements would be."[19] However, *Word Words* was the exception in those early years—the Judson dancers would not consciously foreground the ethics and aesthetics of shared authorship until the early 1970s, with dance collective Grand Union and contact improvisation.[20]

Given jazz's ideological prominence in postwar discourses of spontaneity, Sally Banes's speculation that black artists "may not have had a taste for the kind of iconoclastic activity" at Judson appears all the more puzzling.[21] (Compare Banes with LeRoi Jones: "Negro music is *always* radical in the context of formal American culture."[22]) This strange speculation has elicited strenuous critiques about the wider context of downtown New York in the 1960s, critiques with which I largely agree.[23] Other commentary lingers on the animations of African American aesthetics that operated in a register removed from epidermal presence.[24] As historian Brenda Dixon Gottschild wrote of her own experience of the downtown scene at the time, "Everything in my immediate world looked/felt basically white, until the winds of African-American studies, cultural studies, and race studies blew me off center and helped me see the black at the center of it all."[25] She was referring to relaxed carriage, heterogeneous movement vocabularies, and citation and double entendre, all stylistic features of Africanist dance aesthetics.[26] I've also suggested that the authorial politics of improvisation itself might be there at the center of it all (fig. 5).

73

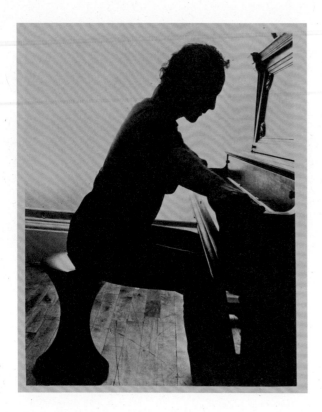

(7) Philip Corner rehearsing at
Judson Memorial Church, c. 1962.
Photographer unknown

The black aesthetic was certainly not missing
entirely from the *musical* side of Judson. It was there in
pianist Cecil Taylor's collaboration with dancer Fred
Herko at Concert of Dance #1. It was there in Tenney's
tape piece "Collage #1 ('Blue Suede')," which he built
in 1961 at Bell Labs in Murray Hill, New Jersey, with
source material from Elvis Presley, and which was
played at Concert of Dance #10 in 1963. It was there
in Corner's riff on free jazz, "Big Trombone," and,
delightfully, in the music for William Davis's *Crayon*
(1963), which consisted of three doo-wop songs by the
Volumes, Dee Clark, and the Shells.[27] If Goldstein's
"Ludlow Blues" gave away hints of his training at
Columbia—it was a scored work for three winds and
bleep-bloop tape music—then at least the title projected
a wider frame of cultural reference.

By 1964, Goldstein had begun his journey away
from those uptown aesthetics and toward free impro-
visation. (He might have been tugged downtown,
aesthetically, by his wife, Arlene Rothlein, who per-
formed in Judson dances.) He began rehearsing with
saxophonist Archie Shepp, and the two appeared in
concert at Corner's loft on April 4, 1964, and again
with Corner on piano later that year.[28] Shepp would
also appear with his quartet in a benefit for the Student

Nonviolent Coordinating Committee and the Council
of Federated Organizations that Corner (fig. 7) orga-
nized in November 1964.[29] (Corner had spent the sum-
mer of 1964 registering voters in Mississippi.) Corner
asked other black jazz musicians to perform, but they
expected to get paid, an expectation that was unusual
among the white experimentalists who regularly under-
took free and underpaid work during these years. The
reluctance of these jazz musicians to accept unremu-
nerated gigs echoes John Perpener's explanation for the
dearth of African American artists in the experimental
dance of the 1960s: having worked hard to partici-
pate in a modern dance idiom so persistently defined
against black concert dance, they were in no rush to
dismantle that mid-century edifice.[30] Likewise, black
avant-garde musicians had far fewer social connections
to the fine-art establishment or graduate degrees from
places like Columbia University—what we now often
call white privilege. "We saw it as giving all that stuff
up, and you're right that we probably didn't," Corner
remarks. "I mean, look at what eventually happened to
me. I gave it all up, and I got it all back, without lifting
a finger to do it."[31]

NOTES

1. Thank you to Julia Bryan-Wilson and Marina Rosenfeld for reading drafts of this text and to Jay Arms, Tamar Barzel, Robert Isaacs, Martha Joseph, Scott Krafft, Cassie Mey, and Eric Smigel for other assistance. Above all, I am grateful to Philip Corner for his gracious commentary.

2. Philip Corner, interview with the author, Reggio Emilia, Italy, December 18, 2017.

3. Branden W. Joseph, *Experimentations: John Cage in Music, Art and Architecture* (New York: Bloomsbury Academic, 2016), 1–34.

4. Philip Corner, *NY 60s: Scenes from the Scene* (Lebanon, NH: Frog Peak Music, 1995), 11.

5. Corner, interview with the author.

6. Ramsay Burt, *Judson Dance Theater: Performative Traces* (New York: Routledge, 2006), 59; Susan Rosenberg, *Trisha Brown: Choreography as Visual Art* (Middletown, CT: Wesleyan University Press, 2017), 32–33.

7. Rosenberg, *Trisha Brown*, 33.

8. George E. Lewis and Benjamin Piekut, "Introduction: On Critical Improvisation Studies," in *The Oxford Handbook of Critical Improvisation Studies*, ed. Lewis and Piekut (New York: Oxford University Press, 2016), 1–36.

9. Janice Ross, "Atomizing Cause and Effect: Ann Halprin's 1960s Summer Dance Workshops," *Art Journal* 68, no. 2 (Summer 2009): 73.

10. La Monte Young to Anna Halprin, n.d. [1960], Anna Halprin Papers, 1;76, Museum of Performance + Design, San Francisco; "Sounds Presented at Lamonte's [sic] Class in the Summer Session," Anna Halprin Papers, 5;43, Museum of Performance + Design, San Francisco.

11. Joseph, *Beyond the Dream Syndicate: Tony Conrad and the Arts After Cage* (New York: Zone, 2008), 84; see also Carrie Lambert-Beatty, "More or Less Minimalism: Six Notes on Performance and Visual Art in the 1960s," in *A Minimal Future? Art as Object, 1958–1968*, ed. Ann Goldstein and Lisa Gabrielle Mark (Cambridge, MA: MIT Press, 2004), 103–9.

12. Virginia B. Spivey, "The Minimal Presence of Simone Forti," *Woman's Art Journal* 30, no. 1 (2009): 11–18; and Meredith Morse, *Soft Is Fast: Simone Forti in the 1960s and After* (Cambridge, MA: MIT Press, 2016).

13. Forti was an early but short-lived member of Young's Theatre of Eternal Music. Her *Trillium* tape strongly indicates that she was also in dialogue with avant-garde musician Henry Flynt in these years—hear Flynt's "Central Park Transverse Vocals" (1963).

14. Rosenberg, *Trisha Brown*, 30.

15. Piekut, "Not So Much a Program of Music as the Experience of Music," in *Merce Cunningham: Common Time*, ed. Joan Rothfuss (Minneapolis: Walker Art Center, 2017), 113–29.

16. Tony Conrad, "LYssophobia: On Four Violins," in liner notes to *Early Minimalism*, Table of the Elements, 1997, 15; see also Patrick Nickleson, "The Names of Minimalism: Authorship and the Historiography of Dispute in New York Minimalism, 1960–1982" (PhD diss., University of Toronto, 2017).

17. Susan Leigh Foster, *Dances that Describe Themselves: The Improvised Choreography of Richard Bull* (Middletown, CT: Wesleyan University Press, 2002), 49–51.

18. Steve Paxton and Liza Béar, "Steve Paxton: Like the Famous Tree," *Avalanche* 11 (Summer 1975): 26.

19. Paxton and Béar, "Steve Paxton," 27.

20. Steve Paxton, "The Grand Union," *Drama Review: TDR* 16, no. 3 (September 1972): 128–34; Cynthia Novack, *Sharing the Dance: Contact Improvisation and American Culture* (Madison: University of Wisconsin Press, 1990); Foster, *Dances That Describe Themselves*.

21. Sally Banes, *Greenwich Village 1963: Avant-Garde Performance and the Effervescent Body* (Durham, NC: Duke University Press, 1993), 154.

22. LeRoi Jones, *Blues People* (New York: Morrow Quill Paperbacks, 1963), 235; italics in original.

23. Fred Moten, *In the Break: The Aesthetics of the Black Radical Tradition* (Minneapolis: University of Minnesota Press, 2003); and George E. Lewis, *A Power Stronger Than Itself: The AACM and American Experimental Music* (Chicago: University of Chicago Press, 2008).

24. Foster, *Dances That Describe Themselves*; Burt, *Judson Dance Theater*, 127–30.

25. Gottschild, "By George! Oh Balanchine!," *Discourses in Dance* 3, no. 1 (2005): 75, quoted in Burt, *Judson Dance Theater*, 128.

26. Brenda Dixon Gottschild, *Digging the Africanist Presence in American Performance: Dance and Other Contexts* (Westport, CT: Greenwood Press, 1996), 50–57.

27. Banes, *Democracy's Body: Judson Dance Theater, 1962–1964* (Durham, NC: Duke University Press, 1983), 64.

28. Flyer, "From Pitt Street," April 4, 1964, unprocessed Philip Corner papers, McCormick Library of Special Collections, Northwestern University; flyer, "Masks, Matches, Mannikins," Jean Erdman Theatre of Dance, May 23–24, 1964, Philip Corner papers.

29. Flyer, "Second Concert for Mississippi," 2 Pitt Street, New York, November 15, 1964, Philip Corner papers.

30. John O. Perpener, III, *African-American Concert Dance: The Harlem Renaissance and Beyond* (Urbana: University of Illinois Press, 2001), 204–7.

31. Corner, interview with the author.

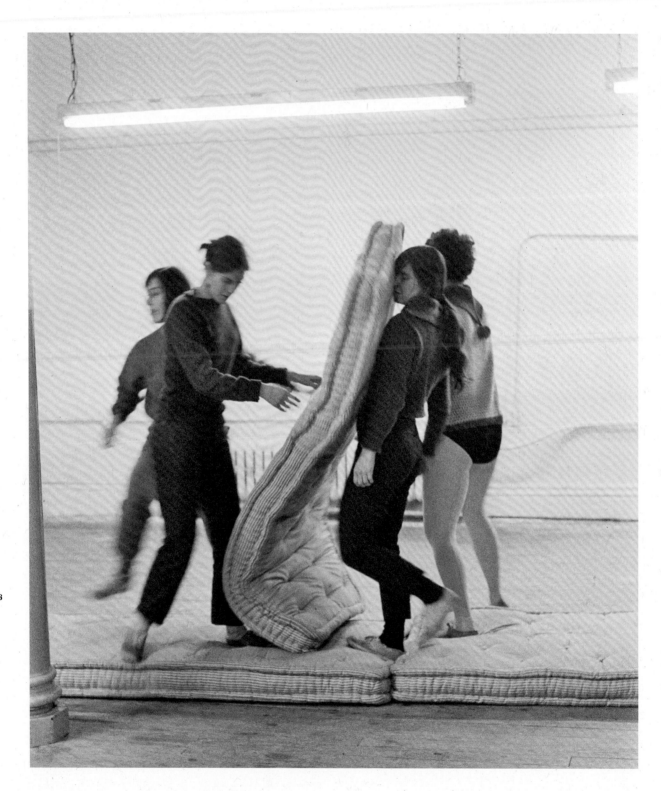

Judson Dance Theater performances were full of objects: cardboard boxes, chairs, ladders, wooden planks, mattresses, tires—the list goes on. In 1964, *Village Voice* critic Jill Johnston went so far as to characterize these performances as "impeccable object-events."[1] Choreographer Yvonne Rainer and sculptor Robert Morris, two Judson artists whose use of objects offers especially rich terrain for analysis, used equally hybrid terms to describe the objects in their works: "body-substitutes," "object-protagonists," and "body surrogates," "body adjuncts," "animated objects," "inert protagonist[s]."[2] As this varied list demonstrates, Judson's choreographers were exploring what objects made possible when activated in performances.

I propose adding another: *sculptural prop*.[3] Neither simply sculpture nor theatrical prop, the sculptural prop exists always in relation to the performing body in motion. It is activated in a performative context, whether by the artist or by a performer at the direction of the artist. In identifying the sculptural prop as a particular class of thing, I aim to conceptualize the relationships Judson members created between sculpture and performance. The ways Judson performers used objects generated new economies of movement that were considered departures from traditional modern dance. Johnston observed that, when at their best, Judson's object-events were rigorously structured "by that economy of gesture where nothing is superfluous in each specific problem posed by handling an object. The result of [these] performances is that action, object, and dancer merge in a single affective unit." This merging of action, object, and performer is key to defining the sculptural prop. I focus here on the work of Rainer and Morris because they both engaged in an ongoing dialogue about the role of objects in their work.

In New York, in the early to mid-1960s, a group of Minimalist artists was immersed in redefining sculpture. They turned away from the (modernist) preoccupation with the visual art object itself and toward a phenomenological situation in which the viewer beholds the object.

Judson performers shared many of these same concerns; as critics noted at the time, privileging the viewer's experience of the art object in real time and space was innately linked to performance as a medium.[4] Rainer was one of the first to draw parallels between the recent developments in dance and sculpture. Her "A Quasi Survey of Some 'Minimalist' Tendencies in the Quantitatively Minimal Dance Activity Midst the Plethora, or an Analysis of *Trio A*," which she wrote in 1966, two years before it was first published, opens with a chart aligning the "literalness" and "simplicity" of Minimalist objects with "task or tasklike activity" and "singular action, event, or tone" in dance (fig. 5, page 80).[5] The chart also identifies a shared preoccupation with scale: "human scale" appears as the preferred substitute for monumentality in sculpture and for virtuosity in dance. In dance, these human-scale movements often involved objects and included the everyday gestures sometimes synonymous with Judson. Rainer's schema demonstrates the extent to which she and the Judson group were in dialogue with parallel developments in sculpture.

Judson also shared with other artists of this moment an interest in eliminating creative decision-making to deemphasize the role of authorship in making art. In dance, manipulating objects became an important strategy for achieving this goal. Artist Simone Forti pioneered the use of objects to generate movement and do away with deliberation. Her Dance Constructions, first presented at Reuben Gallery in December 1960 and then again at Yoko Ono's loft in May 1961, both in New York, wielded objects and built structures to prompt task-based movements unmediated by preconceived notions of style.[6] Although Forti did not herself participate in Judson performances, many Judson members either saw the Dance Constructions or performed in them and were profoundly influenced by Forti's work.

Morris and Rainer were among those future Judsonites to perform in them. In *See Saw* (1960), at Reuben Gallery, they interacted with a plank of wood. To start, Morris set the plank of wood on a sawhorse and fastened each end to the adjacent walls with strips of elastic. Then he applied pressure to the plank so that it began to tip alternately from one side to the other. A toy attached to the underside of the plank punctuated each dip with a distinct *moo*. Rainer soon joined Morris on stage, and the two climbed onto the apparatus, where they negotiated balancing the plank. As Forti noted, "Any change in the arrangement of body parts, the slightest change in position by either performer affects the balance of the entire setup."[7] Forti was interested in the mutual responsiveness

(1) Al Giese's photograph of Yvonne Rainer (left) and unidentified performers rehearsing Rainer's *Parts of Some Sextets*, 1965. Pictured in New York, January 1965

necessitated by the setup. Here the plank-and-sawhorse combination was a sculptural prop that mediated two bodies, guiding their movements in relation to each other.

The significance of Forti's concerts was immediately felt.[8] Morris and Rainer, who performed in Forti's pieces at both events, found themselves deeply influenced by the work, as they pointed out thereafter in writing and interviews.[9] Morris, writing in 1965, described the impact of watching *Slant Board*, another Dance Construction performed at Ono's loft, in which two or three performers simultaneously ascended a wooden ramp set at a forty-five-degree incline using knotted ropes attached at the top: "The device, the inclined plane, structured the actions. . . . Here focused clearly for the first time were two distinct means by which new actions could be implemented: rules or tasks and devices (she termed them 'constructions') or objects."[10] For Morris, Forti's structural approach to dance and her concept of the "construction" affected the way he approached his own sculpture making.

Morris's six choreographed dances, *War* (1962–63), *Arizona* (1963), *21.3* (1964), *Site* (1964), *Check* (1964), and *Waterman Switch* (1965), built on the possibilities introduced by Forti, while also distinguishing his own approach. In his 1965 *Notes on Dance*, he wrote that objects were for him a "means for dealing with specific problems involving space, time, and alternate forms of a unit, etc."[11] Two early experiences making work informed what he would eventually do with objects in his dances. First, he made two performances that transformed objects from stage decor into main event, or what Rainer would later call "inert protagonists," referring to Morris's work.[12] *Box with the Sound of Its Own Making* (1961) was a wooden cube accompanied by a sound recording of the sawing, drilling, and hammering noises generated during the cube's fabrication. *Box* appeared onstage in a performance at Harvard University's Paine Hall in Cambridge, Massachusetts, in March 1961 as part of a concert of avant-garde music.[13] *Column*, a performance at the experimental Living Theatre in New York in February 1962, began with an upright eight-foot-tall rectangular column onstage. After three and a half minutes, Morris toppled the column from offstage by yanking an attached string, giving the column the appearance of spontaneous movement. Now horizontal, the column lay on the ground for another three-and-a-half minutes, at which time the performance was over. In both of these instances, the objects stood in place of a performer, calling attention to the experience of time and making the viewer aware of herself as a perceiving subject.

Second, around the same time Morris began investigating sculptures that directly addressed a relationship to the body. In a February 1961 letter to composer John Cage, Morris described plans for an unrealized sculpture: "It consists of a set of four cabinets: Standing, Leaning, Sitting, Lying. They are to be placed next to each other; there is just enough room inside for one to assume the stated positions—baffles fitted inside Leaning and Sitting so that one must conform to these positions when the door is closed."[14] Morris would realize only one, *Box for Standing* (1961; fig. 2), a work he repurposed from a platform he had built for the first performance of Forti's *Platforms* (1961) at Ono's loft.[15] (In *Platforms*, two performers, each concealed and reclining underneath a rectangular wooden box, whistle at different pitches on their out-breath [fig. 3].) The relationship of *Box for Standing* to the (artist's) body is made explicit through both the title and a 1961 photograph typically used to represent the work, in which Morris is standing in the sculpture in his studio.[16] These early sculptures were designed to support, enable, and contain certain bodily actions. For his performances, Morris would select objects that "could be manipulated" such that they "did not dominate [his] actions nor subvert [his] performance," according to the artist.[17]

By the time Morris presented *Site* in spring 1964, he had begun to combine elements from these earlier works.[18] *Site* opened with Morris, wearing white work clothes, white gloves, and a mask of his own face (made by artist Jasper Johns), standing downstage left with his

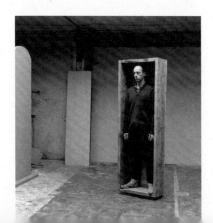

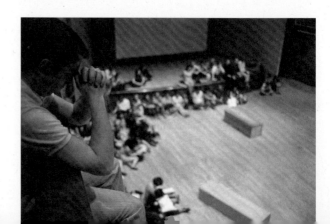

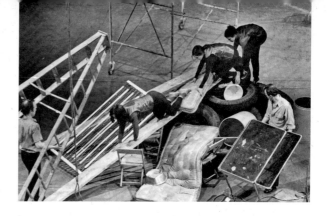

back to the audience. The soundtrack, a jackhammer recorded from street construction outside his studio, emanated from a white box downstage. Morris then walked upstage toward a large, boxlike plywood structure and began to dismantle it, picking up and carrying off to the side the rectangular sheets of plywood. At one point, Morris moved a sheet to reveal an undressed Carolee Schneemann, motionless and reclining on a white plywood platform, "a facsimile," as Johnston observed, of Edouard Manet's *Olympia* (1863) in pose and costume.[19]

Throughout *Site*, Morris emphasized the relationship between the size of the board and the size of the artist's body: the board's width in relation to Morris's arm span; its standing height in relation to Morris's standing height; its breadth in relation to Morris's breadth, both in profile and facing the audience. He extended the line of his spine as he bent forward at the hips and knees, the board resting on his back; the plywood cantilevered out from his waist, accentuating the shifting center of gravity as he lowered to the ground.[20] Here the board functioned as a sculptural prop in which "action, object, and dancer merge[d] in a single affective unit," to reiterate Johnston's phrase, emphasizing parallels in scale and movement between body and board.

Rainer's approach to using objects in her work differed from Morris's in at least one substantive way: the value she assigned to the objects onstage in relation to that of the performers. In her 1967 "Notes on Two Dances by Deborah Hay," Rainer summarized the typical relationship between performer and object as hierarchical, wherein the performers manipulate and control the objects. "Invariably," she wrote, "the focus of attention in these events has been the human performers, however minimal their 'performance.'"[21]

For Morris, maintaining this hierarchy was important. When performers become "assistants," he argued in a caustic 1965 review of a work by Steve Paxton, in which Paxton ministered to the objects on stage, it is a detriment to the work: the viewer's focus on the movements as such diminishes and the result can be overly

"pictorial" works.[22] Rainer, however, took interest in subverting this hierarchy, delighting in the ability of banal objects to supersede, for instance, a "dancing girl," as transpired in the two works by Hay she discussed in the review quoted above.[23] For Rainer, whose own work is invested in the body's objectlike properties, this inversion of the hierarchy helps to disrupt the traditional narcissistic presentation of the performer.

In her performances as well as in her writings, Rainer handles objects as compositional units, equivalent to passages of text or movement. For example, in her 1973 text "Etymology of Objects, Configurations, and Characters," Rainer traces the origins and changing meanings of the various elements that have appeared across the performances and films comprising her work to date, treating choreographic components and movements such as "Trio A," "Valda's Solo," "herds," and "*V* formation (forward lean)" on par with objects such as "pillows," a "large wooden box," and a "mattress and mat."[24] Rainer included the mattress, for example, in *Room Service* (1963; fig. 4), *Parts of Some Sextets* (1965), *The Mind Is a Muscle (Trio A and Mat)* (1968), *Performance Demonstration* (1968), *Continuous Project—Altered Daily* (1970), and *This is the story of a woman who . . .* (1973).[25] Her reuse of the same objects, or types of objects, across various dances, performances, and films is evidence of her interest in the "'load' of associations" that objects carry with them—in the case of the mattress, "sleep, dreams, sickness, unconsciousness, sex"—as well as the different ways meaning accrues in the objects as they pass from work to work.[26] Moreover, it is confirmation that the tension between the way these objects carry associations and the way they "can be exploited as strictly neutral" is essential to her work.[27]

By her own account, Rainer first recognized the potential of the mattress to engender a "self-contained act" in a 1964 performance of *Room Service*, wherein two performers lugged a mattress offstage, exiting through the audience and reentering through another access, bringing the mattress with them. Writing in 1965, she observed that there was "something ludicrous

79

Opposite left: (2) Robert Morris. Box for Standing, 1961. Pine, 74 x 25 x 10½". Opposite right: (3) Peter Moore's photograph of student performers in Simone Forti's *Platforms*, 1961. Performed at Loeb Student Center, New York University, May 4, 1969. Above: (4) Peter Moore's photograph of Yvonne Rainer's *Room Service*, 1964. Performed at Concert of Dance #13, Judson Memorial Church, November 20, 1963. Pictured, from left: Al Hansen, Yvonne Rainer, Sally Gross, Carla Blank, and an unidentified performer

A QUASI SURVEY OF SOME "MINIMALIST" TENDENCIES IN THE QUANTITATIVELY MINIMAL DANCE ACTIVITY MIDST THE PLETHORA, OR AN ANALYSIS OF TRIO A by Yvonne Rainer

Yvonne Rainer is one of the major figures of the highly experimental and influential Judson Dance Theatre in New York. In this essay based on her dance in five parts called *The Mind Is a Muscle*, she discusses ideas concerning smoothness of continuity in dance. Repetition, phrasing, and energy are redefined; formal content and progression in dance are challenged. As Kenneth King points out: "What the new dance-theater does is RE-PROGRAM symbolic actions, subjects, and movement. Dance need no longer be a minor art with segregated specialization of mere movement."

Miss Rainer was born in San Francisco in 1934, and has performed her works in several American cities, as well as in Europe. Her most recent choreography includes *The Mind Is a Muscle* and *Carriage Discreteness*, the latter being a work for twelve performers using electronic equipment devised by Bell Laboratory scientists, which was presented at the 69th Regiment Armory in New York as part of the series called "Nine Evenings: Theatre and Engineering."

Objects	Dances
eliminate or minimize	
1. role of artist's hand	phrasing
2. hierarchical relationship of parts	development and climax
3. texture	variation: rhythm, shape, dynamics
4. figure reference	character
5. illusionism	performance
6. complexity and detail	variety: phrases and the spatial field
7. monumentality	the virtuosic movement feat and the fully-extended body
substitute	
1. factory fabrication	energy equality and "found" movement
2. unitary forms, modules	equality of parts
3. uninterrupted surface	repetition or discrete events
4. nonreferential forms	neutral performance
5. literalness	task or tasklike activity
6. simplicity	singular action, event, or tone
7. human scale	human scale

(5) Page from Yvonne Rainer's "A Quasi Survey of Some 'Minimalist' Tendencies in the Quantitatively Minimal Dance Activity Midst the Plethora, or an Analysis of Trio A," 1968. First published in *Minimal Art: A Critical Anthology*, 1968 (cover shown on far left). Edited by Gregory Battcock and published by E. P. Dutton & Co., New York

and satisfying about lugging that bulky object around, removing it from the scene and reintroducing it. No stylization needed. It seemed to be so self-contained an act as to require no artistic tampering or justification."[28] This "self-contained" act of hauling the mattress invited a number of different movement possibilities, which became the crux of her 1965 *Parts of Some Sextets*, "a dance for 10 people and 12 mattresses" (fig. 1, page 76).[29]

A receipt dated January 7, 1965, from Bilt-Rite Mattress & Bedding for the purchase of the twelve mattresses for Rainer's *Parts of Some Sextets* reminds us that the mattress is a perfectly mundane object. She chose twelve identical, interchangeable units, each with the same material properties: striped and with a soft rolled edge, they contained no springs. She decided on twelve because when stacked they reached as high as a person standing. When carried upright, the mattresses towered just above the performers' heads, blocking their view and obscuring the front half of their bodies from the audience.

In rehearsal, Rainer and the dancers developed thirty or so possible different activities, most involving the twelve mattresses. Rainer assigned them to individual performers and laid them out in a sequence to form the dance's score. The mattress pile defined and augmented the performance space. The dancers crawled through the stack, flung themselves onto it, and dismantled it, peeling off one mattress at a time and carrying them either individually or in pairs. They used the stack as a pedestal, standing or sitting on top of it. Indeed, in the rehearsal photographs, we can see the resistance of the mattresses; we can see their weight and heft. The mattresses organized the movements of the dance, and, in their onerous relationship to the performers' bodies, became active participants onstage. The performers, in turn, took on an objectlike quality, as they too were hauled about onstage.

Like the plywood in *Site*, then, the mattresses harbored the potential for any number of permutations of movement, the dancers interacting with and relating to the objects. But Rainer, unlike Morris, was interested in the interchangeability of bodies and objects; after all, hers was a performance where the mattresses outnumbered the human participants. Whereas for Morris, the sculptural prop enabled the performer's movements, acting in service to them, for Rainer the objects served as equals to the performers, even, at times, superseding them in prominence.

Morris's and Rainer's performances reveal to us two important ways that Judson performers integrated objects in their works. But Judson performers integrated objects for more than generating the new, self-contained action that characterized the group's "object-events"; they also insisted that these objects existed in time. Within the structuring duration of the performance, Judson choreographers negotiated the relation between objects and a perceiving, moving subject. In the handling of Judson's objects, the hierarchy between performer and object

shifted, and as the objectlike qualities of the performers themselves were emphasized, the potential of the sculptural prop emerged.

NOTES

1. Jill Johnston, "Dance: The Object," *Village Voice*, May 21, 1964, 12. The Johnston quotation in the next paragraph is from the same work.

2. For "body-substitutes" and "object-protagonists," see Yvonne Rainer, "Notes on Two Dances by Deborah Hay," *Ikon* 1, no. 1 (February 1967): 2–3; for "animated objects" and "body surrogates," see Robert Morris, "Dance," *Village Voice*, February 3, 1966, 25; for "inert protagonist" and "body adjuncts," see Rainer, *Feelings Are Facts: A Life* (Cambridge, MA: MIT Press, 2006), 236, 319. Additionally, Johnston uses the term "action-object" in "Morris-Childs," *Village Voice*, May 20, 1965.

3. This essay borrows from my in-progress dissertation, which investigates and further defines my concept of the sculptural prop.

4. While art historian Michael Fried decried the relationship between Minimalist sculpture and the situation of beholding as "theatrical," Rosalind Krauss and Annette Michelson saw it as an important art historical development. For an incisive summary of Minimalism's entanglement with the theatrical, see Carrie Lambert-Beatty, "More or Less Minimalism: Six Notes on Performance and the Visual Art in the 1960s," in *A Minimal Future? Art as Object, 1958–1968*, ed. Ann Goldstein and Lisa Gabrielle Mark (Cambridge, MA: MIT Press, 2004), 104–5.

5. Rainer, "A Quasi Survey of Some 'Minimalist' Tendencies in the Quantitatively Minimal Dance Activity Midst the Plethora, or an Analysis of *Trio A*," in *Minimal Art: A Critical Anthology*, ed. Gregory Battcock (New York: E. P. Dutton & Co., 1968), 263.

6. Forti would not coin the term Dance Construction until her May 1961 performance, which she called Five Dance Constructions and Some Other Things. See Forti, "The Dance Constructions," in *Simone Forti: Thinking with the Body*, ed. Sabine Breitwieser (Salzburg: Museum der Moderne, 2014), 80. See also Forti, "The Dance Constructions," Forti collection files, Department of Media and Performance, The Museum of Modern Art, New York. For a list of works performed at each showing, see "Simone Forti" on page 136 in this volume.

7. Forti, *Handbook in Motion* (1974; repr., Northampton, MA: Contact Editions, 1998), 39–42. For descriptions of this performance, see Forti, "The Dance Constructions," n.p. See also Forti's *See Saw* drawing with handwritten description, Forti collection files, Department of Media and Performance Art, The Museum of Modern Art, New York.

8. Composer La Monte Young conveyed his excitement about the performance at Reuben Gallery in a letter to California-based choreographer Anna Halprin, a former teacher of Forti's. The letter is undated (c. December 1960–January 1961), Anna Halprin Papers, 1;76, Museum of Performance and Design, San Francisco.

9. There were many such instances over the years. For three earlier examples, see Robert Morris, "Notes on Dance," *Tulane Drama Review* 10, no. 2 (Winter 1965): 179; Paul Cummings, oral history interview with Robert Morris, March 10, 1968, Archives of American Art, Smithsonian Institution. Access online at https://www.aaa.si.edu/collections/interviews/oral-history-interview-robert-morris-13065; and Liza Béar and Willoughby Sharp, "The Performer as a Persona: An Interview with Yvonne Rainer," *Avalanche* no. 5 (Summer 1972): 54.

10. Morris, "Notes on Dance," 179.

11. Ibid., 180.

12. See Rainer, *Feelings Are Facts* 236.

13. For a description of *Box*'s appearance at Harvard and a reproduction of the March 31, 1961, concert program, see Branden W. Joseph, "The Tower and the Line: Toward a Genealogy of Minimalism," *Grey Room* 27 (Spring 2007): 64.

14. Letter from Robert Morris to John Cage, February 27, 1961, published in Morris, "Letters to John Cage," *October* 81 (Summer 1997): 76.

15. See Wade Guyton, "Robert Morris," *Interview Magazine*, January 5, 2014, https://www.interviewmagazine.com/art/robert-morris.

16. This 1961 photograph now circulates in relation to subsequent iterations of the sculpture. See *Untitled (Box for Standing)* (1961/1994) in the collection of Museo Nacional Centro de Arte Reina Sofía, Madrid.

17. Morris, "Notes on Dance," 180.

18. The first performances of *Site* took place March 2 and 9, 1964, at Stage 73, Surplus Dance Theater, New York, followed by another on April 29, 1964, as part of Concert of Dance #16 at Judson.

19. Johnston, "Dance: The Object," 12.

20. These descriptions of movements are largely based on the 1993 restaging in the film by Babette Mangolte, in which Andrew Ludke performed this role. The film was made for inclusion in Morris's retrospective at the Solomon R. Guggenheim Museum in New York in 1964. A brief excerpt of filmed footage of an earlier performance of *Site* by Morris and Schneemann was distributed by *Aspen*.

21. Rainer, "Notes on Two Dances by Deborah Hay," 2.

22. See Morris, "Dance," *Village Voice*, published in two parts, February 3, 1966, and February 10, 1966. André Lepecki observes a related distinction between Morris's and Rainer's respective approaches to objects in *Singularities: Dance in the Age of Performance* (New York: Routledge, 2016), 32–37.

23. Rainer, "Notes on Two Dances by Deborah Hay," 2.

24. Rainer, "Etymology of Objects, Configurations, and Characters," *Work 1961–73* (Halifax: Press of the Nova Scotia College of Art and Design, 1974), 335–36.

25. Rainer, "Etymology of Objects, Configurations, and Characters," 335–36.

26. Rainer, "Miscellaneous Notes," 106.

27. Ibid.

28. Rainer, "Some Retrospective Notes on a Dance for 10 People and 12 Mattresses Called 'Parts of Some Sextets,' Performed at the Wadsworth Atheneum, Hartford, Connecticut, and Judson Memorial Church, New York, in March, 1965," *Tulane Drama Review* 10, no. 2 (Winter 1965): 168.

29. Ibid.

82

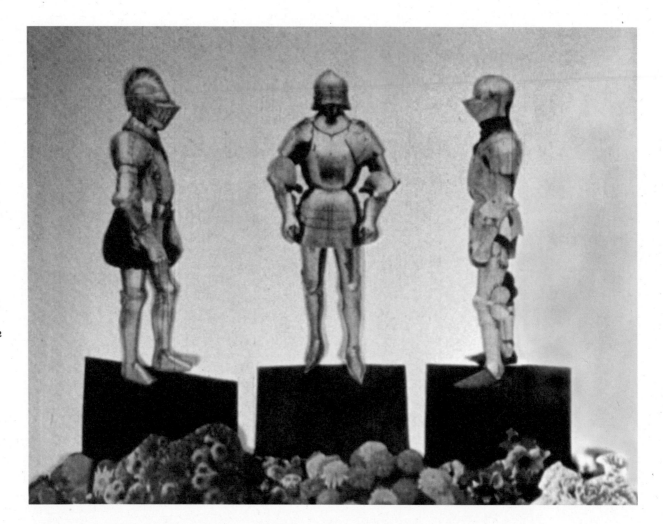

The first work presented by Judson Dance Theater, at Concert of Dance #1 in 1962, was not a straightforward dance performance but an experimental film titled *Overture*. Projected onto a curtain backdrop, *Overture* featured short clips documenting Judson rehearsals intercut with found footage and scenes composed and shot by the film's maker, Elaine Summers in collaboration with Gene Friedman, John Herbert McDowell, and others. Summers made productive use of the chance methods she first learned earlier that year in Judith and Robert Dunn's choreography workshops at Merce Cunningham Studio, juxtaposing clips of W. C. Fields's popular comedy films alongside her own choreography and setting them to a musical score. *Overture*'s integration of moving bodies with moving images anticipated the diverse ways that Judson would interweave film and sound into its dances and marked the start of an investigation Summers would pursue throughout her career. "It was a film that was made to dance with intermedia," Summers said of *Overture* in a 2008 interview.[1] By *intermedia*, Summers was referring to what had become her life's work: experimental events merging the temporal dynamics of mass media—repetition, seriality, broadcast, and playback—with the intimacy of dance and the embodied experience of public encounters (fig. 2, page 84). In the five decades following *Overture*, Summers combined strategies of modern dance, art history, and popular culture; analog sources (radio, television, and consumer magazines, as well as photography and film); and emerging networked models of distribution like closed-circuit television (CCTV) as well as (later) the internet to generate sensorial environments that hinged on audience engagement—events which she termed intermedia.

Intermedia is thus vital to Judson's formation and to the development of Summers's own work. In 1968, still deeply involved with Judson, Summers founded the influential Experimental Intermedia Foundation, formalizing her ardent advocacy for the idea. Yet, despite its essential role in Judson, intermedia remains underexamined. One significant reason might be that

the term itself is capacious. Like the contemporaneous idiom *expanded cinema*, intermedia is a close counterpart to the neo-avant-garde aesthetic experiments that exploded in New York in the 1960s, including Fluxus and Happenings, and represented a newfound openness toward alternative means of staging works of art.[2] However, intermedia did not become synonymous with specific venues in the way that the Reuben Gallery in New York became associated with the Happenings of artists Jim Dine, Red Grooms, Allan Kaprow, Claes Oldenburg, and Robert Whitman. Instead Summers relied on a loose network of changing venues and formats, such as traveling festivals and serial screening programs. As critic John Gruen noted: "So it is at places such as the Filmmakers' Cinematheque, the Bridge Theater, and rented lofts that audiences are exposed to cinematic free-for-alls that range from grueling exercises in boredom to events that are neither cinema, music, dance, painting, poetry, nor drama, but often deafening and blinding combinations of all of them."[3]

Even by 1980, when Summers organized the more formal seminars, public panels, screenings, and workshops that comprised the First Intermedia Art Festival in New York, the term itself remained hard to differentiate from other monikers given to the various live events that incorporated emerging media technology, including video cameras, recording playback monitors, audiotapes, microphones, and speakers, to stunning effect. As dance historian Sally Banes wrote in her review of the Intermedia Art Festival, this difficulty persisted in part due to Fluxus poet and composer Dick Higgins's earlier use of *intermedia* to refer to "the gap between any two art forms."[4] By the festival's end, Banes wryly surmised, "It seemed to me that intermedia meant any instance when technology intrudes on performance."[5]

Yet a close reading of Summers's projects reveals that intermedia in fact means something more specific than what Barnes had offered. While intermedia does include the intrusion of technology on performance, it cannot be described as an accretion of technological developments in film alone. Nor can it be wholly accounted for by the wider availability of more affordable and portable devices, including compact cameras. Rather, Summers's concept of intermedia rests on the introduction of network-based models of communication and the durational qualities of her multisensorial environments that emphasized the construction and circulation of images and bodies. More specifically, her works anticipated the ways that these early systems for

83

Opposite: (1) Elaine Summers. Still from *Judson Fragments*, 1964

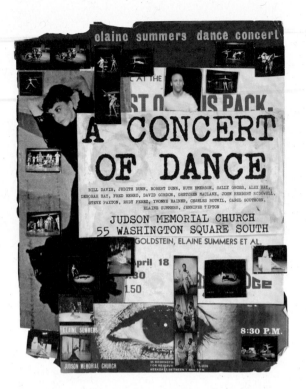

the transmission of images such as CCTV and video playback would reflect the conditional relationship between the rhetoric of access and agency and their inverses: the mechanisms of control and manipulation that would condition the protocols and behaviors of digital networks soon to follow.

OVERTURE

Summers was interested in filmmaking as early as she was in dance. Supplementing her formal studies at Juilliard and her training at the Martha Graham School, she learned how to shoot and edit her own 16mm and 8mm films through the informal mentorship of Gene Friedman, who worked as a professional cameraman for television and films. According to Summers, it was a generative exchange: she gained the expertise of in-camera editing, while Friedman learned to take broader artistic license.[6] At this time, Summers was also in regular conversation and collaboration with artist and filmmaker Stan VanDerBeek, whose own expanded cinema experiments often involved contributions from choreographers such as Merce Cunningham, composers including David Tudor and John Cage, poets such as M. C. Richards, and other artists who formed New York's creative and intellectual diaspora following

the dissolution of Black Mountain College in western North Carolina. Like Summers, VanDerBeek was prolific, his projects throughout the 1960s and 1970s sliding effortlessly between the exhibition frameworks of cinema and visual art.

Overture was one of Summers's first films. For the assembly, she solicited contributions from her Judson circle, including Friedman's own shorts, and borrowed from composer John Herbert McDowell's collection of W. C. Fields films to supplement her own assortment of popular comedy cinema.[7] To determine the sequence of these disparate sources she relied on a conceptual procedure. "We made [the filmstrips] into these little rolls and put numbers on them; one, two, three, etc.," she has recounted. "We went to the telephone book to choose the films. The first number from the telephone book that we picked out by chance was the first that we used."[8] Summers's equal reliance on chance operations and an alphanumeric data classification system was indicative of her presciently conceptual approach to filmmaking. In fact, another eight years would pass before the watershed exhibitions of 1970 *Software: Information Technology—Its New Meaning for Art*, mounted by Jack Burnham at the Jewish Museum in New York; *Information*, organized by Kynaston McShine at The Museum of Modern Art, New York; and *Explorations*, orchestrated by Gyorgy Kepes at the National Museum of American Art in Washington, DC, put into full view the ways that visual artists interpolated concepts such as seriality and modularity derived from emerging communications technology in celebratory and critical ways.

Summers's systems-based method for *Overture* also reflected a distinctly modern approach to dance—what Louis Horst, one of modern dance's most powerful voices, called "cerebralism."[9] Cerebralism referred to a selection of modern dance movements gleaned not from emotion or sentiment, but from a "conscious mechanical and abstract manipulation of space and rhythm," a turn toward more conceptual and analytic methodologies.[10]

Summers's own projects would transition away from emotion toward the notion of energy, the capacity of a physical system to perform work through a variety of forms and formats.

In *Overture*, the integration of collage film, modern dance, and music displayed physiological and psychic forms of energy that ask the audience to participate in subtle and continuous acts of exchange and transfer, an affective form of audience labor.[11] Importantly for Summers, this crossing of disciplinary styles distinguished intermedia works from those considered "multimedia." In Summer's estimation, multimedia works merely connoted a plurality of images and did not attend to the ways that these images disrupt and distort one another. "Intermedia is when you enter the image and get wrapped up in it. You become a part of the image," Summers insisted.[12] In this way, *Overture* can be read as a pervasive metaphor for the mutability of media itself, a critique of the rigidity of the category.

FANTASTIC GARDENS

Fantastic Gardens, of 1964, was Summers's first evening-length intermedia performance at Judson Memorial Church (figs. 3–4). The ambitious enterprise relied on the contributions of dozens of visual artists, dancers, and musicians, as well as the audience members; its thirteen vignettes translated dance improvisation into filmic improvisation. Film provided a unifying element among the work's visual cacophony of changing scenes, shifting seating arrangements, and blurred image sources. Summers spliced found material together with her own films, including sequences from *Overture* and new scenes designed specifically for the event. "I used every bit of film I ever made," Summers reflected.[13] The first vignette started with the audience looking at a clearly demarcated stage arranged "like an altar," according to Summers; the sixteen dancers formed eight couples whose improvised dances recalled the way pairs rhythmically turn during traditional waltzes, and who were outfitted in starkly contrasting black-and-white costumes—a mix of long gowns and satin gloves for the women; tuxedos, tailored suits, and ties for the men.[14] The coded symbolism of the restricted black-and-white palette referenced "black tie"—the convention of dress for evening events among the upper social ranks—as well as high-contrast film and, equally, the coded language of race.

As in *Overture*, Summers arrived at the script and score using chance methods. Her choreographed prompts and stage directions had to be construed by the dancers. Rudy Perez shouted extempore phrases while spontaneously leaping and jumping. Herko and Sally Stackhouse danced nude as painter Elizabeth Munro covered their skin in an extempore painted pattern of her own making. "By the end of the performance they looked like iridescent dragonflies," Summers observed.[15] Audience members, unrehearsed and unaware of what was to come, reacted to the changing configurations of the performance and interpreted Summers's instructions. After an intermission, for example, they were asked to arrange their chairs in a triangle and were given handheld mirrors typically used to check one's own visage. Turned outward, the mirrors became a tool to interrupt and redirect the streams of images being projected, amplifying and multiplying the images and spotlighting the dancers' bodies in uneven and spontaneous ways.[16] Here Summers scrambled the roles typically ascribed to the audience as passive spectators and the performers as active agents. In this way, *Fantastic Gardens* drew attention to the conventions that regulate bodies in public space and the power dynamics that ensue from them.

Fantastic Gardens also explored the emotional and psychological identification that we experience while navigating built environments with architecturally scaled images over an extended duration—what is often called "immersion." In the context of contemporary visual art, the term *immersive* tends to refer to a

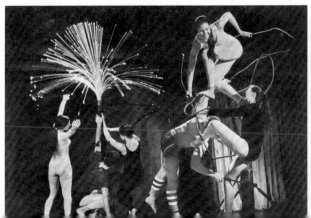
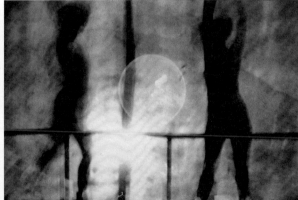

type of illusionism that transports viewers out of their current context into one represented on the screen.[17] In *Fantastic Gardens*, however, viewers do not become absorbed in the diegetic space of the screen; instead, they perceive the particular intensity and demands of dance training and of working in a corps. They are aware of being surrounded by other bodies, including those of the dancers and other audience members, and register empathy and its counterpart, estrangement, along the body's surfaces. Many of Summers's decidedly lowfi intermedia events were exercises in patience for dancers and audiences alike and her use of bodies enveloped in images and images interrupted by bodies qualifies the concept of immersion as an illusionistic and disembodied experience. This approach proved generative throughout her ensuing artistic endeavors both inside and outside of Judson.

As *Fantastic Gardens* demonstrates, Summers did not engage emerging media through the same rhetoric of radical revolution that would announce the advent of video art slightly later, but in the more inchoate terms of a complex social sphere in which art and technology intersected with civil rights activism and feminism. "One of the important things that happened with Intermedia, because of women's liberation and the socioeconomic relationship of women . . . is that it is the first-time women have been able to have a pioneering role to play in the development of a new art form," Summers remarked in 1980 in a special issue of *Performance Art*.[18] She also noted the lack of recognition given to women in advancing the critical use of media technology in the visual arts: "In fact, if you read histories of intermedia the work of women has been ignored. I'm saying this partially as the first artist in New York City to combine multiple film images with dance, music, and sculpture in *Fantastic Gardens* in 1964." The choice to employ emerging media technologies was not just formal but political. Women artists turned to film and video to disrupt the dominant medium-specific lineages of photography, sculpture, and painting.

JUDSON FRAGMENTS

The film *Judson Fragments* (1964; transferred to digital video in 2007) is on one level a document of the Judson group's activities between 1962 and 1964 (fig. 1, page 82; fig. 5). *Fragments* interlaces footage used in *Overture* and *Fantastic Gardens*, including black-and-white scenes of Herko in leather boots and underwear watering the trashcans outside of Summers's Cornelia Street apartment, with close-ups of botanical elements and vaudevillian shtick that would later read as camp, the dancers mugging for the camera or making overaccentuated eye gestures. Summers also incorporated material from colleagues and collaborators, synthesizing the experimental strategies of the period. A vibrant color sequence at the start shows Victorian-era paper dolls shuffling and dancing through VanDerBeek's stop-motion animation, for example. These aristocratic women dressed in period clothing are then pushed out of frame by a riotous bunch of blooming flowers. The astute observational lens of Friedman's *3 Dances* (1964) surfaces in a tightly framed sequence containing two nude males jostling and wrestling; without any markers of periodization, the segment freezes and isolates the action as a timeless dance.

Fragments offers not a documentary of the various performances recorded on film but, I would posit, an abstraction of them. This work does not replicate the live experience of seeing the dances nor adhere to the orthodoxy of fidelity to record and document. Summers's editing techniques actively demonstrated the durational *logic* of time-based media: fast-forwarding, freeze-framing, and making time stand still. The film can be described in the analog terms of its own time: as an "assembly," or, when projected, an "environment." *Fragments* affirms that an ethos of variability in media, one that reflected diverse subjectivities, was essential to the first wave of new media art. Simultaneously, when viewed in the current digital moment, this film also provides a media archaeology, tracing the history of outmoded formats that run at a pace more disjointed than

Left: (5) Elaine Summers. Still from *Judson Fragments*, 1964. Opposite: (6) Elaine Summers. Layout for Elaine Summers's *Energy Changes* performed at The Museum of Modern Art, New York, September 21–23, 1973

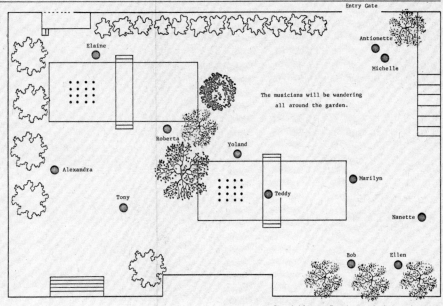

digital video's seamlessness. In some sections, *Fragments* moves at the staccato pacing of 35mm slides, or alludes to the shakiness of handheld cameras, or suggests the manual maneuvering of transparencies on overhead projectors.

More speculatively, *Fragments* seemingly anticipated behaviors today associated with digital formats, such as compositing—assembling several smaller images to create a larger whole, for example. Perhaps, then, Summers's decision in 2007 to make a digital transfer offers the best metaphor for the work, insofar as it emphasizes the compression of information and also history.

ENERGY CHANGES AND SKYDANCE

Summers's recognition within art historical narratives tends to end with the dissolution of Judson Dance Theater. Yet in the 1970s and 1980s, her work continued to integrate media and bodies, investigating how each performs continuous acts of exchange and transfer. In *Energy Changes*, presented in 1973 in the Sculpture Garden at The Museum of Modern Art, twelve performers wearing identical gender-neutral leotards in a gradient of flesh tones danced outside among the outdoor marble sculptures. Contrary to expectation, they slowed their

movements to such an extreme that they were rendered almost static. And it was the audience members who perambulated freely around the outdoor setting while striking gongs and bells in an improvised manner. CCTV monitors positioned around the garden mediated the dancers' slowed movements, marking an early use of live video feedback to generate a type of kinesthetic disorientation for the viewer.[19] *Energy Changes* complicated the notion of what it meant to be present at an event before the advent of the discourse on presence ushered in by the rise of network culture (fig. 6).

In *SkyDance*, of 1984, ten dancers scaled the interior rotunda of the Guggenheim Museum in New York as lights and filmic images were projected in an improvised manner onto their bodies, likewise highlighting issues of delay and transfer. Nine musicians performed a choreographed score composed by Summers's frequent collaborator Carman Moore, who developed six distinct movements, each centered around inflatable fabric sculptures designed by Otto Piene.[20] While *Energy Changes* and *SkyDance* took on the monumental scale of the institutions at which they were presented, they nonetheless remained tethered to the materiality of the human body.

Overall, Summers's intermedia attended to digital technology's various protocols of display, dissemination,

and circulation in both technical and conceptual ways. Her notion of intermedia thus puts forward a methodology for contemporary art history that can be thought of as a type of critical transposition—that is, an exchange between film and dance, performers and audience, bodies and space, past and present that is grounded in the material conditions of the work's own production and transmission. This type of reciprocity of experience provides a generative framework to consider Judson's aesthetic response to the history of art as well as the genealogy of media at the very moment their two pathways converged in the 1960s. In the end, recognizing how Summers's intermedia attempted to work against established commercial conventions for image refinement, sound synchrony, and material stability offers a model for the ways that Judson's own history remains iterative and transformative.

NOTES

1. Kristine Marx, "Gardens of Light and Movement: Elaine Summers in Conversation with Kristine Marx," *PAJ: A Journal of Performance and Art* 30, no. 3 (September 2008): 26.
2. For an extended consideration of the moving-image experiments that coalesced under the loose rubric of expanded cinema, see my book, *The Experience Machine: Stan VanDerBeek's Movie-Drome and Expanded Cinema* (Cambridge, MA: MIT Press, 2015).
3. John Gruen, *The New Bohemia: Combine Generation* (New York: Grosset and Dunlap, 1966), 108.
4. Sally Banes, "First Intermedia Art Festival," *Dance Magazine* 54 (May 1980): 44.
5. Ibid. Summers pointedly remarked how even after his passing Higgins's interpretation of intermedia continued to overshadow her own in part due to his influence as a critic and publisher in addition to his work as a poet, artist, composer, and teacher. See interview with Elaine Summers conducted by Joan Arnold, 2010, NYPL Oral History Project Dance Division, New York Public Library, disc 6.
6. Ibid.
7. Summers and others associated with Judson Dance Theater often evoked the slapstick comedy of W. C. Fields, Charlie Chaplin, and other popular film actors whose physical dexterity appealed to dancers and choreographers. For a detailed discussion of slapstick and modernist sensibilities, see Malcolm Turvey, *The Filming of Modern Life: European Avant-Garde Film of the 1920s* (Cambridge, MA: MIT Press, 2011).
8. Marx, "Gardens of Light and Movement," 26.
9. Louis Horst and Carroll Russell, *Modern Dance Forms in Relation to the Other Modern Arts* (Princeton, NJ: Princeton Book Company, 1961; reprinted 1987), 107.
10. Ibid.
11. Art historian Julia Bryan-Wilson astutely takes up the notion of labor within Judson in her analysis of how the group's use of "found" or everyday gestures is often read as effortless. She argues that, on the contrary, Judson dances demanded endurance. See "Practicing *Trio A*," *October* 140 (Spring 2012): 62. See also Carrie Lambert-Beatty's important work on issues of "difficulty" and "seeing" in Judson in her watershed book, *Being Watched: Yvonne Rainer and the 1960s* (Cambridge, MA: MIT Press, 2008).
12. Marx, "Gardens of Light and Movement," 26.
13. Ibid., 27.
14. Ibid.
15. Ibid.
16. Sally Banes, *Democracy's Body: Judson Dance Theater 1962–1964* (Durham, NC: Duke University Press, 1983), 89.
17. For a historical account of *immersion* and its origins in the illusionary art of antiquity, see Oliver Grau, *Virtual Art from Illusion to Immersion* (Cambridge, MA: MIT Press, 2003). Erkki Huhtamo's *Illusions in Motion: Media Archaeology of the Moving Panorama and Related Spectacles* (Cambridge, MA: MIT Press, 2013) provides an incisive and compelling consideration of immersion based on precinematic devices.
18. This quotation and the one following can be found in Elaine Summers, "Intermedia Is," *Performance Art Magazine* 3 (1980): 12. For a consideration of the discourses on feminism and embodiment as read through the work of Summers's contemporaries, see Elise Archias, *The Concrete Body: Yvonne Rainer, Carolee Schneemann, Vito Acconci* (New Haven, CT: Yale University Press, 2016).
19. For a detailed overview of *Energy Changes*, see Ann-Sargent Wooster, "Elaine Summers: Moving to Dance," *Drama Review: TDR* 24, no. 4, Dance/Movement Issue (December 1980): 59–70.
20. New York–based composer Carman Moore discusses his collaborations with Summers and gives a detailed account of the challenges of working across various media and fields in his memoir, *Crossover: An American Biography* (New York: Grace Publishing, 2011).

CONCERTS OF DANCE: PORTFOLIOS

Photographs of Judson Dance Theater performances are the primary means by which contemporary audiences can access these otherwise ephemeral works. For the abundance of images that endure today, we owe thanks mainly to a handful of dedicated photographers, who chronicled the scene with verve and perspicacity, as well as to the keepers of their archives. What follows is a selection of images from two of the Concerts of Dance most thoroughly documented: #3 and #13, parts of a whole, evenings once experienced in real time. These photographs are presented in chronological sequence, dance by dance, traces of what it was to have been there.

CONCERT OF DANCE #3
January 29, 1963
A Portolio of Photographs by Al Giese

Concert of Dance #3 took place in the basement gym of Judson Memorial Church, where the audience watched from the edges of the basketball-court-turned-stage. Al Giese, a photographer for *Newsweek*, documented the performances with a sense of proximity, as was characteristic of the many Judson concerts he shot. The dances explored the relationship between the ordinary and the performative. Yvonne Rainer's *We Shall Run*, Fred Herko's *Little Gym Dance*, and Carolee Schneemann's *Newspaper Event* were each performed in street clothes. Elaine Summers's *Suite* was danced in both plain leotards and festive attire: Summers wore a harlequin-print ruffled tent dress and the performers in the "Twist" segment of the dance dressed for a party. Steve Paxton's *Word Words* was performed nearly nude: Paxton and Rainer wore small underwear and, in the case of Rainer, pasties. Surprisingly, the nudity was leveraged not for the sake of provocation but rather as an attempt to focus attention on the duo's movements. Several dances incorporated quotidian objects. In Schneemann's *Newspaper Event*, the dancers manipulated newspapers, which were in scarce supply in New York in 1963 during a widespread newspaper strike. In the performance, the accumulation and proliferation of this ubiquitous material turned scant transformed the otherwise commonplace into something noteworthy.

Composer Philip Corner was the musical director for the concert, which included unconventional pairings of movement and sound. William Davis's *Field* featured transistor radios as both prop and soundscape. Davis and Barbara Dilley danced with the radios, each set to a different station. Occasionally strange coincidences emerged, as when a sports broadcast about an athlete's knee injury played while Davis, who wore a kneepad to protect a dance injury, performed.[1] Paxton and Rainer danced Paxton's *Word Words* in total silence. For her own performances, Rainer paired ballet and ordinary movements, like running, with classical music: a section of Hector Berlioz's Requiem (1837) for *We Shall Run* and

Igor Rachmaninoff's Piano Concerto No. 2 (1901) for *Three Seascapes*. The latter dance also featured La Monte Young's "Poem for Chairs, Tables, Benches, Etc.," comprised of the recorded sound of furniture being dragged across a floor. Rainer concluded the dance with a screaming fit.

The evening's dances juxtaposed ordinary movement with classical technique, evidence against the commonplace idea that Judson dancers rejected virtuosity wholesale. Herko's *Little Gym Dance*, Summers's *Suite*, and Carol Scothorn's *The Lazarite*, an homage to the early twentieth-century modern art dancer Doris Humphrey, were inflected with a balletic sensibility. Group dances tended to feature repetition, task-based movements, and improvisational tactics. The score for Rainer's *We Shall Run*, for example, which highlighted the deceivingly simple act of running, had each performer sprinting in a pattern of circles, diagonals, and loops. Several dances tested the boundary between individual movement and group cohesion. *Word Words* and *Field* interrogated the boundaries between the solo and the duet; between two dancers together on stage performing movement independently and also necessarily in relationship to each other.

Concert of Dance #3 was billed alongside Concert of Dance #4—presented the following night—as a "double concert." Several critics found the performances overwhelming, commenting on their attention-defying length. Most agreed that even the outright "boring" parts had been worth enduring for the intermittent moments of magic.[2] *Village Voice* critic Jill Johnston commended Judson's indiscriminate tactics: "I think it's great to be as inclusive as possible," she wrote, "because it's more like life that way."[3] —VAC

Notes
1. Sally Banes, *Democracy's Body: Judson Dance Theater, 1962–1964* (1983; repr. Durham, NC: Duke University Press, 1993), 86.
2. Ibid., 86.
3. Jill Johnston, "Judson Concerts 113, #4," *Village Voice*, February 28, 1963.

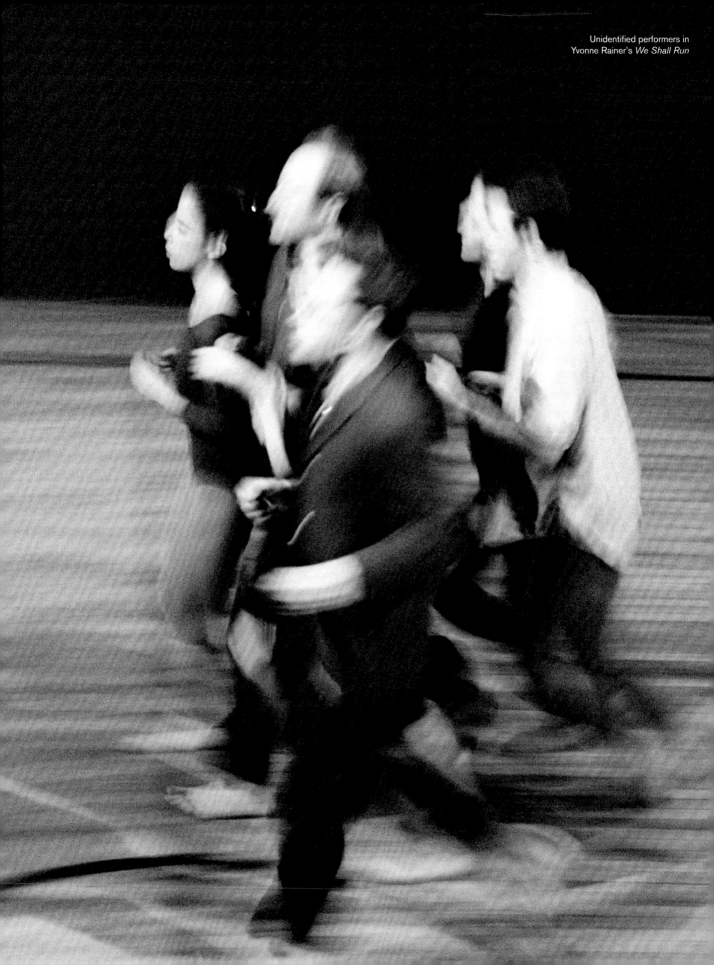

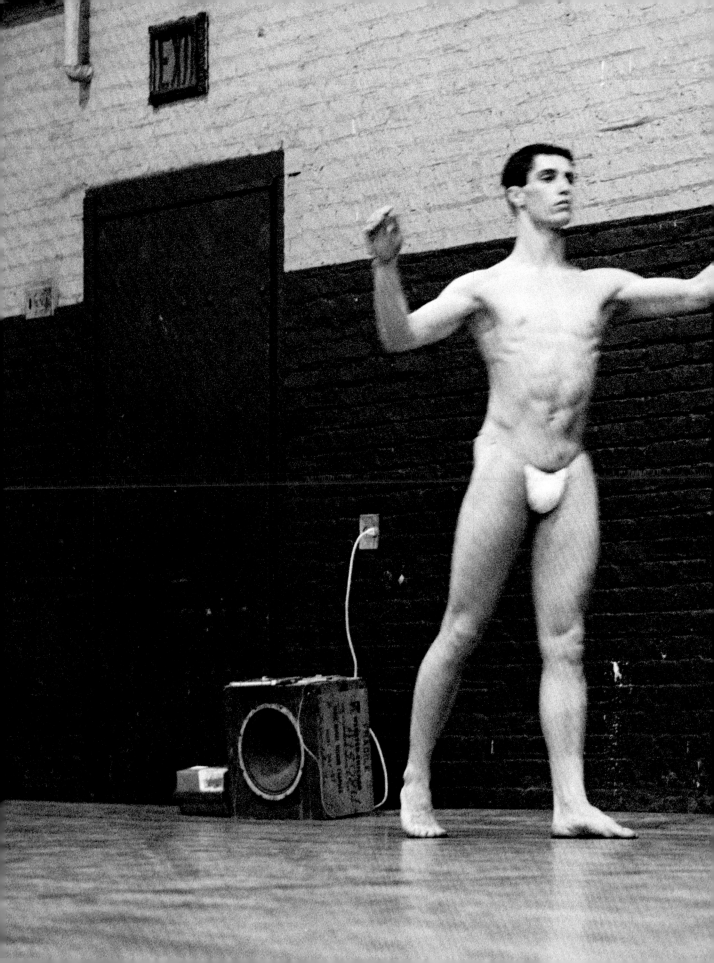

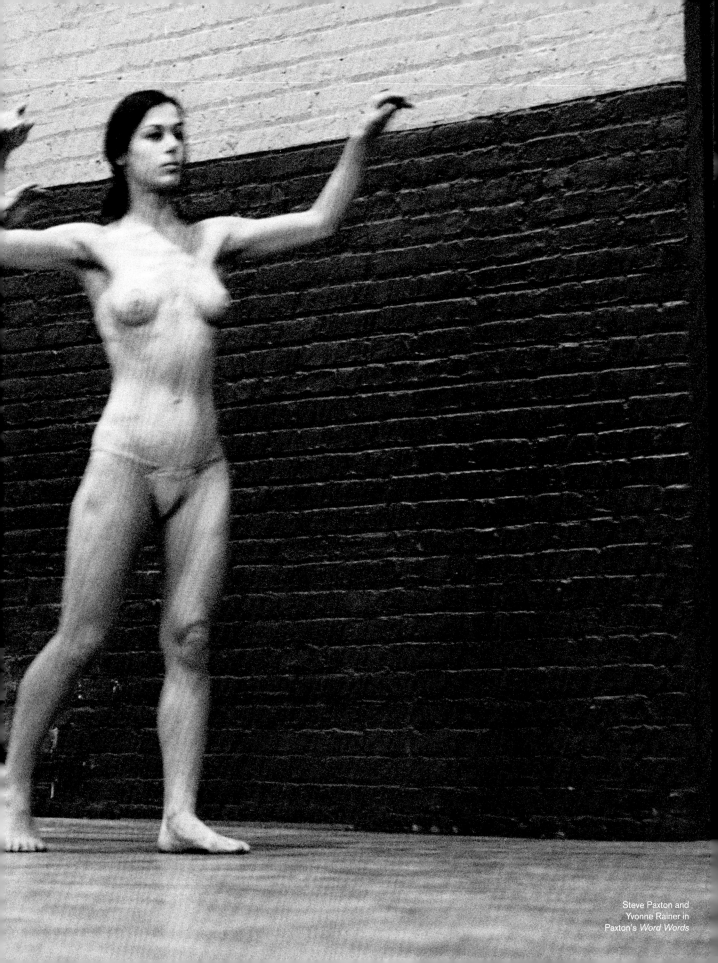

Steve Paxton and
Yvonne Rainer in
Paxton's *Word Words*

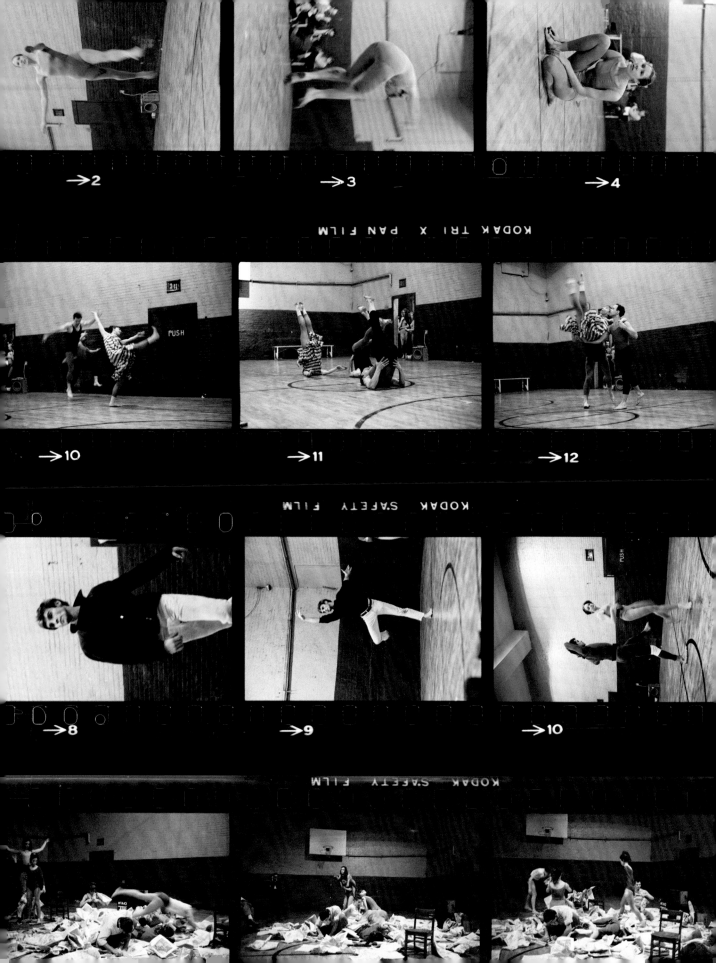

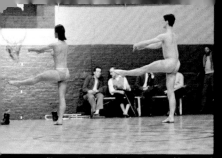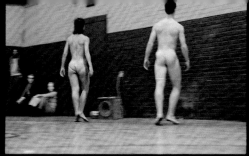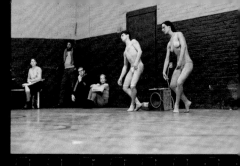

→5 →6 →7

Ruth Emerson in her *Giraffe*; Steve Paxton and Yvonne Rainer in Paxton's *Word Words*

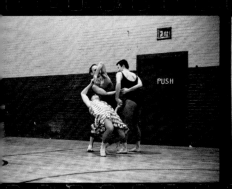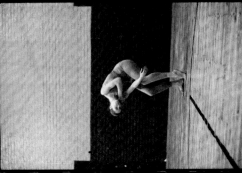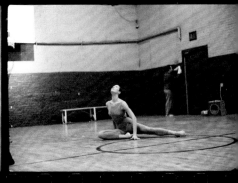

→13 →14 →15

Elaine Summers, John Worden, and Rudy Perez in *Summers's Suite*; Carol Scothorn in her *The Lazarite*

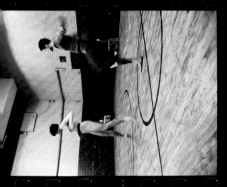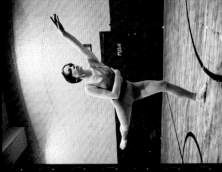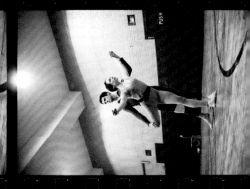

→11 →12 →13

Fred Herko in his *Little Gym Dance before the Wall for Dorothy*; William Davis and Barbara Dilley in Davis's *Field*
Below: Carolee Schneemann and performers in Schneemann's *Newspaper Event*

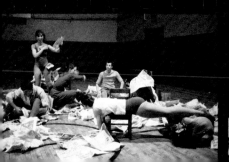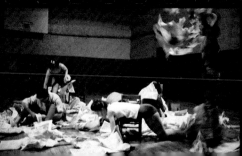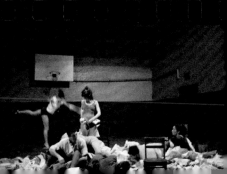

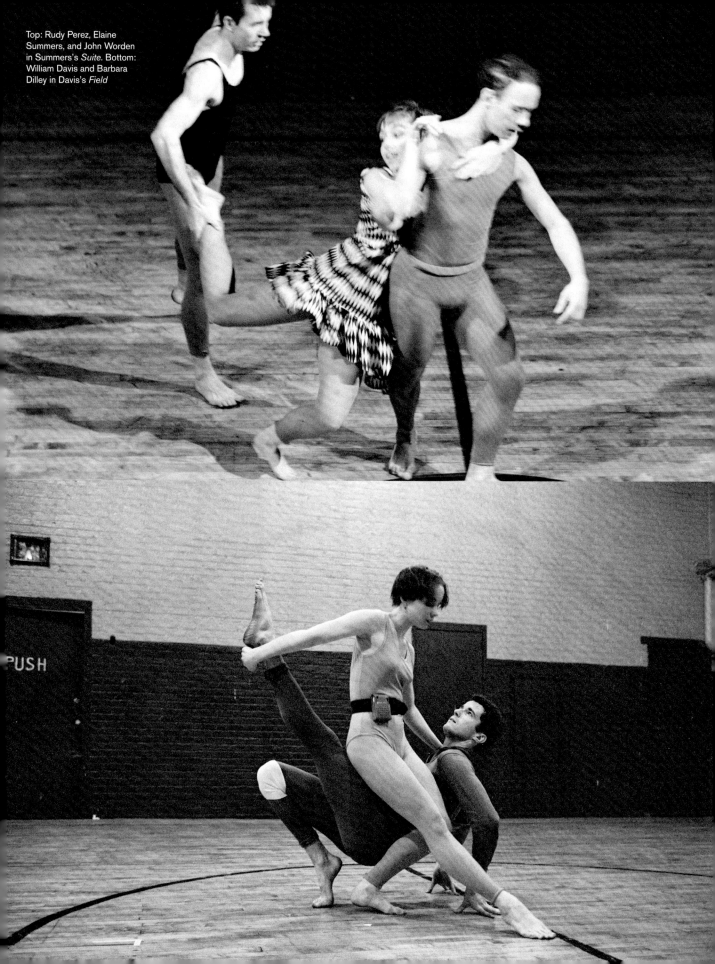

Top: Rudy Perez, Elaine Summers, and John Worden in Summers's *Suite*. Bottom: William Davis and Barbara Dilley in Davis's *Field*

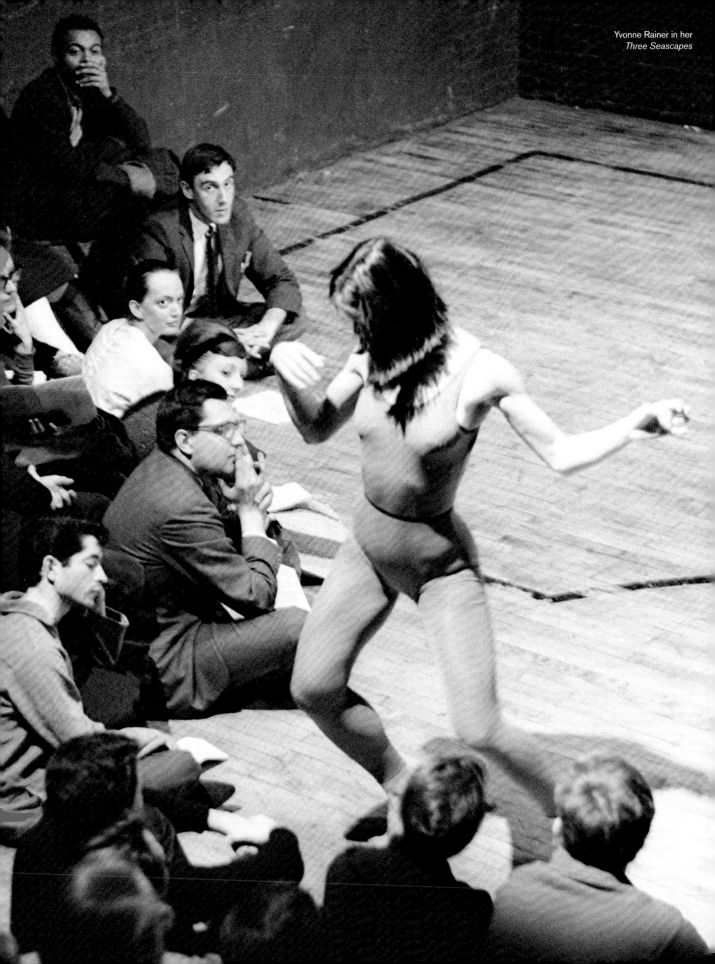

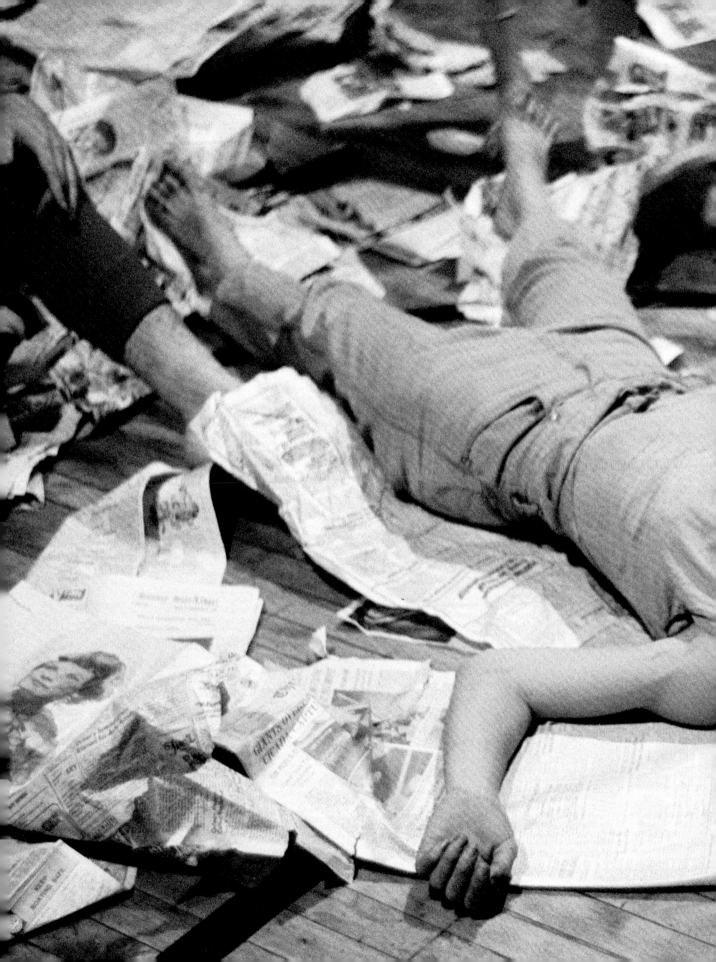

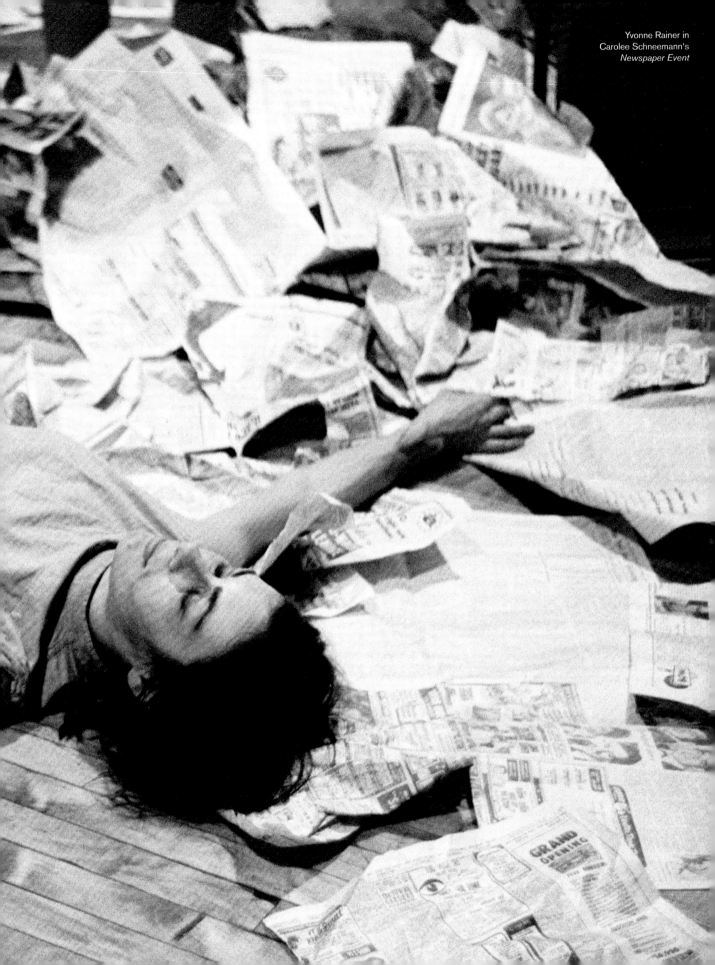

The program for Concert of Dance #13 described it as a "collaborative event" involving thirty performers in a series of energetic cooperative exercises and performances.[1] The evening, which took place in the church's vast sanctuary, was organized around an environment built especially for the concert by sculptor Charles Ross. The structure's central element, a giant, lopsided trapezoid, was composed of welded metal pieces that Ross had transported from California in his yellow van and bolted together in New York. The space also featured an eight-foot-tall suspended platform made of wooden planks, a seesaw, and sundry materials such as ropes, tires, ladders, slabs of sheet metal, chairs, mats, and brooms. Each of the concert's twelve distinct dances melded into the next, with open-ended performances by composer Philip Corner and artist Carolee Schneemann filling in the gaps between works. These intermittent spaces were also replaced by "free-play" sessions, wherein the evening's performers activated the various components of the surrounding environment and the broad range of available props. Aerial images taken by Judson documentarian Peter Moore from the balcony highlight the degree to which the performances occupied the entirety of the sanctuary. The photographs' blurred faces and limbs capture the evening's kinetic force.

The trapezoid, which was physically impossible to maneuver without at least three people, necessarily encouraged cooperation and exaggerated movements on the part of the dancers. It simultaneously imbued the evening with a sense of cohesion and showcased the broad range of manners that could be used to interact with it. Ruth Emerson, who had grown impatient with the general trepidation toward the trapezoid, performed a nimble, swinging gymnastic exercise along the full scale of the structure. In Carla Blank's Turnover, eight women collaborated to flip the unwieldy structure, a task later characterized by Yvonne Rainer as "politically significant" for its defiance of gender norms.[2] Alex Hay, meanwhile, conveyed his discomfort via a humorous, awkward choreography. As he climbed the structure with a pillow-padded stomach against the pipes, an audio track repeated variants of "Are you comfortable? This is not very comfortable." In Joan Baker's Ritual, performers took turns climbing to the top of the structure and purposefully flinging themselves to the ground, while the remaining dancers, wearing tie-dyed yarmulkes, chanted and rocked.

Some performances playfully mirrored children's games. Ross and Rainer's Room Service involved three "follow-the-leader" teams who moved the ladders, tires, and other objects while climbing and jumping around the space. In Deborah Hay's Would They or Wouldn't They?, the men assisted the women as they dangled from the iron bars in a way that recalled children at the playground. Schneemann's Lateral Splay required running at full speed until colliding with an obstacle. The free-play sessions included tug-of-war and tire swinging.

Toward the end of the concert, Ross and musical historian Felix Acppli assembled a towering structure of various chairs held together by sheer gravitational magic, filling the wooden platform. The evening concluded with Lucinda Childs's Egg Deal. With the aid of one of the nearby chairs, Childs used ropes to suspend large, empty egg boxes from the trapezoid at varying heights and directed performers to stack, toss, and kick the boxes. The performance, a meditative comedown, calmed the evening's otherwise frenetic pulse. —VAC

Notes
1. Program for Concert of Dance #13, Judson Memorial Church Archive, MSS 094, 3;31, Fales Library & Special Collections, New York University Libraries.
2. Yvonne Rainer, oral history interview conducted by Ana Janevski and Thomas J. Lax, Department of Media and Performance Art, The Museum of Modern Art, New York, February 26, 2018.

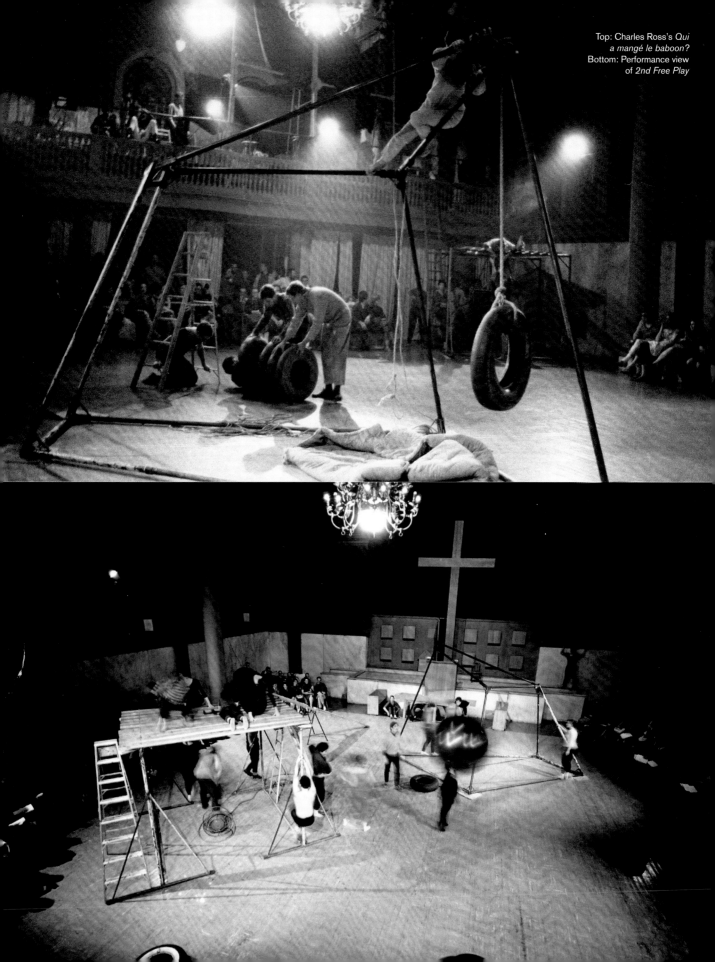

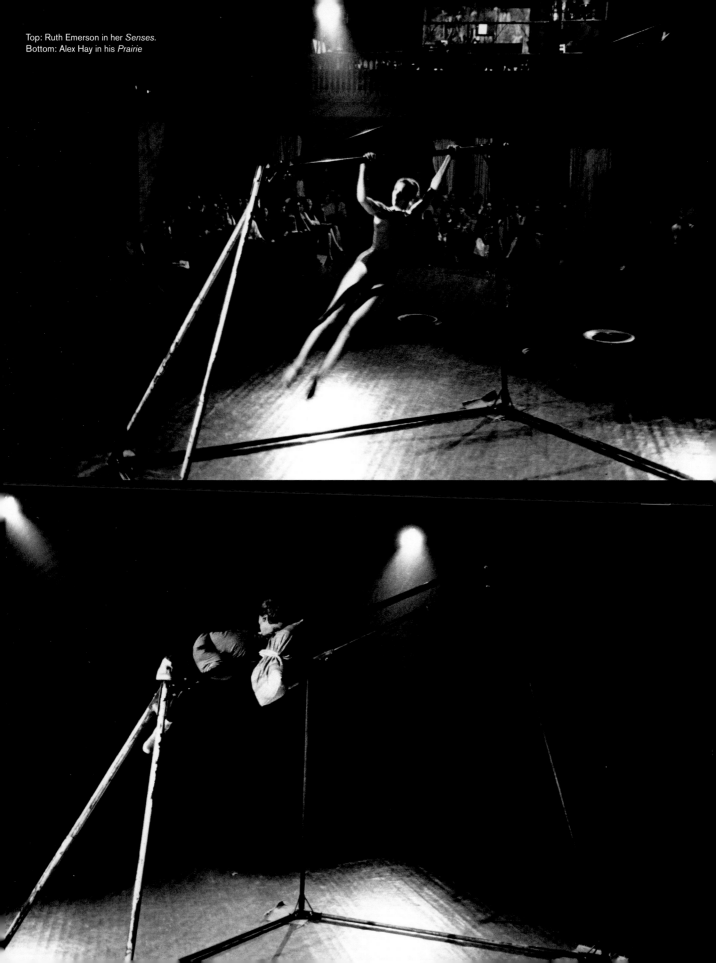

Top: Ruth Emerson in her *Senses.*
Bottom: Alex Hay in his *Prairie*

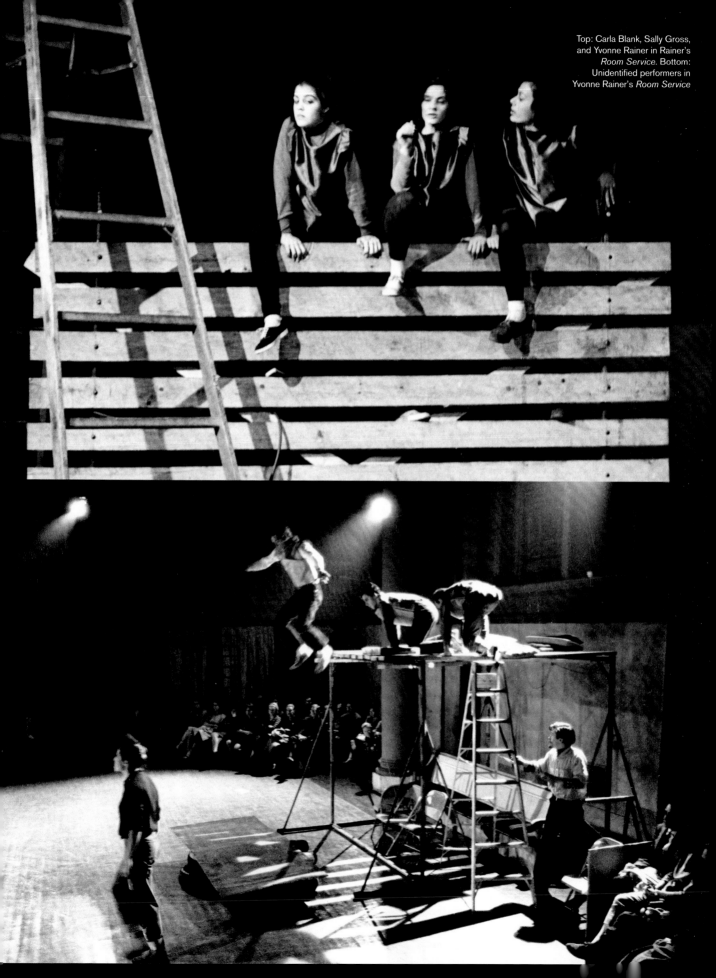

Top: Carla Blank, Sally Gross, and Yvonne Rainer in Rainer's *Room Service*. Bottom: Unidentified performers in Yvonne Rainer's *Room Service*

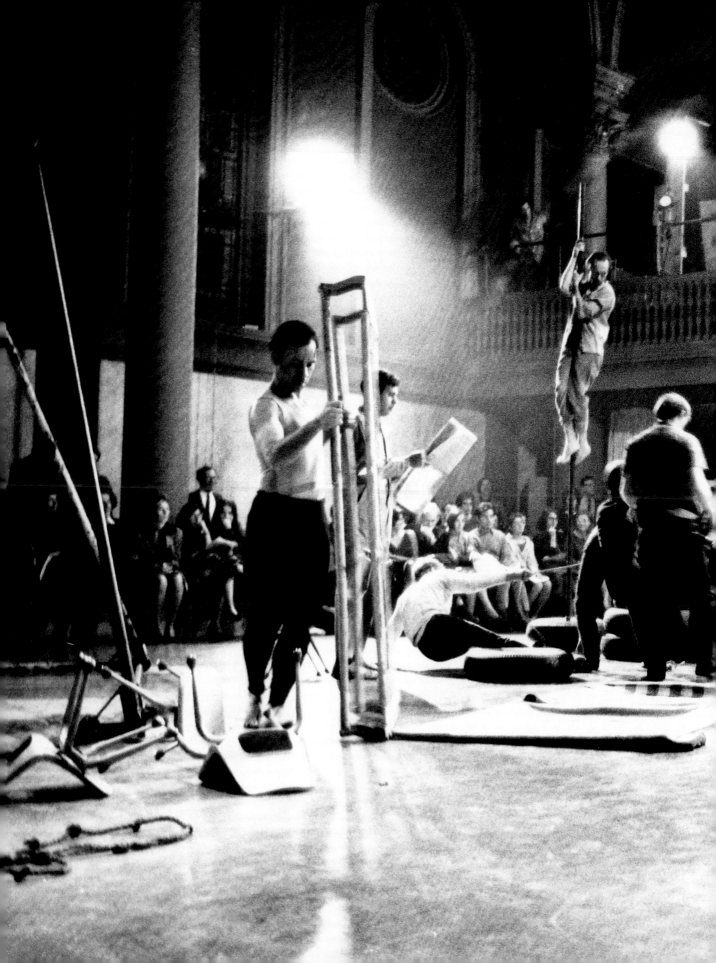

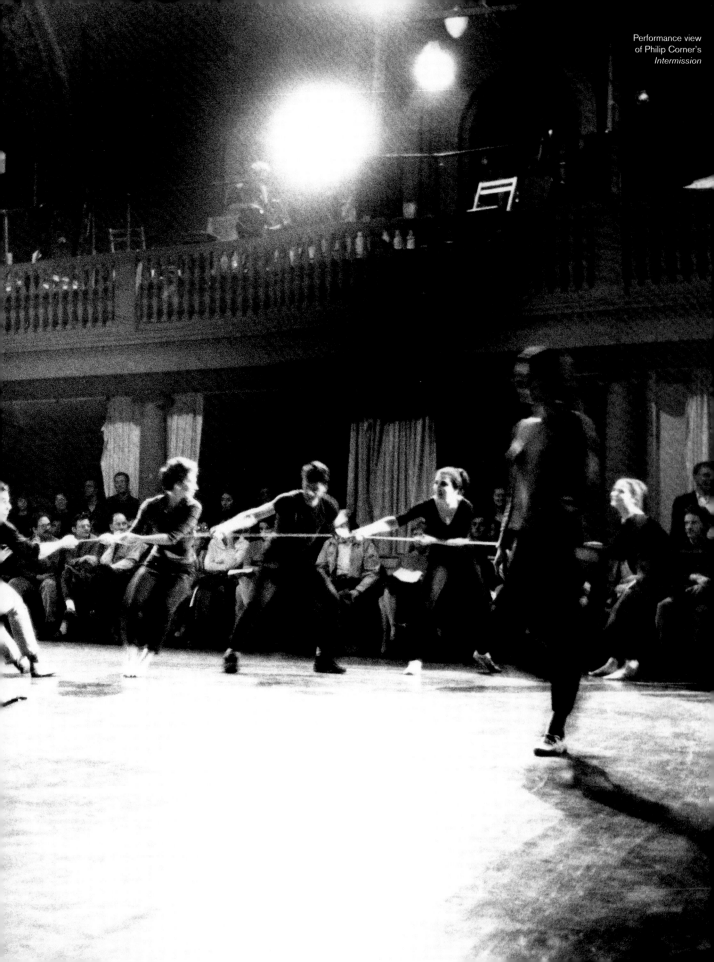

Performance view
of Philip Corner's
Intermission

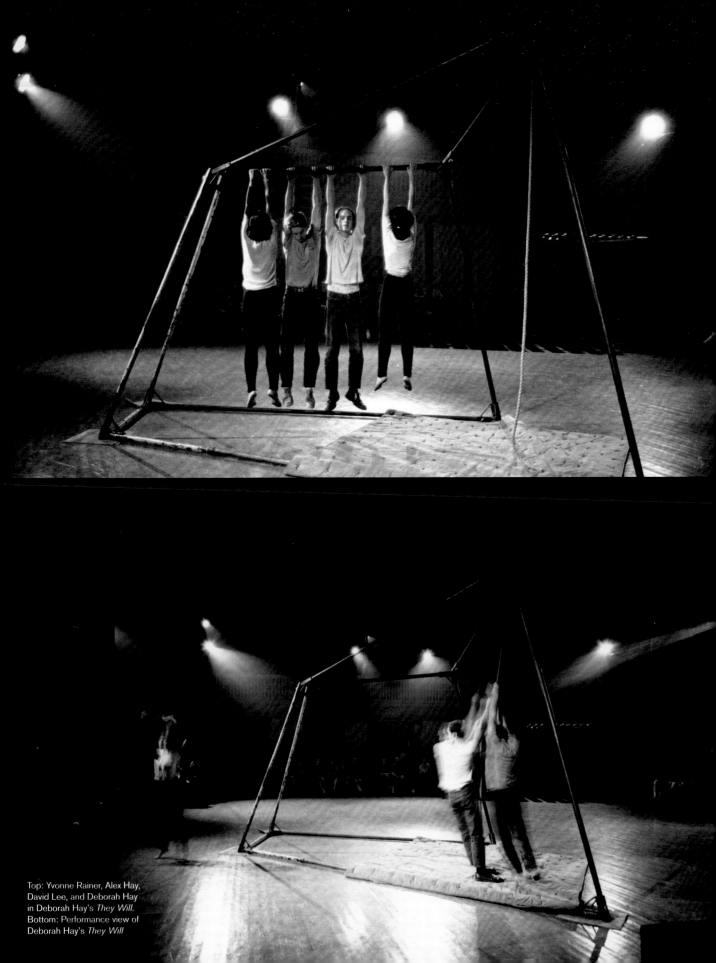

Top: Yvonne Rainer, Alex Hay, David Lee, and Deborah Hay in Deborah Hay's *They Will*. Bottom: Performance view of Deborah Hay's *They Will*

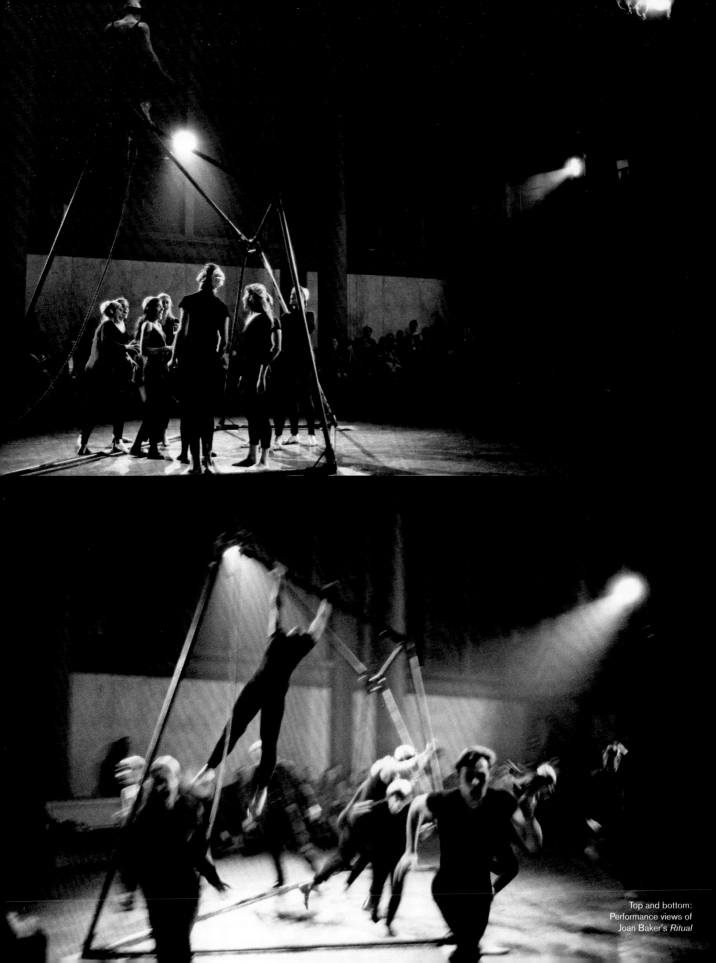

Top and bottom:
Performance views of
Joan Baker's *Ritual*

Performance view of Carolee
Schneemann's *Lateral Splay*

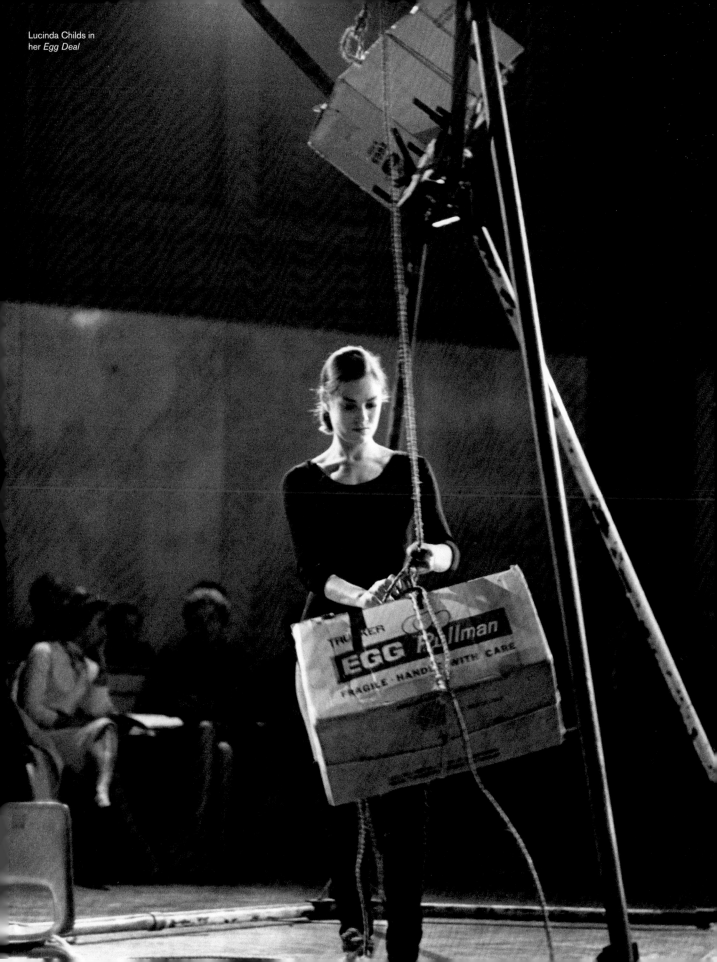

Lucinda Childs in
her *Egg Deal*

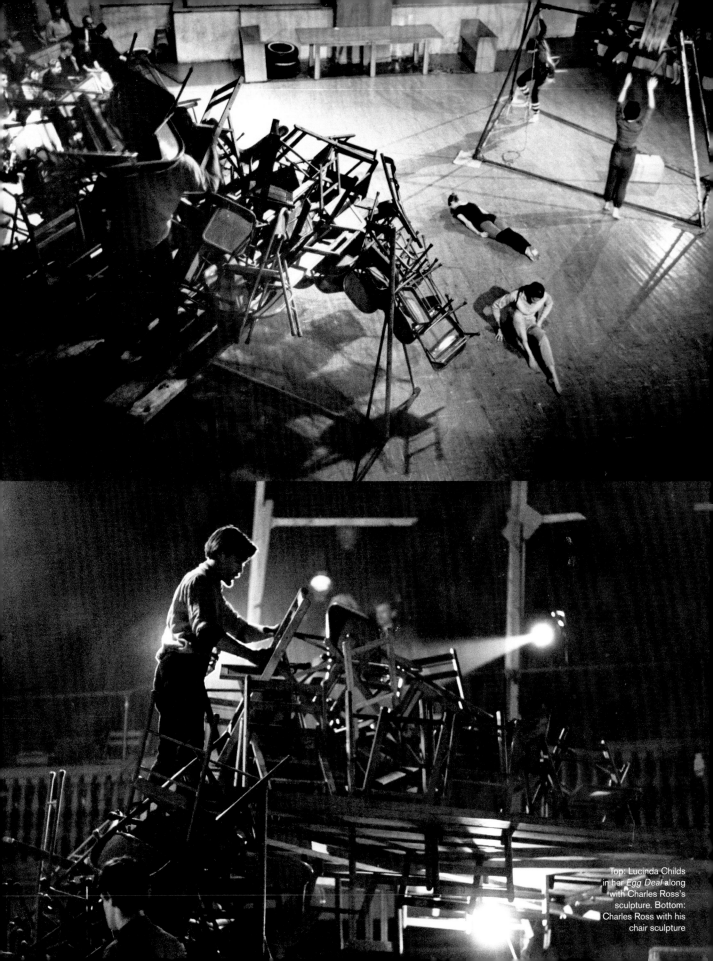

Top: Lucinda Childs in her *Egg Deal* along with Charles Ross's sculpture. Bottom: Charles Ross with his chair sculpture

I like where history sits.
In a pile of papers, a collection of clippings, a group of photos laid out on a contact sheet.
In a folder.
In a box.

Of course this describes an old-school archive. The kind you have to go to, or, on occasion, the kind that is unloaded on you because you've offered to care for it in the neighborly way that we do as coworkers or kin.

Depending on the status of the archive—whether the depositors had means to care for the materials, whether the archivists have resources to maintain that care, whether or how the materials are contested or fought over—documents, folders, and boxes exist in various states of legibility. They are sometimes a mess with loose organizational categories, misidentifications, and big leaps across time or place. Sometimes the materials are well labeled with dates, places, events, authors, photographers, and the people pictured identified.

No matter the condition, the unruliness of the materials is never fully tamed.

In the piles, folders, and boxes, various words, images, names, dates, objects, actions, narratives, people, bodies, and notes comingle—clarifying and confusing each other.

In her introduction to *Work 1961–73*, Yvonne Rainer compares the task of translating performance into book form to that undertaken by an amateur archeologist: "Not only did we have to deal with shards (the actual objects with which my work abounds), papyri (program notes, published texts, and literary material used in the work) and hieroglyphics (the notebooks, which, in their fastidious verbal renderings of movement, so seductively create the illusion of documentation), but with those mysterious and inscrutable petroglyphs left by the visual historian of our age, the photographer."

That she calls photographs of her own work "mysterious and inscrutable" offers the rest of us forgiveness for our inability to understand what we are looking at when we look at images of performance.

It may seem strange to assert the inscrutability of these photographs, since they so often come with clear identifications, particularly those that make up the broad collection of images taken of the artists, choreographers, dancers, poets, musicians, and activists working in and around Judson Memorial Church in the early 1960s.

These photographs are named and described with such specificity that it is easy to think they tell the history of the performance they document. But photographs of performance never perfectly represent the performance. They may resemble it, but they crop out as much as they make visible and render some aspects central while excluding whole realms of sensory experience. They are misleading artifacts, which is also to say they lead us astray. These photographs pull us into other realms of feeling and experience. They steer us away from chronicling

what happened and into lines of flight that carry a mix of desires: to capture bodies, be visited by the dead, mark time, track luminous personalities, remember we weren't there, wish we were; to try to grasp our present moment and where we are going in the future; to experience moments and movements, gestures, fragments, scenes, places, traumas, and ecstatic possibilities.

In the archive, *Village Voice* staff photographer Fred W. McDarrah's images of Fred Herko, performing in Concert of Dance #1 at Judson Church, July 6, 1962, sit alongside his photos of Charles Mingus playing a month later at the Five Spot Café; of David Hilliard, Black Panther Party chief of staff, speaking at a political rally in New Haven, Connecticut, May 1, 1970; of Allen Ginsberg, LeRoi Jones, Diane di Prima, and others at Cedar Street Tavern and the Artist's Studio; of gay liberationists such as Marsha P. Johnson, Jill Johnston, or Craig Rodwell outside the Stonewall Inn or the Oscar Wilde Memorial Bookshop or in Central Park or at the Gay Activists Alliance Firehouse.

McDarrah moved to Greenwich Village after returning from World War II and began photographing artists at the Greenwich Village Art Show. He followed this social thread into spaces like Cedar Tavern and the Poetry Center at the 92nd Street YM-YWHA where his intellectual and artistic worlds expanded. McDarrah's photographs had both public and personal audiences. They were distributed through the newspaper, printed as gifts, and published in books he edited with his wife, Gloria. Throughout the early 1960s, Peter Moore and his wife, Barbara, attended Judson events at the gallery, the Hall of Issues (where community members aired social and political concerns), and the Poets' Theater. They collaborated on an article for *Mademoiselle* that featured the Judson community and its drug-counseling program. From there, they began attending Judson Dance Theater performances—Peter with his camera in tow.

These four were part of a group of artists and photojournalists who were moved by various impulses, not all of which were clear, to take pictures from inside the worlds they found themselves in.

The photographs by McDarrah, Hugh Bell, Roy DeCarava, Moore, Al Giese, and Robert McElroy make obvious that these image makers were part of the histories they captured. They were participant witnesses engaged in the impossible task of picturing moments that exceeded themselves; of recording in stillness events, concerts, and collectives that roused feelings, moods, sounds, movements.

The stories of these "visual historians" might be best understood from their contact sheets and their archives (remarkably cared for by partners/collaborators, including Gloria, Mary Hottelet Giese, Barbara, and Sherry Turner DeCarava). The clarifying confusion of these collections brings us into contact with a time that was not singular; with bodies that aged; with people whose aesthetic, social, political, and emotional relationships transformed, often rapidly. It brings us into places that closed down, burned up, were taken apart, carried on, and certainly were never isolated—not even from us.

114 SITES OF COLLABORATION

**SELECTION OF ANNOTATED WORKS
IN CHRONOLOGICAL ORDER**

118 Lawrence and Anna Halprin, the Dance Deck

120 Anna Halprin, *The Branch*

122 James Waring, *Dances before the Wall*

124 Merce Cunningham, *Antic Meet*

126 John Cage, "Fontana Mix"

128 Allan Kaprow, *18 Happenings in 6 Parts*

130 Jim Dine and Claes Oldenburg, *Ray Gun Spex*

132 La Monte Young, Compositions 1960, #2–5

134 Robert Whitman, *American Moon*

136 Simone Forti, Dance Constructions

138 Cecil Taylor, "Mixed" from Gil Evans's *Into the Hot*

140 Aileen Passloff, *Strelitzia*

142 Ruth Emerson, *Narrative, Giraffe, Sense*

144 Steve Paxton, *Word Words, Jag vill gärna telefonera*

146 David Gordon, *Mannequin Dance, Random Breakfast*

148 Trisha Brown, *Trillium, Lightfall*

150 Rudy Perez, *Take Your Alligator with You*

152 Andy Warhol, *Jill and Freddy Dancing*

154 Fred Herko, *Binghamton Birdie*

156 Yvonne Rainer, *Terrain, We Shall Run, Parts of Some Sextets*

158 Robert Morris, *Arizona, Site*

160 Philip Corner, "Flares"

162 Deborah Hay, *They Will* (then titled *Would They or Wouldn't They?*)

164 Judith Dunn, *Motorcycle*

166 Carolee Schneemann, *Banana Hands, Newspaper Event, Meat Joy*

168 Bill Dixon, *Dew Horse, Pomegranate*

170 Lucinda Childs, *Street Dance*

172 Alex Hay, *Leadville, Colorado Plateau*

174 Elaine Summers, *Judson Fragments*

176 Gene Friedman, *3 Dances*

178 Storm de Hirsch, *Newsreel: Jonas in the Brig*

180 Robert Rauschenberg, *Pelican, Sleep for Yvonne Rainer, Spring Training*

182 Stan VanDerBeek, *Site, Dances/Bob Rauschenberg (81st St. Theatre Rally)*

184 Jill Johnston, *Marmalade Me*

186 **JUDSON DANCE THEATER PARTICIPANTS**

1. Judson Poets' Theater, 55 Washington Square South
2. Reuben Gallery, 61 Fourth Avenue
3. The *Village Voice*, 22 Greenwich Avenue
4. The Living Theatre, 530 Sixth Avenue
5. The Film-Makers' Cinematheque and
Film-Makers' Cooperative, 80 Wooster Street
6. Judson Memorial Church, 55 Washington Square South
7. Merce Cunningham Studio, 530 Sixth Avenue
8. Chambers Street Loft Series, 112 Chambers Street
9. Judson Gallery, 55 Washington Square South
10. The Five Spot Café, 5 Cooper Square
11. Joint Emergency Committee to Close Washington
Square Park to Traffic, Washington Square Park
12. The *Floating Bear*, 309 East Houston Street

1. Judson Poets' Theater

In November 1961, Judson's high-spirited minister, Al Carmines—also a composer, actor, vocalist, and accompanist—initiated Judson Poets' Theater to host works of experimental theater for which no other venue existed. It was part of a range of new approaches to theater that included spaces such as Caffe Cino and La MaMa Experimental Theatre Club, which emerged as a reaction against the commercialism and professionalism of Broadway and off-Broadway

theaters. Joel Oppenheimer's *The Great American Desert*, in which three desperados—a con man, a murderer, and a gay man—roam about the American West, launched the theater's first season.

Among the most notable performances that took place there were plays by Gertrude Stein set to music by Carmines and directed in-house by Larry Kornfeld. *In Circles*, for example, was adapted by Carmines from Stein's *A Circular Play: A Play in Circles*, a collection of short texts published in 1920. Carmines created the production by pairing compositions as varied as the barbershop quartet, ragtime, and opera. The theater also introduced musicals with scores written by Carmines; *Home Movies*, for example, which featured Fred Herko, interwove narratives of a dysfunctional family. Many of these productions were critically acclaimed and

some even became commercial productions. The theater continued producing plays under Carmines's guidance until in 1982 the effects of an aneurysm took their toll on the pastor and forced him to resign from the church. Although the church continued to put on the occasional production, the heyday of Judson Poets' Theater was synonymous with Carmines's passionate commitment. —HC

2. Reuben Gallery

In 1959, Anita Reuben opened Reuben Gallery at 61 Fourth Avenue to exhibit experimental art practices focused on public events and new media. Reuben asked artist Allan Kaprow to help conceptualize the space based on his involvement with Hansa Gallery, a cooperative he cofounded with former classmates. At Reuben Gallery, Kaprow presented *18 Happenings in 6 Parts* (1959), a set of simultaneous events set in environments built from painted vinyl sheets, wooden panels, and plastic fruits. The evening marked the beginning of Happenings, partially improvised performances and events that engaged

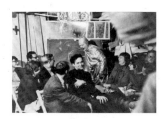

audience participation; in addition to Kaprow, these would be organized by artists such as Richard Maxfield and Al Hansen. Reuben Gallery brought together students and faculty of Rutgers University in New Jersey and students from John Cage's experimental

composition class at the New School in New York. In a 1960 exhibition with Jim Dine and Claes Oldenburg, Simone Forti presented *See Saw* and *Roller Boxes*, the first two performances in her Dance Constructions, which isolated and recontextualized simple, everyday movements.

Despite the impact of these historically significant performances, the gallery's programming was not financially viable. In May 1961, the short-lived gallery closed, although its influence continued throughout the 1960s. —HC

3. The *Village Voice*

The *Village Voice* was founded in 1955 by Dan Wolf, Ed Fancher, and Norman Mailer as

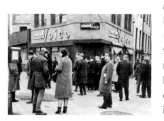

a biweekly newspaper combining news reports, investigative journalism, and coverage of the cultural landscape of New York City. The paper's editorial voice was shaped by the downtown art scene in Greenwich Village, its initial coverage area, and offered a distinctive alternative to mainstream journalism. Jonas Mekas explored the development of the underground film movement as an early columnist, while Jill Johnston served as the dance critic for many years, beginning in 1959. Fred McDarrah began his career there as an ad salesman before becoming its staff photographer. As the newspaper moved away from the two-bedroom apartment that was its first office, its coverage

and influence expanded across New York City, creating a community of readers who waited in line in front of its office in Sheridan Square to purchase the ten-cent newspaper. The *Voice*'s political stance against real estate speculation, its idiosyncratic letters to the editor, and its entertaining personal ads have long shaped the voice of alternative journalism in the United States. —HC

4. The Living Theatre

Actress Judith Malina and painter Julian Beck cofounded the Living Theatre in 1947 to host works of experimental theater, such as *The Brig* by Kenneth H. Brown (1963), as well as rarely produced plays by European playwrights such as Jean Cocteau and Bertolt Brecht. In *The Connection* (1959) by Jack Gelber, a theater crew shoots jazz musicians and people who use heroin as they wait for their dealer. The theater helped initiate the off-Broadway movement in the 1950s by challenging the commercialism of Broadway productions.

In the early 1960s, the Living Theatre was located in the same building as Merce Cunningham's studio; their proximity helped foster a dynamic artistic discourse in downtown New York by connecting visual art, theater, dance, and music. The theater's frequent conflicts with government authorities led to its closure in 1963; thereafter it toured the world, organizing

productions in nontraditional venues such as prisons and steel mills. The company found a temporary home in New York's Lower East Side from 2006 to 2013, and today continues to operate as an itinerant crew, staging productions in various sites across the United States. —HC

5. The Film-Makers' Cinematheque and Film-Makers' Cooperative
In 1962, twenty-two filmmakers including Jonas Mekas, Gregory Markopoulos, and Jack Smith founded the Film-Makers' Cooperative as a membership organization to support and disseminate moving image art. In 1964, Mekas

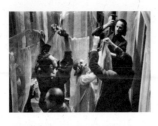

started organizing screenings of avant-garde cinema and community gatherings. These itinerant screenings, presented in varied venues such as City Hall and American Theater for Poets, comprise the Film-Makers' Cinematheque. Artists such as Nam June Paik and Robert Whitman also organized musical events and performances that accompanied the screenings. For brief periods, the Cinematheque found a home at the 41st Street Theater and later at 80 Wooster Street, but frequent confrontations with the police and increasing financial burdens ended the screenings by 1968. In 1970, Mekas, along with P. Adams Sitney, Stan Brakhage, and others, founded Anthology Film Archives as

a permanent location for the exhibition and preservation of moving image works. It has since become one of the most important archives and screening venues of avant-garde cinema, fulfilling Mekas's desire for the proliferation of experimental films. —HC

6. Judson Memorial Church
Judson Memorial Church was founded in 1890 by Edward Judson as a place of worship catering to various immigrant communities in Greenwich Village. Stanford White, the architect behind the Washington Square Arch, designed the building. The church has from its inception actively engaged with social issues, and in the 1960s offered an abortion-referral service and provided medical support for homeless people, drug users, and sex workers. From 1962 to 1979, pastors Bernard (Bud) Scott and Al Carmines facilitated the church's artistic endeavors, hosting Judson Dance Theater, the Judson Gallery, and Judson Poets' Theater. Judson Memorial Church still plays a vital role in its community,

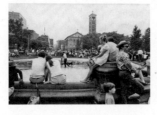

providing a space where religion, art, and social activism converge. —HC

7. Merce Cunningham Studio
From 1959 to 1966, Merce Cunningham's dance studio was located on the top floor of 530 Sixth Avenue, in the

same building as the Living Theatre, before moving to its iconic Westbeth location where it remained until 2012.

Yvonne Rainer, Deborah Hay, and Steve Paxton regularly visited the studio to attend choreography classes with Cunningham and with Robert Dunn, who had been a student of composer John Cage. —HC

8. Chambers Street Loft Series
In 1960, artist Yoko Ono rented a loft on Chambers Street where she began organizing performances, avant-garde concerts, and poetry

readings with composer La Monte Young. Artists such as John Cage, Simone Forti, and Allan Kaprow presented their works in the minimally furnished space, which became a catalyst for the type of artistic experimentation across music, dance, and performance that would later define the Fluxus movement. —HC

9. The Judson Gallery
In 1958, artists Eva Hesse, Tom Wesselmann, and Marcus Ratliff cleared out the

basement of Judson Memorial Church and created artist studios that also doubled as housing. The following January, the space became the Judson Gallery, one of the first gathering places in New York for a new generation of artists dissatisfied with the concerns of Abstract Expressionism. Along with Anita Reuben's Reuben Gallery and Red Grooms's Delancey Street Museum, the Judson Gallery became a meeting place for artists mak-

ing work beyond the canvas— what would soon become known as Happenings. In this space Jim Dine made *The House* and Claes Oldenburg made *The Street*, both from 1960; these performance-oriented works used detritus found in the streets of the surrounding neighborhood. Although these artists soon began presenting work in a more traditional gallery setting, Judson helped evolve Happenings. —EG

10. The Five Spot Café
The Five Spot Café was a jazz club owned by brothers Joe and Iggy Termini. The humble, unassuming room, with a maximum capacity of seventy-five, was active from 1956 to 1962 at its original Cooper Square location and from 1963 to 1967 at its address on St. Marks Place. The Five Spot served as the center of modern jazz in New York as well as a gathering place for

bohemians, including Willem de Kooning and Franz Kline.

As its first major engagement, the Five Spot hired experimental pianist Cecil Taylor for a six-week residency; other groundbreaking musicians such as Ornette Coleman, John Coltrane, Bill Dixon, Eric Dolphy, and Thelonious Monk would soon follow. These figures pioneered free jazz, which emphasized collective improvisation. The musical approach of this black avant-garde found an affinity with the ethos of the largely white experimental performance scene, leading to Taylor's and Dixon's collaborations with members of Judson Dance Theater.

Such collaborations, however, were not common: in the 1960s, white and black artists largely performed in separate spaces. Moreover, black artists had access to far fewer resources than white

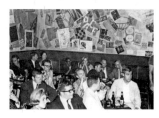

artists, including infrastructure and institutional support.

Despite its popularity, the Five Spot faced ongoing licensing obstacles, unremitting pressure from the police, and consistent unprofitability, and was eventually forced to shut down. —VL

11. Joint Emergency Committee to Close Washington Square Park to Traffic

The Joint Emergency Committee to Close Washington Square Park

to Traffic (JEC) was a grass-roots organization formed to protest plans for additional traffic in one of Greenwich Village's few open public spaces: Washington Square Park. In 1952, public official

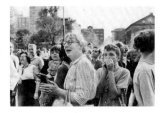

Robert Moses revealed his proposal to expand the park's narrow pathway into a forty-eight-foot-wide highway for high-speed traffic. In response, Village residents Shirley Hayes and Edith Lyons founded the Washington Square Park Committee, later retitled the JEC. The committee initiated petitions and letter-writing campaigns that successfully cultivated the support of politicians. Eventually, the city agreed to a trial closing of the park to vehicles, which was implemented in 1958 and extended indefinitely a year later.

In resonance with the collectivist spirit of Judson, whose headquarters were located directly across the street from the park, the JEC brought together various community groups into a coalition. These included writer Jane Jacobs, who debuted there as an activist. In her influential 1961 book, *The Death and Life of Great American Cities*, Jacobs advocates for a populist approach to urban planning, declaring that "cities have the capability of providing something for everybody, only because, and only when, they are created by everybody." —VL

12. The *Floating Bear*

The *Floating Bear* (1961–69) was a free literary newsletter distributed to a private mailing list of about three hundred readers. Coedited by LeRoi Jones and Diane di Prima, the *Floating Bear* mainly featured new literary work by "out-of-the-way and unpublished poets," as well as by countercultural figures including William S. Burroughs, Allen Ginsberg, Frank O'Hara. The newsletter carried reviews of music, art, theater, and dance, covering events such as Judson's Concert of Dance #1.

The *Floating Bear*'s spare, mimeographed pages and straightforward, typewritten layout precluded graphics, columns, or advertisements. The *Floating Bear* was able to streamline its publishing process and produce issues at high frequency, fostering direct communication among its writers and readers. Collaborations, conflicts, and gossip permeated into and resulted from the newsletter's candid reviews and chains of impassioned letters.

Di Prima's apartment at 309 East Houston Street (and later 229 East Fourth Street) served as the newsletter's headquarters and a social locus. Downtown New York artists and writers bonded as they spent marathon weekends

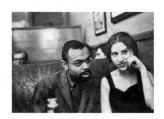

compiling and distributing each issue; some of these artists, such as Fred Herko and Cecil Taylor, would collaborate after being introduced there. —VL

Lawrence and Anna Halprin's Dance Deck, 1954
Designed by Lawrence Halprin and Arch Lauterer

In 1954, landscape architect Lawrence Halprin (1916–2009) and choreographer Anna Halprin (born 1920) built an outdoor deck for dancing behind their family home in Kentfield, California. Adjacent to their house on the slopes of Mount Tamalpais, the deck inspired experimentation in their respective fields of work and reframed their relationships to both the natural environment and family life. Lawrence worked with theater designer Arch Lauterer (1904–1958) to create this redwood outdoor dance studio. Lauterer, known predominantly for his stage sets and lighting design, was a professor of drama and theater at Mills College, in Oakland, California, and worked on productions for choreographers Martha Graham and Merce Cunningham, among others. Lawrence and Lauterer's many-sided polygon reaches into the forest, breaking from the traditional rectilinear proscenium. Initially, the deck included several holes in the flooring for trees to grow up and out of it. "[The deck] did not become an object in the landscape," Lawrence explained. "It became part of the landscape and that is very different. The fact of its free form, which moves around responding to the trees and to the mountain views and other things, has been a premise of mine ever since."[1] Its unusual geometry echoes that of the house above designed by the architectural firm Wurster, Bernardi and Emmons, visually linking the Halprin home and deck.

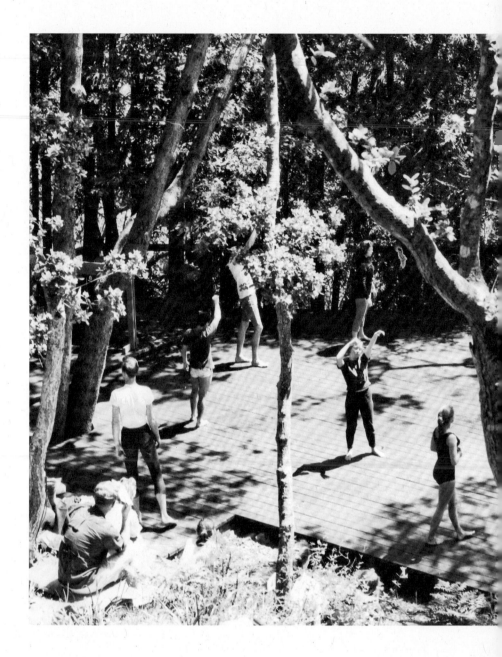

Notes
1. Janice Ross, *Anna Halprin: Experience as Dance* (Berkeley: University of California Press, 2007), 104.
2. Janice Ross, "Atomizing Cause and Effect: Ann Halprin's 1960s Summer Dance Workshops," *Art Journal* 8, no. 2 (Summer 2009): 68.
3. Anna's biographer, Janice Ross, points out that this tension was particularly palpable for the artist. See Ross, *Anna Halprin*, 103.

Inspired by the Bauhaus architects' interest in interdisciplinary learning, the Halprins created the deck equally as a site for performance and for educational activities, with one side featuring benches built into the hill to serve as seating. The Dance Deck's pared-down functionality exemplifies Lawrence's integration of nature and design to better the social conditions of daily life, as in his garden plans from the 1950s or in his St. Francis Square, a racially integrated residential community in San Francisco. Designed by Lawrence in collaboration with architectural firm Marquis and Stoller and completed in 1963, the community's cooperative housing, school, and recreational buildings were deliberately organized around a park.

The proximity of the Dance Deck to the Halprin home created an environment in which professional artistic life and family life were inextricably linked. In the late 1940s, Anna shared a studio in downtown San Francisco with dancer Welland Lathrop, which they used for their choreographic work and teaching. By the early 1950s, Anna, now the mother of two small children, would continue teaching by moving her studio closer to home. Works such as *Birds of America or Gardens without Walls* (1957) prominently featured her young daughters as performers.[2] The deck grew into both studio and home, reframing the tension between Anna's various roles as working teacher, choreographer, and mother.[3] The Dance Deck would become Lawrence and Anna's greatest collaboration. —MJ

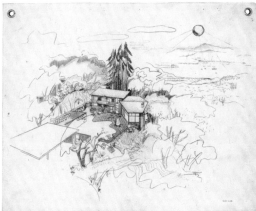

Above: Lawrence Halprin's photograph of choreographer John Graham teaching a workshop on the Halprin family's Dance Deck, c. 1960. Right: Lawrence Halprin's drawing of a bird's-eye perspective of the Halprin house and garden, c. 1951

119

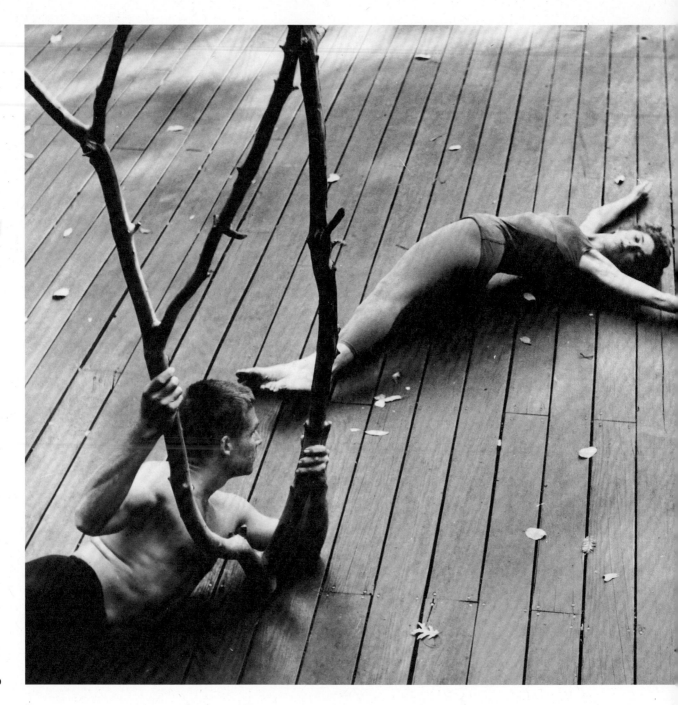

Warner Jepson's photograph
of A. A. Leath, Anna Halprin,
and Simone Forti (from left) in
The Branch, 1957. Performed
on the Halprin family's Dance
Deck (1954), Kentfield,
California, 1957

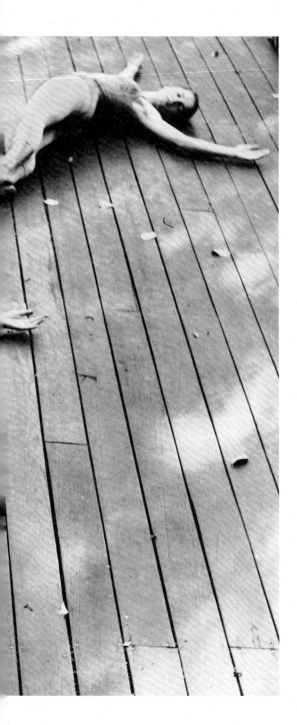

Anna Halprin
The Branch, 1957

Anna Halprin's *The Branch* joins improvisation-based movement with the natural world through both setting and prop: the setting is Halprin's Dance Deck, nestled among the redwood, madrone, and oak trees on the slopes of Mount Tamalpais in California; the prop, an oversized madrone branch roughly as tall as the human body. Photographs taken by electronic music composer Warner Jepson—who also provided the accompaniment, an electronic composition made from recordings on the Dance Deck—show Halprin (born 1920) with dancers Simone Forti and A. A. Leath wearing tights and leotards and engaging with a branch; they hold, drag, and mimic their prop, using it as a prompt for movement. Forti, who studied with Halprin from 1955 to 1959, later recalled the importance of nature in Halprin's teaching method: "She taught the process of going into the woods and observing something for a period of time, and then coming back and somehow working from those impressions."[1] Halprin created this work before she started making written scores, but her scoring practice would develop soon after, coalescing during her summer workshop in 1960 and formalizing in the late 1960s with the RSVP Cycles.

Halprin would continue to use humble materials in this way in her later works. In *Paper Dance*, from Halprin's groundbreaking performance *Parades and Changes* (c. 1965) for example, dancers crinkled, tore, and rolled around in long sheets of brown paper. For Halprin, these mundane objects served no narrative or psychological function, as they do in the work of modernist choreographer Martha Graham, which Halprin had first encountered in Vermont in 1937, at a summer workshop at Bennington College.[2] Rather, with these objects, Halprin introduced into her choreography everyday tasks and ordinary movements. The separation of gesture from narrative and storytelling would be one of Halprin's great contributions to the history of dance.

The Branch exemplifies Halprin's approach to task-based improvisation that begins with the body. In the 1930s, Halprin studied at University of Wisconsin in Madison with pioneering dance educator and former gym teacher Margaret H'Doubler, whose method for teaching dance stemmed from her interest in athletics and encouraged exploration through simple motions, such as running or jumping. In the mid-1950s, Halprin returned to this kind of kinesthetic improvisation as a way to explore unconventional forms of movement.[3] In her work as both artist and teacher, Halprin's process began from individual bodily investigation and improvisation rather than from prescribed actions. Improvisation and use of materials from the natural world would influence the Judson artists who participated in Halprin's 1960 summer workshop. —MJ

121

Notes
1. Forti quoted in Janice Ross, *Anna Halprin: Experience as Dance* (Berkeley: University of California Press, 2007), 126. Halprin writes about the importance of nature in relationship to form in the program notes for an evening of performance on the deck on June 18, 1960. Echoing the words of John Cage, she remarks that she is interested not in work that mimics nature but that is naturalistic in its "manner of operation." See her "Program Notes of June 18, 1960," Anna Halprin Papers, 5;44, Museum of Performance and Design, San Francisco.
2. Libby Worth and Helen Poynor, *Anna Halprin* (London: Routledge, 2004), 3.
3. Joyce Morgenroth, *Speaking of Dance: Twelve Contemporary Choreographers on Their Craft* (New York: Routledge, 2004), 26.

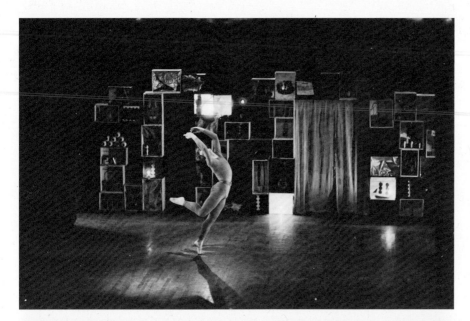

Above top and bottom: Vincent Warren or Fred Herko (top) and Toby Armour, Sallie Bramlette, and Valda Setterfield (bottom, from left) in *Dances before the Wall*, Henry Street Playhouse, 1958. Photographer unknown. Opposite: James Waring. *Untitled*, 1959

James Waring
Dances before the Wall, 1958

James Waring's *Dances before the Wall*, "an evening-length choreographic suite for ten dancers,"[1] comprised twenty-two sections of solos, duets, and quintets featuring Waring (1922–1975) alongside formally trained dancers Toby Armour and Vincent Warren, as well as future Judson Dance Theater participants David Gordon, Fred Herko, and Valda Setterfield (the latter two of whom were also formally trained). Waring's choreography combined technically demanding balletic movements with emerging modern dance strategies and "'nondance'" actions.[2] In one section, Gordon rubbed his thighs very slowly twenty-one times while kneeling on the floor.[3] The titular wall, designed by Living Theatre cofounder Julian Beck, was made up of clustered, differently sized wooden boxes surrounding a curtained doorway and adorned with light bulbs, frying pans, a radio, a telephone, a bugle, candlesticks, paintings, books, and other ephemera. The lighting and music were timed to be independent from the action on stage, following the principles of indeterminacy derived from the teachings of composer John Cage and choreographer Merce Cunningham.[4] His scores borrowed from a range of sources (Mozart, Stravinsky, Cage, and Fanny Brice, among them), reflecting his high- and low-art influences.

Waring began his formal dance training at seventeen in San Francisco, studying both ballet and the Martha Graham technique. In the late 1940s, he moved to New

York, where he trained with Merce Cunningham and Louis Horst. Throughout his career, Waring dabbled in acting and musical composition as well as other components of the theatrical arts. In 1961, he was one of the cofounders of the New York Poets Theatre, where he staged his own plays and served as a theater director. Jill Johnston, one of the preeminent writers on Judson Dance Theater, also credited Waring and dancer-choreographer Remy Charlip with her appointment as a writer for the *Village Voice*.[5]

Also a visual artist, Waring staged performances in a way that mirrored the strategies of his collage practice. Speaking of his own work, Waring wrote: "I don't have a single style. I don't worry about having a style. Style is a result of the artistic process, and not interesting in itself. What is interesting is process."[6] Waring's costumes, made for his own productions and for others', were among the most distinguishing aspects of his oeuvre. Often bright in color and made of embellished, lush materials, his creations merged the elaborate and the handmade in ways that made them at once spectacular—i.e., visible from afar—and highly personal. Although Waring was not directly affiliated with Judson, his influence on several of its participants was significant. In 1959 and 1960, he taught composition classes attended by Gordon, Yvonne Rainer, and other Judsonites, in which they were first exposed to techniques such as chance procedures and non-dance gestures now more closely associated with the courses taught by Robert Dunn between 1960 and 1962. Several dancers

in the James Waring Dance Company were also active in Judson, including Herko, Rainer, Lucinda Childs, and Deborah Hay.[7] Waring's sole participation in a Judson event occurred at Concert of Dance #12 in 1963. Waring described his contribution, *Imperceptible Elongation No. 1*, as a five-second Happening: several hands burst through a white screen to release jars full of confetti while "big white puff balls" descended from the balcony.[8]

Waring's work is often interpreted through a framework of camp, and his influence on the Judson figures and beyond is both celebrated and underrecognized precisely for this reason. Waring's merging of traditional ballet, modern dance, and camp aesthetics is not neatly understood within the terms through which Judson is interpreted. He was at once experimental and innovative, traditional and classic, generously egalitarian and unabashedly exuberant.—VAC

Notes
1. James Waring, press release for *Dances before the Wall*, no date, David Vaughan Collection, New York.
2. Jack Anderson, "The Extravagant Whimsy of James Waring," *New York Times*, April 23, 1978.
3. Radio program with Valda Setterfield, David Gordon, Yvonne Rainer, and Aileen Passloff, interviewed by Marcia B. Siegeon, hosted by Jim D'Anna, WRVR radio, January 10, 1976, New York, quoted in David Vaughan's untitled manuscript on Waring (unpublished, no date), word document, David Vaughan Collection, New York.
4. I owe this observation to David Vaughan's untitled manuscript.
5. Leslie Satin, "James Waring

and the Judson Dance Theater: Influences, Intersections, Divergences," in *Reinventing Dance in the 1960s: Everything Was Possible*, ed. Sally Banes with Andrea Harris (Madison: University of Wisconsin Press, 2003), 57.
6. Waring quoted in Anderson, "The Extravagant Whimsy"
7. Sally Banes, *Democracy's Body: Judson Dance Theater 1962–1964* (1983; repr. Durham, NC: Duke University Press, 1993), 165.
8. Waring quoted in Banes, *Democracy's Body*, 161. Originally from Waring, John Herbert McDowell, Judith Dunn, Arlene Croce, and Don McDonagh, "Judson: A Discussion," *Ballet Review* 1, no. 6 (1967): 45.

Merce Cunningham
Antic Meet, 1958

In summer 1958, at the American Dance Festival at Connecticut College in New London, choreographer Merce Cunningham (1919–2009) debuted *Antic Meet,* a dance consisting of ten seemingly incongruous vaudevillelike vignettes—"a series of absurd situations," he would explain, "one after the other, each one independent of the next."[1] In one, Cunningham dances a duet—first alongside a seemingly self-propelled door and later with dancer Carolyn Brown—with a bentwood chair strapped to his back. In another, Brown and Viola Farber perform classical ballet steps while pantomiming a competitive scuffle. Several segments feature the full six-person cast, their quasi-balletic movements offset by walks, tumbles, and falls. For Cunningham, the movements of everyday life were integral to choreography, and almost anything was fair game. "I may see something out of the corner of my eye," he explained. "The slight way a person climbs a curb, the special attack of a dancer to a familiar step in class, an unfamiliar stride in a sportsman . . . and then I try it."[2]

Over the course of his career, Cunningham pioneered a dance style that eschewed cohesive narrative for experiments with chance, indeterminacy, and other depersonalizing compositional strategies. Born in Centralia, Washington, in 1919, he moved to New York in 1939 to dance as a soloist in the Martha Graham Dance Company. He left the company shortly thereafter to choreograph independently, eventually establishing his own troupe in 1953. A generation older than the Judson dancers, Cunningham challenged Graham's tradition of modern dance, which had become widely known both in America and abroad in the 1930s. "Climax is for those who are swept by New Year's Eve," he once wrote in a cheeky rebuke of Graham's use of narrative and virtuosic movement.[3] In *Antic Meet*, Cunningham parodied her directly, appearing in a sweater knit with four sleeves and no neck hole; comically shuffling his head from one narrow sleeve to the next, he took aim at *Lamentation* (1910), in which Graham dances in a nearly all-encompassing fabric garment designed to heighten the dramatic impact of her movements. In the same segment, Cunningham is joined by four female dancers who bound onto the stage in dresses made from surplus parachutes. They *penché* or lean forward in arabesque, causing the dresses to swing before them, offsetting the weight of their legs like a balance or scale, and proposing a kind of readymade counter-movement of their own. If Graham used costumes to illustrate a dancer's character or to accentuate her technically sophisticated and grand movements, Cunningham used costumes, here designed by Robert Rauschenberg, to complement and at times extend the openness of his choreography, generating accidental juxtapositions of steps, sounds, and objects.

The choreography in *Antic Meet* was set to Cage's "Concert for Piano and Orchestra" (1957–58), a variable composition that was

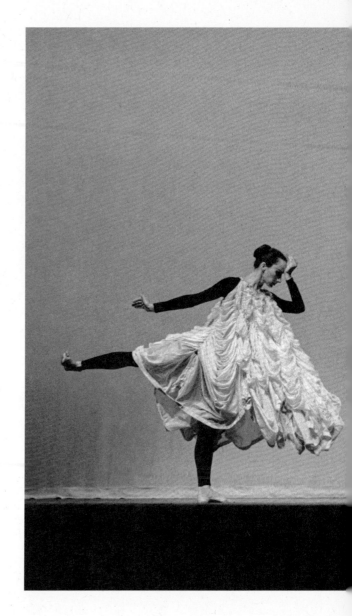

Above: Marvin Silver's photograph of Carolyn Brown, Merce Cunningham, Shareen Blair, Barbara Dilley (partially visible), and Viola Farber (clockwise from left) in *Antic Meet*, 1958. Performed at University of California, Los Angeles, 1963. Opposite left and right: Video stills from *Antic Meet*, 1958

124

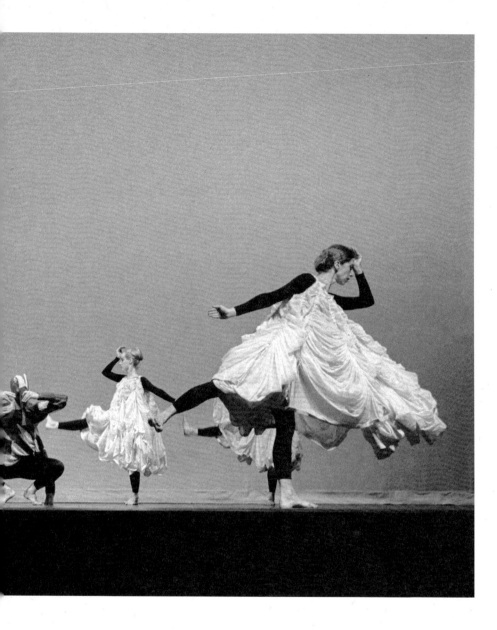

both indeterminate and dependent on chance operations. By 1960, these principles had become the basis for a new composition course that took place at Cunningham's studio, led by Robert Dunn, a composer and accompanist for Cunningham classes, and his wife, Judith, a dancer in the Cunningham Company. Many Judson choreographers, among them Yvonne Rainer and Trisha Brown, began taking Cunningham's and Dunn's classes. Others, like Steve Paxton and Deborah Hay, would perform in Cunningham's company. "There was a feeling of excitement and anticipation in the air," Rainer would later recall of Cunningham's studio. "It was truly the beginning of a zeitgeist."[4] —JH

Notes

1. Merce Cunningham, quoted in Jacqueline Lesschaeve, *The Dancer and the Dance: Merce Cunningham in Conversation with Jacqueline Lesschaeve* (London: Marion Boyars, 1999), 94. Following its 1958 debut, *Antic Meet* remained in the company's repertoire through the 1960s and was revived during the troupe's final appearances in 2010 and 2011.
2. Cunningham, "Choreography and the Dance" [1970], in *Merce Cunningham*, ed. Germano Celant (Milan: Edizioni Charta, 2000), 44.
3. Cunningham, "Space, Time and Dance" [1952], in *Merce Cunningham: Dancing in Space and Time: Essays 1944–1992*, ed. Richard Kostelanetz (Chicago: Chicago Review Press, 1992), 39.
4. Yvonne Rainer, *Feelings Are Facts: A Life* (Cambridge, MA: MIT Press, 2006), 189.

John Cage
"Fontana Mix," 1958

On January 5, 1959, in Rome, John Cage (1912–1992) premiered the indeterminate composition "Fontana Mix" with a simultaneous performance of "Aria" by experimental vocalist Cathy Berberian.[1] The score for this four-part multichannel tape composition consists of ten sheets of instructions and twelve transparencies printed with lines and dots. The instructions direct the performer to layer the transparencies over a grid, creating a random visual arrangement of lines and dots that indicates when and how sounds should be produced. While Cage used magnetic tape for the premiere, the score's instructions stipulate that any instruments, including voice, can be employed to realize the composition. Over the next decade, numerous artists, composers, and choreographers responded to Cage's prompt, performing works inspired by *Fontana Mix* inside and outside of Judson Memorial Church.

Cage's influence on Judson choreographers came through composer Robert Dunn, an accompanist for Merce Cunningham Dance Company, who, along with his wife, Judith, a Cunningham dancer, taught choreography workshops in New York beginning in fall 1960. Robert had taken Cage's class in experimental composition at the New School in New York, which exposed many artists downtown (George Brecht, Allan Kaprow, and Jackson Mac Low, among others) to chance procedures, a technique Cage deployed to introduce indeterminacy into a work—rolling dice, tossing coins, or allowing performers to make compositional decisions. Cage taught that anything within the audible spectrum of sound can be considered music and proposed the radical untethering of musical accompaniment from movement in a dance composition, an idea he explored in collaborations with Cunningham.

In his own workshops, Dunn encouraged his students to use Cage's indeterminate scores. Yvonne Rainer combined "Fontana Mix" with a tripartite structure from Erik Satie's Gymnopédies (1888) to create *Three Satie Spoons* (1961). At Judson's Concert of Dance #1, on July 6, 1962, both *Isolations* by Carol Scothorn and *Shoulder r* by Ruth Emerson used Cage's "Cartridge Music" (1960) as accompaniment. Rainer and other Judson artists continued to experiment with indeterminacy over the next few years to create new juxtapositions of movement, language, and music.

Many Judson choreographers expressed ambivalence toward Cage's teachings, mixing his strategies with radically non-Cagean aesthetics like personal narrative or camp.[2] Simone Forti noted that although Cage's compositions supposedly eliminated choice or authorial control over compositional content, "his hand could still be strongly felt in the original structuring of the procedure, and in the resulting quality of space containing autonomous events."[3] Rainer reflected that while chance procedures were an affront to the old guard in 1960, not long after, "the Cagean effect [became] almost as endemic as the encounter group."[4] Yet one of Cage's greatest legacies in Judson Dance Theater is the idea that any movement can be dance, just as any sound can be music. —MJ

Notes
1. "Fontana Mix" may be performed simultaneously with other Cage scores such as "Concert for Piano and Orchestra," "Aria," "Solo for Voice 2," and/or "Song Books."
2. Cage famously disavowed Charlotte Moorman's performance of "26'1.1499" for a String Player" for its inclusion of explicit references to female sexuality in the section indicating nonstring sounds. See Benjamin Piekut, *Experimentalism Otherwise: The New York Avant-Garde and Its Limits* (Berkeley: University of California Press, 2011), 1.
3. Simone Forti, *Handbook in Motion* (Halifax: Press of the Nova Scotia College of Art and Design, 1974), 36.
4. Yvonne Rainer, "Looking Myself in the Mouth," *October* 17 (Summer 1981): 37.

Above: Realization of a score for "Fontana Mix," 1958. Opposite left: Earle Brown's photograph of John Cage and Cathy Berberian during the recording session for "Aria," 1958. Pictured at Capitol Records Studios, New York, c. 1961. Opposite right: Fred W. McDarrah's photograph of John Cage (center) and others. Pictured at Concert of Dance #1, Judson Memorial Church, July 6, 1962

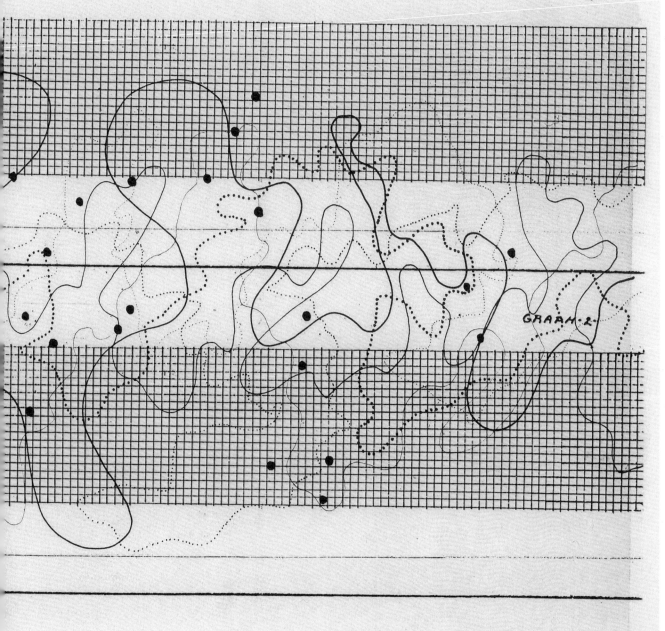

GRAPH·2·

GRAPH·2·

Allan Kaprow
18 Happenings in 6 Parts,
1959

18 Happenings in 6 Parts by
Allan Kaprow (1927–2006),
considered to be the first
Happening, inaugurated pro-
gramming at Reuben Gallery
in New York. The Happenings
took place over six evenings
(October 4, 6–10) in three
distinct but contiguous rooms,
each separated by semitrans-
parent plastic sheets painted
and collaged with references
to Kaprow's earlier works.
Each room had six distinct
sets featuring different events.
The events, which took place
simultaneously, were metic-
ulously scored by Kaprow,
assembling movement, live
and recorded sound, spoken
language, scent, electric light,
film, painting, and sculpture.
Writer Samuel Delany, who
was in the audience one eve-
ning, recounted feeling unable
to experience the piece in its
totality while at the same time
having the sense of being part
of the larger structure.[1]

In addition to Kaprow,
Jim Dine, Red Grooms,
Sam Francis, Jasper Johns,
Lester Johnson, Jay Milder,
Rosalyn Montague, Shirley
Prendergast, Robert
Rauschenberg, Lucas
Samaras, George Segal,
Bob Thompson, and Robert
Whitman participated. They
each received Kaprow's cali-
brated instructions depicting
pedestrian activities, including
playing chess, playing flute
and violin, squeezing oranges,
sweeping the floor, shouting
political slogans, and painting.
These instructions, which
included drawn stick figures
representing every movement
as well as detailed written
descriptions, made use of

128

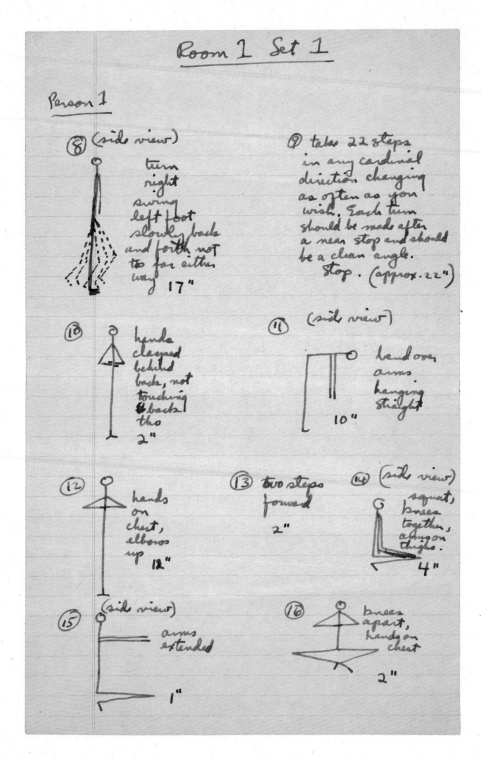

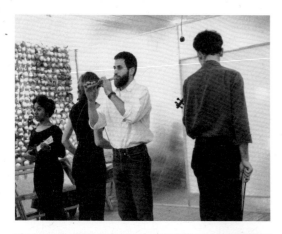

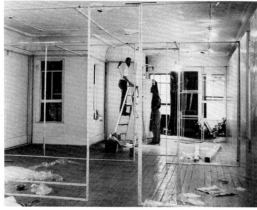

strategies more commonly aligned with choreography and dance:[2] "Keep arms up for 11" until buzzer sounds. If at the end of 11 counts the buzzer has not yet sounded maintain as long as possible. When tired return to straight up and down and at buzzer walk slowly out."[3] Audience members were given three stapled cards that provided instructions for their participation.

Kaprow studied philosophy at New York University while also taking painting classes with artist Hans Hofmann. At Columbia University, he wrote his master's thesis on painter Piet Mondrian. In 1957 he began teaching at Rutgers University in New Jersey, marking the beginning of his long academic career. It was also at Rutgers that he began to expand his painterly practice into environmental works that included smell, light, and sound. At the peak of his experimentation, he joined John Cage's classes in experimental composition at the New School.

The term *Happening* first surfaced in Kaprow's article "The Legacy of Jackson Pollock." Published in 1958, two years after painter Jackson Pollock's death, Kaprow offered that Pollock's legacy would reside not in painting but in action-based work. "Pollock, as I see him, left us at the point where we must become preoccupied with and even dazzled by the space and objects of our everyday life," he wrote, "either our bodies, clothes, rooms, or, if need be, the vastness of Forty-second Street."[4] Kaprow's Happenings demonstrated how art could turn to the everyday, an idea that would resurface a few years later in the experiments by Judson Dance Theater.

The Happenings' extended duration, their demand for audience mobility, their corporeity, and their ephemerality prefigured the experience audience members would have at Judson performances.

Despite the negative reviews it received at the time, Kaprow's environmental performance inaugurated a scene around the Reuben and Judson galleries that would soon flourish, prompting artists and audiences alike to reassess the boundary between art and life. —AJ

Notes

1. Samuel Delany, *The Motion of Light in Water: Sex and Science Fiction Writing in the East Village, 1957–1965* (New York: Plume, 1988), 174.
2. André Lepecki, "Not as before but Simply Again," in *Perform, Repeat, Record: Live Art in History*, eds. Adrian Heathfield and Amelia Jones (London: Routledge, 2012), 152.
3. Allan Kaprow, detail from the movement score for Room 2 Set 1, the Allan Kaprow Papers, 5;9, the Getty Archives, Los Angeles.
4. Kaprow, "The Legacy of Jackson Pollock," *Art News* 57, no. 6 (October 1958): 24–60.

Opposite: Score for *18 Happenings in 6 Parts*, 1959. Above top: Fred W. McDarrah's photograph of Shirley Prendergast, Rosalyn Montague, Allan Kaprow, and Lucas Samaras (from left) rehearsing for Kaprow's *18 Happenings in 6 Parts*, 1959. Performed at Reuben Gallery, New York, October 2, 1959. Above: Fred W. McDarrah's photograph of Allan Kaprow and Robert Whitman (from left) preparing for *18 Happenings in 6 Parts*, 1959. Pictured at Reuben Gallery, August 5, 1959

Jim Dine and
Claes Oldenburg
Ray Gun Spex, 1960

Ray Gun Spex, a series of performances organized by artists Jim Dine (born 1935) and Claes Oldenburg (born 1929), took place at Judson Memorial Church from February 29 through March 2, 1960. The previous year, artist Allan Kaprow had asked the church's assistant pastor, Bud Scott, to open the sanctuary and gymnasium, in addition to the Judson Gallery, to artists for performances and exhibitions. Scott granted the request and then organized a panel with Kaprow titled "The Human Image in Art." Kaprow invited Dine, Oldenburg, and Lester Johnson to speak. On the panel, Oldenburg expressed his desire to make work that could "do more than hang in galleries."[1] Afterward, the artist began planning a series of live events, which he called "Ray Gun Spex." ("Spex" means "spectacle" or "burlesque" in Oldenburg's native Swedish.)

The series included work by Oldenburg, Dine, Kaprow, Al Hansen, and Dick Higgins.[2] Oldenburg performed *Snapshots from the City* inside his immersive environment, *The Street*, in the Judson Gallery. Audience members looked through the gallery doors as Lucas Samaras turned the lights on and off thirty-two times at random intervals. At the same time, Oldenburg and performance artist Patty Mucha, dressed in bandages splattered with paint, assumed poses meant to evoke the suffering and poverty of the Lower East Side. Dine performed a parody of action painting called *The*

Above: Claes Oldenburg.
Ray Gun Poster, 1961.
Opposite: Stan VanDerBeek.
Stills from *Snapshots of the City*, 1961

Notes
1. Transcript of "The Human Image in Art," December 2, 1959, Judson Memorial Church Archive, MSS 094, 16;3, Fales Library & Special Collections, New York University Libraries.
2. Red Grooms was also supposed to perform but did not participate.

Smiling Workman in his gallery environment *The House*. Wearing a painter's smock, the artist scrawled, "I love what I'm doing, HELP!" across a canvas before drinking red paint (actually tomato juice) and jumping through the scribbled words. Fluxus artist Al Hansen showed *Projection*s, wherein performers with handheld film projectors cast newsreel images, including of airplanes, parachutists, and rock-and-roll concerts, onto the walls and ceiling.

After a brief intermission, in which Oldenburg read Baroness Orczy's *The Scarlet Pimpernel* (1905) in Swedish from a balcony while wearing a feather-covered football helmet, orange shorts, and mukluk boots, viewers reassembled on the basketball court for Kaprow's *Coca Cola, Shirley Cannonball*. In *Cannonball*, Dine, Oldenburg, and Samaras moved a giant cardboard foot around the floor while obscured by theatrical scenery flats. The flats contained holes that real and painted faces occasionally appeared in.

Spectators then returned upstairs, where they could wander about and buy comic books, pieces of the assemblages, and magazines made by the artists. The audience reassembled for Robert Whitman's *Duet for a Small Smell*, where Mucha hacked at a "body" covered with bags of paint, while Whitman drove away the audience by lighting a noxious-smelling incense. To conclude the evening, Higgins presented *Edifices, Cabarets, Contributions*, a piece composed of many small Happenings intended to drive the audience away. In one, the artist merely counted in German. The piece concluded when everyone had left. —EG

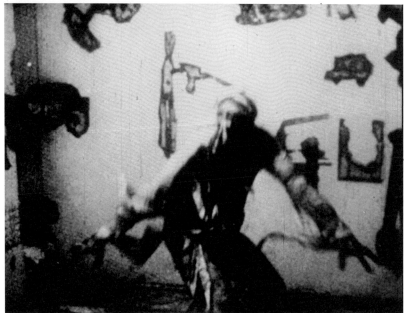

131

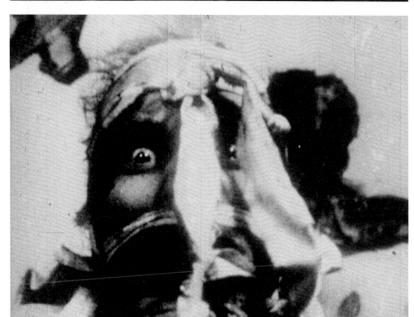

Composition 1960 #2

Build a fire in front of the audience. Preferably, use wood although
other combustibles may be used as necessary for starting the fire or
controlling the kind of smoke. The fire may be of any size, but it
should not be the kind which is associated with another object, such
as a candle or a cigarette lighter. The lights may be turned out.

After the fire is burning, the builder(s) may sit by and watch it for
the duration of the composition; however, he (they) should not sit
between the fire and the audience in order that its members will be
able to see and enjoy the fire.

The composition may be of any duration.

In the event that the performance is broadcast, the microphone may be
brought up close to the fire.

La Monte Young
5·5·60

Composition 1960 #3

Announce to the audience when the piece will begin and end if there
is a limit on duration. It may be of any duration.

Then announce that everyone may do whatever he wishes for the
duration of the composition.

La Monte Young
5·14·60

Composition 1960 #4

Announce to the audience that the lights will be turned off for
the duration of the composition (it may be any length) and tell
them when the composition will begin and end.

Turn off all the lights for the announced duration.

When the lights are turned back on, the announcer may tell the
audience that their activities have been the composition, although
this is not at all necessary.

La Monte Young
6·3·60

Composition 1960 #5

Turn a butterfly (or any number of butterflies) loose in the
performance area.

When the composition is over, be sure to allow the butterfly to
fly away outside.

The composition may be any length, but if an unlimited amount of
time is available, the doors and windows may be opened before the
butterfly is turned loose and the composition may be considered
finished when the butterfly flies away.

La Monte Young
6·8·60

132

From top: "Composition 1960 #2"
(May 5), "Composition 1960 #3"
(May 14), "Composition 1960 #4"
(June 3), and "Composition 1960 #5"
(June 8), 1960. Opposite: La Monte
Young (editor and publisher), Jackson
Mac Low (publisher), George
Maciunas (designer). Interior pages
from An Anthology, 1962

La Monte Young
Compositions 1960 #2–5, 1960

While serving as the musical director of choreographer Anna Halprin's interdisciplinary workshops in 1960, composer La Monte Young (born 1935) presented his event scores "Composition 1960 #2" and "Composition 1960 #5" written in May and June of that year. The classes took place on Halprin's outdoor Dance Deck at her home in Kentfield, California, and afforded Young the opportunity to experiment with sounds from the natural world. "Composition 1960 #2" instructs the performer to build a fire; "Composition 1960 #5" instructs the performer to turn butterflies loose in the performance area. Framed as musical compositions, the scores ask audiences to listen to what they would ordinarily see or to look at what they would ordinarily hear.[1] Compositions 1960, with their use of indeterminacy and readymade natural events, are marked by the influence of composer John Cage; in 1962 they would be published in Young's edited volume, *An Anthology*, which collected music scores, visual and concrete poetry, graphics, instruction-based works, and essays by more than a dozen artists, including George Brecht, Simone Forti, Ray Johnson, and James Waring. Many of these artists, including Young, would go on to be associated with Fluxus, an international group of interdisciplinary artists founded by George Maciunas.

While working with Halprin, Young and fellow Minimalist pioneer Terry Riley began experimenting with very long tones and recorded sounds.[2] The two improvised with materials such as empty garbage cans and made use of Halprin's tape recording studio. As its title suggests, "2 sounds" manipulates two discrete sounds recorded on electronic tape—the circular friction of metal against glass and the friction of metal against wood—to change their overall tone and timbre. Young described them as "ancestors of the wild sounds—natural sounds abstract sounds."[3] "2 sounds" would later be featured in Simone Forti's *Accompaniment for La Monte's "2 sounds" and La Monte's "2 sounds"* (1961) and Merce Cunningham's *Winterbranch* (1964).

Young's involvement in the Judson story spans both coasts: after his stint in California, he arrived in New York in late 1960, where he organized a series of events with Yoko Ono at her loft on Chambers Street. On April 11, 1960, at the Living Theatre, Cage and composer David Tudor performed Young's musical composition "Poem for Chairs, Tables, and Benches, Etc. (or Other Sound Sources)." For just under seven minutes, the two performers pulled benches across the tiled floor, producing amplified squeaks and scratches. Cage described the sound in spatial terms: "The sound was magnificent, the whole building was put into vibration."[4] This description foreshadows Young's later work that would deal explicitly with the spatialization of sound, culminating in *Dream House*, a site for sonic experience. "Poem for Chairs" was performed again at Judson Memorial Church in Concert of Dance #3 during Yvonne Rainer's *Three Seascapes* (1961).—MJ

Notes
1. Richard Kostelanetz, *The Theater of Mixed Means* (London: Pitman, 1970), 192.
2. Young spoke of these sounds in bodily terms: "I began to see how each sound was its own world and that this world was only similar to our world in that we experienced it through our own bodies, that is, in our own terms."
3. Ibid.
4. Jeremy Grimshaw, *Draw a Straight Line and Follow It: The Music and Mysticism of La Monte Young* (Oxford, UK: Oxford University Press, 2011), 68

Janice Ross, "Atomizing Cause and Effect: Ann Halprin's 1960s Summer Dance Workshops," *Art Journal* 68, no. 2 (Summer 2009): 72.

Robert Whitman
American Moon, 1960

Robert Whitman (born 1935)
performed *American Moon* at
Reuben Gallery in New York
from November 29 through
December 4, 1960, with a
cast that included George
Bretherton, Kamaia Deveroe,
Simone Forti, Lucas Samaras,
Clifford Smith, and Whitman
himself. The performers inter-
acted with ropes, pulleys, and a
vacuum cleaner to manipulate
the set, and their movements
consisted of stomps, hops,
and a bounce performed in a
plank position—what Simone
Forti has called a "heap."
American Moon is perhaps
best remembered for partition-
ing the audience into separate
tunnels or bays, from where
they could see the action
unfolding with limited lateral
visibility. "Nowhere in scripture,"
Whitman would later muse,
"does it say that everybody has
to see the same thing all the
time." The tunnels, as Whitman
called them, were made
from craft paper stapled to a
wooden framework. Partway
into the performance, plastic
sheets affixed with squares
of white paper descended in
front of each tunnel, serving as
makeshift screens; an 8mm film
showed the cast in a wooded
landscape. Later, Whitman,
aided by an immense clear
balloon, appeared to float in
the central arena. Throughout,
performers in tense positions
made surprise appearances
when periods of extreme
darkness gave way to light—as
toward the end, when Samaras
was revealed perched on a
fragile swing above the audi-
ence. By then the viewers had
emerged from their caves and
into the center of the perfor-
mance space.

134

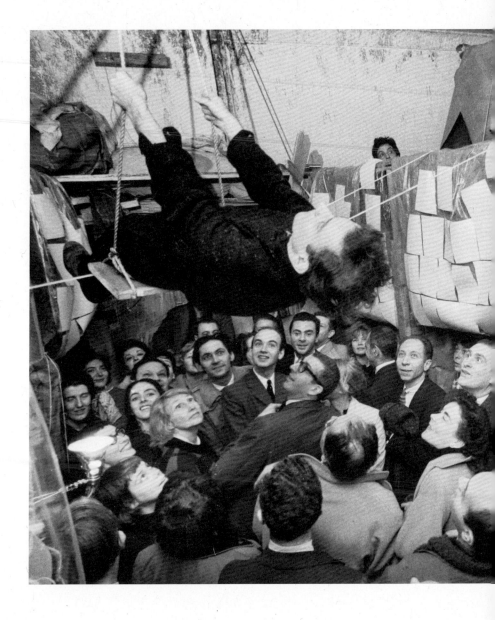

Above: Robert McElroy's photographs of
American Moon, 1960. Pictured: Lucas
Samaras (on swing) and Martha Edelheit,
Martha Jackson, Steve Joy, and Rolf
Nelson (in audience). Performed at Reuben
Gallery, November 29–December 4, 1960.
Opposite: Preparatory sketch for *American
Moon* performance (1960), 1959

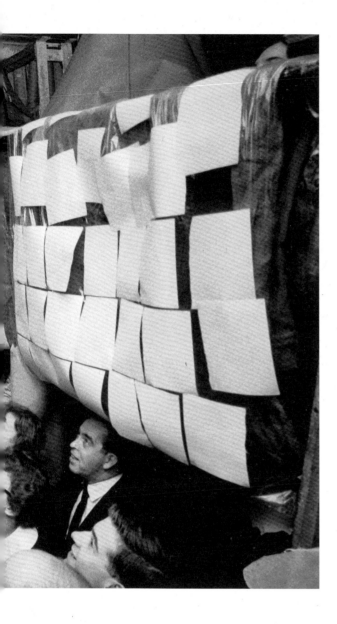

Whitman, who had studied with artist Allan Kaprow at Rutgers University in New Jersey, was a member of the Happenings scene congregated around Reuben Gallery, and his theater pieces were rooted in the rough-hewn-assemblage aesthetic of contemporaries like Claes Oldenburg and Jim Dine. Yet Whitman would emerge as the only artist from this group to devote his work to theatrical performances and installations without veering into the production of discrete objects. As evidenced in *American Moon*, Whitman's performances fragmented and obfuscated the viewer's field of vision—nodding to the idea that the experience of a work is generated as much by the audience as by the performer.

Recalling her role in the performance, Forti has said, "When we would appear as people to the audience, we were carrying out some necessity, most of the time." Forti's formulation here—"appearing as people"—precisely highlights Whitman's interest in having his performers manifest in various ways before the audience, sometimes as projected images, sometimes hidden behind partitions, and sometimes fully visible as people. It also underlines the commonality between Whitman's theater pieces and various practices clustered around Judson Dance Theater—for example, performers interacting with projected images and simple objects.

Forti first met Whitman after attending a previous performance of his at Reuben Gallery and was "struck by the affinity between her own developing aesthetic ideas and those found in [his] theater pieces." The movements in *American Moon* have been connected to her contemporaneous Dance Constructions, in part through their shared focus on intuitive interactions between human performer and material object. Yet despite the evident synchronicities between Whitman's own berserk theater pieces and Judson Dance Theater, Whitman utilized architectural assemblages to direct his audiences, making his work distinct from the straightforward presentation of movements and actions emerging from Judson. —GB

Notes
1. I'd like to thank Robert Whitman for his generous recollections.
2. Robert Whitman, "1000 Words: Robert Whitman," *Artforum* 49, no. 8 (April 2011): 193–96. Accessed online at https://www.artforum.com/print/201104/1000-words-robert-whitman-27828.
3. Simone Forti, interview with Julie Martin, in *Robert Whitman: Performances from the 1960s*, dir. Julie Martin (Houston: Artpix, 2003), Tate Britain, DVD.
4. Tom McDonough, "Robert Whitman's *American Moon*: A Reading in Four Phases," in *Robert Lehman Lectures on Contemporary Art, vol. 5*, ed. Lynne Cooke and Stephen Hoban (New York: Dia Art Foundation, 2014), 110.
5. Julia Bryan-Wilson, "Simone Forti Goes to the Zoo," *October* 152 (Spring 2015): 40.

2nd huddle with from instructions

slant board

wall with pipes for from instructions

accompaniment

1st huddle

platform

hangers

see saw

Simone Forti
See Saw, 1960;
Accompaniment for La Monte's "2 sounds" and *La Monte's "2 sounds"*, 1961; *Censor*, 1961; *Huddle*, 1961; *Platforms*, 1961; *Slant Board*, 1961. From *Dance Constructions*, 1960–61

In December 1960, artist and dancer Simone Forti (born 1935) premiered *See Saw* and *Roller Boxes* (then titled *Rollers*) in an evening program of Happenings at Reuben Gallery in New York. The two performances featured simple plywood constructions and performers carrying out a set of tasks. In *See Saw*, Forti's then-husband, Robert Morris, and choreographer Yvonne Rainer balanced on a long wooden plank atop a sawhorse, shifting their weight to move up and down. They wore red sweaters and shorts. A small toy, affixed to the bottom of the plank, made a *moo* sound with every movement. At one point, Rainer shrieked wildly while Morris read aloud from *ArtNews* magazine in a monotonous tone. Toward the end, both artists stood in the center of the plank, gently balancing, while Forti, from where she stood working the lights, sang a song that begins, "Way Out on a Sunbaked Desert."[1] In her memoir, Rainer recalls artist George Sugarman stating enthusiastically, "It's like a Chekov play!,"[2] while others likened it to the absurd domestic dramas of Samuel Beckett.[3] In *Roller Boxes*, Forti and artist Patty Mucha, Claes Oldenburg's wife at the time, sat in wooden boxes singing long, sustained tones while audience members wildly pulled the boxes around

by ropes and the singing turned to screaming.

Both *See Saw* and *Roller Boxes*, along with some of the works Forti would perform the next spring at Yoko Ono's loft in New York, are known today as Dance Constructions.[4] With this suite of nine works, Forti explored the nature of social relationships, often instructing the performers to carry out a set of instructions collaboratively, as in *See Saw* and *Roller Boxes*. She was also interested in upsetting established onstage hierarchies—between performers and objects as well as between the visual and the auditory. All but one of her Dance Constructions integrated objects that served alternately for human use and as sculptures to be regarded. (The exception is *Huddle*—itself a live sculpture—in which seven to nine performers huddle together and take turns lifting themselves up on top of the others to create a mountain of shifting forms.) These works frame a relationship between the sculptural object and the body in motion that prefigures many concerns of Minimalist sculpture in the 1960s by implying that objects and bodies have similar properties: both are material with mass, volume, and weight, and carry a spatial relationship to objects and bodies around them.[5] Addressing the hierarchy between vision and sound were *Accompaniment for La Monte's "2 sounds" and La Monte's "2 sounds,"* which inverted the traditional movement/music relationship by calling the dance the "accompaniment" to the music, and *Platforms*, in which the dancers entered coffinlike plywood boxes and proceeded to whistle for the duration of

the performance; effectively invisible to audiences, the sounds they made took primacy on stage.

While Forti never showed her dances at Judson Memorial Church, they often featured Judson performers, and, much like the works of Judson choreographers, they grappled with task-based, everyday movement. Forti, who was influenced by her studies in the 1950s under Anna Halprin in northern California, drew upon somatic awareness and improvisation in her choreographic approach. She participated in Halprin's summer 1960 workshop and in Robert and Judith Dunn's workshop that fall where she danced alongside Rainer, Steve Paxton, and Trisha Brown.

In December 2015, The Museum of Modern Art acquired the rights to perform, loan, and care for the Dance Constructions. As a part of the acquisition, the Department of Media and Performance Art is exploring new methods of preserving the legacy of performance by collaborating with Danspace Project. Through this collaboration, regular workshops will teach the Dance Constructions to a younger generation of dancers and educators, ensuring that the somatic memory of performing these works stays alive. —MJ

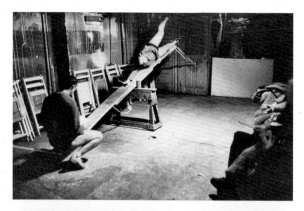

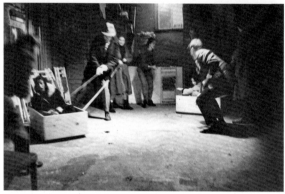

Opposite: Map of Dance Constructions at Yoko Ono Chambers Street loft, New York, 1974. Above: Robert McElroy's photographs of Yvonne Rainer and Robert Morris in *See Saw,* 1960 (top); and Simone Forti and Patti Mucha (from left) in *Roller Boxes,* 1960 (then titled *Rollers*). Performed at Reuben Gallery, New York, December 16–18, 1960

Notes
1. Simone Forti, *Handbook in Motion* (Halifax: Press of the Nova Scotia College of Art and Design, 1974), 39.
2. Yvonne Rainer, *Feelings Are Facts: A Life* (Cambridge, MA: MIT Press, 2006), 196.
3. Meredith Morse, "Between Two Continents: Simone Forti's *See-Saw*," in *Simone Forti: Thinking with the Body*, ed. Sabine Breitwieser (Salzburg: Museum der Modern, 2014), exh. cat., 43.
4. At Five Dance Constructions and Some Other Things at Yoko Ono's loft in 1961, the following works were performed: *Slant Board, Huddle, Hangers, Platforms, Accompaniment* for La Monte's "2 sounds" and La Monte's "2 sounds," Censor, From Instructions, Herding, and Paper Demon. At the time, only *Slant Board, Huddle, Hangers, Platforms,* and *Accompaniment* were considered Dance Constructions, but since then *Censor* and *From Instructions* have also been designated as such. In 1960, when Forti created *See Saw* and *Roller Boxes*, she had not yet coined the term Dance Constructions; she later considered them part of the same series.
5. Virginia B. Spivey, "The Minimal Presence of Simone Forti," *Woman's Art Journal* 30, no. 1 (Spring/Summer 2009): 5–6.

Cecil Taylor
"Mixed" from Gil Evans's *Into the Hot*, 1962

Jazz pianist and composer Cecil Taylor (1929–2018) was a paradoxical figure in the world of free jazz, combining influences from atonal classical composition and American popular music such as ragtime and the blues. "Mixed," one of Taylor's tracks from jazz pianist and bandleader Gil Evans's 1962 album *Into the Hot*, is characteristic of his mode of stylistic experimentation. As with both "Pots" and "Bulbs," two other songs of his on the album, it features Taylor on piano, Archie Shepp on tenor saxophone, Jimmy Lyons on alto saxophone, Henry Grimes on bass, and Jimmy (Sunny) Murray on drums. Ted Curson on trumpet and Roswell Rudd on trombone join the group on "Mixed" for a fuller orchestral sound, though, unlike the other musicians, they do not solo. "Mixed" is a composition in three parts; it begins with a slow melodic dialogue between the alto and tenor saxophones, accompanied by atonal atmospheric textures in the piano. Movement picks up when the piano propels it forward with a luscious melody. Abruptly, the drums kick in with a hard bop beat, and the horns play a whirling tune in unison as the piano becomes increasingly more atonal and rhythmic. Taylor's percussive tone clusters and staccato chords are characteristic of his signature piano style— what he described as imitating "on the piano the leaps in space a dancer makes."[1] With his virtuosic skill at rapid scales and polyrhythms, Taylor often created his own scales

138

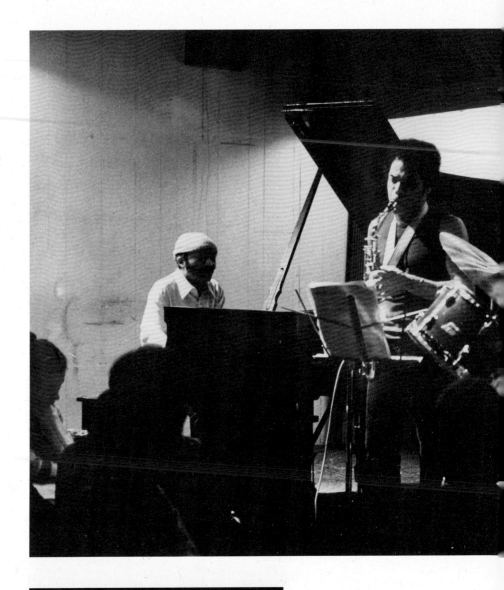

Above: Fred W. McDarrah's photograph of Cecil Taylor, Jimmy Lyons, and Andrew Cyrille (from left) performing at the Five Spot Café, New York, April 18, 1975. Left: Michael Cuscuna's photograph of Cecil Taylor playing the piano during the recording session for his album *Unit Structures*, New York, May 19, 1966. Opposite: Geoff La Gerche's cover art for Gil Evans's 1962 album *Into the Hot*

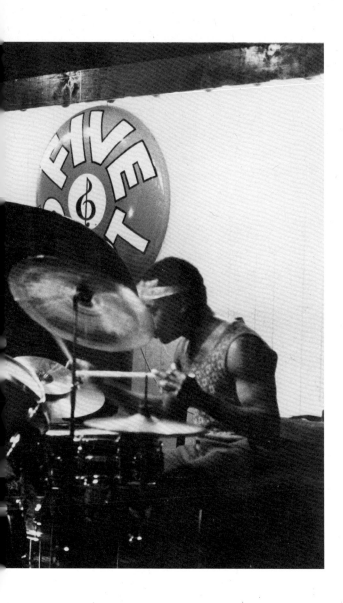

through unconventional note choices. Toward the end, the slow theme returns, and the piano's percussive chords cede to light pointillist playing.

For Taylor, who studied composition at New England Conservatory of Music in Boston between 1951 and 1955, musical structure was quintessential. He often made charts and scores, and deployed improvisation within rigidly defined musical structures. This made him an anomaly in the free jazz community: according to writer LeRoi Jones (later Amiri Baraka), Ornette Coleman's album Free Jazz from 1961 "re-established the absolute hegemony of improvisation in jazz,"[2] Taylor called his music "constructivist," explaining that "the emphasis in each piece is on building a whole, totally integrated structure."[3] He stated, "My purpose is to carry on the tradition of Fletcher Henderson and Duke Ellington and therefore to reaffirm and extend the line of black music that goes back thousands of years."[4]

In Judson's Concert of Dance #1 in 1962, Taylor collaborated with dancer Fred Herko on Like Most People—for Soren. Herko and Taylor, who had interacted at production meetings for Diane di Prima and LeRoi Jones's semimonthly newsletter, the Floating Bear,[5] dedicated Like Most People to their friend, "gay-artist-hustler-druggie"[6] Soren Agenoux. Di Prima's review of the concert describes Herko performing inside a brightly striped hammock with Taylor on piano; she calls it a "marvelous and unexpected" congruence of movement and music. Taylor continued to collaborate with choreographers throughout

his career, including Mikhail Baryshnikov in 1979.[7]

In Taylor's work, the relationship between soloist and ensemble is distinct. A standard bebop performance begins with a theme that establishes the musical language of the work; each member of the ensemble uses this language to play a solo in turn. Taylor, by contrast, alternates between individualism and collectivism; the musicians are sometimes at odds and sometimes together, as on Into the Hot, where cacophony alternates with harmony and unison. In 1963, Taylor would play at New York's Philharmonic Hall with an ensemble called the Cecil Taylor Jazz Unit, a name that his band would carry on throughout the following decades; the term unit rather than ensemble or quintet emphasizes structure as the mediator between form and group dynamics.[8] —MJ

Notes
1. Robert Palmer, The Black Perspective in Music 2, no. 1 (1974): 94–95.
2. LeRoi Jones, "Present Perfect (Cecil Taylor)" [1962], Black Music (New York: Akashic Books, 2010), 122.
3. The Gil Evans Orchestra, Into the Hot, recorded 1961, Impulse!, 1991, compact disc, liner notes.
4. Robert Levin, "Cecil Taylor: 'This Music Is the Face of a Drum,'" Jazz & Pop Magazine (April 1971). Accessed online at https://robertlevin.wordpress.com/2009/04/09/cecil-taylor-this-music-is-the-face-of-a-drum.
5. Sally Banes, Democracy's Body: Judson Dance Theater, 1962–1964 (1983; repr. Durham, NC: Duke University Press, 1993), 55.
6. Diane di Prima, Recollections of My Life as a Woman (New York: Viking, 2001), 330.
7. Lynette Westendorf, "Cecil Taylor: Indent—Second Layer," Perspectives of New Music 33, no. ½ (Winter–Summer 1995): 296.
8. Fred Moten eloquently addresses the term unit in relation to the ensemble in In the Break: The Aesthetics of the Black Radical Tradition (Minneapolis: University of Minnesota Press, 2003), 159–60.

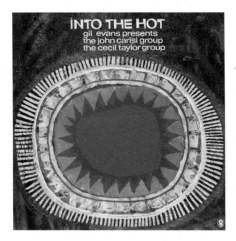

INTO THE HOT
gil evans presents
the john carisi group
the cecil taylor group

Aileen Passloff
Strelitzia, 1961

Aileen Passloff (born 1931) was a key figure in the 1950s dance and broader performative arts scene in New York. She first met avant-garde choreographer James Waring, a lifelong collaborator, while studying at the School of American Ballet. At thirteen, Passloff joined Waring's company and, through his encouragement, began choreographing her own dances at the Living Theatre and the Master Institute of Arts. Beginning in 1952, she was active in Dance Associates, a multidisciplinary collective of practitioners that included dancers, playwrights, actors, and visual artists. With Aileen Passloff and Company (sometimes also referred to as Aileen Passloff and Dance Company), which she founded in 1958 and led for ten years, Passloff choreographed abstract, nonnarrative works.

Strelitzia, first performed in 1961,[1] featured a duet with movements that were classical and lyrical. The dancers wore costumes prepared by Waring, who cut a thrifted evening dress in half and modified the two halves to make two-piece costumes. In Waring's characteristic collage style, the costumes combined old sheets, gloves, pieces of fur, shoelaces, and gauze for the top, and felt circles, set along the hem, for the bottom. The headpieces were made with teal mesh, lavender lace, and antennaelike wires.

Accompanying the dancers was a composition called "Night Music" by electronic music innovator Richard Maxfield, for which

Above and opposite bottom: Photographs of Aileen Passloff and Martha Jane Charney in Passloff's *Strelitzia*, 1961. Performed at Fashion Institute of Technology, New York, February 1961. Opposite top: Poster for Aileen Passloff and Company, Judson Memorial Church, March 8–10, 1965

140

he extracted extraneous noises from a Cunningham performance tape—coughs, sneezes, the rattling of paper—and processed them electronically. Passloff felt the composition, whose title referenced the similarities between the electronically generated music and the nocturnal sounds of birds and insects in New York's parks, aligned perfectly with the "don't throw anything away" sensibility she had inherited from Waring. Although it was easy to mistake the dance's movements as independent from the music, they were in fact deeply related and together set the overall peculiar, dreamlike tone. For Passloff, the music was "like a place you walked into; you could feel the music bathe you."[2]

Passloff, who was classically trained in ballet, began choreographing her own dances partially because she lacked "the typical ballet dancer's body."[3] Her company welcomed dancers of different sizes, heights, and shapes, emphasizing people's distinctiveness rather than suppressing it. Her dances made everyday gestures as important as ballet movements. In her solo *Asterisk* (1960), she walked around the stage in a silk dress, heels, and stockings while smoking a cigarette. At the time, it was rare to do so little on stage, and Passloff's eclectic merging of styles and references was an important influence on many Judson Dance Theater participants.

Yvonne Rainer and Elaine Summers have both described the influence of seeing diverse bodies in Passloff's performances.[4] Rainer was so moved by attending Passloff's work for the first time—a 1960

performance of *Tea at the Palaz of Hoon*—that she sought out Passloff to pursue studying with her. Rainer would later write of *Tea* that it mapped "a territory beyond technique class" and was inspirational at a time when she had just begun to "take [herself] seriously as a dancer."[5] At Passloff's suggestion, Rainer would soon begin attending classes in Waring's studio. By 1961, Passloff was sharing her East Village studio with both Waring and Rainer. In late 1962, this shared studio became a temporary gathering place for early Judson Dance Theater workshops on Mondays after Waring's class.[6] —VAC

Notes
1. *Strelitzia* was performed at Fashion Institute of Technology, the Master Institute of Arts, Brooklyn Academy of Music, the Gramercy Arts Theater, and Judson Memorial Church, with alternating casts including Passloff, Dilley, and Martha Jane Charney. Few records of these performances exist and their precise dates are unknown.
2. Aileen Passloff, oral history interview conducted by Ana Janevski and Thomas J. Lax, Department of Media and Performance Art, The Museum of Modern Art, New York, February 22, 2018.
3. Sally Banes, *Democracy's Body: Judson Dance Theater 1962–1964* (1983; repr. Durham, NC: Duke University Press, 1993), xvii.
4. For Elaine Summers on Passloff's influence, see her quote in Banes, *Democracy's Body*, 22.
5. Yvonne Rainer, email to author, December 21, 2017.
6. Banes, *Democracy's Body*, 77.

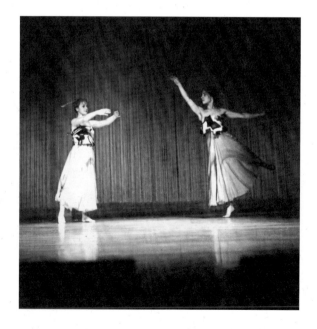

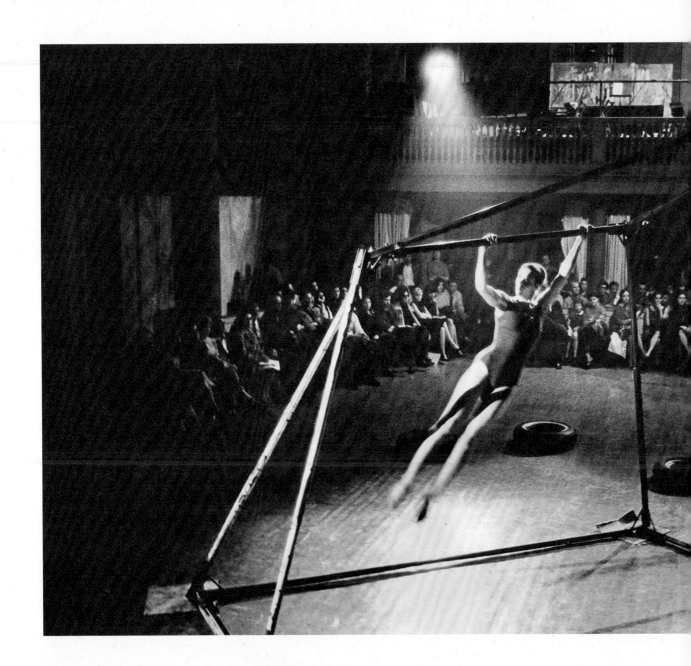

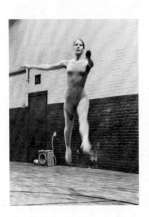 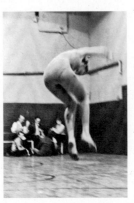

Above: Peter Moore's photograph of Ruth Emerson in *Sense*, 1963. Performed at Concert of Dance #13, Judson Memorial Church, November 20, 1963. Opposite: Al Giese's photographs of Ruth Emerson in *Giraffe,* 1963. Performed at Concert of Dance #3, Judson Memorial Church, January 29, 1963

Ruth Emerson
Narrative, 1961; *Giraffe*, 1962; *Sense*, 1963

Ruth Emerson's solo *Sense*, performed at Concert of Dance #13 at Judson Memorial Church, was a gymnastic exploration of a large, tridimensional trapezoid in the sanctuary of the church. The trapezoid was part of an interactive environment created for the concert by sculptor Charles Ross. Emerson (1938–2015), wearing a leotard that she made herself, looked more gymnast than dancer. She moved, according to dance writer Jill Johnston, "with equipoise around all the bars, making two sudden breathless springs on the top bars, wrapping her long legs around them and sliding in smooth hoists."[1] Many of Emerson's peers, like Yvonne Rainer, remember the piece for its extraordinary athleticism and bravery.[2] According to the artist, the title reflected her fear of executing movements high off the ground but also her desire to overcome that fear. "It's not hard, it's easy, it's fun," Emerson remarked.[3] In *Giraffe,* a solo presented a year earlier, at Concert of Dance #3, Emerson explored a similar movement vocabulary, but with her body crashing up and down on the floor (the movements were not meant to evoke the animal with which the piece shares its title). Music by composer John Herbert McDowell accompanied the wild and energetic dance, which had no score structure.

In high school, Emerson studied dance with Margaret Erlanger at University of Illinois in Urbana, where she learned the Graham technique. She continued dancing through college, while earning a degree in mathematics. In 1960 Emerson attended Anna Halprin's summer workshop in Kentfield, California, where she met Rainer, Simone Forti, and Trisha Brown. Later that year, she moved to New York, where she took classes at Merce Cunningham Studio; as a student in the workshops of Robert Ellis Dunn, she joined others who would go on to form Judson, all while working in the field of mathematics. Dunn's compositional workshops were score based, and Emerson appreciated his nonauthoritarian and nonhierarchical approach to teaching dance. It was as his student that Emerson first produced scores with her signature interest in mathematical conceptualization, time structures, and chance methodologies.

Emerson was active as a dancer and choreographer throughout all sixteen Concerts of Dance. Her three-section *Narrative* was the first live performance at Concert of Dance #1. Judith Dunn, McDowell, Steve Paxton, and Rainer performed the score's walking patterns at designated tempos and heeded instructions on where to direct their gaze; they also followed cues based on other dancers' actions. Despite the dance's title, there was no "narrative" to glean; unlike an older generation of modern dance, it was, as historian Sally Banes observed, "without a specific or coherent symbolic meaning," making it "a new twist on an old modern dance theme."[4]

Emerson, who was a Quaker, introduced some of the Christian movement's ideas to the Judson group. To program the lineup for each Concert of Dance, Judson participants held auditions and then used the Quaker-taught process of consensus to make their selections. Emerson also worked as a volunteer at the American Friends Service Committee, a Quaker organization devoted to peace and social justice in the United States, and some of her scores from the Dunn workshops contained movements and verbal content that reference nonviolent resistance. —AJ

Notes
1. Jill Johnston quoted in Sally Banes, *Democracy's Body: Judson Dance Theater, 1962–1964* (1983; repr. Durham, NC: Duke University Press, 1993), 172.
2. Yvonne Rainer quoted in ibid.
3. Ibid.
4. Ibid., 42.

Steve Paxton
Word Words, 1963; *Jag vill gärna telefonera (I Would Like to Make a Phone Call)*, 1964

Steve Paxton (born 1939) developed the silent ten-minute dance *Word Words* with fellow Judson Dance Theater participant Yvonne Rainer. After auditioning for a dance program at the 92nd Street YMHA, and later hearing that one of the jury members had remarked "those people at Judson all [look] alike," Paxton and Rainer embraced the criticism and created a work in which they deliberately resembled each other as much as possible in movement, expression, and appearance.[1] Rainer supplied "twisting poses and tiny, repetitive gestures," while Paxton contributed complex movements emerging from his training as a dancer for Merce Cunningham Dance Company.[2] Rainer began the dance with a solo performance. Paxton followed with a solo of his own. Gradually, the audience came to understand that Paxton was reperforming Rainer's solo movement for movement. To conclude the dance, Rainer and Paxton performed the movements as a duet.

Word Words playfully engages the tension between sameness and difference, congruity and individuality. The title likewise replicates the dance's "singularity and plurality play," as Paxton describes it. "The first word is a word," he observes, "the second is the same but pluralized."[3] Unable to afford the rental fees of the gorilla or Santa costumes Paxton originally wanted, the duet opted instead to perform the dance seminude, wearing small underwear and, in the case of Rainer, pasties in order

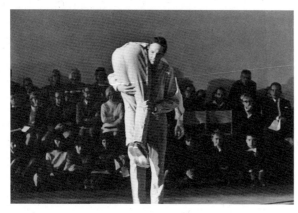

Opposite: Visual score for *Jag vill gärna telefonera (I Would Like to Make a Phone Call)*, 1964. Above: Stig T. Karlsson's photograph of Robert Rauschenberg (standing) and Steve Paxton in *Jag vill gärna telefonera (I Would Like to Make a Phone Call)*, 1964. Performed at Five New York Kvällar (Five New York Evenings), Moderna Museet, Stockholm, September 13, 1964. Below: Robert McElroy's photograph of Steve Paxton and Yvonne Rainer in *Word Words*, 1963. Performed at Concert of Dance #3, Judson Memorial Church, January 29, 1963. Below bottom: Robert McElroy's photograph of Steve Paxton in *Music for Word Words,* 1963. Performed at Concert of Dance #4, Judson Memorial Church, January 30, 1963

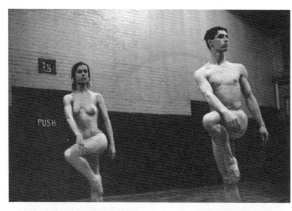

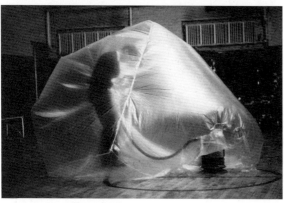

to abide by nudity laws. Each mirrored the other so precisely in movement and affect that the nudity problematized rather than affirmed gendered notions of difference and was approached as an inconsequential aspect of the work.

Music for Word Words (1963) was performed separately on the following night and alluded to the previous evening's silent duet. Paxton used a vacuum cleaner to inflate and subsequently deflate a twelve-foot-square structure, while Rainer stood alongside the plastic construction with a tape recorder, capturing the sounds of the vacuum and the audience. At the end of the performance, Paxton, who stood inside the structure as it was deflated, wore it as a costume. Whereas other choreographers had experimented with dissociating movement from sound, *Music for Word Words* took this impulse to a new limit by temporally estranging the dance and its supposed accompaniment. Choreographer Aileen Passloff, whose concerts sometimes included music only during the intervals between dances, is among the influences that Paxton has cited.[4]

Paxton danced and toured as a Cunningham dancer from 1961 to 1965. Drawing on his experiences in a company, Paxton sought to shift the dynamics between choreographer and performer away from the norm of imitation. In *Proxy* (1961) and *Jag vill gärna telefonera* (*I Would Like to Make a Phone Call*) (1964), both works whose movements were drawn from scores of mostly sports photographs, each performer learned the precise poses but was free to interpret how to execute and transition between them. While some of

what Paxton calls the "graphic options"[5] are thus predetermined, he ultimately cedes control of their execution.

The visual score for *Jag vill*, whose duet portion was originally performed by Paxton and artist Robert Rauschenberg, includes blue dots and red dots to indicate those poses selected by each performer. The photographic poses are occasionally marked with arrows, signaling how they are to be sequenced. The dancers must also negotiate how to integrate shared movements. In one instance, an image of a soldier carrying another person across his shoulder prompts the dancers to replicate this action. More broadly, Paxton has championed autonomy within collaboration, commonly encouraging performers to adapt his scores to their individual styles. Paxton's early adaptive and open-ended approach also informed the principles of Contact Improvisation. This collaborative movement practice between two or more participants, first developed by Paxton in 1972, uses tactile methods to develop dances, a marked shift from more commonplace visual methods. —VAC

Notes

1. See Steve Paxton and Yvonne Rainer quoted in Sally Banes, *Democracy's Body: Judson Dance Theater, 1962–1964* (1983; repr. Durham, NC: Duke University Press, 1993), 88–89.
2. Ibid.
3. Paxton quoted in Ramsay Burt, *Judson Dance Theater: Performative Traces* (New York: Routledge, 2006), 74. Originally published in Steve Paxton with Liza Béar, "Like the Famous Tree," *Avalanche* 2 (Summer 1975): 26.
4. Banes, *Democracy's Body*, 97.
5. Steve Paxton, oral history interview conducted by Ana Janevski and Thomas J. Lax, Department of Media and Performance Art. The Museum of Modern Art, New York, March 15, 2018.

David Gordon
Mannequin Dance, 1962; *Random Breakfast*, 1963

David Gordon (born 1936) first performed the nine-minute *Mannequin Dance* at Concert of Dance #1. Gordon has remarked that he created the work, an assignment for Robert Dunn's choreography workshop, while in a bathtub waiting "for A-200 to take effect on a bad case of crabs."[1] A study of movement in a compressed space, *Mannequin Dance* saw Gordon moving upstage via a series of off-balance pliés before gradually squatting down to the floor while slowly extending his arms forward and wiggling his fingers.[2] He wore a bloodied lab coat and belted out popular songs from musicals (Nancy Walker's "Get Married, Shirley" and Fanny Brice's "Second Hand Rose"). Choreographer James Waring, Gordon's friend and teacher-mentor, distributed balloons to audience members who filled and emptied them, producing the sound of air being released.

Gordon first came to dance when in 1956, as a fine arts student at Brooklyn College (and taking occasional classes at a modern dance club), he encountered Waring in a chance meeting in Washington Square Park. In 1958, Gordon appeared in Waring's first production, *Dances before the Wall*, for which he was paired in a duet with the British-born dancer Valda Setterfield. The duo would marry in 1961 and continue collaborating on dance long-term.

Gordon, who worked as a window dresser, was interested in how commodities and artworks are similarly staged for consumption. In his original conceit for the performance,

Gordon intended to integrate rented department store mannequins in various states of dress. In the art of the window display he saw a framework analogous to dance—to the ways choreography brings disparate elements together on stage and that we as spectators understand these compositions from the exterior.[3] His plan was to repeat the dance ten times throughout the evening, rearranging the mannequins and changing their costumes for each iteration.[4] He never did either, but the name stuck. In 1972, Gordon integrated the dance into a longer work called *The Matter*, in which forty performers—skilled and non-skilled, clothed and unclothed—performed *Mannequin Dance* (now referred to as *Mannequin*) in unison.

Random Breakfast was an elaborate five-part duet with Setterfield, the majority of which was improvised based on a general structure. The dance involved various costume changes, props, and theatrical cues, with Setterfield performing a complicated striptease out of a Victorian-era costume and Gordon in Carmen Miranda-esque drag, a reenactment of a TV appearance by comedian Milton Berle. In the section titled "Prefabricated Dance," Gordon improvised a modern dance history lesson that included a satirical demonstration of Judson's signature techniques. Today, Gordon is recognized for having leveraged humor and absurdist spectacle to deconstruct the conventions of performance while maintaining a self-reflexive levity. Reviewing *Random Breakfast*, Jill Johnston concluded, "Gordon and Setterfield are classic wits on the scene. Long live classic wits."[5] —VAC

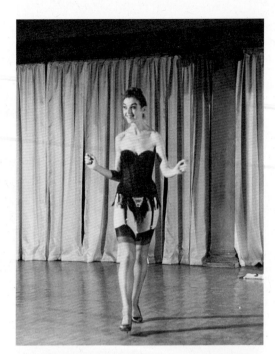

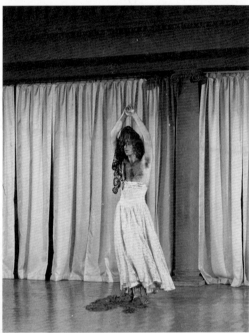

Notes
1. Interview with David Gordon, conducted by Gia Kourlas, June 2012, NYPL Oral History Project, MGZTL 4-2919, Jerome Robbins Dance Division, New York Public Library.
2. Diane di Prima, "A Concert of Dance: Judson Memorial Church" (1962), quoted in Sally Banes, *Democracy's Body: Judson Dance Theater, 1962–1964* (1983; repr. Durham, NC: Duke University Press, 1993), 54–55.
3. Joyce Morgenroth, "David Gordon," in *Speaking of Dance: Twelve Contemporary Choreographers on Their Craft* (New York: Routledge, 2004), 49.
4. David Gordon, "It's about Time," *Drama Review: TDR* 19 (March 1975): 44.
5. Jill Johnston, "From Lovely Confusion to Naked Breakfast," *Village Voice*, July 18, 1963.

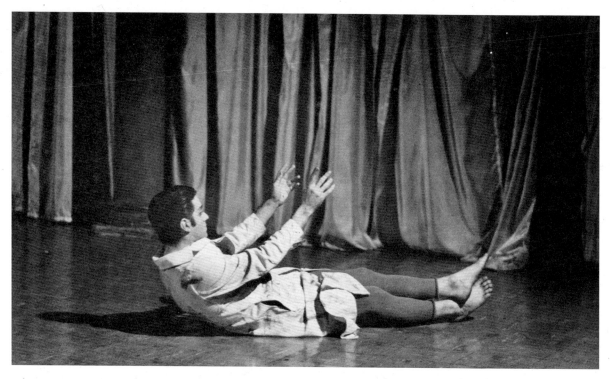

Opposite: Al Giese's photographs of Valda Setterfield (top) and David Gordon (bottom) in *Random Breakfast,* 1963. Performed at Concert of Dance #7, Judson Memorial Church, June 24, 1963. Above: Peter Moore's photograph of David Gordon in *Mannequin Dance*, 1962. Performed at Dance Concert of Old and New Works by David Gordon, Yvonne Rainer, Steve Paxton, Judson Memorial Church, January 10, 1966. Below: Babette Mangolte's photograph of David Gordon, Valda Setterfield, and unidentified performers in *The Matter*, 1972. Performed at Merce Cunningham Studio, New York, 1972

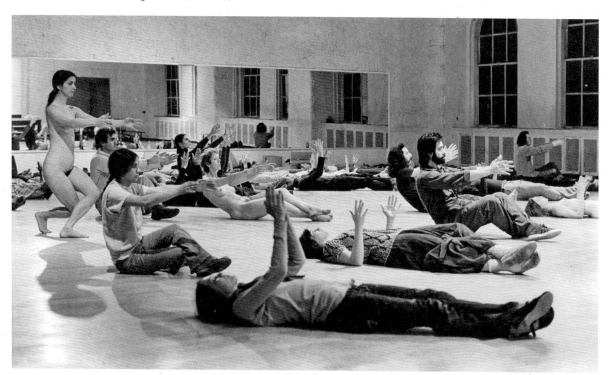

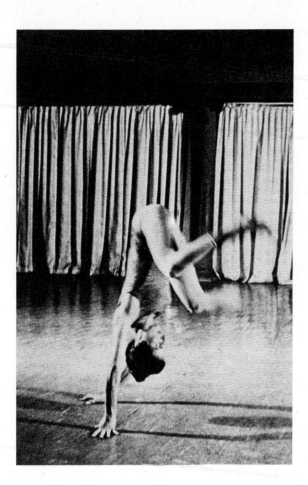

Above: Al Giese's photograph of Trisha Brown in *Trillium*, 1963. Performed at Concert of Dance #7, Judson Memorial Church, June 24, 1963. Opposite: Peter Moore's photographs of Trisha Brown and Steve Paxton in *Lightfall*, 1963. Performed at Concert of Dance #4, Judson Memorial Church, January 30, 1963

Trisha Brown
***Trillium*, 1962; *Lightfall*, 1963**

Reflecting on *Trillium*, her first professionally presented dance, choreographer Trisha Brown (1936–2017) explained: "I was working in a studio on a movement exploration that moved to or through the three positions of sitting, standing, and lying. I broke those actions down into their basic mechanical structure, finding the places of rest, power, momentum, and peculiarity."[1] Beyond this description of the three defining states or tasks and the dance's soundtrack—a recording of Simone Forti's vocal improvisations—little remains of Brown's choreographic debut,[2] which she showed at New York's Maidman Playhouse. By all accounts, Brown, performing solo, seems to have turned herself upside down. "When I saw *Trillium*," Elaine Summers would recall, "I decided that Trisha didn't know about gravity and therefore gravity had no hold on her."[3] Steve Paxton would recount that the dance had "a handstand in it and a lot of very beautiful, indulgent movement."[4] And William Davis, a dancer with Merce Cunningham's company at the time, would describe Brown's movements as "elastic and floppy," adding, "she fell and touched herself in surprising ways."[5]

At the urging of Forti and Yvonne Rainer, Brown arrived in New York from California in the fall of 1961 with the goal of participating in Robert Dunn's composition workshops. *Trillium*, which featured improvisation within a fixed score structure, combined Dunn's lessons about chance and other compositional strategies with those of Anna Halprin, whose improvisation and task-based techniques Brown absorbed in California in the summer of 1960. For Brown, improvisation offered a way of engaging with movement more actively—one that was unavailable to ballet and modern dancers, who simply repeated memorized steps. During structured improvisation, she explained, "you are using your wits, thinking; everything is working at once to find the best solution to a given problem."[6] The effect, she believed, was a way of bringing life, the real world, into the world of dance. In *Trillium*, as in her later dances, improvisation was the key to unlocking the virtuosic, at times wild potential of the moving body.

Perhaps an implicit preoccupation in *Trillium*, gravity became central to Brown's investigations in *Lightfall*, her second dance and the first to be presented at the Judson Memorial Church. Like *Trillium*, *Lightfall* was a work of structured improvisation, this time in the form of a duet performed with Paxton. "Using the simple action of waiting (football style, hands on knees) as a recurrent 'base,'" Jill Johnston wrote of the work, "the dancers initiated a spontaneous series of interferences—ass-bumping and back-hopping."[7] Paxton and Brown took turns sitting on one another's back, only to be dumped onto the floor as the bent-over partner stood up, "activating gravity's entropic effect."[8]

Fittingly, when later reflecting on the activities that took place at Judson in these years, Brown would invoke yet another falling metaphor: "It

was a phenomenal period of experimentation . . . and olde modern dance, exhausted by the battering it took on all fronts, keeled over like an elephant . . . rested, then rose again, changed forever."[9] In falling, central to each of these early dances, Brown found a place to begin. —JH

Notes
1. "Trisha Brown," in *Contemporary Dance*, ed. Anne Livet (New York: Abbeville Press, 1978), 46.
2. Susan Rosenberg, *Trisha Brown: Choreography as Visual Art* (Middletown, CT: Wesleyan University Press, 2016), 25.
3. Elaine Summers quoted in Marianne Goldberg, *Reconstructing Trisha Brown: Dance and Performance Pieces (1960–1975)* (PhD diss., New York University, 1980), 94.
4. Steve Paxton quoted in Sally Banes, *Democracy's Body: Judson Dance Theater, 1962–1964* (Ann Arbor, MI: UMI Research Press, 1983), 121.
5. William Davis quoted in ibid., 121.
6. "Trisha Brown," 48.
7. Jill Johnston quoted in Banes, *Democracy's Body*, 100.
8. Rosenberg, *Trisha Brown*, 67–68.
9. Trisha Brown, "How to Make a Modern Dance When the Sky's the Limit," in *Trisha Brown*, 290.

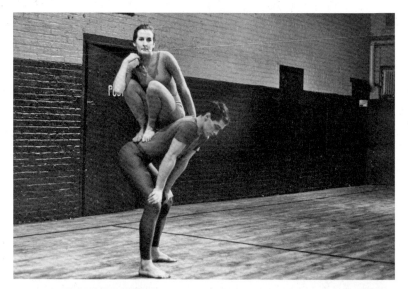

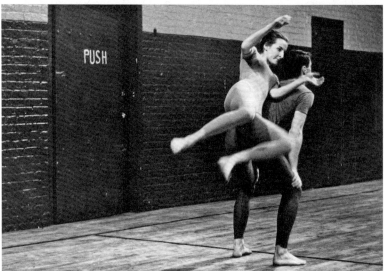

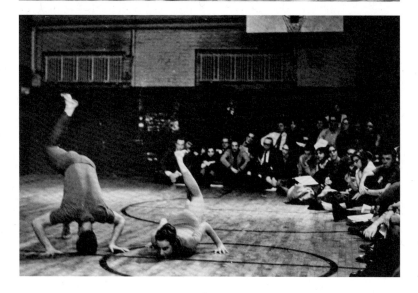

149

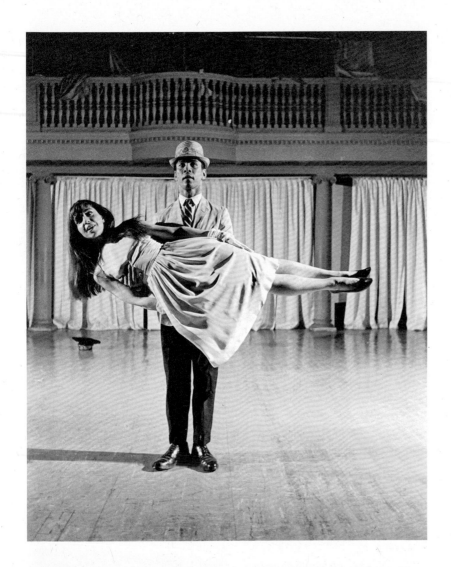

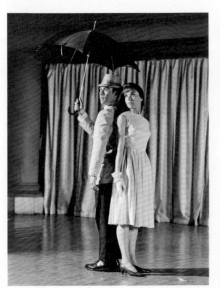

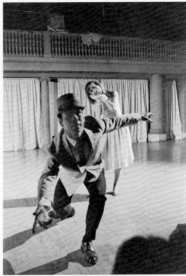

Rudy Perez
Take Your Alligator with You,
1963

For *Take Your Alligator with You*, Rudy Perez's inaugural work of choreography at Judson Dance Theater, the Bronx-born dancer and choreographer clipped poses from fashion magazines and newspaper advertisements and loosely sequenced them into a dance duet that he performed with choreographer Elaine Summers. *Alligator*, named after a brand of raincoat, became a commentary on commercial advertising, calling attention to its highly gendered representations. Summers wore a dress, oversize gloves, and high heels, while Perez (born 1929) donned a suit jacket and hat and carried an umbrella. The movements were sparse but highly exaggerated. In one sequence, Perez, with one leg outstretched in a backkick, placed his palms on Summers's rear as Summers covered her mouth with both hands in fake disbelief. In another, Summers stood in a relaxed version of ballet's first position, while Perez leaned in for a kiss on the cheek. The dance culminated as Perez lifted and carried Summers horizontally as if "she were a suitcase," as writer Sally Banes observed. Banes described the duo's choreographed dynamic as "halfway between a bourgeois couple and a vaudeville team."[1]

Perez's first of many appearances in a Judson performance was in Summers's *The Daily Wake* (1962) at Concert of Dance #1. Before Judson, Perez trained with Merce Cunningham and at the Martha Graham School in New York, where he developed the

classical dance training from which his more experimental tactics would evolve. Perez was recognized for reducing movement to its essential elements, simplifying and dramatizing spare gestures. "Everything unnecessary is stripped from his work, and the bare bones are polished until they gleam," critic Deborah Jowitt remarked in an early 1971 review.[2] In both *Alligator* and *Countdown* (1966), Perez's first solo work and one of his most iconic, he prolonged the ordinary task of smoking a cigarette using extended slow motion. The protracted pace set stillness and movement into arresting tension. Perez employed stillness for its "charged potential," as Jowitt wrote, much as composer John Cage used silence in his sound compositions.[3] Critics have frequently compared the halted action of Perez's choreography and its reduced vocabulary to Minimalist sculpture.[4]

A theatricality that is typically written out of the discourse on Judson characterizes Perez's choreography. *Alligator* is perhaps Perez's most overtly humorous dance, imbuing minimalist gestures with camp inflections. Perez maneuvers the tension between stoicism and drama via measured evocations of emotion. Reflecting on the ways his tactics subtly challenged the broader resistance to theatricality at Judson, Perez noted: "The people at Judson were anti-drama and emotion and I think I suppressed the very thing I'm good at. That's how I arrived at the stillness that I'm known for. But underneath I try to poke fun at all that."[5] —VAC

American's new "Wife Vacation Plan"

151

Notes
1. Sally Banes, *Democracy's Body: Judson Dance Theater, 1962–1964* (1983; repr. Durham, NC: Duke University Press, 1993), 145.
2. Deborah Jowitt, "The Stillness of Rudy Perez," *Art in America* (May 1971): 102.
3. Ibid.
4. In the aforementioned review, Jowitt likens Perez's choreography to the "primary structures of contemporary sculpture." *Primary Structures* was a 1966 exhibition at the Jewish Museum in New York that highlighted emerging Minimalist tendencies in sculpture.
5. Perez quoted in Jennifer Dunning, "Men's Company to Bow at Judson Church," *New York Times*, February 5, 1978.

Opposite: Al Giese's photographs of Rudy Perez and Elaine Summers in *Take Your Alligator with You*, 1963. Performed at Concert of Dance #7, Judson Memorial Church, June 24, 1963. Above: Newspaper clipping used in preparation for Rudy Perez's *Take Your Alligator with You*, 1963

Andy Warhol
Jill and Freddy Dancing, 1963

Jill and Freddy Dancing, an early Andy Warhol (1928–1987) short silent film, features critic Jill Johnston and performer Fred Herko in a duet on the rooftop of painter Wynn Chamberlain's legendary loft at 222 Bowery in New York.[1] The film begins as Johnston unwinds her arms and sways her hips standing atop a chair. From off-camera-left, Herko emerges suddenly—tall, lean, and shirtless. He circles his friend; pirouettes, sautés, and raises his arms into fourth position; and then grabs Johnston by the hand. Warhol shot the footage on his Bolex camera from several positions and edited the hundred-foot roll in-camera. As with many of his silent films, he projected it at sixteen frames per second rather than the twenty-four frames per second he shot it at, slowing down the performers' motion. The dancers' virtuosic movements are juxtaposed with everyday activities, as they smoke cigarettes, drink beer, and throw discs at one another. Warhol captures the antics of a fleeting moment of friendly flirtation in which Herko and Johnston are aware of themselves as objects of the camera's desire.[2]

Various references to the world of dance emerge repeatedly in Warhol's oeuvre. Choreographer Lucinda Childs, costume designer Kenneth King, and critic Edwin Denby, for instance, each feature as the intimate subject of one of his *Screen Tests*. (King also appeared in three unused rolls shot for *Couch* [1964] and Childs is the star of *Shoulder* [1964].) In Warhol's first exhibition, at New York's Stable Gallery in 1962, he installed his black-and-white Dance Diagram silkscreens, commercially available diagrams for social dances such as the fox-trot and the tango, directly on the floor, as if for use. In dance, Warhol found an avenue for his subjects and viewers to participate.

Warhol frequented the Judson performances and workshops from early in the group's formation. He filmed Ruth Emerson and Arlene Rothlein performing in leotards in the church basement in early 1964 and Yvonne Rainer performing at James Lee Byars's 1963 exhibition at Green Gallery in New York. It was at Judson that he saw Herko, whom he would feature in multiple films. In *Dance Movie*, of 1963, also known as *Roller Skate* (which is lost as of the time of publication), Herko ambles down a New York City street on roller skates. Warhol was inspired by Herko's performance in *Binghamton Birdie* earlier the same year; in it, Herko dances on one skate, his T-shirt imprinted with the word *Judson*. In *Haircut (No. 1)*, also of 1963, Herko flashes his genitals during one of the free haircutting salons held by Judson lighting designer Billy Linich (aka Billy Name).[3] Herko also appears in rolls intended for use in *The Thirteen Most Beautiful Boys* (1964) and *Kiss* (1963–64).

Warhol also included Johnston in a number of films, where she displays her own set of dance-related hijinks. In three rolls from 1963, she performs a duet with a rifle the Sunday after President John F. Kennedy was shot. In *Jill Johnston Dancing* (1964)—some of the first footage Warhol shot at the

Above: Alfred Statler's photograph of Andy Warhol's exhibition opening at Stable Gallery, November 1962. Opposite: Andy Warhol. Stills from *Jill and Freddy Dancing*, 1963

Factory, his iconic stage and production center in New York—she spins, sweeps, and twirls a broom.

Warhol made *Jill and Freddy Dancing* four months after first picking up a camera. The rooftop setting in the film, not quite public, not quite private, anticipates the use of rooftops in a number of essential works of the era, including Trisha Brown's *Roof Piece* (1971) and Joan Jonas's *Song Delay* (1973), as well as Warhol's own *Batman Dracula* (1964). Each marks urban space as a zone of intimacy and encounter where groups of people rely on movement to communicate, seduce each other, or just make one another laugh. —TJL

Notes
1. Jill Johnston, "Dance Journal," *Village Voice*, November 28, 1968.
2. Paisid Aramphongphan, "Real Professionals? Andy Warhol, Fred Herko, and Dance," *Performing Arts Journal* 110 (May 2015): 1–12.
3. Callie Angell, "*Haircut (No. 1)* (1963)," *The Films of Andy Warhol: Part II* (New York: Whitney Museum of American Art, 1994), 12.

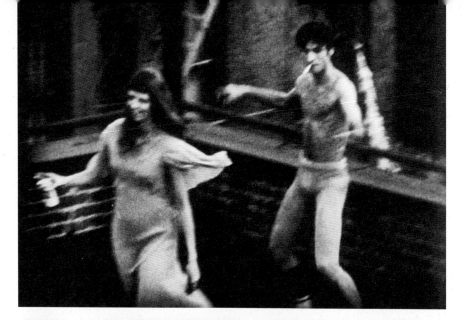

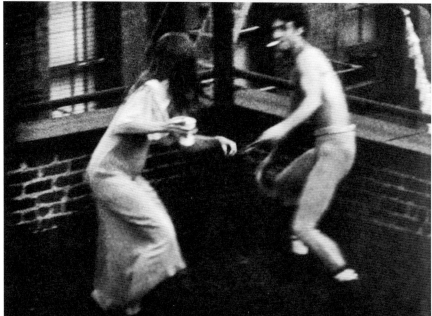

Fred Herko
Binghamton Birdie, 1963

Fred Herko's *Binghamton Birdie*, performed at Concert of Dance #6 at Judson Memorial Church, was a five-part sextet that included music by Joe Jones and an assemblage of broken every-day objects by artist George Herms. The dance opened as Herko (1936–1964), wearing a black cape and holding a black umbrella, whimsically played a flute while walking in a squat. Next, the curtains hanging from the choir loft parted to reveal the performers moving in set formations between the pillars supporting the balcony, followed by Jones's chan-delierlike self-playing drums being lowered from above. Herko appeared through the curtain, this time wearing black tights and a yellow-and-blue athletic jersey with the word *Judson* emblazoned across the front, parodying the group's self-reflexivity as well as the heroic ideal of the male dancer's body associated with ballet. Wearing only one roller skate—a pedestrian surrogate for a point-shoe—he glided around the structure, shifting his arms and free leg into vari-ous balletic positions and thus dividing his body between the pop entertainment associated with the skate's leisure and tradition's classical form. He then stopped to dance on his toes in relevé before disappearing backstage. The work ended as the six per-formers reprised their earlier movements.[1] Describing its structure, critic Jill Johnston wrote that its five sections "cohere with that strange logic of parts that have no business being together, but which go

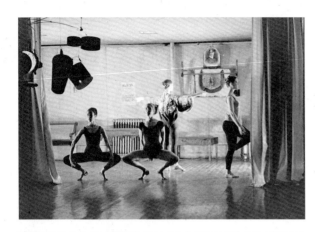

together anyway because anything in life can go with anything else if you know what you're doing."[2]

Fred—or Freddie—Herko came to New York in the early 1950s to study piano at the Juilliard School. He trained at the American Ballet Theatre School (associated with New York City Ballet), danced with James Waring Company, and served as muse to Diane di Prima, coeditor of the *Floating Bear* newsletter. Herko performed two works at the Judson premiere, where, as cofounder of Judson Poets' Theater, he was among the most well-known performers, one of three included in the concert's *Village Voice* announcement.[3] Herko's work consistently displayed his commitment to classical dance while irreverently sending up its norms. For example, in a passage of Elaine Summers's film *Judson Fragments* (1964), he leaves the back of a downtown Manhattan building wearing only a dance belt and a fur coat and waters a garbage can. His open caring for the discarded matter reveals a neoromantic sensibility di Prima described in *Freddie Poems*. In "Formal Birthday Poem: February 23, 1964," penned on Herko's birthday the year he would die while high on amphetamines, she uncannily observed: "yes, now you are 28, you are shooting A / you are getting evicted & there is another coldwave / you are worried about your costumes—can you take them / with you & to where you are late a lot for performance / and not very good, although you are sure you are perfect."[4]

Herko made work with and for his friends, and *Binghamton Birdie* lifts its title directly from the nickname

of a familiar he hung out with at the bohemian San Remo Coffee Shop in Greenwich Village and at Andy Warhol's Factory on Forty-Seventh Street. Herko performed in six Warhol films, including the 1963 *Dance Movie*, also called *Roller Skate*. The following year, Herko jumped from an apartment window in front of his friend John Dodd, who was also Judson's lighting designer. Dodd later described the jump as a perfect jeté, observing that no part of Herko's body touched the window frame: the coalescing of reality and representation at Judson was at times haunting. Gerard Malanga, who also hung out at the Factory, imagined the perverse emotions of this paradox in a poem he recited at a screening of *Roller Skate* organized shortly after Herko's death: "Perhaps, as I imagine hunger and pain, / You are the night in a very expensive place, gorgeous and vulgar."[5] —TJL

Notes
1. Sally Banes, *Democracy's Body: Judson Dance Theater, 1962–1964* (Ann Arbor, MI: UMI Research Press, 1983), 136.
2. Jill Johnston, "Dance: Judson Speedlimits," *Village Voice*, July 25, 1963.
3. "What's On: Village and Vicinity," *Village Voice*, June 28, 1962, 20.
4. Diane di Prima, *Freddie Poems* (Point Reyes, CA: Eidolon Editions, 1974), 62.
5. Gerard Malanga, "Rollerskate," *Floating Bear* 29 (March 1964): 358. *the Intermedia* (Carbondale: Southern Illinois University Press, 1984), 18–21.

155

Opposite and above top: Al Giese's photographs of Fred Herko (opposite) and unidentified performers (above) in *Binghamton Birdie*, 1963. Performed at Concert of Dance #6, Judson Memorial Church, June 23, 1963. Above bottom: George Herms's photograph of Fred Herko, 1964. Published in Diane di Prima's *Freddie Poems*, 1974

Yvonne Rainer
Terrain, 1963; *We Shall Run*, 1963; *Parts of Some Sextets*, 1965

Yvonne Rainer's *Terrain* was the Judson group's first evening-length presentation of a single work by one choreographer, as well as the first concert to use the name Judson Dance Theater in its publicity materials. *Terrain*'s five sections, each performed by six dancers, used games as a guiding compositional principle. The dance began with "Diagonal," a rule-based game involving two categories of movement, one designated by letters and the other by numbers. Performers traveled diagonally across the stage area enacting various letter/number combinations that were called out by members of the group, clustering according to instructions provided by Rainer (born 1934). Some movements distorted ballet steps or reenacted movie scenes from films such as Jean-Luc Godard's *Breathless*. The compositional structure of the dance's other four sections similarly relied on games; for example, the fourth section, titled "Play," consisted of eleven games, each with its own set of rules.

Terrain's third section, "Solo," began with two dancers performing solos while reciting the essays "On the Truth" and "On Evil" by poet Spencer Holst. Filmmaker Hollis Frampton, who was at the performance, told of being shocked to see dancers speaking on stage. Here Rainer challenged the muteness of the modern dancer, imbuing her performers with a different type of agency. Steve Paxton described having to learn to dance and speak at the same time: "The Spencer Holst solo was the first time that I performed speaking; I remember trying to get the sense of the story across while moving and going through all kinds of perambulations."[1] Rainer would continue to explore the combination of speech and movement in her later work.

Rainer's dance training in the early 1960s ranged from classes with eminent choreographers Anna Halprin, Merce Cunningham, and James Waring to composition workshops with Robert Dunn, where Rainer was exposed to scoring and John Cage's chance procedures. In her own work, she experimented with athletic and everyday movements such as running, walking, and falling. "I love the body," she wrote toward the end of the 1960s. "Its actual weight, mass, and unenhanced physicality."[2] In *We Shall Run*, the dancers run toward each other and then scatter in a number of different configurations to the bombastic and brassy Tuba mirum of Hector Berlioz's Requiem (1837). This pattern—of performers breaking off from the group to come together with one or two others—recurs throughout the piece. This choreography's interplay between individual and group represents a dynamic analogous to Judson Dance Theater's own processes as a collective. The juxtaposition of Berlioz's high Romanticism and the ordinary nature of the dancers' movements exemplifies Rainer's ongoing interest in staging two contrasting dynamics: the high drama of music set against uninflected movement.

Parts of Some Sextets, performed at the Wadsworth Atheneum in Hartford, Connecticut, and at Judson

Above: Yvonne Rainer. Score for Yvonne in "Bach" from *Terrain*, 1963. Opposite top: Peter Moore's photograph of *Terrain*, 1963. Performed at Judson Memorial Church, April 28, 1963. Pictured, from left: William Davis and Albert Reid (foreground); Yvonne Rainer, Judith Dunn, Trisha Brown, and Steve Paxton (background). Opposite middle: Al Giese's photograph of Yvonne Rainer and unidentified performers rehearsing for *Parts of Some Sextets*, 1965. Pictured in New York, January 1965. Opposite bottom: Peter Moore's photograph of *We Shall Run*, 1963. Performed at Two Evenings of Dances by Yvonne Rainer, Wadsworth Atheneum, Hartford, Connecticut, March 7, 1965. Pictured, from left: Robert Rauschenberg and Joseph Schlichter (back, hidden); Sally Gross, Tony Holder, Deborah Hay, and Robert Morris (middle); Yvonne Rainer, Alex Hay, and Lucinda Childs (front).

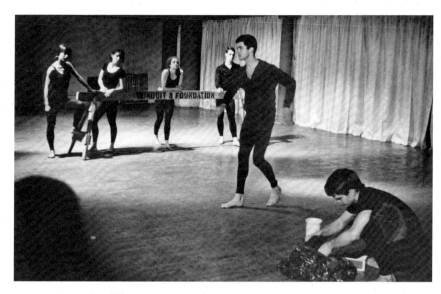

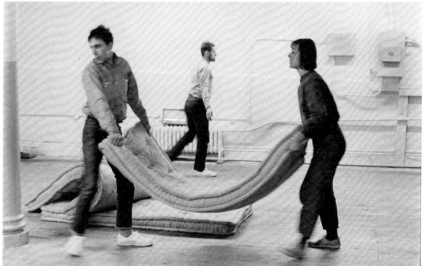

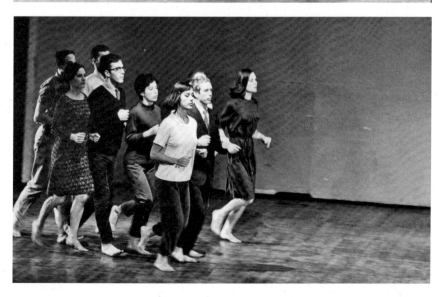

Memorial Church is a dance for ten people and twelve mattresses.[3] Two years prior, Rainer had used mattresses in *Room Service*, invoking the prop's connotations from the somnolent to the sexual. For the score of *Parts of Some Sextets*, she drafted a chart that arranges thirty-one choreographic scenarios alongside a vertical column indicating thirty-second segments annotated with the dancers' initials. This material included: "Duet: Leaning away through 1st embraces," "Bird run," "Bent-over walk," "Sleeping figure," "Quartet," "Human flies on mattress pile," and "Swedish Werewolf." An audio recording of Rainer reading from *The Diary of William Bentley, D. D.*, a late-eighteenth-century Episcopal minister, from the New York Public Library, accompanied the piece.

In her notes on *Parts of Some Sextets* from that same year, Rainer first articulated her renowned No Manifesto stating, "No to spectacle no to virtuosity no to transformations and magic . . . no to style no to camp no to seduction of spectator by the wiles of the performer." In the same statement, she described her hope that the work would operate in the spaces between dramatic theater and nontheater (Happenings).[4] —MJ

Notes
1. Sally Banes, *Democracy's Body: Judson Dance Theater, 1962–1964* (1983; repr. Durham, NC: Duke University Press, 1993), 111.
2. Yvonne Rainer, "Statement" [1968], program for *The Mind Is a Muscle*, Anderson Theater, New York, April 1968, reprinted in Rainer, *Work 1961–73* (Halifax: Press of the Nova Scotia College of Art and Design, 1974), 71.
3. Rainer often reworked similar material into different pieces or various versions of pieces. The duet version was titled *Part of a Sextet*.
4. Rainer, *Work*, 45–50.

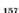

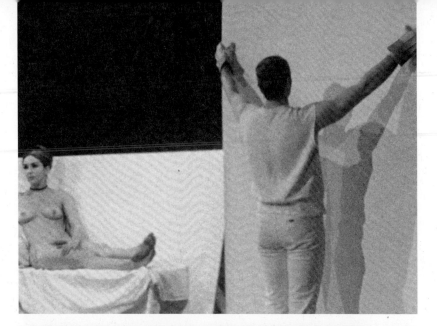

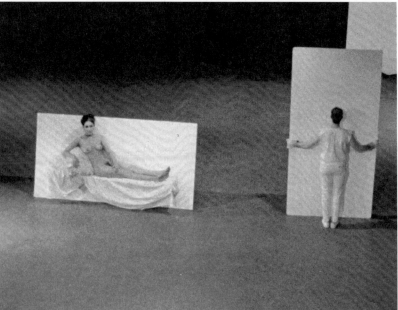

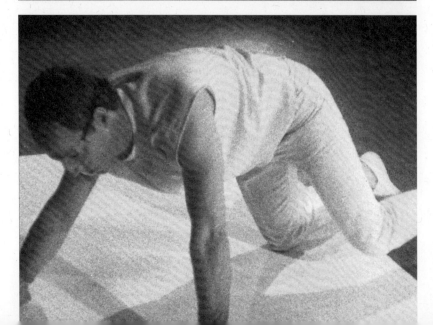

Robert Morris's *Site* combines the artist's interest in work that emphasizes a temporal and bodily engagement with sculptural forms and art making as a form of labor. Morris (born 1931) enters the stage wearing worker's clothing, gloves, and a white mask. Piece by piece, he disassembles a boxlike structure, carrying, balancing, and flipping the sheets of white plywood as he removes them; eventually, a nude Carolee Schneemann is revealed. Centrally positioned and also painted white, she has assumed the pose of the courtesan from Edouard Manet's *Olympia* (1863). According to Morris, in his performances "space, like time, was reduced to context, necessity; at most a way of anchoring the work, riveting it to a maximum frontality."[1] In *Site*, this emphasis on frontality alludes to the traditional orientation of easel painting. Schneemann plays the archetypal female nude, remaining immobile, the passive object of the male gaze, while Morris assumes the role of the painter, but in three-dimensions; he transforms space, framing, revealing, and concealing Schneemann's body. As scholar Rebecca Schneider notes, Morris's centering of the focus on himself as an artist and worker obscures the other manifestations of labor in Manet's work, including Olympia's role as a courtesan who sells her body and the black maid in the painting who brings Olympia flowers from a potential suitor. Schneider reframes Schneemann's performance as a subversive act in which

this passivity is performative, with Schneemann "replaying the prostitute across her own body as an artist." Schneider notes, however, that the erasure of the black woman in the performance creates a situation where "Schneemann's whiteness in her claiming agency appeared unmarked."[2]

In Morris's *Arizona*, performed the year prior, the artist investigated the "specific problems involving space, time, and alternate forms of a unit."[3] In part one of the piece, he turned slowly while a tape of his voice animatedly described the movement of cows; in part two, he aimed and threw a javelin; in part three, he manipulated a T-shaped wooden construction, shifting its position until he had completed a preset number of possible orientations; finally, in part four, he swung a light bulb on a long cord over his head in widening circles until the light became so distant that he could no longer be seen.

Site and *Arizona* expand on Morris's exploration of the relationship between an object and the body that he had earlier examined in *Column* (1962). Morris placed a gray, body-sized rectangular column made of plywood in the center of the stage and after three and a half minutes toppled it using a string. The artist had originally intended to stand inside the column but was injured during rehearsal. Morris then left the column resting horizontally on the floor for the same amount of time. *Column* incorporated Morris's theorization of scale, in which the "relative size of the human body enters into the total continuum of sizes and establishes itself as a constant"[4] by anthropomorphizing

the column as a performing body. He created a series of situations exploring movement and stasis based upon the interaction between performers and objects. His performances, as with his Minimalist work, explore the interaction of the body and the sculptural object. They also prefigure his future interest in process art, in which production and artistic labor became the work itself. —EG

Notes

1. Robert Morris, "Notes on Dance," *Tulane Dance Review* 10, no. 2 (Winter 1965): 183.
2. Rebecca Schneider, *The Explicit Body in Performance* (New York: Routledge, 1997), 31.
3. Morris, "Notes on Dance," 180.
4. Morris, "Notes on Sculpture, Part 1" [1966], in *Continuous Object Altered Daily: The Writings of Robert Morris* (Cambridge, MA: MIT Press, 1995), 230.

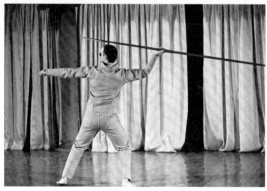

159

Opposite: Stan VanDerBeek. Stills from *Site*, 1965. Above: Al Giese's photographs of Robert Morris in *Arizona*, 1963. Performed at Concert of Dance #6, Judson Memorial Church, June 23, 1963

160

Left: Scores for "Flares," 1963.
Opposite: Peter Moore's photo-
graphs of "Flares," 1963. Performed
at Concert of Dance #8, Judson
Memorial Church, June 25, 1963

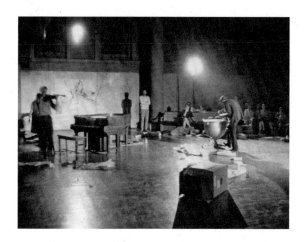

Notes
1. In Concert of Dance #8, "Flares" was performed by Corner, Malcolm Goldstein, Dick Higgins, Norma Marder, Elizabeth Munro, Max Neuhaus, Arlene Rothlein, Beverly Schmidt, James Tenney, and Vincent Wright.
2. Other works such as *Moving Piece* (1961) and *Air Effect* (1961) featured scores similarly inspired by calligraphy. "Flares" was the only calligraphic score to use color.
3. Sally Banes, *Democracy's Body: Judson Dance Theater, 1962–1964*

(1983; repr. Durham, NC: Duke University Press, 1993), 151.
4. Works that feature music by Corner include: Waring, *Corner Piece* (1958); Schmidt, *Pindaric* (1962); Schmidt, *Prelude to a Masked Event* (1962); Schneemann, *Glass Environment for Sound and Motion* (1962); Rainer, *Terrain* (1963); Childs, *Pastime* (1963), among others.
5. Eventually Corner would draft written notes for use by future performers of this work. Banes, *Democracy's Body*, 155.

Philip Corner
"Flares," 1963

"Flares," performed at Concert of Dance #8, alternated loud bursts of electronic sound, projected images, and movement with complete darkness and silence. Corner invited the performers to translate the composer's abstract calligraphic drawings into sound and movement.[1] His instructions were permissive: the performers could treat the line drawings as musical notations and try to replicate the shape in sonic form, or perform an action inspired by the shape. Corner displayed slides of the drawings on the wall using an overhead projector. Their ink medium and brush style were inspired by East Asian calligraphy, which Corner learned during his military service in Korea.[2] The tape recording of "Flares," made at the Columbia-Princeton Electronic Music Center in the early 1960s, features pitch modulations from low to high and vice versa, with intermittent bursts of loud tones. While the performance incorporated movement and visual imagery, Corner considered the work a piece of music, claiming: "I extended what it is to be a musician."[3] This integration of dance, drawing, and projection is characteristic of the interdisciplinary ethos in the Judson circle.

Corner (born 1933) studied composition under Olivier Messiaen in France in the 1950s and returned to New York for his master's at Columbia University in 1957. Although he traveled in circles influenced by John Cage, his musical impulses tended toward the sensual, emotional, or improvisational. Along with composers Malcolm Goldstein and James Tenney, he founded the chamber ensemble Tone Roads, a group that initially featured music by American composers such as Charles Ives and Edgard Varèse and later expanded to include more contemporary American avant-garde musicians. He was likewise inspired by jazz and other improvisatory musical practices, collaborating with Goldstein on improvisations for decades to come. In addition to performing at Judson, he composed scores for his choreographer peers James Waring and Beverly Schmidt, and occasionally for Elaine Summers, Lucinda Childs, Sally Gross, Carolee Schneemann, and Yvonne Rainer.[4]

Like his contemporaries, Corner experimented with scoring, but more than expanding musical notation to better represent experimental sounds—as others, such as Earle Brown, did with graphic notation—he challenged notation's relationship to performance. For "Big Trombone" (1963), he forewent written notation entirely, producing a tape recording instead of a score.[5] At Columbia, he met Fluxus members Dick Higgins and Alison Knowles, and experimented with action-based works such as "Keyboard Dances" (1963), in which he performed with his forearms or feet, playing not only the keys but also the strings inside the piano, prompted by a series of scrolls with instructions like "Dance low inside piano—lying stretched, or crouched on knees," "Ball, marbles, etc rolled over on the strings," and "Sexual intercourse in conjunction with a piano," bringing a new physicality to musical performance.—MJ

Deborah Hay
They Will (then titled *Would They or Wouldn't They?*), 1963

Deborah Hay (born 1941) premiered *They Will* (then titled *Would They or Wouldn't They?*) in the sanctuary of Judson Memorial Church at Judson Dance Theater's Concert of Dance #13. As with all of the dances in the concert, *Would They* responded to an interactive environment created by sculptor Charles Ross. This sculpture included a three-dimensional trapezoid from which the dancers could hang; ropes; a long seesaw; a wooden platform; and a collection of chairs, tires, and mattresses. Reviewing the concert for the *Village Voice*, Jill Johnston noted, "The balancing, climbing, sliding, swinging, hanging, jumping, and falling activities made possible by this construction set the tone of dominant physical movement that the Judson dancers have projected on a smaller scale since the beginning."[1] Alex Hay, Deborah, David Lee, and Yvonne Rainer performed, accompanied by music composed by Al Hansen.

As the piece opened, the women performed balletic movements outside the trapezoidal structure, while the men attempted to rise to standing while keeping their foreheads pressed together. Like children on a playground, the men then hung from ropes attached to the iron trapezoid and treated the construction like monkey bars. Throughout the piece, the women directed the men, calling out to them with requests to be moved or carried. At one point, the men lifted the women, allowing them to dangle from the sculpture, then jumped

up themselves, facing in the opposite direction. They all hung from the bars until their arms gave out and one by one dropped to the ground. With *Would They*, Hay inverted traditional gender dynamics: the women directed the action, while the men responded to their instructions. "Women had parts; men had mostly supportive roles," Hay has remarked of the dance. "It didn't have emotional intentions. It was formal; it was [a way of] using the structure."[2]

In *All Day Dance*, Hay used composer John Herbert McDowell's score to cue the dancers to jump, kick, or somersault. Hay continued her investigations in her post-Judson dance *Ten* (1968), for which she created an environment for the dancers to respond to. Divided into groups of different sizes, the performers navigated around a vertical and a horizontal bar that bisected the stage. Behind the horizontal barrier, the Third Eye, a rock band, played live accompaniment. Hay's work exemplifies her belief in the potential playfulness of dance and the responsiveness of the dancing body to the surrounding environment. —EG

Notes
1. Jill Johnston, "Judson Collaboration," *Village Voice*, November 28, 1963.
2. The piece was shown again in 1964 under the title *They Will* at the Concert for New Paltz, New York; the ONCE Festival in Ann Arbor, Michigan; and Stage 73 in the Exchange concert. In the three subsequent performances Robert Rauschenberg replaced David Lee. Film footage of work from Judson performances is rare, but a clip from the *They Will* in the Exchange program has been preserved.

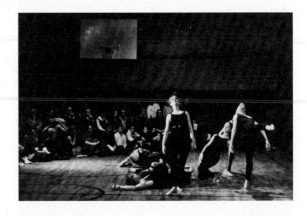

Above: Peter Moore's photograph of Gretchen MacLane (left), Deborah Hay (right), and unidentified performers in *City Dance*, 1963. Performed at Concert of Dance #4, Judson Memorial Church, January 30, 1963. Below: Elisabeth Novick's photograph of Alex Hay, Robert Rauschenberg, Barbara Dilley, and Deborah Hay (from left) performing *They Will*, 1963. Performed at First New York Theater Rally Concert #3, former CBS studio, May 25, 1965. Opposite: Peter Moore's photographs of Alex Hay, David Lee, Yvonne Rainer, and Deborah Hay (top, from left) and Alex Hay, Deborah Hay, and Rainer (bottom, from left) in *They Will* (then titled *Would They or Wouldn't They?*), 1963. Performed at Concert of Dance #13, Judson Memorial Church, November 20, 1963

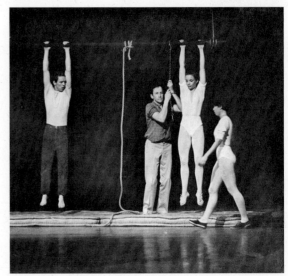

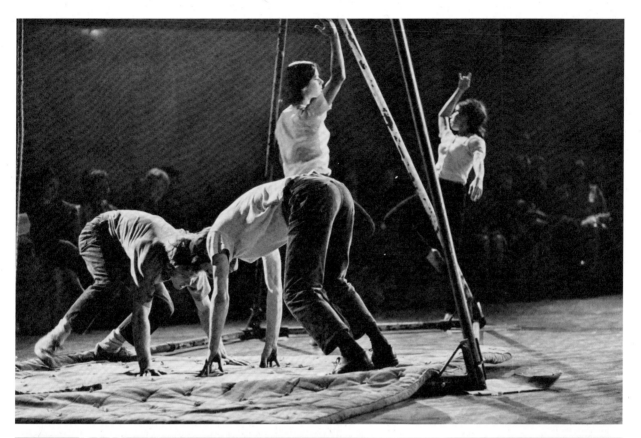

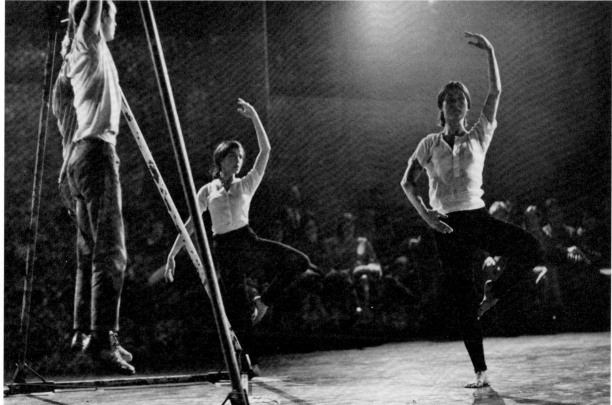

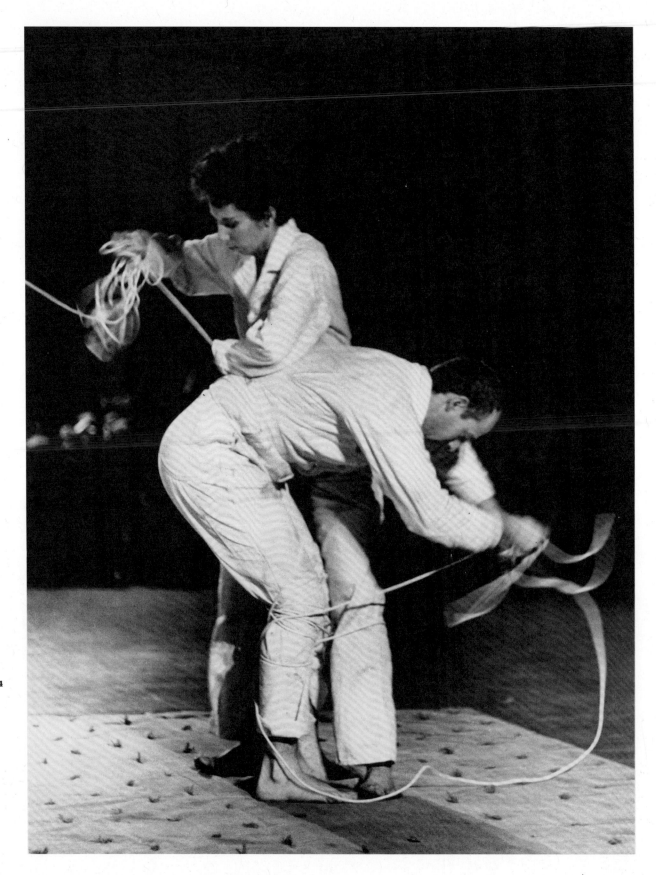

Judith Dunn
Motorcycle, 1963

On December 6 and 7, 1963, Judson Dance Theater presented Judith Dunn's evening-length concert Motorcycle, featuring twelve of the choreographer's dances. *Speedlimit*, shown earlier the same year, appeared in the round.[1] The dancers balanced, tumbled, and grappled on a gym mat, while engaging props including a car, a pole, flags, and ropes. Dunn (1933–1983) showcased similarly playful choreography in *Acapulco*, which featured Deborah Hay brushing Lucinda Childs's hair in slow motion and Yvonne Rainer being wheeled in on a cart and dropped on the ground. *Motorcycle*, the performance that gave the evening its name, was inspired by the motorcycle culture around Washington Square Park.[2] In this new solo piece, Dunn held a yogic Lion Pose, mouth open with the tongue out and eyes rolled back in the head, before transitioning to delicate falls and static poses that recalled her tenure at the Merce Cunningham Dance Company from 1959 to 1963.

Dunn began choreographing her own work after joining the second composition course led by her husband, Robert, at the Cunningham studio in the spring of 1961. By fall, she had begun actively facilitating the course, as she would the early concerts at Judson Memorial Church. In the program notes for Concert of Dance #2, the class thanks both Dunns: "We would like to acknowledge our debt to Robert and Judith Dunn, who provided a framework in which dancers could freely explore their art and themselves."[3] In 1966,

Dunn collaborated with Gene Friedman on a film titled *Index* (1967), in which she dances a duet with Tony Holder. The film features three superimposed versions of the dance set to a cello composition by Bill Dixon, which he overdubbed and looped on tape six times.

Dunn collaborated frequently. In *Last Point: A Collaborative Event* (1964), she choreographed the movements, Friedman projected films onto screens that the dancers moved between, and Robert Dunn recited an original poem as accompaniment. Writing for the *New York Times*, Allen Hughes described the piece as a "forest of screens with their images and the dancers as elements in a field of moving sculpture."[4] Dunn's interest in experimentation and collaboration explain in part her refusal to classify the Judson concerts as a movement: "I feel that the Judson Dance Theater is not a 'group,' is more than a 'movement' and more than any one person's view of its products. Undoubtedly certain aspects of the work will 'go down in history.' Well, let the future worry about that. The concern for history interests me less than the total activity that has taken place and the work that continues at this moment."[5] —EG

Notes
1. *Speedlimit* was performed previously at Concert of Dance #8 at Judson Memorial Church (June 25, 1963).
2. Sally Banes, *Democracy's Body: Judson Dance Theater, 1962–1964* (1983; repr. Durham, NC: Duke University Press, 1993), 111.
3. Program for Concert of Dance #2, Judson Memorial Church Archive, MSS 094, 3;31, Fales Library & Special Collections, New York University Libraries.
4. Allen Hughes, "Dance: 'Last Point' Given at Judson," *New York Times*, October 20, 1964, 42.
5. Judith Dunn, "My Work and Judson's," *Ballet Review* 1 no. 6 (1967): 23.

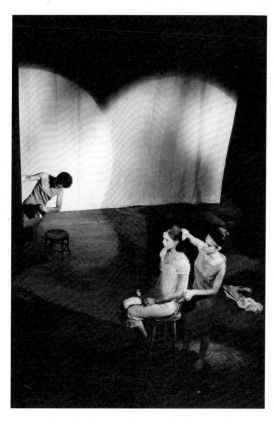

Opposite: Peter Moore's photograph of Judith Dunn and Robert Morris in *Speedlimit*, 1963. Performed at the concert Motorcycle, Judson Memorial Church, December 6, 1963. Above: Peter Moore's photograph of Judith Dunn, Lucinda Childs, and Deborah Hay (from left) in *Acapulco*, 1963. Performed at Concert of Dance #9, Gramercy Arts Theater, July 30, 1963. Below: Peter Moore's photograph of Judith Dunn in *Witness II*, 1963. Performed at the concert Motorcycle, Judson Memorial Church, December 6, 1963. Pictured: Tony Holder, Alex Hay, John Worden, and Steve Paxton (background, clockwise from left, performing Robert Ellis Dunn's *Doubles for 4*); Judith Dunn (foreground).

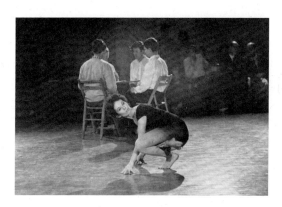

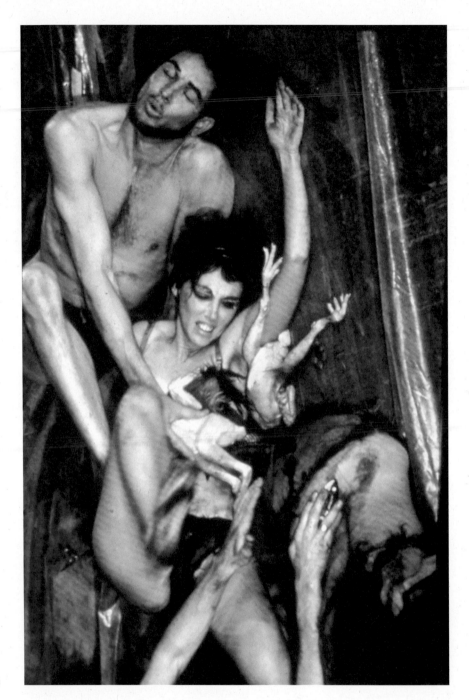

Above: Al Giese's photograph of Stanley Gochenouer, Dorothea Rockburne, James Tenney (hands), and Carolee Schneemann (from left) in *Meat Joy,* 1964. Performed at the event Meat Joy, Judson Memorial Church, December 17, 1964. Opposite top: Al Giese's photograph of Carol Summers, Deborah Hay, and Lucinda Childs (from left) in *Chromelodeon (4th Concretion),* 1963. Performed at Concert of Dance #7, Judson Memorial Church, June 24, 1963. Opposite bottom: Carolee Schneemann. Watercolor for *Banana Hands,* 1962

Carolee Schneemann (born 1939) staged her first work under the Judson banner, *Newspaper Event*, in the basement of Judson Memorial Church at Concert of Dance #3. Eight dancers walked onto the floor with cartons of newspapers, which they strew throughout the space and used to create impromptu costumes. Schneemann assigned each dancer a task as well as body parts to inspire their movements (spine, legs and face, shoulders and arms, neck and feet, hands, head, or fingers). She instructed Arlene Rothlein to explore the sensation of horizontality and Yvonne Rainer to spend the entire performance making an enormous pile of newspapers. Performers were given instructions and, unbeknownst to them, these instructions often interfered with other performers' assigned tasks. Schneemann timed the piece and crawled on the floor with a flag in her mouth, planting it on the other participants.[1] She envisioned *Newspaper Event* as an absorptive cellular organism that could engulf the process-based conventions of Judson Dance Theater, creating an overwhelming sensorial event: "I wanted touch, contact, tactile materials, shocks—boundaries of self and group to be meshed and mutually evolving."[2] The artist describes the effect of the piece as "an image of a huge exploded collage."[3]

Schneemann was born and raised in Fox Chase, Pennsylvania. In 1961, after completing her MFA in painting at the University of Illinois in

Urbana, she moved to New York where she gravitated toward the city's performance scene. She was one of the few painters to choreograph at Judson, and her background, she has argued, distinctly informed her consideration of the church's visual context—particularly its basketball court and exit sign—as a support for the group's performances.[4] For Schneemann, performance functioned as an expansion of her visual arts practice. Her scores, for example, emerged as "a series of sequences and actions embodied by these figurations I would draw."[5] Her 1962 *Banana Hands* was a "dream-like vision" made for but unrealized by David Gordon and Valda Setterfield. In the series of pen and watercolors on paper, Schneemann's gestural, expressive configurations hover between animal and human.[6] This work developed out of her childhood fantasies, an obsession in the form of drawings, notations, and moving imagery.[7]

She continued to draw on her evocative childhood imagery in her Judson works, including *Chromelodeon (4th Concretion)* (1964), in which she imagined the performers embodying colors. Performed in the church sanctuary, participants engaged in "a wild and lyrical assemblage of rags, hemp, costume, paint, movement, and objects" while performing a series of dramatic episodes.[8] A sound collage by Schneemann's then partner, James Tenney, accompanied the piece. The women dressed and undressed themselves (and were dressed and undressed by the men), Carol Summers (husband of Elaine Summers) chased Deborah Hay, and Lucinda Childs, and Ruth Emerson

climbed up to the balcony to play the organ and put on tutus made from curtains.

Newspaper Event's improvisation and *Chromelodeon*'s episodic structure inspired Schneemann's opus, *Meat Joy*, in which eight participants crawled and writhed together on plastic sheeting, playing with raw fish, meat, and poultry.[9] They covered their bodies with wet paint, scraps of paper, and paint brushes. *Meat Joy* exemplifies Schneemann's concept of "kinetic theater," where "each piece is structured on a basic visual metaphor which acts as a shifting plane on which tactile, plastic, kinetic encounters are realized—immediate and sensuous." [10] Her aim was to create art that "expose[ed] and confront[ed] a social range of current cultural taboos and repressive conventions."[11] Schneemann's work at Judson inspired her burgeoning feminist practice, in which she mobilized her body simultaneously as the material of her art and the locus of her artistic agency. —EG

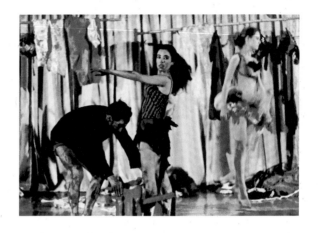

Notes
1. Carolee Schneemann, *More Than Meat Joy: Performance Works and Selected Writings*, ed. Bruce R. McPherson (New Paltz, NY: Documentext, 1979), 33–35.
2. Ibid., 33.
3. Jill Johnston, "The New American Modern Dance," in *The New American Arts*, ed. Richard Kostelanetz (New York: Collier Books, 1967), 189.
4. Schneemann, oral history interview conducted by Ana Janevski and Thomas J. Lax, Department of Media and Performance Art, The Museum of Modern Art, New York, March 6, 2018.
5. Ibid.
6. Ibid.
7. Schneemann, *More Than Meat Joy*, 27.
8. Johnston, "The New American Modern Dance," 189.
9. First performed at the Festival of Free Expression in Paris, France, May 19, 1964.
10. Schneemann, "Carolee Schneemann: Image as Process," in *Creative Camera*, no. 76 (October 1970): 304.
11. Ibid.

Bill Dixon
Dew Horse, 1963;
Pomegranate, 1963

In July 1966, dancer Judith Dunn and jazz trumpeter Bill Dixon (1925–2010) organized Three Programs of Music and Dance at Judson Memorial Church. The concert series was the product of a year-long collaboration between the two artists, who met after Dunn saw Dixon perform in Aldo Tambellini's expanded cinema piece *Black Zero* in 1965. Impressed with Dixon's performance, Dunn telephoned the musician and invited him to attend a meeting of her New Dance Group in her loft at 1024 Sixth Avenue, the former studio of chore-ographer-dancer Paul Taylor. According to writer Danielle Goldman, their partnership "as an interracial couple (both professionally and romanti-cally)" created conditions in which the duo "explored and openly acknowledged the rela-tions between what has been deemed a black, masculine tradition of improvised music and the rather white world of postmodern dance."[1] This alliance was based on their rigorous, extended project forming an improvisational ensemble where the two artists "*worked* to be on stage together," exploring the power dynamics of gender and race, and the interaction of music and dance practice.[2] Making clear their personal and professional commitment, they refused to perform separately, forming the Bill Dixon–Judith Dunn/Judith Dunn–Bill Dixon Company; which name appeared first on a listing was determined by whether the duo was participating in a dance event or a music one.

The first concert in their collaborative series at Judson opened with *Dew Horse* (the second version[3]), in which the two performers alternated on stage, with Dunn dancing and Dixon playing either trumpet or flugelhorn. After trading solos several times, they combined their performances, with Dunn alternating between spins and static poses for the remain-der of the twenty-five-minute piece. *Pomegranate* (parts one and two), also shown in the first concert, showcased Dixon's interest in polyphony. The five musicians performed in the round, playing two themes sequentially as a continuous work, while Dunn improvised a series of move-ments as accompaniment. Dixon's exploration of polyph-ony extended to overlapping tape loops in a collaboration with filmmaker Gene Friedman on *Index* (1967). The film fea-tures a languid duet performed by Dunn and Tony Holder; using multiple exposures, Friedman turned the duet into a sextet. Dixon mimicked this structure, overlooping his cello composition four times using a tape player.

Dunn and Dixon also improvised concert-length performances, including a thirty-seven-minute version of *Pomegranate* at the Newport Jazz Festival performed the week before their first Judson concert. For Dunn, Dixon's improvisation functioned as an extension of the Judson group's desire to abandon old habits and find new ways of moving. While for Dixon, Dunn's movements inspired new modes of improvisation: "Rhythmically, no one could move the way that she did. . . . I viewed, or heard every movement that she did as a sound."[4] —EG

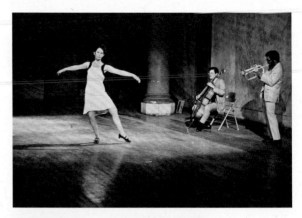

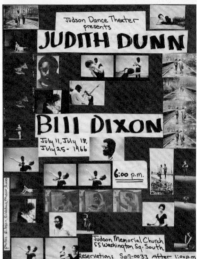

Above top: Peter Moore's photograph of Judith Dunn, Joel Freeman, and Bill Dixon (from left) in Dunn and Dixon's *Ground Speed*, 1963. Performed at Three Programs of Music and Dance, Judson Memorial Church, July 18, 1966. Above: Poster for Three Programs of Music and Dance with Judith Dunn and Bill Dixon, 1966. Opposite: Fred W. McDarrah's photograph of Judith Dunn and Bill Dixon in *Ground Speed*, 1963. Performed at 4th Annual Avant Garde Festival of New York, the conservatory pond in Central Park, New York, 1966

Notes
1. Danielle Goldman, *I Want to Be Ready: Improvised Dance as a Practice of Freedom* (Ann Arbor: University of Michigan Press, 2010), 65, 24.
2. Ibid., 69.
3. Dunn had attempted an early composition of *Dew Horse* in 1963 with her then-husband, Robert Dunn.
4. Bill Dixon, "Program Statement, Dewhorse," *L'Opera: A Collection of Letters, Writings, Musical Scores, Drawings, and Photographs (1967–1986)*, vol. 1 (North Bennington, VT: Metamorphosis Music, BMI, 1986), 53–55.

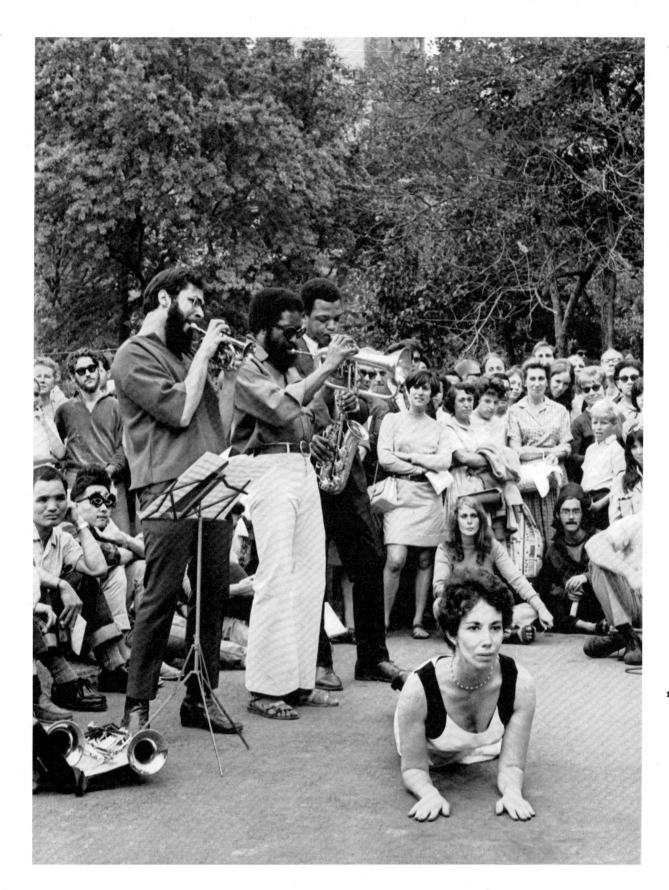

Lucinda Childs
Street Dance, 1964

Lucinda Childs (born 1940) created *Street Dance* while taking part in musician and choreographer Robert Ellis Dunn's composition workshop in New York in the summer of 1964, following his open prompt to create a six-minute choreography. The work was first performed at Judith Dunn's Chinatown studio and restaged in 1965 at Robert Rauschenberg's loft on 809 Broadway, a frequent rehearsal and workshop space for Judson Dance Theater members. *Street Dance* begins in the studio, then continues as Childs descends in the elevator and emerges onto the street opposite the building, where she joins another performer. As Childs moves into the elevator, a recording of her voice directs the audience to look out the window. From the window, the audience watches Childs and her partner as they move through the street while pointing to architectural features, signage, and minute details beyond the audience's perception. Childs's voiceover serves as the narration of these actions, at times reaffirming what the audience witnesses from afar and at others providing the only clear representation of what is happening in the far-away dance. Although the two performers are unable to hear the recording, they maintain synchronicity with it via the use of a stopwatch, their precisely timed movements corresponding to key words.

Robert Dunn described *Street Dance* "as one of the most mysteriously beautiful events I have seen," attributing its brilliance to "the distance

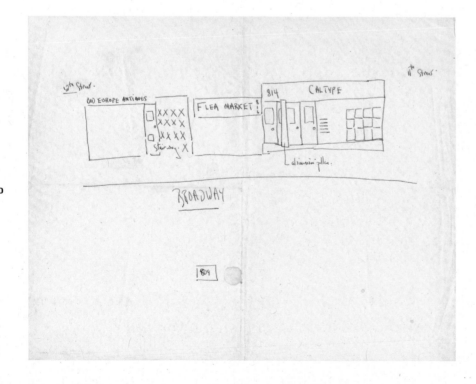

and glass-separated sound-lessness in which we experienced Lucinda's miniaturized physical presence" alongside "her somewhat flattened but sensuous voice on the tape in the room with us."[1] The spatial and temporal gap between the audio and visual dimensions of the work—between the viewer and the performer, and between the live, often imperceptible action and the prerecorded corresponding audio—gives the work a televisual dimension.[2] Insofar as it responds to and incorporates elements from the street on which it is being performed, the dance is necessarily contingent; for each iteration, it must be rewritten for its new context. *Street Dance* is at once permeable and exclusive, open to outside influences while also preserving a specific viewing community. Seen from the ground, the performance is rendered "invisible," blending into the street's everyday activities and even incorporating chance happenings. Childs, for instance, has happily recalled a passerby, unable to recognize the dance as such, asking her a question during the performance.[3] However, as Judson choreographer Yvonne Rainer has recounted, seen from the loft, where the windows create a framing device, the movements assumed the quality of a performance.[4]

As with *Street Dance*, Childs frequently incorporated into her dance vocabulary objects and gestures from everyday life, as well as spoken word and other nontraditional audio accompaniments. *Carnation* (1964) saw her manipulate commonplace items like sponges, hair curlers, and a colander; *Pastime* (1963) included a

score of water faucet and pipe noises by Philip Corner; *Minus Auditorium Equipment and Furnishings* (1963) featured Alex Hay sawing through a cardboard box; and *Geranium* (1965) incorporated a recording of an NFL championship game. Her practices were aligned with Judson's interest in everydayness and its call to activate nontraditional performance spaces. With works such as *Street Dance*, Childs tests the limits of what constitutes dance, asking viewers to consider our understanding of movement both within the designated space of performance and outside of it. —VAC

Notes
1. Robert Dunn quoted in Sally Banes, *Democracy's Body: Judson Dance Theater 1962–1964* (1983; repr. Durham, NC: Duke University Press, 1993), 208–9.
2. Carrie Lambert-Beatty, *Being Watched: Yvonne Rainer and the 1960s* (Cambridge, MA: MIT Press, 2008), 39–40.
3. "Lucinda Childs," interview with Anne Livet, in *Contemporary Dance: An Anthology of Lectures, Interviews and Essays with Many of the Most Important Contemporary American Choreographers, Scholars and Critics*, ed. Livet (New York: Abbeville Press, 1978), 63.
4. Lambert-Beatty, *Being Watched*, 38. See also "Lucinda Childs," 61.

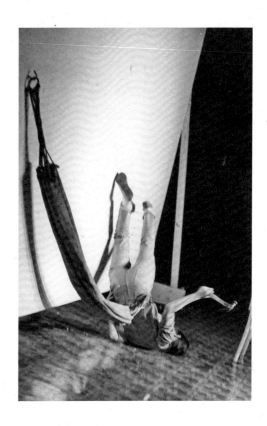

Opposite top: Sidney Phillip's photograph from the window of Robert Rauschenberg's loft, where the second performance of *Street Dance* took place in fall 1965; the photograph was taken in 1973. Opposite bottom: Lucinda Childs. Drawing for *Street Dance*, 1964. Above: Peter Moore's photograph of Lucinda Childs in *Geranium*, 1965. Performed at the concert Geranium, 940 Broadway, January 29, 1965. Right: Al Giese's photograph of Lucinda Childs in *Carnation*, 1964. Performed at Concert of Dance #16, Judson Memorial Church, April 29, 1964

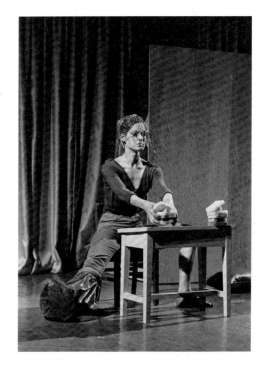

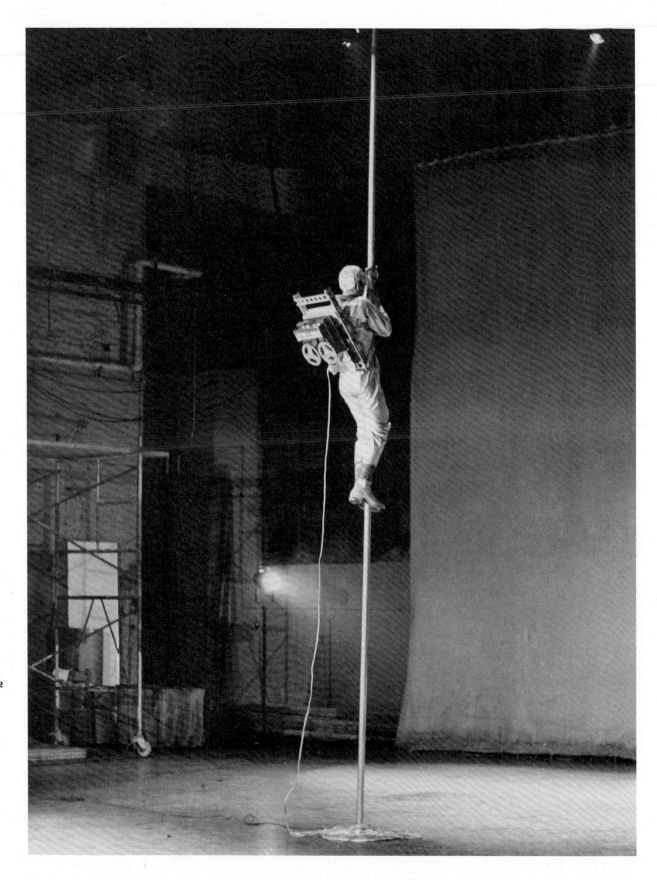

Alex Hay
Leadville, 1964; Colorado Plateau, 1964

In *Leadville*, Alex Hay appeared dressed as an astronaut, wearing a metallic jumpsuit, cap, and boots. A large Wollensak tape recorder was strapped to his back like an astronaut's pack as he slowly descended a tall pole from the ceiling. The dance was performed inside the spacious Stage 73, an Upper East Side theater that in early 1964 hosted two programs by performers associated with Judson Dance Theater, including Hay. A range of sounds emanated from the tape deck: insects buzzing, turkeys gobbling, Sid Tepper and Roy C. Bennett's song "Red Roses for a Blue Lady," and finally, the staccato rattle of a machine gun.[1] As the tape played, the reel unraveled from the deck and trailed below and then behind him. As Hay approached the ground, he twirled his feet before placing them on the floor, then squatted with his hands on the stage. His steps were tentative and slow, as if he were gauging his relationship to gravity. He moved in a sequence of lunges and occasional jumps while looking down at his feet. He took a wide stance and swung from one side to the other, with one arm extended and the other bent. He concluded by crawling across the floor.

Hay, who earned a master's degree in fine art and identified primarily as a visual artist, considered himself a "non-dancer" and often incorporated awkward and untrained movement in his works for dramatic or comedic effect. In *Prairie* (1963), for example, he slowly maneuvered across sculptor Charles Ross's giant trapezoidal structure while expressing his discomfort. Hay moved to New York from Florida in 1959 and married dancer Deborah Hay (née Goldensohn) in 1961. He credits her for his involvement with Judson: with Deborah he attended Merce Cunningham's classes and Robert and Judith Dunn's workshops, where he first met Robert Rauschenberg.[2] Rauschenberg and Hay became close collaborators, and, in 1964, Hay traveled as Rauschenberg's assistant during the Merce Cunningham Dance Company's world tour. While in Japan, Hay reperformed *Prairie* at the Sogetsu Art Center in Tokyo.

Rauschenberg and Hay first collaborated on Hay's *Colorado Plateau*, performed in January 1964 at the State University of New York at New Paltz. The five other dancers—Deborah Hay, Steve Paxton, Lucinda Childs, Tony Holder, and Yvonne Rainer—wore protruding, white wooden boards with numbers painted on them and stood in a circle, erect and immobile. As with Hay's other dances, a recorded soundtrack was central, directing Hay to move each dancer according to compass directions (northeast, southwest, and so on) and to place them either vertically or horizontally. The instructions gradually increased in speed until they were impossible to keep up with. With works such as *Colorado Plateau*, *Prairie*, and *Leadville*, Hay found subtle ways to mock and subvert dance's physical demands by exaggerating rather than concealing its difficulties. —VAC

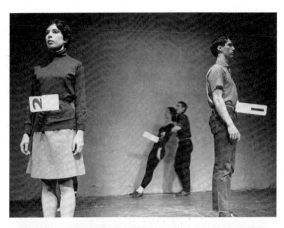

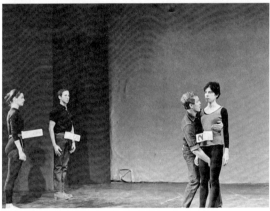

Opposite: Peter Moore's photograph of Alex Hay in *Leadville*, 1964. Performed at First New York Theater Rally Concert II, former CBS studio, New York, May 12, 1965. Above top: Peter Moore's photograph of Deborah Hay, Yvonne Rainer, Alex Hay, and Steve Paxton (from left) in *Colorado Plateau*, 1964. Performed at Surplus Dance Theater: Program sur+, New York, February 17, 1964. Above bottom: Hans Namuth's photograph of Lucinda Childs, Robert Rauschenberg, Alex Hay, and Deborah Hay (from left) in *Colorado Plateau*, 1964. Performed at Surplus Dance Theater: Program sur+, New York, February 17, 1964

Notes
1. "Alex Hay Oral History Interview [2014]," Robert Rauschenberg Foundation, https://www.rauschenberg foundation.org/artist/oral-history/alex-hay.
2. *The Judson Project: Trisha Brown, Alex Hay and Robert Rauschenberg*, video interview by Sally Banes, taped at Robert Rauschenberg's loft, New York City, 1981 (New York: Bennington College, 1983), U-matic, two videocassettes.

Elaine Summers
Judson Fragments, 1964

Judson Fragments, a sixteen-minute 16mm film, comprises snippets from Elaine Summers's collection of film footage shot by herself and other Judson artists. In the film, Summers (1925–2014) joins clips of stop-motion animation by her husband, Carol, with excerpts from Philip Corner's multimedia performance "Flares" (1963), scenes of James Waring teaching a ballet class, and dances performed by Yvonne Rainer, Deborah Hay, Steve Paxton, and Carolee Schneemann. In a particularly charming and absurdist fragment, dancer Fred Herko waters trash cans until they sprout plantlike sculptures. The film's soundtrack, a chorus of voices under the title "Illuminations," was composed by Malcolm Goldstein; in his chance-based score, the choices of individual singers affected the notes sung by the rest of the group.

Parts of *Judson Fragments* were first shown during Summers's groundbreaking *Fantastic Gardens* (1964), which combined live performance and multiple film projections at Judson Memorial Church. The vegetative sculptures featured as both props and scenery, and Goldstein's "Illuminations" was performed live. In a column for the *Village Voice*, later republished in the issue of *Film Culture* devoted to "expanded cinema," filmmaker and critic Jonas Mekas described *Fantastic Gardens* as "by far the most successful and most ambitious attempt to use the many combinations of film and live action" he had seen, a "balletic-happening often

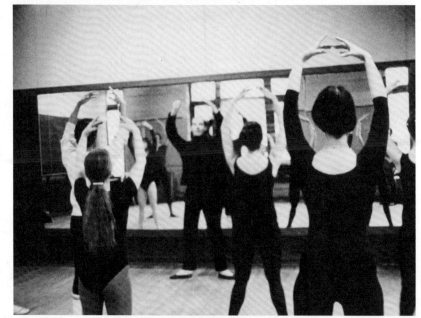

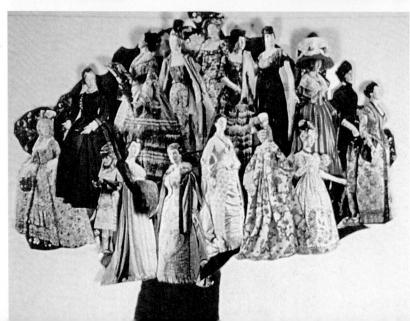

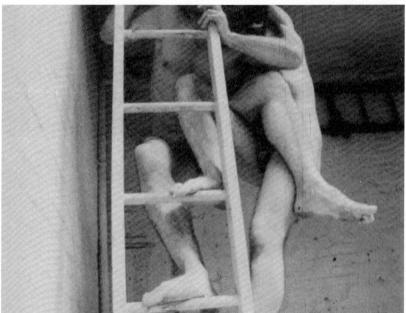

involving the entire audience, and often using the entire presence of the church itself."[1]

Two years after *Fantastic Gardens*, artist Dick Higgins coined the term *intermedia* to describe Allan Kaprow's Happenings, calling such work an "uncharted land that lies between collage, music, and theater."[2] Summers incorporated the moniker into the name of her Experimental Intermedia Foundation, a nonprofit that facilitated and funded complex artistic projects across media. Two of its members were her Judson contemporaries Goldstein and Corner.

Summers's conception of intermedia differs from other artists interested in the mixing of mediums. Susan Sontag described Happenings as an art of "radical juxtaposition," suturing dissimilar material using the logic of collage.[3] *Judson Fragments* uses the film splice to perform such a suture, connecting the performances of Summers's Judson cohort. Her montage captures Judson's diverse choreographic languages, functioning both as an autonomous work and as a memorial of its time, a rare filmic record of the ephemeral coming together of these artists over a four-year period. —EG

Notes
1. Jonas Mekas, "Movie Journal," *Village Voice*, February 27, 1964.
2. Dick Higgins, "Intermedia," *Something Else Newsletter* 1, no. 1 (February 1966): 3. Reprinted in Dick Higgins, *Horizons: Poetics and Theory of the Intermedia* (Carbondale: Southern Illinois University Press, 1984), 18–21.
3. Susan Sontag, "Happenings: An Art of Radical Juxtaposition" [1962], in *Against Interpretation: And Other Essays* (New York: Farrar, Straus and Giroux, 1966), 267–69.

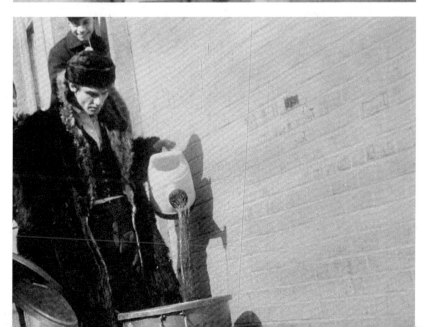

Stills from *Judson Fragments*, 1964

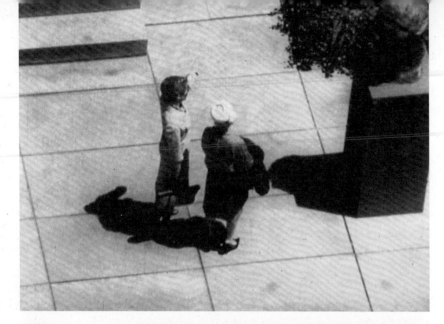

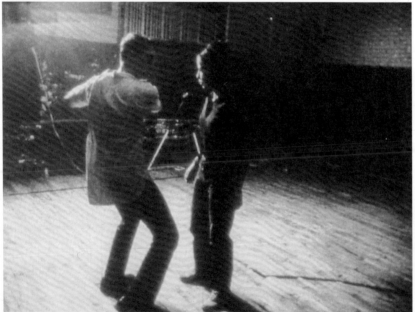

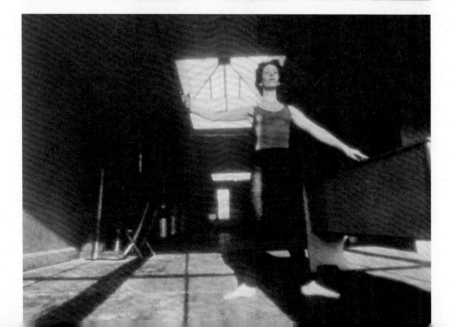

Gene Friedman
3 Dances, 1964

Gene Friedman's eighteen-minute *3 Dances*, which he shot in New York on 16mm film, is divided into three sections: "Public," "Party," and "Private." "Public" opens with a view of The Museum of Modern Art's Sculpture Garden in a wide shot from above, accompanied by John Herbert McDowell's string music. The camera follows visitors as they start and stop, intently observing the sculptures; it zooms in to frame a single onlooker, for example, then out again to depict the unsuspecting crowd weaving through the garden. Friedman (born 1928) created in-camera multiple exposures by rewinding and reusing the exposed film, overlaying close-ups of individuals onto the larger mass of visitors moving throughout the garden.

In "Party," Judith Dunn, Alex Hay, Deborah Hay, Steve Paxton, and Robert Rauschenberg dance together, doing the twist and other social dances on the basketball court in the basement of Judson Memorial Church. Again, Friedman used multiple exposures, superimposing onto the dancing couples close-ups of their footwork, creating a dizzying swirl. In one scene, Dunn watches Paxton, playfully mimicking his intricate footwork. The influence on Judson of popular dance was apparent from their first Concert of Dance, when Fred Herko incorporated the Suzy-Q (a variation of the twist) into *Once or Twice a Week I Put on Sneakers to Go Uptown* (1962).

In the film's final section, "Private," Dunn, alone in her studio, stretches and performs

an impromptu modern dance routine with delicate hand movements that recalls her training as a dancer with Merce Cunningham Dance Company. "Private" is a duet between dancer and cameraman: from off-camera, Friedman described the framing and composition of the shot he would use and Dunn improvised a sequence of movements in response. McDowell, who wrote soundtracks for Judson and other theatrical productions, composed the accompanying soundtrack of atonal vocals sung by Janet McCall.

Friedman, who began his career as a commercial filmmaker, started using chance procedures to assemble clips from previous works after attending Robert Ellis Dunn's second seminar series at the Cunningham studio in fall 1961. In his 16mm film *Index* (1967), he overlaid three exposures of Judith and Tony Holder dancing, accompanied by an original cello piece written and performed by Bill Dixon. He taught filmmaking and editing to Elaine Summers and worked with her and her husband, Carol, on the projections for two of her intermedia performances, *Overture* (1962) and *Fantastic Gardens* (1964). He also designed a tripartite projection structure using mirrors for Judith Dunn's *Last Point* (1964). Like Friedman's other works, *3 Dances* engages chance and improvisation, while exploring the multiple forms of movement that inspired Judson choreography, from everyday activities in "Public," social dance in "Party," and rehearsal and experimentation in "Private." —EG

Stills from *3 Dances*, 1964

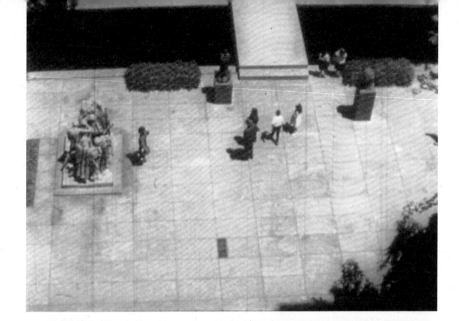

177

Storm de Hirsch
Newsreel: Jonas In the Brig, 1964

Storm de Hirsch (1912–2000)
shot her film *Newsreel: Jonas in
the Brig* during Jonas Mekas's
filming of the Living Theatre's
theatrical production of *The
Brig*.[1] The play, which depicted
a group of prisoners and guards
in a Marine Corps prison, was
written by Kenneth H. Brown
and based on his experience
as a marine in the 1950s.
Mekas had been enticed to
film the play after attending its
final performance in 1963; the
venue would be closing for
taxes owed to the IRS. "The
performance, by this time,
was so precisely acted that
it moved with the inevitability
of life itself," explained Mekas
in his report on filming the
production.[2] The next day, with
the support of Living Theatre
founders Judith Malina and
Julian Beck, Mekas, with the
cast and equipment, sneaked
into the repossessed theater
through a coal chute under the
cover of darkness.[3] Although
Mekas does not mention her
in his account, de Hirsch was
also present, filming Mekas as
he filmed the performers. De
Hirsch's understanding of the
interconnection between film
and theater may have inspired
Mekas's own: in July 1964,
before he was compelled
to shoot *The Brig*, Mekas

interviewed de Hirsch for his
"Movie Journal" column. When
she remarked that she had
just finished a play, Mekas
dismissed her achievement:
"Phooey. The theatre. Phooey."
De Hirsch responded: "Not
really. Essentially, it's still film
for me, my play."[4]
De Hirsch was a poet
and filmmaker who, alongside
Mekas, Shirley Clarke, Stan

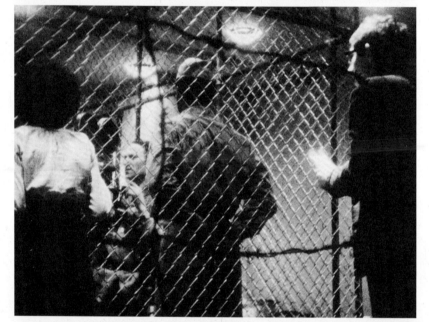

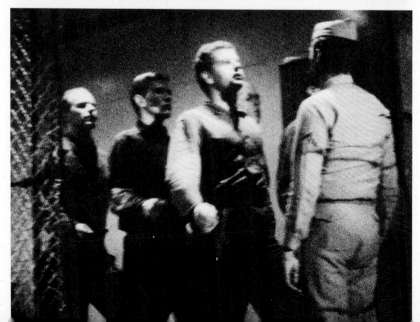

Brakhage, and others, founded the Film-Makers' Cooperative in 1962. *Newsreel: Jonas in the Brig* captures the choreography of bodies and cameras moving about as the theatrical production unfolded and Mekas endeavored to record it on film. De Hirsch shot Mekas stepping deftly along the stage, his camera over his eye or cradled in his arm, at times intervening to direct the actors or stop the production to reload the camera. De Hirsch shows Mekas moving alongside, within, and back out from the cage in which the actors anxiously get dressed, stand at attention, and drill. Through her camera, we see how Mekas's vigorous movement through the action and lively filming style echoed the intensity of the actors' performance. Mekas is electrified as the military drills reach a fever pitch—until the action stops and the scene is reset.

The repetition of strenuous physical movements drawn from Marine Corps prison life, including performing drills, marching, standing at attention, and cleaning, form the structure of *The Brig*. Describing her experience directing the play, Judith Malina wrote that the Living Theatre "used the techniques of evil as the innoculist uses the fatal virus. . . . We drilled. We exercised. We paid attention to accuracy."[5] *The Brig*'s use of readymade movements struck Mekas as akin to cinema's use of verité style to represent reality.[6] With *Newsreel: Jonas in the Brig*, de Hirsch documents the physical encounter between the Living Theatre's performance and Mekas's filming style, exposing theatrical realism and direct cinema as artificial constructions rooted in reality effects. —GB

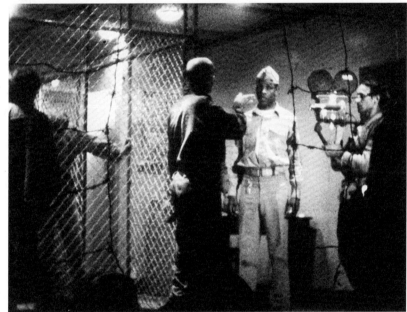

Stills from *Newsreel: Jonas in the Brig*, 1964

Notes
1. For further critical discussion of the two films and their context, see Anna Gallagher-Ross, "Whispers in the Grass: The Living Theatre and *The Brig*" (master's thesis, CCS Bard College, 2017).
2. Jonas Mekas, "Shooting *The Brig*," in *Movie Journal: The Rise of New American Cinema, 1959–1971*, 2nd ed. (New York: Columbia University Press, 2016), 199.
3. Ibid., 198–99.

4. Mekas, "An Interview with Storm de Hirsch," in *Movie Journal*, 156.
5. Judith Malina, "Directing *The Brig*," in Kenneth H. Brown, *The Brig* (New York: Hill and Wang, 1965), 95–96.
6. As Mekas wrote, "One of the ideas that I was pursuing—or getting out of my system—was the application of the so-called cinema verite (direct cinema) techniques to a stage event." See Mekas, "Shooting *The Brig*," 199.

Robert Rauschenberg
Pelican, 1963; *Sleep for Yvonne Rainer*, 1965; *Spring Training*, 1965

Pelican, Robert Rauschenberg's choreographic debut, premiered during Concert of Dance #5, at America on Wheels, an abandoned roller-skating rink in Washington, DC. Rauschenberg (1925–2008) and artist Per-Olof Ultvedt[1] appeared in gray sweat suits and propelled themselves onto the stage in makeshift vehicles comprised of an axle-like pole and two bicycle wheels. Taking the venue as a prompt, the performers roller-skated with winglike parachutes strapped to their backs billowing behind them. They were soon joined by the sweat suit–clad Carolyn Brown, a longtime member of Merce Cunningham Dance Company. While Ultvedt and Rauschenberg circled the rink on wheels, Brown danced in pointe shoes, alternating between simple movements on the floor and upright, balletic steps on her toes. Rauschenberg would later characterize these choices as using "the limitations of the materials as a freedom that would eventually establish the form."[2] In *Pelican*, as in his other dances, the collision of bodies and objects—wheels, parachutes, and pointe shoes—and the restrictions these objects imposed, became the impetus for the study and creation of movement.

Rauschenberg cut his teeth bridging the worlds of performance and painting in 1954, when he began designing sets and costumes for Cunningham and Paul Taylor, also a choreographer. As he began to incorporate everyday objects into his combines—Rauschenberg's term for works that combined qualities of both painting and sculpture—he likewise reimagined objects as performative props, which would become central to his engagement with dance. For Cunningham's *Antic Meet* (1958), their fifth collaboration and perhaps the most notable for its incorporation of found objects, Rauschenberg supplied items that included a bouquet of paper flowers, a door on wheels, sunglasses, a fur coat, and an umbrella outfitted with light bulbs, which Cunningham integrated into the choreography.

Through the Cunningham troupe, Rauschenberg grew familiar with the Judson choreographers and participated in their earliest activities. He attended their classes and workshops and frequently designed the lighting for their dances, including Yvonne Rainer's *Terrain* (1963) and Trisha Brown's *Lightfall* (1963). Steve Paxton, Rauschenberg's partner at the time and a central figure in the Judson scene, later noted that the artist's approach to materials was essential to Judson's founding ethos: "We began with this idea of Bob's that you work with what's available, and that way the restrictions aren't limitations, they're just what you happen to be working with."[3]

Judson's embrace of untrained dancers offered Rauschenberg opportunities to choreograph and perform that were previously unavailable to him through the more technically stringent work of Cunningham and Taylor. "I was so envious of the fact that it was such a total medium," he reflected. "Painting tends to remain fixed, to be made out of its external materials. The idea of having your own body and

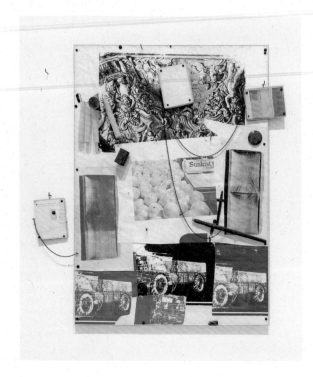

Above: *Sleep for Yvonne Rainer*, 1965. Below: Stig T. Karlsson's photograph of Alex Hay, Oyvind Fahlstrom, Robert Rauschenberg, and Steve Paxton (from left) in Hay's *Colorado Plateau*, 1964. Performed at Five New York Kvällar (Five New York Evenings), Moderna Museet, Stockholm, September 8–14, 1964. Opposite top: Peter Moore's photograph of Robert Rauschenberg in *Spring Training*, 1965. Performed at First New York Theater Rally Concert II, former CBS studio, New York, May 12, 1965. Opposite bottom: Elisabeth Novick's photograph of Robert Rauschenberg in *Pelican*, 1963. Performed at First New York Theater Rally Concert III, former CBS studio, New York, May 25, 1965

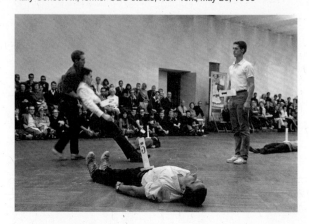

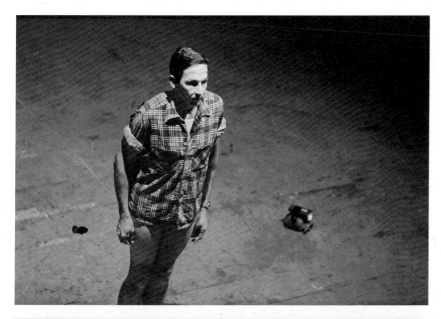

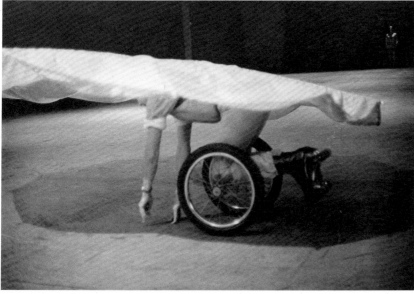

its activity be the material—that was really tempting."[4]

For *Spring Training* (1965), he extended these investigations to a cast of seven people—Brown, Viola Farber, Deborah Hay, Barbara Dilley, Paxton, and his son, Christopher—as well as to a large group of roving turtles, each carrying a flashlight strapped to its back. These makeshift lighting designers merged with other object-driven images throughout the dance. The effect might be described as a moving com-bine: in one performance, eggs fell from the ceiling, color slides were projected onto a screen mounted on Hay's back, and Christopher ripped pages from a New York City phonebook.[5]

Rauschenberg's involve-ment with the world of avant-garde performance informed his studio-based practice. Works like *Sleep for Yvonne Rainer*—an explicit homage to the choreographer[6]—were intended to be activated and manipulated by their viewers over time, in this case, through the variable placement of movable materials and objects, primarily three Plexi-covered collage panels either hung on hooks or mounted on the sur-rounding walls.[7] One of three such works from 1965 that evoke Rauschenberg's Judson collaborators, *Sleep* combines the image permutations of his preceding series of silkscreen paintings, some eighty works that feature transfer prints of found photographs, with the mutability of his Elemental Sculptures, interactive works made in the early 1950s using materials he scavenged from around Lower Manhattan. These interests are here united through Rauschenberg's deep engagement with Judson Dance Theater. —JH

Notes

1. Per-Olof Ultvedt's role was later performed by Alex Hay in both 1965 and 1966.
2. Robert Rauschenberg quoted in *Robert Rauschenberg*, exh. cat. (Washington, DC: National Collection of Fine Arts, Smithsonian Institution, 1976), 184.
3. Robert Rauschenberg quoted in Calvin Tomkins, *Off the Wall: Robert Rauschenberg and the Art World of Our Time* (Harmondsworth, UK: Penguin Books, 1980), 226.
4. Tomkins, *Off the Wall*, 93.
5. See Nina Sundell, *Rauschenberg/Performance, 1954–1984: An Exhibition*, exh. cat. (Cleveland: Cleveland Center for Contemporary Art,

1984), 13–14. The account including eggs being dropped from the ceiling probably refers to the dance's pre-miere in May 1965, which took place in a former CBS studio in New York. The action was likely infeasible in the subsequent performance, which took place in a parking structure at the University of Michigan in Ann Arbor the following September.
6. The title of the work likely refers to "Sleep Solo" from Rainer's *Terrain* (1963), in which a dancer removes objects from a bag and holds them to his or her body while appearing to sleep.
7. See the digital entry on this work in SFMoMA's Rauschenberg Research Project, https://www.sfmoma.org/artwork/FC.695.A-D.

181

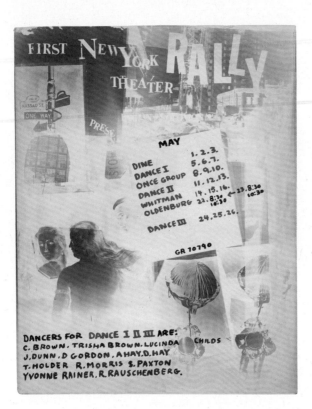

DANCERS FOR DANCE I II III ARE:
C. BROWN. TRISHA BROWN. LUCINDA
J. DUNN. D GORDON. A HAY. D. HAY
T. HOLDER R. MORRIS S. PAXTON
YVONNE RAINER, R. RAUSCHENBERG.

Above: Robert Rauschenberg. Poster
for the First New York Theater Rally,
1965. Opposite: Stills from *Dances/
Bob Rauschenberg (81st St. Theatre
Rally)*, 1965

■■■■■

Stan VanDerBeek
Site, 1965; *Dances/Bob
Rauschenberg (81st St.
Theatre Rally)*, 1965

Stan VanDerBeek's films
Site and *Dances/Bob
Rauschenberg (81st St.
Theatre Rally)* feature some of
the only extant footage of two
different events at the First
New York Theater Rally orga-
nized by choreographer Steve
Paxton and Alan Solomon in
1965. Shot on 16mm black-
and-white film, *Site* documents
Robert Morris's performance
of the same name, in which
Morris wears a mask of his
own face as he manipulates
a series of four-by-eight-foot
boards of plywood; eventually
he pulls away a board to reveal
a nude Carolee Schneemann
posed as Edouard Manet's
Olympia (1863). *Dances/Bob
Rauschenberg* features some
of the only footage of Robert
Rauschenberg's *Spring
Training*, including its memora-
ble use of live turtles strapped
with flashlights, alongside
other performances from the
Theater Rally. VanDerBeek's
films point to the profound
entanglement of performance
and media in his work and his
understanding of cinema as an
event that, like dance, is sub-
ject to processes of editing
and iteration.

From 1949 to 1951,
VanDerBeek (1927–1984)
studied at Black Mountain
College in North Carolina,
where he took courses in
photography and architecture
and became acquainted with
Rauschenberg, composer
John Cage, and choreogra-
pher Merce Cunningham.
Earlier VanDerBeek films,
like *Street Meat/Meet* (1959)
and *Skullduggery* (1960),
feature collage techniques

that presage VanDerBeek's
later investment in utilizing
what he called the vast image
library of contemporary
society to "re-order the level
of awareness of any person."[1]
This idea was epitomized in
his vision for a global network
of Movie-Drome structures.
These domes, designed to
display films and images set
to multiple different scores,
would serve a kind of sweat
lodge for the contemporary,
mediatized world.

In both films, VanDerBeek
uses long takes that cap-
ture wide, spacious views
of bodies in motion. In the
editing, however, VanDerBeek
accumulates smaller gestures
and fragments instead of
one complete, continuous
performance. He shows
Rauschenberg's young
son, Christopher, retriev-
ing some turtles to place
on stage, abruptly cuts to
Rauschenberg mopping the
stage, then cuts back to
Christopher carrying turtles
again. Here VanDerBeek
chooses to show the turtles
as they are transported
instead of showing them
as they "perform." *Site* and
Dances/Bob Rauschenberg
abound with moments like
these—a technique that
belies VanDerBeek's belief
in his performance films as
cumulative processes in which
minute details are gathered
into a whole.

VanDerBeek's approach
to these performances
serves as a further reminder
that his understanding of
cinema as a networked site
of circulating images was
based in part on the logic
of performance, an artistic
practice rooted in variation
and iteration. VanDerBeek's
interest in instantiation can
be seen in the way his films

were disseminated—from cinema to Movie-Drome to other multiscreen experiments that occasionally included live dance—including *Variations V* (1965), a collaboration with Cage and Cunningham that included VanDerBeek's *Movie Mural* (1965). It can also be seen in the multiple versions of his computer-generated *Poemfields* films, which VanDerBeek created with a range of different scores and in various color schemes. In at least one program of his work, VanDerBeek's *Site* showed on one of three screens; the film was also distributed in *Aspen* magazine as an 8mm reel.[2] VanDerBeek explicitly recognized the cinematic potential of fusing event and object toward the end of his iconic "CULTURE: Intercom and Expanded Cinema, A Proposal and Manifesto": "Cinema will become a 'performing' art . . . and image library." For VanDerBeek, these were one and the same.[3] —GB

Notes
1. Stan VanDerBeek, "CULTURE: Intercom and Expanded Cinema," in *Stan VanDerBeek: The Culture Intercom*, ed. João Ribas (Cambridge, MA: MIT List Visual Arts Center, 2011), 29.
2. See *Aspen* 5/6. Thanks to Chelsea Spengemann of the Stan VanDerBeek Estate for this information. See also Gloria Sutton, *The Experience Machine* (Cambridge, MA: MIT Press, 2015), 226, n. 26.
3. Ibid., 129.

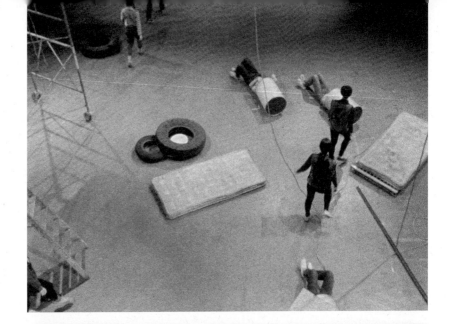

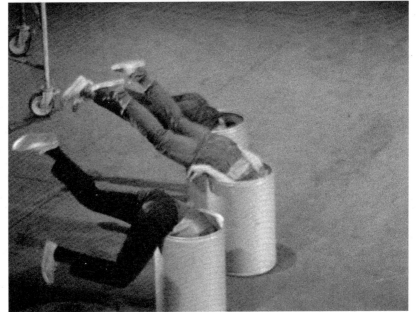

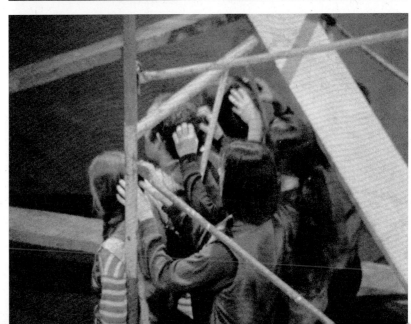

183

Jill Johnston
Marmalade Me, 1971

Jill Johnston (1929–2010) began her career in 1955 as a writer for *Dance Observer*; by 1960 she was a staff writer for the *Village Voice*.[1] Her column, "Dance Journal," functioned as a weekly diary combining art criticism about emergent performance genres, such as environments, Happenings, and Fluxus, with the personal anecdotes comprising her confessional literature. In 1971, at the suggestion of painter and critic Gregory Battcock, Johnston's observations were collected as *Marmalade Me*. The anthology tracked her writing on what was then called "the new dance"—experiments by Trisha Brown, Lucinda Childs, Robert Morris, Steve Paxton, Yvonne Rainer, and others at Judson Dance Theater.

The collection opens with the 1967 "Untitled," which describes her experiences engaging work across artistic disciplines. She asks, "What is of more consequence than something else?," acknowledging the hierarchy of mediums and senses that had for centuries positioned painting and sight at the top, and calls for an "intermedia attempt to put the object back in the forest where it's a tree among trees."[2] Johnston elaborates in a 1967 essay that gives the collection its alliterative title: "I like tangerine trees and marmalade skies, and I think I should inform somebody that Deborah Hay is now taking belly-dancing classes."[3] Invoking the Beatles' "Lucy in the Sky with Diamonds" released that same year, Johnston irreverently claimed both for her column and the art of the time a "cross-over"[4] of multiple mediums as well as pop and avant-garde cultures.

Against the presumption that a critic be an objective tastemaker, Johnston understood criticism to be a full-bodied art form in itself. In her 1965 article "Critics' Critics," included in *Marmalade Me*, she wrote, "Criticism wears me out. . . . [I'll] criticize the constellations if that's what I happen to be looking at."[5] Johnston's prose, crowded with found phrases and non sequiturs, abandons any explicit object of analysis. Her writing resembles a choreographic blur in which topsy-turvy depictions reflect back what she called "the theater of my life."[6]

Johnston, who sometimes used the pen name F. J. Crowe, wrote committedly on topics besides art: in *Lesbian Nation: The Feminist Solution* (1973), for example, she articulated the stakes of the radical lesbian feminist separatist movement. She also published travel writing. Johnston was likewise an engaged activist and even performed some, building on her dance training with José Limón. In *Dance–Lecture–Event #2* (1963), which she presented in the Judson church sanctuary, she extended her arms into various balletic positions while reading from prepared notes; artist-musicians Ben Patterson and George Brecht stood in front of her. Across genres, as both witness and participant, Johnston continually paired formal rigor with personal observation, cruising life's daily minutiae for a place to share with others. —TJL

184

D281 A Dutton Paperback Original $2.45 In Canada $2.95

MARMA-LADE ME

Jill Johnston

Introduction by Gregory Battcock

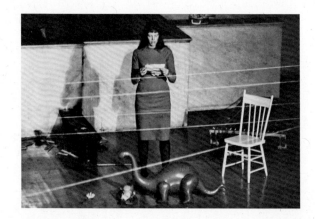

Notes

1. Sally Banes, "Jill Johnston: Signaling through the Flames," in *Writing Dancing in the Age of Postmodernism* (Middletown, CT: Wesleyan University Press, 1994), 3–10.
2. Jill Johnston, "Untitled," *Marmalade Me* (New York: E. P. Dutton & Co, 1971), 20. Originally published October 10, 1968, in the *Village Voice*.
3. Jill Johnston, "Marmalade Me," *Marmalade Me*, 28. Originally published December 12, 1968, in the *Village Voice*.
4. "Untitled," 19.
5. Jill Johnston, "Critics' Critics," *Village Voice*, September 16, 1965.
6. Clare Croft, "'I'm Gay,' She Never Said," *Brooklyn Rail*, June 1, 2017, http://brooklynrail.org/2017/06/dance/Im-gay-she-never-said.

Opposite top: Cover for *Marmalade Me*, 1971. Designed by Karl Stuecklen. Published by E. P. Dutton & Co., New York. Opposite bottom: Peter Moore's photograph of Jill Johnston in the evening-length *Dance–Lecture–Event #2*, 1963. Performed at Judson Memorial Church, March 4, 1963. Right: Jill Johnston's "Dance Journal" column published in the *Village Voice*, December 12, 1968

the village VOICE, *December 12, 1968*

MARMALADE ME

dance
JOURNAL

by Jill Johnston

I thought to write last week on a bunch of poetry events I saw one afternoon, November 17, at Longview Country Club. About 21 two-minute events by poets, organized by Hannah Weiner. But the ivory tower has become the control tower as the naked ape speeds toward the moon. If the flight for the moon overshoots its mark the announcers will go off the air immediately, the families of the astronauts will be notified in person instantly, the President will simultaneously be informed and will then go on the air to advise the population of the disaster. The operation will take 20 minutes exactly. Presumably the control tower will continue to communicate with the astronauts as they speed toward infinity, sipping their final meals out of their final plastic bags. That might be the ultimate poetry. If all philosophy since 400 B. C. has been a footnote to Plato possibly all poetry since Sappho has been a preparation for astronautical communications during operation sayonara. But I don't really believe it (although I believe everything). The handwriting on the wall is the first mark made by a delighted infant. When did the human animal begin to notice its own footprint as a mark of pleasure, a visible imprint on its environment, another auto-erotic involvement, having no functional design (i. e., the bear follows the tiger to the water's edge, etc.). Putting it another way, when did the human animal make a sandcastle out of its own shit after how many eons of dropping it and forgetting it like the horses at the circus. Did the human animal become human when it called itself human? It doesn't matter. I'm thinking of the calling as an invisible mark, the handwriting as current in the air, as the sound that became a fury. The sound (and motion) came first. The sound was the noise of an infant's disapproval at separation from its cave of blood and water. When did the sound become so specified as to signify a particular object? Other animals make such sounds, but so far as we know they don't get very deep into grammatical complications. (Can you write a simple declarative sentence with seven grammatical errors?) But I presume all animals enjoy the sounds they make. Do you think that when someone talks just for the sake of talking they are saying the most original and truthful thing they can say?

The sound is a current is a heartbeat is a footstep is a footprint is a handshake is one thing you do dead and alive whenever you do anything and whenever you make a sound you do everything else too, even eating your words. I suppose the origin of human poetry as it's classically defined means the transition from essential sound (expressing a pain or a pleasure, or signifying a need and later the object who might gratify the need) to the sound made for the sake of making a sound as a pleasurable extension of body sense not thinking about the next meal or the fine feathers on a new peacock. But I don't believe this either. The ultimate poetry might be that first noise of a shocked infant spilling out of a bloody canal. Moreover, I think it's impossible to separate the pure pleasure of making a play on a bodily extension (sound, motion, etc.) from the expressions of the so-called functional needs of food, shelter, affection. The ancient primitive rites demonstrate the wedding of the two in the totality of living which we compartmentalize through language. Still, we have this thing called art. I have an image of an animal turning back on its tracks to examine the shape of one of its footprints. Maybe he compares the shape to a memory of a footprint he once followed to the water's edge. Maybe he goes home and makes a lot of footprints around the campus just to go back and notice how he made them and how they look alike or different according to the texture and firmness of the ground. Maybe he examines the bottom of his foot to correlate the shape of the foot with the imprint he's making. Exhausting these possibilities he might really freak out on directional extensions. The campus begins to look like a study in advanced geometry. Pretty soon he's making the same marks inside on the walls and floors and he's using a piece of bark he brought in from a tree and he's got an object between his toes or fingers looks like a cock he's using for a pencil he fashioned with his teeth out of a piece of slate. Next thing you know he's doing a doctoral dissertation on the shadows cast by abominable snowmen. Now, there isn't any ultimate poetry. It begins and ends with a scream on the way in (or out) and a conversation on the way out (or in). The astronauts could be screaming in their conversation on the way out and the infants could be talking in their screaming on the way in.

Maybe the animal with a pencil outlining his foot on a piece of bark made the first human poem. Making a mark, writing and drawing, were originally one. The image as a representation of foot also becomes the image sent abroad to a relative to convey some information about a foot. A bunch of other symbols (sun for hot, straight lines for fast action, five circles for repetition) convey the information that "hot foot is on the move again." One of the biggest head trips you can take is thinking backward and forward and in circles on the subject of writing and drawing, or painting. A lot of observers have described Franz Kline's paintings as "calligraphy." And Mark Tobey's painting as "white writing." Not to mention Pollack, although the word they liked for that was

185

JUDSON DANCE THEATER PARTICIPANTS

The following list contains the names of the choreographers, visual artists, composers, performers, lighting designers, stage managers, costume designers, conductors, advisors, and assistants who participated in Judson Dance Theater events from 1962 to 1966. While Judson Dance Theater originated at Judson Memorial Church on Washington Square Park, its network of relationships soon reached beyond the church and even beyond New York City. Additional performance locations included Turnau Opera House in Woodstock, New York; the America on Wheels roller rink in Washington, DC; a parking structure in Ann Arbor, Michigan; the forest outside electrical engineer Billy Klüver's house in Berkeley Heights, New Jersey; Stage 73, a former CBS studio, on Manhattan's Upper West Side; Pocket Theatre in New York's East Village; State University of New York at New Paltz; Institute of Contemporary Art in Philadelphia; the Milwaukee Art Center (now Museum) auditorium; and on the streets of New York City.

The list, compiled by Elizabeth Gollnick and Martha Joseph, with assistance from Gabriella Shypula, accounts for a wide range of Judson Dance Theater events and affiliated concerts, including the sixteen Concerts of Dance, other works performed at Judson Memorial Church by participants in the sixteen concerts, and works performed elsewhere that are closely aligned with Judson. Monographic presentations of the work of Judson artists at other locations are not included.

Sources consulted in the compilation of this chronology include "Judson: A Dance Chronology" in *Ballet Review* 1, no. 6 (1967); Sally Banes's *Democracy's Body: Judson Dance Theater, 1962–1964* (1983), and her additional scholarship; Jill Johnston's "Dance Column" reviews for the *Village Voice*, many of which were collected as *Marmalade Me* (1971); Jonas Mekas's reviews for the *Village Voice*, many of which were collected as *Movie Journal* (1972); *New York Times* reviews from the period; the chronology included in the Judson Memorial Church Archive at Fales Library & Special Collections; a survey of articles in contemporary newspapers from the era; Yvonne Rainer's notebooks; the estates of various artists; the chronology compiled by the Robert Rauschenberg Foundation; and archival holdings at New York Public Library's Jerome Robbins Dance Division.

Paul [surname unlisted]
Marilyn Ackerman
Charles Adams
Olga Adorno
Felix Aeppli
Mose Allison
Laurindo Almeida
Richard Andrews
David Antin
Eleanor Antin
Arakawa
Toby Armour
Mary Ashley
Robert Ashley
Lee Bailey
Joan Baker
Ansel Baldonado
Ernestine Barrett
Edward (Eddie) Barton
Mac Benford
Harold Berkin
Maurice Blanc
Carla Blank
Joseph Bloom
Edward V. Boagni
Abel Bomberault
Leroy Bowser
Pearl Bowser
Henri Boyer
George Brecht
Paul Breslin
Edward Brewer
Kastle Brill
Carolyn Brown
Lou Brown
Trisha Brown
Joseph Byrd
John Cage
Christine Callahan
Judith Callen
Kathleen Carlin
Lucy Carmait
Al Carmines
Janet Castle
Diana Cernovich
Remy Charlip
Sandra J. Chew
Lucinda Childs
Carolyn Chrisman
Christo
Arthur Cohen
Milton Cohen
Robert David Cohen
Sheila Cohen
Rick Colbeck
Chuck Connor

Michael Corner
Philip Corner
Bob Cunningham
Kenneth Dallow
[Name unlisted] Davis
William Davis
Laura De Freitas
Walter De Maria
Brian De Palma
Laura Dean
Cecily Dell
Ken Dewey
Diane di Prima
Henry Diakoff
Barbara Dilley (then Lloyd)
Bill Dixon
Kathy Dobkin
Johnny Dodd
Nannette Domingos
Pamela Dover
John Dowd
Rachel Drexler
Judith Dunn
Robert Dunn
Judith Dvorkin
Carol Ehrlick
June Ekman
Susan Elias
Joan Elmsley
Ruth Emerson
Beverly Emmons
Ted Enslin
Joe Evans
Jose Evans
David Everhart
Abigail Ewert
Öyvind Fahlström
Viola Farber
Lulu Farnsworth
Jim Feavel
William Fields
William Finley
Terry Foreman
Barbara Forst
Simone Forti
Joel Freedman
Don Friedman
Eugene Friedman
Gretal Friedman
Mark Gabor
Rhona Ginn
Madeline Gins
Stanley Gochenouer
Malcolm Goldstein
Grace Goodman

David Gordon
Tom Gormley
Iris Grayson
Marty Greenbaum
Joe Greenstein
Red Grooms
Gary Gross
Rachel Gross
Sally Gross
Sidonia Gross
Suzushi Hanayagi
Al Hansen
Johnny Harris
Mimi Hartshorn
Alex Hay
Deborah Hay
Mark Hedden
Jon Hendricks
Carol Henry
Fred Herko
Clyde Herlitz
George Herms
Louise Herms
Dick Higgins
Irv Hochberg
Tony Holder
Robert Holloway
Spencer Holst
Dorothy Hoppe
John Hoppe
Jerry Howard
Helene Hui
Robert Huot
Scott Hutton
Ed Iverson
Daniel Jahn
Alex John
Harold Johnson
Ray Johnson
Jill Johnston
Brooklyn Joe Jonas
Joan Jonas
Joe Jones
LeRoi Jones (later Amiri
 Baraka)
Mario Jorrin
Julie Judd
Howard Kadison
Ustad Ali Akbar Kahn
Magic Karen
Barbara Kastle
Michael Katz
Susan Kaufman
Isamu Kawai
Mark Kawasaki
Elizabeth Keen

Kenneth King
Michael Kirby
Billy Klüver
Alison Knowles
Shielah Komer
Takehisa Kosugi
Ruth Krauss
Juell Krauter
Judith Kuemmerle
Al Kurchin
Arthur Kushner
Ka Kwong Hui
Carolyn Lamb
Pandit Chatur Lal
Rosie Lax
Carl Le Brune
David Lee
Deborah Lee
Ro Lee
Betsy Leek
Leroy Lessane
Marc Levin
Suzanne Levine
Ira Lieberman
William Linich
Larry Loonin
Clare Lorenzi
Gretchen MacLane
Angus MacLise
Paula Madawick
Michael Malcé
George Manupelli
Carol Marcy
Norma Marder
Alan Marlowe
Ira Matteson
John Herbert McDowell
Annette Mendel
William Meyer
Al Meyers
Christine Meyers
Meredith Monk
Charlotte Moorman
Robert Morris
Roger Morris
Dorothy Moskowitz
Gordon Mumma
Elizabeth Munro
Bill Myers
Judy Nathanson
Sandra Neels
Max Neuhaus
Phoebe Neville
Ruth Noble
Tom O'Donnell
Frank O'Hara

Lila Pais
William Pardue
Joan Parker
Michael Pass
Aileen Passloff
John Patton
Steve Paxton
Andrew Peck
Rudy Perez
Elmer Peterson
Petunia (Ray Johnson's
 pet skunk)
Christine Pickles
Eva Pietkiewicz
Katherine Pira
The Pocket Follies
 Academic Festival
 A Capella Group
Trina Posner
Lanny Powers
Neville Powers
Dede Pritzlaff
John Quinn
Yvonne Rainer
Robert Ranieri
Elna Rapp
Robert Rauschenberg
Eric Regener
Albert Reid
Grover Reidy
Diana Reil
Lucy Reisman
Joshua Rifkin
Richard Robbins
Dorothea Rockburne
Richard Rodney
Lou Rogers
M. Edgar Rosenblum
Charles Ross
Arlene Rothlein
Charles Rotmil
Arlene Rubawsky
Mark Saegers
Mark Saffron
Barbara Salthe
Stan Salthe
Kenneth Sarch
Joanne Schielke
David Schiller
Joseph Schlichter
Beverly Schmidt
Carolee Schneemann
Bob Schuler
Carol Scothorn
Larry Segal
Valda Setterfield

Andrew Sherwood
Linda Sidon
N. F. Simpson
H. Frederick Smith
Ruth Sobotka
Alan Solomon
Elsene Sorrentino
Benita Spieler
Sally Stackhouse
Charles Stanley
Polly Stearns
Gertrude Stein
Susan Streeter
Carol Summers
Elaine Summers
Kyle Summers
Florence Tarlow
Andy Tatarsky
Laurie Tatarsky
Cecil Taylor
James Tenney
David Thuesen
Jennifer Tipton
Thomas Traherne
Lennie Tristano
Per-Olof Ultvedt
Johanna Vanderbeek
Steve Vasey
Fred Vassi
David Vaughan
Joanna Vischer
Hunce Voelcker
Carolyn Voigt
Judy Vyssotsky
Ruth Wagner
James Waring
Vincent Warren
Joseph Wehrer
Mark Weinstein
Zena Weiss
Lou Welke
David White
David Whitney
Arthur Williams
Christine Williams
Glenn Williams
Ann Wilson
Bill Wilson
James Wilson
Roberta Winston
Shirley Winston
Philip Wofford
Christian Wolff
Marilyn Wood
John Worden
Vincent Wright

Thomas Wyatt
Argie Xinos
La Monte Young

*Note: Any incomplete
names on this list were
incomplete on the original
performance program*

WORKS IN THE EXHIBITION

Note: Works in Posters and Flyers,
Atrium: Recollections, Gallery 1, and
Gallery 2 are listed chronologically.
Works in Galleries 3 and 4 are
listed alphabetically.

▬

Donald B. and Catherine C. Marron
Atrium Performance Program

Works on view in the performance
program are listed in a separate
pamphlet available for the duration
of the exhibition.

▬

Posters and Flyers

All posters and flyers appear
as facsimiles.

Poster for an Evening of Dance,
Judson Memorial Church, New York,
April 28–29, 1962
Yvonne Rainer Papers, The Getty
Research Institute, Los Angeles
(2006.M.24)

Poster for Concert of Dance #1,
Judson Memorial Church, New York,
July 6, 1962
Designed by Steve Paxton
Yvonne Rainer Papers, The Getty
Research Institute, Los Angeles
(2006.M.24)

Poster for Concerts of Dance #3
and #4, Judson Memorial Church,
New York, January 29 and 30, 1963
Yvonne Rainer Papers, The Getty
Research Institute, Los Angeles
(2006.M.24)

Poster for Concert of Dance #5,
America on Wheels, Washington, DC,
May 9, 1963
Judson Memorial Church Archive,
Fales Library & Special Collections,
New York University Libraries

Poster for Concerts of Dance #6, #7,
and #8, Judson Memorial Church,
New York, June 23, 24, and 25, 1963
Designed by Carolee Schneemann
Judson Memorial Church Archive,
Fales Library & Special Collections,
New York University Libraries

Poster for Steve Paxton's *Afternoon*
(a forest concert), 101 Appletree Row,
Berkeley Heights, New Jersey,
October 6, 1963
Designed by Steve Paxton
Judson Memorial Church Archive,
Fales Library & Special Collections,
New York University Libraries

Poster for Concert of Dance #13,
Judson Memorial Church, New York,
November 19–20, 1963

Judson Memorial Church Archive,
Fales Library & Special Collections,
New York University Libraries

Poster for Elaine Summers's *Fantastic*
Gardens (1964), Judson Memorial
Church, New York, February 17–19, 1964
Artwork by Carol Summers
Performing Arts Research Collections,
Jerome Robbins Dance Division,
New York Public Library. Gift of
Elaine Summers

Flyer for Elaine Summers's *Fantastic*
Gardens (1964), Judson Memorial
Church, New York, February 17–19, 1964
Judson Memorial Church Archive,
Fales Library & Special Collections,
New York University Libraries

Poster for Judson Dance Group
at Institute of Contemporary Art,
University of Pennsylvania,
Philadelphia, April 24, 1964
Judson Memorial Church Archive,
Fales Library & Special Collections,
New York University Libraries

Poster for Concerts of Dance #14,
#15, and #16, Judson Memorial
Church, New York, April 27, 28, and
29, 1964
Yvonne Rainer Papers, The Getty
Research Institute, Los Angeles
(2006.M.24)

Poster for Fred Herko's *The Palace of the*
Dragon Prince (1964), Judson Memorial
Church, New York, May 1–2, 1964
Judson Memorial Church Archive,
Fales Library & Special Collections,
New York University Libraries

Poster for Five New York Kvällar (Five
New York Evenings), Moderna Museet,
Stockholm, September 13, 1964
Yvonne Rainer Papers, The Getty
Research Institute, Los Angeles
(2006.M.24)

Poster for Judith Dunn's *Last Point*
(1964), Judson Memorial Church, New
York, October 19–21, 1964
Judson Memorial Church Archive,
Fales Library & Special Collections,
New York University Libraries

Poster for Carolee Schneemann's *Meat*
Joy (1964), Judson Memorial Church,
New York, November 16–18, 1964
The Museum of Modern Art Library,
New York

Poster for Two Evenings of Dances
by Yvonne Rainer, Avery Theater,
Wadsworth Atheneum, Hartford,
Connecticut, March 6–7, 1965
Yvonne Rainer Papers, The Getty
Research Institute, Los Angeles
(2006.M.24)

Poster for Aileen Passloff and
Company, Judson Memorial Church,
New York, March 8–10, 1965

Judson Memorial Church Archive,
Fales Library & Special Collections,
New York University Libraries

Flyer for Judson Dance Theater
presents Yvonne Rainer and Robert
Morris, Judson Memorial Church, New
York, March 23–25, 1965
Yvonne Rainer Papers, The Getty
Research Institute, Los Angeles
(2006.M.24)

Poster for Carla Blank, Suzushi
Hanayagi, Meredith Monk, Carolee
Schneemann, and Elaine Summers's
Dance by 5, Judson Memorial Church,
New York, April 20–21, 1965
Judson Memorial Church Archive, Fales
Library & Special Collections, New York
University Libraries

Poster for the First New York Theater
Rally, former CBS studio, 81st Street and
Broadway, New York, May 1–26, 1965
Designed by Robert Rauschenberg
Judson Memorial Church Archive, Fales
Library & Special Collections, New York
University Libraries

Poster for Yvonne Rainer and Robert
Morris's Modern Dans, Studentafton,
Lund, Sweden, September 9, 1965
Yvonne Rainer Papers, The Getty
Research Institute, Los Angeles
(2006.M.24)

Mailer for Dance Concert of Old Work
and New Work by David Gordon,
Yvonne Rainer, and Steve Paxton, Judson
Memorial Church, January 10–12, 1966
Yvonne Rainer Papers, The Getty
Research Institute, Los Angeles
(2006.M.24)

Flyer for an Evening of Dancing and
Talking with David Gordon, Jill Johnston,
and Yvonne Rainer, Fairleigh Dickinson
University, Madison, New Jersey,
February 25, 1966
Yvonne Rainer Papers, The Getty
Research Institute, Los Angeles
(2006.M.24)

Poster for Trisha Brown and Deborah
Hay Dance Concert, Judson Memorial
Church, New York, March 29–30, 1966
Designed by Robert Breer
Yvonne Rainer Papers, The Getty
Research Institute, Los Angeles
(2006.M.24)

▬

Atrium | Recollections

Al Carmines interviewed by Wendy
Perron, 1983
Bennington College Judson Project
Video (black-and-white, sound)
25:40 min
Performing Arts Research Collections,
Jerome Robbins Dance Division, New
York Public Library

Steve Paxton interviewed by Nancy
Stark Smith, 1983
Bennington College Judson Project
Video (black-and-white, sound)
59 min
Performing Arts Research Collections,
Jerome Robbins Dance Division,
New York Public Library

Carolee Schneemann interviewed by
Daniel Cameron, 1983
Bennington College Judson Project
Video (black-and-white, sound)
40 min
Judson Memorial Church Archive, Fales
Library & Special Collections, New York
University Libraries

▬

Gallery 1 | 3 Dances

Gene Friedman
3 Dances, 1964/2018
16mm film transferred to three-channel
video (black-and-white, sound)
17:30 min
The Museum of Modern Art, New York.
Gift of the artist

▬

Gallery 2 | Workshops

Robert Ellis and Judith Dunn
Workshops

John Cage
"Fontana Mix," 1958
Ink on paper and transparent sheets
1 title page and 1 information page, ink on
paper: each 11 × 8½" (27.9 × 21.6 cm)
10 pages, drawings of curved lines,
ink on paper: each 10¹³⁄₁₆ × 8⁷⁄₁₆"
(27.4 × 21.4 cm)
1 graph, straight lines (graph 1)
10¹³⁄₁₆ × 1¼" (27.4 × 3 cm)
1 graph, 100 × 2–units (graph 2)
10¹³⁄₁₆ × 3³⁄₁₆" (27.4 × 8 cm)
Kravis Collection

Merce Cunningham
Antic Meet, 1958
16mm film transferred to video
(black-and-white, sound)
27:09 min
Courtesy of the Merce Cunningham
Trust © Sveriges Television AB (SVT).
Courtesy Electronic Arts Intermix,
New York

Yvonne Rainer
Score for *Watering Place*, instructions
for Marnie, c. 1960
Orange crayon, pencil, and ink on
unlined paper
8 × 10" (20.3 × 25.4 cm)
Yvonne Rainer Papers, The Getty
Research Institute, Los Angeles
(2006.M.24)

Yvonne Rainer
Score for *Watering Place*, instructions

for Paul, c. 1960
Orange crayon, pencil, and ink on
unlined paper
8 × 10" (20.3 × 25.4 cm)
Yvonne Rainer Papers, The Getty
Research Institute, Los Angeles
(2006.M.24)

Yvonne Rainer
Score for *Watering Place*, instructions
for Ruth, c. 1960
Orange crayon, pencil, and ink on
unlined paper
8 × 10" (20.3 × 25.4 cm)
Yvonne Rainer Papers, The Getty
Research Institute, Los Angeles
(2006.M.24)

Yvonne Rainer
Score for *Watering Place*, instructions
for Steve, c. 1960
Orange crayon, pencil, and ink on
unlined paper
8 × 10" (20.3 × 25.4 cm)
Yvonne Rainer Papers, The Getty
Research Institute, Los Angeles
(2006.M.24)

Yvonne Rainer
Score for *Three Satie Spoons*, 1961
Crayon on paper
8½ × 11" (21.6 × 27.9 cm)
Yvonne Rainer Papers, The Getty
Research Institute, Los Angeles
(2006.M.24)

Rehearsal of Merce Cunningham
Dance Company prior to its world
tour, Merce Cunningham Studio,
New York, 1964
Photograph by Robert Rauschenberg
Enlarged image
Robert Rauschenberg Foundation,
New York

Gene Friedman
Excerpt from *Heads*, 1965
16mm film transferred to video
(black-and-white, silent)
Courtesy the artist

Anna Halprin Workshops

Workshop on Anna and Lawrence
Halprin's Dance Deck, Kentfield,
California, n.d.
Photographer unknown
Digital print (printed 2018)
Anna Halprin Papers, The Elyse
Eng Dance Collection, Museum of
Performance + Design, San Francisco

Lawrence Halprin
How to Get to Tamalpa, n.d.
Digital print (printed 2018)
Lawrence Halprin Papers, Architectural
Archives, University of Pennsylvania,
Philadelphia. Gift of Lawrence Halprin

Lawrence Halprin
A bird's-eye perspective of the Halprin
house and garden, c. 1951
Colored pencil on photographic

print, mounted
7¾ × 9⅝" (19.7 × 24.4 cm)
Lawrence Halprin Papers, Architectural
Archives, University of Pennsylvania,
Philadelphia. Gift of Lawrence Halprin

Anna and Lawrence Halprin's house
and garden, 1954
Photographs by Ernest Braun
Photographic prints, mounted
15 × 20" (38.1 × 50.8 cm)
Lawrence Halprin Papers, Architectural
Archives, University of Pennsylvania,
Philadelphia. Gift of Lawrence Halprin

Anna and Lawrence Halprin's Dance
Deck, Kentfield, California, 1954
Photograph by Ernest Braun
Enlarged image
Lawrence Halprin Papers, Architectural
Archives, University of Pennsylvania,
Philadelphia. Gift of Lawrence Halprin

Lawrence Halprin
Dance Deck Perspective, 1954
Pencil on tracing paper
24 × 36" (61 × 91.4 cm)
Lawrence Halprin Papers, Architectural
Archives, University of Pennsylvania,
Philadelphia. Gift of Lawrence Halprin

Anna Halprin teaching on her Dance
Deck, Kentfield, California, c. 1956
Photograph by Lawrence Halprin
Digital print (printed 2018)
Anna Halprin Papers, The Elyse
Eng Dance Collection, Museum of
Performance + Design, San Francisco

Anna Halprin
The Branch, c. 1957
Photographs by Warner Jepson
Performed on Anna and Lawrence
Halprin's Dance Deck, Kentfield,
California
Performed by Simone Forti, Anna
Halprin, and A. A. Leath
Digital prints (printed 2018)
Anna Halprin Papers, The Elyse
Eng Dance Collection, Museum of
Performance + Design, San Francisco

Merce Cunningham's lecture delivered
on Anna and Lawrence Halprin's Dance
Deck for the annual summer dance
workshop, Kentfield, California, 1957
Ink on paper
14 × 8½" (35.6 × 21.6 cm)
Anna Halprin Papers, The Elyse
Eng Dance Collection, Museum of
Performance + Design, San Francisco

Merce Cunningham, Ruth Beckford,
and Anna Halprin on Anna and
Lawrence Halprin's Dance Deck,
Kentfield, California, 1957
Photograph by Ted Streshinsky
Digital print (printed 2018)
Bancroft Library, University of
California, Berkeley

Talk given by Anna Halprin for a program
on her and Lawrence Halprin's Dance
Deck, Kentfield, California, June 18, 1960

Ink on paper
11 × 8½" (27.9 × 21.6 cm)
Anna Halprin Papers, The Elyse
Eng Dance Collection, Museum of
Performance + Design, San Francisco

Exercises for Anna Halprin's annual
summer dance workshop in Kentfield,
California, 1960
Ink on paper
10 × 8" (25.4 × 20.3 cm)
Anna Halprin Papers, The Elyse
Eng Dance Collection, Museum of
Performance + Design, San Francisco

Anna Halprin on her and Lawrence
Halprin's Dance Deck, Kentfield,
California, 1960
Photographer unknown
Digital print (printed 2018)
Anna Halprin Papers, The Elyse
Eng Dance Collection, Museum of
Performance + Design, San Francisco

Anna Halprin summer workshop
participants on her and Lawrence
Halprin's Dance Deck, Kentfield,
California, 1960
Photograph by Lawrence Halprin
Digital print (printed 2018)
Yvonne Rainer Papers, The Getty
Research Institute, Los Angeles

La Monte Young
Composition 1960 #2, 1960
Mimeograph with ink additions
3⁷⁄₁₆ × 8½" (8.8 × 21.6 cm)
The Museum of Modern Art, New York.
The Gilbert and Lila Silverman Fluxus
Collection Gift

La Monte Young
Composition 1960 #3, 1960
Mimeograph
3⁷⁄₁₆ × 8⁷⁄₁₆" (8.8 × 21.5 cm)
The Museum of Modern Art, New York.
The Gilbert and Lila Silverman Fluxus
Collection Gift

La Monte Young
Composition 1960 #4, 1960
Mimeograph
3⁷⁄₁₆ × 8⁷⁄₁₆" (8.7 × 21.3 cm)
The Museum of Modern Art, New York.
The Gilbert and Lila Silverman Fluxus
Collection Gift

La Monte Young
Composition 1960 #5, 1960
Mimeograph
3⁷⁄₁₆ × 8⁷⁄₁₆" (8.8 × 21.4 cm)
The Museum of Modern Art, New York.
The Gilbert and Lila Silverman Fluxus
Collection Gift

Sounds presented by La Monte Young
at Anna Halprin's annual summer dance
workshop, 1960
Ink on paper
11 × 8½" (27.9 × 21.6 cm)
Anna Halprin Papers, The Elyse
Eng Dance Collection, Museum of
Performance + Design, San Francisco

Letter from La Monte Young to Anna
(Ann) Halprin describing exercises for
annual summer dance workshop, 1961
Ink on paper
11 × 8½" (27.9 × 21.6 cm)
Anna Halprin Papers, The Elyse
Eng Dance Collection, Museum of
Performance + Design, San Francisco

James Waring Classes

James Waring and Fred Herko in
rehearsal for their performance of
Double Concerto (1964), n.d.
Photograph by Edward Oleksak
Enlarged image
David Vaughan Collection, New York

James Waring's handwritten notes for a
new ballet company, n.d.
Pen and ink on paper
10 × 14" (25.4 × 35.6 cm)
David Vaughan Collection, New York

James Waring's typewritten response to
questions from Gary Gross, n.d.
Typescript page
8½ × 11" (21.6 × 27.9 cm)
David Vaughan Collection, New York

Flyer for a series of four evenings by
eleven choreographers presented
by Dance Associates at the Master
Institute Theater, New York, March 2, 3,
15, and 16, 1956
5½ × 8½" (14 × 21.6 cm)
David Vaughan Collection, New York

Flyer for Two Evenings of New Dances
presented by Dance Associates at the
Master Institute Theater, New York,
c. 1956
4¾ × 6" (12 × 15.2 cm)
David Vaughan Collection, New York

Poster for *Dances before the Wall*
(1958), James Waring and Dance
Company, Henry Street Playhouse,
New York, March 30, 1958
8½ × 5⅜" (21.6 × 13.6 cm)
David Vaughan Collection, New York

James Waring
Dances before the Wall, 1958
Photographer unknown
Performed at Henry Street Playhouse,
New York, 1958
Digital prints (printed 2018)
David Vaughan Collection, New York

Aileen Passloff
Battlepiece, c. 1959
Photographer unknown
Performed by Aileen Passloff. n.d.,
location unknown
Costumes designed by James Waring
Digital prints (printed 2018)
Aileen Passloff Collection, New York

James Waring
Untitled, 1959
Collage on cardboard
13¼ × 9⅞" (33.6 × 25.1 cm) (unframed)

Collection David and Marcel Fleiss;
Galerie 1900–2000, Paris

James Waring
Untitled, 1959
Collage on paper
8 × 10" (20.3 × 25.4 cm)
Gerard Forde Collection, Berlin

James Waring
Costumes for Aileen Passloff's
Strelitzia, 1960
Textile
Aileen Passloff Collection, New York

Aileen Passloff
Strelitzia, c. 1961
Performed at Fashion Institute of
Technology, New York, c. February 1965
Still photographs from film shot by
Albert and David Maysles
Performed by Martha Jane Charney
and Aileen Passloff
Digital prints (printed 2018)
Aileen Passloff Collection, New York

Poster for *Dances before the Wall*
(1958), James Waring and Dance
Company, Henry Street Playhouse,
New York, December 7, 1961
11 × 9" (28 × 22.9 cm)
David Vaughan Collection, New York

▬

Gallery 3 | Downtown:
Sites of Collaboration

An Anthology, 1962, first edition
Artist's book, letterpress and offset
Overall: 7¾ × 8¹⁵⁄₁₆ × ⅜"
(19.7 × 22.7 × 1 cm)
Edited by La Monte Young
Published by La Monte Young and
Jackson Mac Low
Designed by George Maciunas
The Museum of Modern Art, New York.
The Gilbert and Lila Silverman Fluxus
Collection Gift

Ray Johnson, Robert Morris, Simone
Forti, and James Waring's contributions
to *An Anthology*, 1963
Artist's book, letterpress and offset
Overall: 7¾ × 8¹⁵⁄₁₆ × ⅜" (19.7 ×
22.7 × 1 cm)
The Museum of Modern Art Library,
New York

190

Excerpt from Al Carmines's lecture
"The Judson Dance Theater, and the
Avant-Garde Dance," 1968
Recorded September 30, 1968, in the
auditorium of the Lincoln Center Library
and Museum of the Performing Arts,
New York
Sound
Performing Arts Research Collections,
Jerome Robbins Dance Division, New
York Public Library

Rosalyn Drexler
Home Movies, 1964
Photographs by Fred W. McDarrah

Performed at Provincetown Playhouse,
New York, March 14, 1964
Performed by Jim Anderson, George
Bartenieff, Sudie Bond, Al Carmines,
Gretel Cummings, Fred Herko, Otto
Miennes, Barbara Ann Teer, and
Shelndi Tokayer
Digital prints (printed 2018)
Fred W. McDarrah/Courtesy Steven
Kasher Gallery, New York

Poster for Rosalyn Drexler's *Home
Movies*, 1964
8½ × 11" (21.6 × 27.9 cm)
Judson Memorial Church Archive,
Fales Library & Special Collections,
New York University Libraries

Gil Evans
Into the Hot, 1962
LP
12¼ × 12¼" (31.1 × 31.1 cm)
The World Record Club Limited
Purchased for the exhibition

Floating Bear no. 14, October 1961
Edited by Diane di Prima and LeRoi Jones
Mimeograph
11 × 8½" (27.9 × 21.6 cm)

Floating Bear no. 21, August 1962
Edited by Diane di Prima and LeRoi Jones
Mimeograph
11 × 8½" (27.9 × 21.6 cm)
The Museum of Modern Art Library,
New York

Floating Bear no. 29, March 1964
Edited by Diane di Prima and LeRoi Jones
Mimeograph
11 × 8½" (27.9 × 21.6 cm)
The Museum of Modern Art Library,
New York

Simone Forti
Roller Boxes (formerly titled
Rollers), 1960
Photographs by Robert McElroy
Performed in a program of
Happenings at Reuben Gallery,
New York, December 16–18, 1960
Performed by Simone Forti and
Patty Mucha
Digital prints (printed 2018)
Robert R. McElroy photographs of
Happenings and early performance
art, The Getty Research Institute,
Los Angeles (2014.M.7)

Simone Forti
See Saw, 1960
Performance with plywood seesaw
Dimensions and duration variable
The Museum of Modern Art, New York.
Committee on Media and Performance
Art Funds

Simone Forti
See Saw, 1960
Photographs by Robert McElroy
Performed in a program of
Happenings at Reuben Gallery,
New York, December 16–18, 1960
Performed by Robert Morris and

Yvonne Rainer
Digital prints (printed 2018)
Robert R. McElroy photographs of
Happenings and early performance
art, The Getty Research Institute, Los
Angeles (2014.M.7)

Simone Forti
*Accompaniment for La Monte's
"2 sounds" and La Monte's "2
sounds,"* 1961
Performance with natural fiber rope
and sound
13:11 min, dimensions variable
The Museum of Modern Art, New York.
Committee on Media and Performance
Art Funds

Simone Forti
Censor, 1961
Performance with metal pan, screws,
and sound
Dimensions and duration variable
The Museum of Modern Art, New York.
Committee on Media and Performance
Art Funds

Simone Forti
Huddle, 1961
Performance
10 min
The Museum of Modern Art, New York.
Committee on Media and Performance
Art Funds

Simone Forti
Platforms, 1961
Performance with two plywood
boxes, sound
10 min
Plywood box 1: 60 × 36 × 30" (152.4 ×
91.4 × 76.2 cm)
Plywood box 2: 65 × 36 × 24" (165.1 ×
91.4 × 61 cm)
The Museum of Modern Art, New York.
Committee on Media and Performance
Art Funds

Simone Forti
Slant Board, 1961
Performance with plywood and rope
10 min
2 plywood sheets: each 96 × 48"
(243.8 × 121.9 cm)
6 Manila natural fiber ropes: each ⅝"
(1.6 cm) in diameter
The Museum of Modern Art, New York.
Committee on Media and Performance
Art Funds

Simone Forti's map of her Dance
Constructions in Yoko Ono's Chambers
Street Loft, New York, 1974
Pen on paper
7 × 10" (17.8 × 25.4 cm)
The Museum of Modern Art, New York.
Committee on Media and Performance
Art Funds

Storm de Hirsch
Newsreel: Jonas in the Brig, 1964
16mm film transferred to video (black-
and-white, silent)
5 min

Courtesy of the Film-Makers'
Cooperative/the New American Cinema
Group, Inc.

Allan Kaprow
18 Happenings in 6 Parts, 1959
Photograph by Scott Hyde
Performed at Reuben Gallery, New
York, October 4, 1959
Digital print (printed 2018)
Allan Kaprow Papers, c. 1940–1997,
The Getty Research Institute, Los
Angeles (980063)

Allan Kaprow
18 Happenings in 6 Parts, 1959
Photographs by Fred W. McDarrah
Performed at Reuben Gallery, New
York, October 4, 1959
Gelatin silver prints
Composition: 10¼ × 10³⁄₁₆" (26 ×
25.8 cm); sheet: 13⅞ × 10⅞" (35.3 ×
27.7 cm)
The Museum of Modern Art, New York.
Gift of the Estate of Fred W. McDarrah

Press release for Allan Kaprow's *18
Happenings in 6 Parts*, 1959
Ink and pencil on indirect electrostatic
print (Xerox)
10¹⁵⁄₁₆ × 8½" (27.8 × 21.6 cm)
Allan Kaprow Papers, c. 1940–1997,
The Getty Research Institute, Los
Angeles (980063)

Score for Alan Kaprow's *18
Happenings in 6 Parts* (Room 2, Set 1,
Person 1), 1959
Ink on paper
12⁷⁄₁₆ × 7¹⁵⁄₁₆" (31.6 × 20.1 cm)
Allan Kaprow Papers, c. 1940–1997,
The Getty Research Institute, Los
Angeles (980063)

Fred W. McDarrah
Audience members at the Five Spot
Café, New York, 1962
Digital print (printed 2018)
Fred W. McDarrah/Courtesy Steven
Kasher Gallery, New York

Fred W. McDarrah
Diane di Prima with LeRoi Jones
at Cedar Street Tavern after a party
at the Living Theatre, New York,
April 5, 1960
Digital print (printed 2018)
Fred W. McDarrah/Courtesy Steven
Kasher Gallery, New York

Fred W. McDarrah
View of a mural created by Claes
Oldenburg outside the Judson Gallery,
New York, February 20, 1960
Digital print (printed 2018)
Fred W. McDarrah/Courtesy Steven
Kasher Gallery, New York

Fred W. McDarrah
Judson Memorial Church, New York,
March 16, 1966
Digital print (printed 2018)
Fred W. McDarrah/Courtesy Steven
Kasher Gallery, New York

Fred W. McDarrah
The Living Theatre advertises a performance of Jack Gelber's *The Connection* (1959) in Washington Square Park, New York, July 19, 1959
Digital print (printed 2018)
Fred W. McDarrah/Courtesy Steven Kasher Gallery, New York

Fred W. McDarrah
Jane Jacobs in Washington Square Park, New York, August 24, 1963
Digital print (printed 2018)
Fred W. McDarrah/Courtesy Steven Kasher Gallery, New York

Robert McElroy
Reuben Gallery, New York, 1960
Digital print (printed 2018)
Robert R. McElroy photographs of Happenings and early performance art, The Getty Research Institute, Los Angeles (2014.M.7)

Claes Oldenburg
Ray Gun Poster, 1961
Oil paint on torn paper
24 × 18" (61 × 45.7 cm)
The Museum of Modern Art, New York. Richard S. Zeisler Bequest, Nina and Gordon Bunshaft Bequest, gift of John Rewald in memory of Frances Weitzenhoffer, gift of Mr. and Mrs. Peter A. Rübel, gift of Vladimir Horowitz, gift of George Harrison, and gift of Briggs W. Buchanan (all by exchange)

Claes Oldenburg
Program for performances in *Ray Gun Spex*, Judson Gallery, New York, 1960
Lithograph, double-sided (printed 1972)
23¼ × 27½" (59.1 × 69.9 cm)
Collection the artist

Claes Oldenburg
Announcement of Dine/Oldenburg show at the Judson Gallery, New York, 1959
Offset print
11 × 8½" (27.9 × 21.6 cm)
Collection the artist

Claes Oldenburg
Striding Figure (final study for announcement of a dance concert by the Aileen Passloff and Dance Company), 1962
Enamel on paper
17¾ × 12⅛" (45.1 × 30.8 cm)
The Museum of Modern Art, New York. Committee on Drawings and Prints Fund, Richard S. Zeisler Bequest (by exchange), gift of Vladimir Horowitz (by exchange) and the Edward John Noble Foundation

Poster for an Evening of Dance by Yvonne Rainer and Fred Herko, presented by New York Poets Theatre at Maidman Playhouse, New York, March 5, 1962
Designed by Ray Johnson
8½ × 11" (21.6 × 27.9 cm)
Yvonne Rainer Papers, The Getty

Research Institute, Los Angeles (2006.M.24)

Poster for Judson Poets' Theater presentation of *Asphodel/What Happened?* at Judson Memorial Church, New York, 1963
Ink on paper
11 × 8½" (27.9 × 21.6 cm)
Judson Memorial Church Archive, Fales Library & Special Collections, New York University Libraries

Gertrude Stein
What Happened, 1963
Photographs by Peter Moore
Presented by Judson Poets' Theater, New York, October 12, 1963
Performed by Joan Baker, Al Carmines, Lucinda Childs, Hunt Cole, Aileen Passloff, John Quinn, Yvonne Rainer, and Arlene Rothlein
Black-and-white photographs
Courtesy Paula Cooper Gallery, New York

Cecil Taylor
"Mixed" from Gil Evans *Into the Hot*, 1962
Sound
10:11 min
Courtesy Universal Music Group

Stan VanDerBeek
Snapshots of the City, 1961
16mm film transferred to video (black-and-white, sound)
3:30 min
Edition 1 of 6, 2 APs
Courtesy of the Estate of Stan VanDerBeek. Funded by the Celeste Bartos Preservation Fund at The Museum of Modern Art, New York

Village Voice, December 31, 1958
Newsprint
11 × 16" (27.9 × 40.6 cm)

Village Voice, January 1, 1958
Newsprint
11 × 16" (27.9 × 40.6 cm)

Village Voice, August 30, 1962
Newsprint
11 × 16" (27.9 × 40.6 cm)

Village Voice, September 5, 1963
Newsprint
11 × 16" (27.9 × 40.6 cm)

Robert Whitman
American Moon, 1960
Photographs by Robert McElroy
Performed at Reuben Gallery, November 29–December 4, 1960
Performed by George Bretherton, Kamaia Deveroe, Simone Forti, Lucas Samaras, Clifford Smith, and Robert Whitman
Digital reprints (printed 2018)
Robert R. McElroy photographs of Happenings and early performance art, The Getty Research Institute, Los Angeles (2014.M.7)

Robert Whitman
Preparatory sketches for *American*

Moon performance (1960), 1959
Mixed media
7 works on paper from a set of 41, dimensions variable
Courtesy Pace Gallery, New York

Phyllis Yampolsky's announcement for the Best of the Hall of Issues, Judson Memorial Church, New York, June 7–July 1, 1962
Offset
13¹³⁄₁₆ × 18⅞" (35.1 × 48 cm)
The Museum of Modern Art Library, New York

Phyllis Yampolsky's announcement for Hall of Issues, Judson Memorial Church, New York, 1961
Ink on paper
11 × 8½" (27.9 × 21.6 cm)
Judson Memorial Church Archive, Fales Library & Special Collections, New York University Libraries

━━

Gallery 4 | Judson Dance Theater

George Brecht
Comb Music, 1959–62
Photographs by Peter Moore
Performed at Concert of American Contemporary Music at the Pocket Theater, New York, August 19, 1963
Performed by Fred Herko
Black-and-white photographs
Courtesy Paula Cooper Gallery, New York

Trisha Brown
Trillium, 1964
Photographs by Al Giese
Performed at Concert of Dance #7, Judson Memorial Church, New York, June 24, 1963
Digital prints (reprinted 2018)
The Estate of Al Giese

Trisha Brown
Lightfall, 1963
Photographs by Peter Moore
Performed at Concert of Dance #4 at Judson Memorial Church, New York, January 30, 1963
Performed by Trisha Brown and Steve Paxton
Black-and-white photographs
Courtesy Paula Cooper Gallery, New York

Lucinda Childs
Carnation, 1964
Photographs by Al Giese
Performed at Concert of Dance #16 at Judson Memorial Church, New York, April 29, 1964
Performed by Lucinda Childs
Digital prints (reprinted 2018)
The Estate of Al Giese

Lucinda Childs
Drawing for *Street Dance*, 1964
Digital print (printed 2018)
Médiathèque du centre national de

la danse, Archive Lucinda Childs.
Courtesy the artist

Lucinda Childs
Score for *Street Dance* (1964), 1973
Digital print (printed 2018)
Médiathèque du centre national de la danse, Archive Lucinda Childs.
Courtesy the artist

Lucinda Childs
Drawing for *Geranium*, 1965
Digital print (printed 2018)
Médiathèque du centre national de la danse, Archive Lucinda Childs.
Courtesy the artist

Lucinda Childs
Photographic documentation for *Geranium*, 1965
Digital print (printed 2018)
Médiathèque du centre national de la danse, Archive Lucinda Childs.
Courtesy the artist

Lucinda Childs
Soundtrack for *Geranium*, 1965
Original format: magnetic tape; broadcast format: digital
62 min
Médiathèque du centre national de la danse, Archive Lucinda Childs.
Courtesy the artist

Lucinda Childs
Geranium, 1965
Photographs by Peter Moore
Performed at 940 Broadway, New York, January 29, 1965
Performed by Lucinda Childs
Black-and-white photographs
Courtesy Paula Cooper Gallery, New York

Lucinda Childs
"In order to see this dance. . . ," 1973
Digital print (printed 2018)
Médiathèque du centre national de la danse, Archive Lucinda Childs.
Courtesy of the artist

Philip Corner
Scores for "Flares," 1963
India ink and crayon on paper
3 sheets, each 5.5 × 8.5" (13.9 × 21.6 cm)
Judson Memorial Church Archive, Fales Library & Special Collections, New York University Libraries

Philip Corner
"Flares," 1963
Photographs by Al Giese
Performed at Concert of Dance #8, Judson Memorial Church, New York, June 25, 1963
Performed by Philip Corner, Malcolm Goldstein, Dick Higgins, Norma Marder, Elizabeth Munro, Max Neuhaus, Arlene Rothlein, Beverly Schmidt, James Tenney, and Vincent Wright
Digital print (printed 2018)
The Estate of Al Giese

Philip Corner
"Flares," 1963

191

Photographs by Peter Moore
Performed at Concert of Dance #8,
Judson Memorial Church, New York,
June 25, 1963
Performed by Philip Corner, Malcolm
Goldstein, Dick Higgins, Norma Marder,
Elizabeth Munro, Max Neuhaus, Arlene
Rothlein, Beverly Schmidt, James
Tenney, and Vincent Wright
Black-and-white photographs
Courtesy Paula Cooper Gallery,
New York

Diane di Prima
Freddie Poems, 1974
Book
Eidolon Editions, Point Reyes,
California
Purchased for the exhibition

Bill Dixon
Intents and Purposes, 1967
LP
12¼ × 12¼" (31.1 x 31.1 cm)
RCA Victor
Purchased for the exhibition

Judith Dunn
Speedlimit, 1963
Photographs by Peter Moore
Performed at Motorcycle, Judson
Memorial Church, New York,
December 6, 1963
Performed by Judith Dunn and
Robert Morris
Black-and-white photographs
Courtesy Paula Cooper Gallery,
New York

Judith Dunn
Speedlimit, 1963
Photograph by Peter Moore
Performed at Concert of Dance #8,
Judson Memorial Church, New York,
June 25, 1963
Performed by Judith Dunn and
Robert Morris
Black-and-white photographs
Courtesy Paula Cooper Gallery,
New York

Al Giese
Concert of Dance #3, Judson Memorial
Church, New York, 1963
Slideshow of 35 digital photographs
(prepared 2018)
The Estate of Al Giese

192

David Gordon
Mannequin Dance, 1962
Photographs by Peter Moore
Performed at Dance Concert of Old
and New Works by David Gordon,
Yvonne Rainer, Steve Paxton,
Judson Memorial Church, New York,
January 10, 1966
Performed by David Gordon
Black-and-white photographs
Courtesy Paula Cooper Gallery,
New York

David Gordon
Random Breakfast, 1963
Photographs by Al Giese

Performed at Concert of Dance #7,
Judson Memorial Church, New York,
June 26, 1963
Performed by David Gordon and
Valda Setterfield
Digital prints (printed 2018)
The Estate of Al Giese

Fred Herko
Binghamton Birdie, 1963
Photographs by Al Giese
Performed at Concert of Dance #6,
Judson Memorial Church, New York,
June 23, 1963
Performed by Lucinda Childs, Ruth
Emerson, Deborah Hay, Fred Herko,
Arlene Rothlein, and Polly Stearns
Digital prints (printed 2018)
The Estate of Al Giese

Fred Herko
Binghamton Birdie, 1963
Photographs by Peter Moore
Performed at Concert of Dance #6,
Judson Memorial Church, New York,
June 23, 1963
Performed by Lucinda Childs, Ruth
Emerson, Deborah Hay, Fred Herko,
Arlene Rothlein, and Polly Stearns
Black-and-white photographs
Courtesy Paula Cooper Gallery,
New York

Jill Johnston
Marmalade Me, 1971
Hardcover book
8⅜ × 5¾" (21.3 x 14.6 cm)
Published by E. P. Dutton & Co.,
New York
Courtesy Ingrid Nyeboe

Jill Johnston
Marmalade Me, 1971
Paperback book
7⅛ × 4¼" (18.1 x 10.8 cm)
Published by E. P. Dutton & Co.,
New York
Courtesy Ingrid Nyeboe

Robert Morris's text for *Waterman
Switch*, 1963–66
Digital print (printed 2018)
Yvonne Rainer Papers, The Getty
Research Institute, Los Angeles
(2006.M.24)

Robert Morris
Waterman Switch, 1965
Photographs by Peter Moore
Performed at Judson Dance Theater
Presents Yvonne Rainer and Robert
Morris at Judson Memorial Church,
New York, March 25, 1965
Performed by Lucinda Childs,
Robert Morris, and Yvonne Rainer
Black-and-white photographs
Courtesy Paula Cooper Gallery,
New York

Peter Moore
Concert of Dance #13,
November 20, 1963
Slideshow of 38 digital photographs
(prepared 2018)

Courtesy Paula Cooper Gallery,
New York

Steve Paxton
Afternoon (a forest concert), 1963
Photographs by Barbara Moore
Performed at 101 Appletree Row,
Berkeley Heights, New Jersey,
October 6, 1963
Performed by Lucinda Childs, Barbara
Dilley, Tony Holder, Benjamin Lloyd,
Steve Paxton, and Yvonne Rainer
Black-and-white photographs
Courtesy Paula Cooper Gallery,
New York

Rehearsal footage of Steve Paxton's
Afternoon (a forest concert), 1963
Performed at 101 Appletree Row,
Berkeley Heights, New Jersey
Performed by Lucinda Childs, Barbara
Dilley, Tony Holder, Benjamin Lloyd,
Steve Paxton, and Yvonne Rainer
Super 8 film transferred to video
(color, silent)
Robert Rauschenberg Foundation,
New York

Steve Paxton
Flat, 1963
Photographs by Peter Moore
Performed in rehearsal for Surplus
Dance Theater: Program sur+, New York,
February 9, 1964
Performed by Steve Paxton
Black-and-white photographs
Courtesy Paula Cooper Gallery,
New York

Steve Paxton
Music for Word Words, 1963
Photographs by Robert McElroy
Performed at Concert of Dance #4,
Judson Memorial Church, New York,
January 30, 1963
Performed by Steve Paxton
Digital prints (printed 2018)
Robert R. McElroy photographs of
Happenings and early performance
art, The Getty Research Institute, Los
Angeles (2014.M.7)

Steve Paxton
*Jag vill gärna telefonera (I Would Like
to Make a Phone Call)*, 1964
Video by John Sanborn
Performed as part of the Judson Dance
Theater reconstructions, cosponsored
by the Bennington College Judson
Project and Danspace Project, St. Mark's
Church-In-The-Bowery, New York,
April 17, 1982
Bennington College Judson Project
Performed by Stephen Petronio and
Randy Warshaw
Video (color, sound)
5 min
Performing Arts Research Collections,
Jerome Robbins Dance Division, New
York Public Library

Steve Paxton
*Jag vill gärna telefonera (I Would Like
to Make a Phone Call)*, 1964

Printed paper, stickers, ink, and
gouache collage on paper
45¾ × 24 × 4¼" (116.2 × 61 ×
10.8 cm)
The Collection Walker Art Center;
Gift of the Robert Rauschenberg
Foundation, 2013

Steve Paxton
*Jag vill gärna telefonera (I Would Like
to Make a Phone Call)*, 1964
Photographs by Stig T. Karlsson
Performed at Five New York Kvällar (Five
New York Evenings), Moderna Museet,
Stockholm, September 8–14, 1964
Performed by Steve Paxton and
Robert Rauschenberg
Digital prints (printed 2018)
Moderna Museet, Stockholm

Rudy Perez
Take Your Alligator with You, 1963
Photographs by Al Giese
Performed at Concert of Dance #7,
Judson Memorial Church, New York,
June 24, 1963
Performed by Rudy Perez and
Elaine Summers
Digital prints (printed 2018)
The Estate of Al Giese

Rudy Perez's newspaper clippings in
preparation for *Take Your Alligator with
You*, 1963
Digital prints (printed 2018)
Performing Arts Archival Collections
in University of Southern California
Special Collections, University of
Southern California

Sidney Philips
Scene from the window of Robert
Rauschenberg's loft, location of Lucinda
Childs's *Street Dance* (1964), 1973
Digital print (printed 2018)
Médiathèque du centre national de
la danse, Archive Lucinda Childs.
Courtesy the artist

Yvonne Rainer
We Shall Run, 1963
Photographs by Al Giese
Performed at Concert of Dance #3,
Judson Memorial Church, New York,
January 29, 1963
Performed by Trisha Brown, Lucinda
Childs, Philip Corner, June Ekman,
Malcolm Goldstein, Sally Gross, Alex
Hay, Deborah Hay, Tony Holder, Carol
Scothorn, and John Worden
Digital prints (printed 2018)
The Estate of Al Giese

Yvonne Rainer
We Shall Run, 1963
Photograph by Peter Moore
Performed in Two Evenings of Dances,
Wadsworth Atheneum, Hartford,
Connecticut, March 7, 1965
Performed by Sally Gross, Alex Hay,
Deborah Hay, Tony Holder, Robert
Morris, Yvonne Rainer, Robert
Rauschenberg, and Joseph Schlichter
Black-and-white photograph

Courtesy Paula Cooper Gallery,
New York

Program for Yvonne Rainer's
Terrain, 1963
Ink on paper
7¹⁵⁄₁₆ × 4¹⁵⁄₁₆" (20.1 × 12.6 cm)
Yvonne Rainer Papers, The Getty
Research Institute, Los Angeles
(2006.M.24)

Yvonne Rainer
"Bach" from *Terrain*, 1963
Photographs by Al Giese
Performed at Judson Memorial Church,
New York (April 28, 1963)
Performed by Trisha Brown, William
Davis, Judith Dunn, Steve Paxton,
Yvonne Rainer, and Albert Reid
Digital prints (printed 2018)
The Estate of Al Giese

Yvonne Rainer
"Duet" from *Terrain*, 1963
Photographs by Vladimir Sladon
Performed at Judson Memorial Church,
New York (April 28, 1963)
Performed by Trisha Brown and
Yvonne Rainer
Digital prints (printed 2018)
Yvonne Rainer Papers, The Getty
Research Institute, Los Angeles
(2006.M.24)

Yvonne Rainer
"Love" from *Terrain*, 1963
Photographs by Al Giese
Performed at Judson Memorial Church,
New York (April 28, 1963)
Performed by William Davis and
Yvonne Rainer
Digital prints (printed 2018)
Yvonne Rainer Papers, The Getty
Research Institute, Los Angeles
(2006.M.24)

Yvonne Rainer
"Talking Solo" from *Terrain*, 1963
Photographs by Peter Moore
Performed at Judson Memorial Church,
New York (April 28, 1963)
Performed by Trisha Brown, Bill Davis,
Judith Dunn, Steve Paxton, Yvonne
Rainer, and Albert Reid
Black-and-white photographs
Courtesy Paula Cooper Gallery,
New York

Yvonne Rainer
Score for Al in "Bach" from *Terrain*, 1963
Ink, crayon, and pencil on paper
7¹⁵⁄₁₆ × 4¹⁵⁄₁₆" (20.1 × 12.6 cm)
Yvonne Rainer Papers, The Getty
Research Institute, Los Angeles
(2006.M.24)

Yvonne Rainer
Score for Steve in "Bach" from
Terrain, 1963
Ink, crayon, and pencil on paper
7¹⁵⁄₁₆ × 4¹⁵⁄₁₆" (20.1 × 12.6 cm)
Yvonne Rainer Papers, The Getty
Research Institute, Los Angeles
(2006.M.24)

Yvonne Rainer
Score for Trisha in "Bach" from
Terrain, 1963
Ink, crayon, pencil on paper
7¹⁵⁄₁₆ × 4¹⁵⁄₁₆" (20.1 × 12.6 cm)
Yvonne Rainer Papers, The Getty
Research Institute, Los Angeles
(2006.M.24)

Yvonne Rainer
Score for Yvonne in "Bach" from
Terrain, 1963
Ink, crayon, pencil on paper
7¹⁵⁄₁₆ × 4¹⁵⁄₁₆" (20.1 × 12.6 cm)
Yvonne Rainer Papers, The Getty
Research Institute, Los Angeles
(2006.M.24)

Yvonne Rainer
Rehearsal for *Parts of Some
Sextets*, 1965
Photographs by Al Giese
Performed at 112 Greene Street, New
York, January 1965
Performed by Lucinda Childs, Judith
Dunn, Sally Gross, Deborah Hay, Tony
Holder, Robert Morris, Steve Paxton,
Yvonne Rainer, Robert Rauschenberg,
and Joseph Schlichter
Digital prints (printed 2018)
The Estate of Al Giese

Yvonne Rainer
Tape reel titled "Sleep" for "Corridor
Solo" from *Part of a Sextet* (1964), n.d.
4:58 min
Sound
Yvonne Rainer Papers, The Getty
Research Institute, Los Angeles
(2006.M.24)

Robert Rauschenberg
Sleep for Yvonne Rainer, 1965
Mixed media and paper collage
with screenprint
84 × 60 × 7¼" (213.4 × 152.4 ×
18.4 cm)
The Doris and Donald Fisher Collection,
The San Francisco Museum of
Modern Art

Robert Rauschenberg
Pelican, 1963
Photographs by Peter Moore
Performed at First New York Theater
Rally, former CBS studio, 81st
Street and Broadway, New York,
May 25, 1965
Performed by Carolyn Brown, Alex Hay,
and Robert Rauschenberg
Black-and-white photographs
Courtesy Paula Cooper Gallery,
New York

Carolee Schneemann
Watercolors and drawings for *Banana
Hands*, 1962
Ink, pen, and watercolor on paper
6 sheets, each 8 × 11" (20.3 × 27.9 cm)
Collection the artist

Carolee Schneemann
Meat Joy, 1964
16mm film transferred to video

(color, sound)
6 min
The Museum of Modern Art, New York.
Gift of Jerry I. Speyer and Katherine
G. Farley, Anna Marie and Robert F.
Shapiro, and Marie-Josée and Henry
R. Kravis

Elaine Summers
Fantastic Gardens, 1964
Photographs by Al Giese
Performed at Judson Memorial Church,
New York, February 17–19, 1964
Performed by Joan Baker, Edward
Barton, Carla Blank, June Ekman, Ruth
Emerson, Sally Gross, Fred Herko,
Dorothy Hoppe, Christine Meyers,
Bill Myers, Roger Morris, Sandra
Neels, Rudy Perez, Robert Ranieri,
Arlene Rothlein, Larry Seigel, Sally
Stackhouse, Kyle Summers, James
Wilson, and John Worden
Digital prints (printed 2018)
Performing Arts Research Collections,
Jerome Robbins Dance Division, New
York Public Library

Elaine Summers
Fantastic Gardens, 1964
Photographs by Peter Moore
Performed at Judson Memorial Church,
New York, February 17–19, 1964
Performed by Joan Baker, Edward
Barton, Carla Blank, June Ekman, Ruth
Emerson, Sally Gross, Fred Herko,
Dorothy Hoppe, Christine Meyers,
Bill Myers, Roger Morris, Sandra
Neels, Rudy Perez, Robert Ranieri,
Arlene Rothlein, Larry Seigel, Sally
Stackhouse, Kyle Summers, James
Wilson, and John Worden
Digital prints (printed 2018)
Courtesy Paula Cooper Gallery,
New York

Elaine Summers
Judson Fragments, 1964
16mm film transferred to video (color
and black-and-white, sound)
16 min
Performing Arts Research Collections,
Jerome Robbins Dance Division,
New York Public Library, Gift of
Elaine Summers

Trisha Brown and Yvonne Rainer impro-
vising at the Yam Festival, Hardware
Poet's Playhouse, New York, 1963
Film footage shot by Billy Klüver
Super 8 film transferred to video
(color, silent)
Courtesy Klüver/Martin Archive

Stan VanDerBeek
Site, 1965
16mm film transferred to three-channel
video (black-and-white, silent)
8:54 min
Edition 1 of 6, 2 APs
Courtesy of the Estate of Stan
VanDerBeek. Funded by the Celeste
Bartos Preservation Fund at The
Museum of Modern Art, New York

Stan VanDerBeek
*Dances/Bob Rauschenberg (81st St.
Theatre Rally)*, 1965
16mm film transferred to video (black-
and-white, silent)
26:11 min
Edition 1 of 6, 2 APs
Courtesy of the Estate of Stan
VanDerBeek. Funded by the Celeste
Bartos Preservation Fund at The
Museum of Modern Art, New York

Andy Warhol
Jill and Freddy Dancing, 1963
16mm film transferred to video (black-
and-white, silent)
4 min
Original film elements preserved by The
Museum of Modern Art. Collections of
The Andy Warhol Museum, Pittsburgh,
and The Museum of Modern Art, New
York. Contribution The Andy Warhol
Foundation for the Visual Arts, Inc.

*All photographs by Al Giese © Estate
of Al Giese/Licensed by VAGA,
New York, NY*

*All photographs by Peter Moore
© Barbara Moore/Licensed by VAGA,
New York, NY*

ACKNOWLEDGMENTS

Judson Dance Theater was foremost a group effort best characterized as a commitment to collaboration and the experimentation that could result from people coming together. *Judson Dance Theater: The Work Is Never Done* was assembled in this same tradition, and we would like to acknowledge the many collaborators who made the exhibition possible.

We are grateful to the exhibition's institutional lenders, who shared with us both the works in their care as well as their intimate knowledge about them. We extend our thanks to Rebecca Cleman, Electronic Arts Intermix, New York; Barbara Dufty, Katherine Martinez, and Benjamin Houtman, Trisha Brown Dance Company, New York; Marvin J. Taylor, Lisa Darms, and Nicholas Joseph Martin, Fales Library & Special Collections, New York University Libraries; Glenn Phillips, Marcia Reed, Irene Lotspeich-Phillips, and Aimee Calfin, Getty Research Institute, Los Angeles; Tanisha Jones, Thomas Lisanti, Daisy Pommer, and Cassie Mey, Jerome Robbins Dance Division, New York Public Library for the Performing Arts; Francine Snyder and Joshua Peach, Robert Rauschenberg Foundation, New York; Kirsten Tanaka, Museum of Performance + Design, San Francisco; William Whitaker and Heather Isbell Schumacher, Architectural Archives, University of Pennsylvania, Philadelphia; Melinda Hayes and Sue Luftschein, University of Southern California Libraries, Special Collections, Los Angeles; Doris and Donald Fisher, the Doris and Donald Fisher Collection at San Francisco Museum of Modern Art; Gary Garrels, Danica Gomes, and Kelly Parady, San Francisco Museum of Modern Art; Laurent Sebillotte and Juliette Riandey, Centre national de la danse; Siri Engberg and Kayla Hagen, Walker Art Center; Jack Von Euw, the Bancroft Library, University of California, Berkeley; MM Serra, the Film-Makers' Cooperative; SONY Music Entertainment; Universal Music Group; The Library of Congress Music Division; Greg Pierce and Geralyn Huxley, the Andy Warhol Museum, Pittsburgh; Joakim Edholm, SVT International Sveriges Television AB; and Johan Kugelberg and Daylon Orr, Boo-Hooray.

Thank you to the artist estates with whom we worked closely: Ken Tabachnick and Merce Cunningham Trust; Ammiel Alcalay and the Estate of Diane di Prima; Mary Giese and the Estate of Al Giese; Kiira Jepson and the Estate of Warner Jepson; Chris Calhoun Agency and the LeRoi Jones Estate; Timothy McDarrah, Gloria McDarrah, Patrick McDarrah, and the Estate of Fred W. McDarrah; Barbara Moore and the Estate of Peter Moore; Thomas Körtvélyessy, Davidson Gigliotti and the Estate of Elaine Summers and the Kinetic Awareness® Center; Sara VanDerBeek, Chelsea Spengemann, and the Estate of Stan VanDerBeek; and Pepper Fajans, Alla Kovgan, and the David Vaughan Collection. Thank you too to the individuals who generously lent works from their private collections: Gerard Forde; Gene Friedman; David Gordon; Deborah Hay; Marie-Josée and Henry R. Kravis, with the help of Gary Owen; Babette Mangolte; Julie Martin; Ingrid Nyeboe and the Jill Johnston Literary Archive; Claes Oldenburg; Aileen Passloff; Steve Paxton; Rudy Perez; Carolee Schneemann; Walter Verdin; and Cathy Weiss.

Thank you to the galleries with whom we worked closely: Steven Henry, Laura Hunt, Shira Schwartz, and Polina Berlin at Paula Cooper Gallery, New York; Mara McCarthy at the Box, Los Angeles; Wendy Osloff and Anneliis Beadnell at P.P.O.W., New York; Marcel Fleiss and Rodica Sibleyras at Galerie 1900–2000, Paris; Steven Kasher, Cassandra Johnson, Elaina Breen, and Patrice Gonzales at Steven Kasher Gallery, New York; Susan Dunne and Emelia Scheidt at Pace Gallery, New York. In addition to the artists in the exhibition, their studio managers, friends, and loved ones provided invaluable support. These include Lilah Dougherty, Andy Archer, Jung Hee Choi, Diana Byers, Stephanie Earle, Julie Martin, Lisa Nelson, Valda Setterfield, and Agustín Schang. The exhibition's ambitious performance program required the expertise of numerous collaborators. We thank Mikhail Baryshnikov, Eleanor Wallace and Baryshnikov Arts Center, New York; Esa Nickle and Performa, New York; Pat Catterson; Alyce Dissette and Pick Up Performance Co(s), New York; Sarah Swenson; Linda Brumbach and Pomegranate Arts; and Stephen Petronio and Stephen Petronio Company, New York. To all of the dancers who brought the works to life, we thank you for your spirit, generosity, and talent. Their contributions are credited in the exhibition's performance brochure.

We are deeply grateful to the show's supporters. This exhibition is made possible by Hyundai Card. Leadership support is provided by Monique M. Schoen Warshaw and by The Jill and Peter Kraus Endowed Fund for Contemporary Exhibitions. Major support for the exhibition and this publication is provided by MoMA's Wallis Annenberg Fund for Innovation in Contemporary Art through the Annenberg Foundation. Generous funding is made available by The Contemporary Arts Council of The Museum of Modern Art and The Harkness Foundation for Dance. Additional support is provided by MoMA's major Annual Exhibition Fund donors: the Estate of Ralph L. Riehle, Alice and Tom Tisch, The Marella and Giovanni Agnelli Fund for Exhibitions, Mimi and Peter Haas Fund, Brett and Daniel Sundheim, Franz Wassmer, Karen and Gary Winnick, and Oya and Bülent Eczacıbaşı. MoMA Audio is supported by Bloomberg Philanthropies.

We are grateful to our colleagues in the Department of Development, including Todd Bishop, Senior Deputy Director, External Affairs; Maggie Lyko, Director, Special Events and Affiliate Programs; Jessica Smith, Assistant Director, Institutional Giving and Global Partnerships; and Anna Luisa Vallifuoco, Manager, Institutional Giving and Global Partnerships.

This project's commitment to interdisciplinary thinking benefited from insights from virtually every department at the Museum. Our foremost thanks go to Glenn D. Lowry, Director, whose consummate support for and confidence in this project extend back several years to the establishment of the Department of Media and Performance Art and has continued in ways small and big. Kathy Halbreich, former Associate Director and Laurenz Foundation Curator, played multiple roles in this process, sharing with us her welcome counsel and deeply held belief in the project; she continually inspired us. Ramona Bannayan, Senior Deputy Director, Exhibitions and Collections, was consistently generous in her foresight and vision, and Peter Reed, Senior Deputy Director, Curatorial Affairs, provided advice at key junctures. Leah Dickerman, Director, Department of Editorial and Content Strategy, embodied the ethos of collaboration, offering meaningful advice, support, and scholarly exchange. Throughout, Stuart Comer, Chief Curator, Department of Media and Performance Art, was a faithful interlocutor, our primary advocate, and a trusted friend.

We were fortunate to benefit from the expertise of our curatorial colleagues and their generosity with interdepartmental loans. Christophe Cherix, Chief Curator, Department of Drawings and Prints, shared with us his passion for and facility with paper, poetry, and the 1960s; we are grateful for his support along with that of Jodi Hauptman, Senior Curator, and David Platzker, former Curator, Department of Drawings and Prints. We thank Emily Cushman, Collection Specialist, and Emily Edison, Collection Specialist, Acquisitions and Loans, Department of Drawings and Prints. Rajendra Roy, Chief Curator, Department of Film, made rarely seen material available to us, kindly allowing us to once again celebrate the dancers' moving bodies.

We salute Katie Trainor, Film Collection Manager, Department of Film, and Ashley Swinnerton, Collection Specialist, Department of Film. In addition, the exhibition benefited from the intellectual rigor, sense of humor, and genuine interest of all of the Museum's Chief Curators, including Ann Temkin, The Marie-Josée and Henry Kravis Chief Curator of Painting and Sculpture; Quentin Bajac, The Joel and Anne Ehrenkranz Chief Curator of Photography; Martino Stierli, The Philip Johnson Chief Curator of Architecture and Design; Peter Eleey, Chief Curator of MoMA PS1, and Klaus Biesenbach, Chief Curator at Large. Our colleagues in the Department of Archives, Library and Research Collections made their collections available for both study and display. They include Michelle Elligott, Chief of Archives, Library, and Research Collections; Jennifer Tobias, Librarian, Reader Services; Nathaniel Otting, Library Assistant; and Nicole Kaack, Daedalus Fellow, Department of Archives.

Our colleagues in the Marketing and Communications Department crafted a meaningful point of entry for our public; they include Rob Baker, Director of Marketing and Creative Strategy; Sara Beth Walsh, Senior Publicist; Olivia Oramas, Publicist; Rebecca Stokes, Director, Digital Initiatives; and Wendy Olson, Marketing Manager. In the Department of Digital Media, Shannon Darrough, Director, and Sean Yetter, Producer, worked closely with us to make the mediated as alive as the real. The Department of Visitor Services, skillfully led by Sonya Shrier, Director, and Billy Umana, Assistant Director, ensured each visitor was warmly welcomed. In any exhibition that includes live performance, the people in the Department of Security and Operations are the daily heroes who guarantee the safety of the performers. We are lucky to work with Daniel Platt, Director of Security, Department of Security; Tunji Adeniji, Director of Facilities and Safety, Department of Facilities and Safety; and Tyrone Wyllie, Associate Director of Security.

This complex show benefited from an imaginative and ambitious exhibition team. We were heartened by the commitment of the members of the Department of Exhibition Planning and Administration including Erik Patton, Director; Lizzie Gorfaine, Assistant Director and Producer, Performance and Live Programs; Rachel Kim, Exhibition Manager; Kate Scherer, Manager, Performance and Live Programs; and Laura Pfeffer, Production Assistant. The exhibition's rhythm and texture were designed by Matthew Cox, Exhibition Designer, Department of Exhibition Design and Production, and Aaron Harrow, AV Design Manager, Department of Audio Visual; their ongoing dedication and profound curiosity made the daily work of exhibition making a pleasure. Thanks to our artist consultants, Charles Atlas and Jonathan Berger, who offered an important set of eyes and ears and suggested dynamic ways out of tight spaces. We also thank Cori Olinghouse, founder of the Portal Project, as well as Molly Superfine, for their research that informed the development of the exhibition checklist. Victoria Manning, Assistant Registrar,

Department of Collection Management and Exhibition Registration, expertly coordinated bringing hundreds of artworks to the Museum. Patty Lipshutz, General Counsel, Nancy Adelson, Deputy General Counsel, and Alexis Sandler, Associate General Counsel, provided invaluable advice. Odessa Matsubara, Chief Officer, and Laura Coppelli, Associate Director, in the Department of Human Resources, helped with various staffing issues related to our performance program. Thanks also to Lana Hum, Director, Department of Exhibition Design and Production, and Aaron Louis, Director of Audio Visual, who were enthusiastic supporters. We benefited from the fresh and dynamic graphic design created by members of the Department of Graphic Design and Advertising, including Rob Giampietro, Director of Design; Ingrid H. Y. Chou, Associate Creative Director; Claire Corey, Production Manager; Damien Saatdjian, Art Director; and Kevin Ballon, Graphic Designer. Peter Perez, Foreman of the Frame Shop, offered a lucid and elegant vision for framing and casework throughout. The in-house transportation and installation of artworks was smoothly coordinated by Rob Jung, Tom Krueger, and Sarah Wood. Thanks to all of the carpenters and colleagues in the frame shop and art handling.

We are indebted to our extraordinary colleagues in the Department of Conservation: Kate Lewis, Chief Conservator; Peter Oleksik, Associate Media Conservator; Annie Wilker, Associate Paper Conservator; Lee Ann Daffner, Photography Conservator; Lynda Zycherman, Sculpture Conservator.

In addition, our colleagues in Imaging Services, including Robert Kastler, Director, Jennifer Sellar, Digital Asset Management Coordinator, and Kurt Heumiller, Studio Production Manager, ensured the posterity of this exhibition and performance program.

The exhibition benefited from our various collaborators who considered Judson's public reception today. Thanks to Wendy Woon, The Edward John Noble Foundation Deputy Director for Education; Pablo Helguera, Director, Adult and Academic Programs; Jess Van Nostrand, Assistant Director of Exhibition Programs and Gallery Initiatives; Sarah Kennedy, Assistant Director, Learning Programs and Partnerships; Adelia Gregory, Associate Educator, Public Programs and Gallery Initiatives; Leticia Gutierrez, Associate Educator, Learning Programs and Partnerships; Alethea Rockwell, Assistant Educator, Public Programs; Devin Malone, Fellow, Public Programs MoMA/Studio Museum in Harlem; and Myrto Katsimicha, Intern, Academic and Adult Programs, for their openness and camaraderie in developing a robust public program. Thank you to Sara Bodinson, Director, Interpretation, Research, and Digital Learning, Department of Education; Jenna Madison, Assistant Director, Interpretation, Research, and Digital Learning; Maria Marchenkova, Assistant Editor, Department of Publications; and Nina Callaway, Digital Media Freelancer, Department of Digital Media, for their tireless work crafting the exhibition's oral histories and gallery texts.

Our gratitude also goes to the current staff of Judson

Memorial Church, including Reverend Donna Schaper, Senior Minister; Reverend Micah Bucey, Minister; Abigail Hastings, Archivist; André Daughtry, Community Minister; Zac Mosely, House Manager; and Michelle Thompson, Community Engagement, all of whom shared with us its active life. Our collaborators at Movement Research—Barbara Bryan, Executive Director; Moriah Evans, *Performance Journal* Editor-in-Chief; and Lauren Bakst, *Performance Journal* Managing Editor—were steady supporters. We were fortunate to work closely with faculty from New York University's Department of Performance Studies at Tisch School of the Arts, including André Lepecki, Department Chair; Fred Moten, Professor; and Malik Gaines, Assistant Professor; along with Katie Adler, Event Coordinator. We also thank Alex Sloane and Taja Cheek, Curatorial Assistants at MoMA PS1, for hosting our public program. The ongoing care for Simone Forti's Dance Constructions was made possible by the guidance of Judy Hussie-Taylor, Executive Director and Chief Curator of Danspace Project, and Lydia Bell, Program Director. We are lucky to benefit from their friendship and expertise.

The Judson curatorial team, an extraordinarily talented and intrepid group, performed the heavy lifting on this project. We benefited from the hard work of wonderful interns, including Eames Armstrong, J. English Cook, Ivana Dizdar, Alessandra Gomez, Eric Lee, Victor "Viv" Liu, Amauta Marston-Firmino, Nicolas Ochart, Amanda Ryan, and Gabriella Shypula; their work has shaped this project, and we expect they will go

on and shape the future of the field. Atheel Elmalik and Harry C. H. Choi—respectively the 2016–17 and 2017–18 Twelve-Month Interns in the Department of Media and Performance Art—tirelessly researched images and tracked down sundry items for this book, while also managing its production. Much of the research for this exhibition was spearheaded by two phenomenal Museum Research Consortium Fellows: Elizabeth Gollnick, who developed the weekly reading syllabus for collective study and conducted extensive archival work, and Vivian A. Crockett, whose scholarly rigor, bedside manner, and care for objects was exemplary. Their contributions can be recognized in the catalogue and in the exhibition's attempts to embody a feminist practice. Martha Joseph, Curatorial Assistant, Department of Media and Performance Art, gracefully handled a wide set of responsibilities, from securing loans to working closely with artists and researching and writing. Her keen judgment and impeccable insight is reflected in every aspect of the project. The book benefited from conversations and contributions from other curatorial colleagues, including Emily Liebert, Former Curatorial Assistant, Department of Painting and Sculpture; Jennifer Harris, Curatorial Assistant, Department of Painting and Sculpture; and Giampaolo Bianconi, Curatorial Assistant, Department of Media and Performance Art. The insights of the entire Department of Media and Performance Art light up this endeavor, and we are grateful to Elizabeth Henderson, Department Manager; Erica

Papernik-Shimizu, Associate Curator; Athena Holbrook, Collection Specialist; and Chelsea Airey, Assistant to the Chief Curator.

In the Department of Publications, Christopher Hudson, Publisher; Marc Sapir, Production Director; Matthew Pimm, Production Manager; Hannah Kim, Marketing and Book Development Coordinator; and Cerise Fontaine, Department Coordinator, have brought this book from idea to the object in your hands. We began this project with the expert guidance of David Frankel, former Editorial Director, whose early advice helped shape the backbone of the book. We were lucky to continue working with Don McMahon, Editorial Director, who has traveled with us from the weeds to the sky and has been a thoughtful and kind colleague at every step. Our Editor, Sarah Resnick, is this book's left hand; it has benefited from her lucid questions, earnest curiosity, hard work, and talented ear. Elise Archias lent us her invaluable expertise and provided a necessary set of outside eyes. We were fortunate to work with the attentive and gracious Joseph Logan and Katy Nelson, whose design gives this book its elegance and sense of usefulness.

The catalogue is comprised of new essays from a devoted group of artists and art, music, and dance historians, including Malik Gaines, Danielle Goldman, Sharon Hayes, Adrian Heathfield, Benjamin Piekut, Kristin Poor, Julia Robinson, and Gloria Sutton. We are grateful for their original thinking, collaborative spirit, and unmatched expertise.

The symbolic order into which this project enters would not have been possible without the germinal writing by and a series of conversations with the following thinkers: Sally Banes, Carlos Basualdo, Philip Bither, Gregg Bordowitz, Sabine Breitwieser, Julia Bryan-Wilson, Johanna Burton, Boris Charmatz, Lili Chopra, Barbara Clausen, Claire Croft, Lynne Cooke, Kelly Cooper, Donna De Salvo, Simon Dove, Buffy Easton, Okwui Enwezor, Gerard Forde, Anna Gallagher-Ross, Thelma Golden, Saidiya Hartman, Claire Henry, Judy Hussie-Taylor, Bruce Jenkins, Jill Johnston, Kellie Jones, Branden Joseph, Liz Kotz, Carrie Lambert-Beatty, Julie Lazar, Ralph Lemon, André Lepecki, Pavol Liska, Marcella Lista, Andrea Lissoni, Joshua Lubin-Levy, Don McDonagh, Mary McGuire, Sarah Michelson, Sam Miller, Helen Molesworth, Fred Moten, José Esteban Muñoz, Wendy Perron, Greg Pierce, Melissa Ragona, Will Rawls, Bruce Robertson, Janice Ross, Cameron Rowland, David Vaughan, David Velasco, and Catherine Wood. Thank you for the models you have put forth and the space you have made available.

Those closest to the curators may have perhaps felt the burdens of the project most. Thomas is grateful to his family, both inherited and built, as well as to Andrew Wallace, who was there for both the everyday and not-so-ordinary. Ana is grateful to her partner, friends, and family for their presence and support.

The artists in this exhibition were our first and last interlocutors. Thank you to all those listed on pages 186–87 of this catalogue. We were lucky to work closely with Lucinda Childs, Philip Corner, Simone Forti, Gene Friedman, David Gordon, Anna Halprin, Deborah Hay, La Monte Young, Robert Morris, Aileen Passloff, Steve Paxton, Rudy Perez, Yvonne Rainer, and Carolee Schneeman. We were also fortunate to work closely with Babette Mangolte and Claes Oldenburg. Thank you all for giving us a reason to continue the work.

This book is dedicated to Sam Miller (1952–2018).

In reproducing the images contained in this publication, the Museum obtained the permission of the rights holders whenever possible. In those instances where the Museum could not locate the rights holders, notwithstanding good faith efforts, it requests that any information concerning such rights holders be forwarded so that they may be contacted for future editions.

© Claudio Abate. Courtesy of Simone Forti and The Box, Los Angeles: p. 71. © Allan Kaprow Papers, The Getty Research Institute, Los Angeles (980063). Courtesy of Allan Kaprow Estate and Hauser & Wirth: p. 128. © American Map Company. Courtesy of The Museum of Modern Art Library, New York: p. 114. © The Andy Warhol Museum, Pittsburgh, a museum of Carnegie Institute. All rights reserved: pp. 152; 153, all. © George Herms and the Estate of Diane di Prima. Courtesy of Department of Imaging and Visual Resources, The Museum of Modern Art, New York, photo John Wronn: p. 21. © Ernest Braun and The Architectural Archives, University of Pennsylvania, Philadelphia, by the gift of Lawrence Halprin: p. 38. © Artists Rights Society (ARS), New York/VG Bild-Kunst, Bonn, Germany. Courtesy of Department of Imaging and Visual Resources, The Museum of Modern Art, New York: pp. 52, 57. © Trisha Brown Archive: p. 70. © Médiathèque du centre national de la danse, Archive Lucinda Childs, Paris. Courtesy the artist: p. 170, all. © Michael Cuscuna/Corbis Premium Historical/Getty Images. Image, Getty Images: p. 138, bottom. © Philip Corner. Courtesy of Frog Peak Music: p. 68; courtesy of Fales Library & Special Collections, New York University Libraries: p. 160, all. © Ralph Crane/The LIFE Picture Collection/Getty Images. Image, Getty Images: p. 65. © Earle Brown Collection, Paul Sacher Foundation, Basel: p. 127, bottom left. © Gene Friedman. Courtesy of Department of Film, The Museum of Modern Art, New York: pp. 176, all; 177, all. © Simone Forti. Courtesy of Department of Imaging and Visual Resources, The Museum of Modern Art, New York, photo John Wronn: p. 136. © Estate of Al Giese/Licensed by VAGA, New York, NY: back cover, pp. 29, 72, 76, 86, 91, 92–95, 96, 97, 98–99; 140, bottom (left, middle, right); 146, top and bottom; 148; 150, all; 154; 155, top; 157, middle; 159, all; 171, bottom; image, Jerome Robbins Dance Division, New York Public Library: p. 85, fig. 3; courtesy of Carolee Schneemann, Galerie Lelong & Co., and P•P•O•W, New York: pp. 29; 166; 167, top. © The Film-Makers' Cooperative, New York: pp. 178, all; 179, all. © Hugo Glendinning: p. 36. © Herve Gloaguen/Gamma Legends/

Getty Images. Image, Getty Images: p. 48. © Lawrence Halprin. Image courtesy of Anna Halprin: p. 118. © Lawrence Halprin and The Architectural Archives, University of Pennsylvania, Philadelphia, by the gift of Lawrence Halprin: p. 119, bottom. © Lawrence Halprin and Anna Halprin Papers, The Elyse Eng Dance Collection, Museum of Performance + Design, San Francisco: p. 17. © Stig T. Karlsson and Moderna Museet, Stockholm: p. 145, top; 180, bottom. © Hans Namuth Estate / Licensed by Center for Creative Photography, University of Arizona, Tucson. Courtesy of Robert Rauschenberg Foundation, New York: p. 173, bottom. © Henmar Press, C. F. Peters Corporation: pp. 54, fig. 2; 126–27. © George Herms: p. 155, bottom. © The Estate of Warner Jepson: pp. 120–21. © Clemens Kalischer: p. 47. © Geoff La Gerche and Universal Music Group. Courtesy of Department of Imaging and Visual Resources, The Museum of Modern Art, New York, photo John Wronn: p. 139, bottom. © Babette Mangolte: pp. 50; 147, bottom. © Fred W. McDarrah/Premium Archive/Getty Images. Image, Getty Images: pp. 27; 32; 115, all; 116, figs. 5, 6, 7, 9; 117, all; 127, bottom right; 129, all; 138–39, top and bottom left; 169. © Robert R. McElroy photographs of Happenings and early performance art, The Getty Research Institute, Los Angeles (2014.M.7). Image, Research Library, Getty Research Institute: pp. 56; 73; 134–35; 137, all; 145, bottom. © James McMullan. Courtesy of Dutton, an imprint of Penguin Publishing Group, a division of Penguin Random House LLC and Museum of Modern Art Library, New York: p. 80, fig. 5. © Minoru Niizuma and Lenono Photo Archive, New York: p. 116. © Barbara Moore/ Licensed by VAGA, New York, NY. Courtesy Paula Cooper Gallery, New York: front cover, pp. 14, fig. 1; 33, 45, 49, 58, 60, 61, 62, 66; 78, fig. 3; 79; 85, fig. 4; 101, all; 102, all; 103, all; 104–05; 106, all; 107, all; 108–09; 110; 111, all; 140–41; 147, top; 149, all; 157, top and bottom; 161, all; 162, top; 163, all; 164; 165, all; 168, top; 171, top; 172; 173, top; 181, top; 184, bottom. © Robert Morris/Artists Rights Society (ARS), New York. Courtesy of Castelli Gallery, New York: p. 78, fig. 3. © Claes Oldenburg. Courtesy of Department of Imaging and Visual Resources, The Museum of Modern Art, New York, photo Peter Butler: p. 130. © Robert Rauschenberg Foundation, New York: pp. 18; 44; courtesy of San Francisco Museum of Modern Art: 180, top; courtesy of Judson Memorial Church Archive, Fales Library & Special Collections, New York University Libraries, photo Kris Graves: p. 182. © Elisabeth Novick/Licensed by Arena PAL, London. Courtesy of Robert Rauschenberg Foundation, New

York: p. 162, bottom; 181, bottom. © Steve Paxton. Courtesy Contact Quarterly: p. 34; image, Collection of Walker Art Center, Minneapolis: p. 144. © Nicholas Peckham. Image, Anna Halprin Papers, The Elyse Eng Dance Collection, Museum of Performance + Design, San Francisco: p. 39. © Yvonne Rainer Papers, The Getty Research Institute, Los Angeles (2006.M.24). Image, Research Library, Getty Research Institute: pp. 26; 156. © Steve Schapiro/Corbis Premium Historical Collection/Getty Images. Image, Getty Images: p. 69. © Carolee Schneemann, photo Kris Graves: p. 167, bottom. © Marvin Silver: pp. 124–25. © Karl W. Stuecklen. Image, New York Public Library: p. 184, top. © The Estate of Elaine Summers. Image courtesy of Jerome Robbins Dance Division, New York Public Library and Department of Imaging and Visual Resources, The Museum of Modern Art: pp. 82, 84, 86, 87, 174–75. © Sveriges Television AB (SVT), Stockholm: p. 125, bottom. © The Village Voice, New York: pp. 20, 185. © Robert Whitman. Courtesy of Pace Gallery, New York: pp. 54, fig. 3; 135, bottom. © The Estate of Van Williams. Image, Jerome Robbins Dance Division, New York Public Library: p. 63. © La Monte Young. Courtesy Department of Imaging and Visual Resources, The Museum of Modern Art, New York, photo Peter Butler: pp. 132, all; 133, all. © Estate of James Waring. Courtesy of Galerie 1900–2000, Paris: p. 123. © Estate of Stan VanDerBeek: pp. 131, all; 158, all; 183, all. Photographer unknown, image: Anna Halprin Papers, The Elyse Eng Dance Collection, Museum of Performance + Design, San Francisco: p. 16; image, Jerome Robbins Dance Division, New York Public Library: p. 74; courtesy of Barbara Moore Collection: pp. 143, top; 168, bottom; courtesy of Aileen Passloff Collection, photo Kris Graves: pp. 142; 143, bottom; courtesy of Rudy Perez Archive, Special Collections, University of Southern California Library, Los Angeles: p. 151; image, Stedelijk Museum, Amsterdam: pp. 40, 42; courtesy of David Vaughan. Collection and Department of Imaging and Visual Resources, The Museum of Modern Art, New York, photo John Wronn: pp. 19; 122, all.

Published in conjunction with the exhibition *Judson Dance Theater: The Work Is Never Done*, organized by Ana Janevski, Curator, and Thomas J. Lax, Associate Curator, with Martha Joseph, Curatorial Assistant, Department of Media and Performance Art, at The Museum of Modern Art, New York.

HyundaiCard

The exhibition is made possible by Hyundai Card.

Leadership support is provided by Monique M. Schoen Warshaw and by The Jill and Peter Kraus Endowed Fund for Contemporary Exhibitions.

Major support for the exhibition and publication is provided by MoMA's Wallis Annenberg Fund for Innovation in Contemporary Art through the Annenberg Foundation.

Generous funding is provided by The Contemporary Arts Council of The Museum of Modern Art and The Harkness Foundation for Dance.

Additional support is provided by the Annual Exhibition Fund with major contributions from the Estate of Ralph L. Riehle, Alice and Tom Tisch, The Marella and Giovanni Agnelli Fund for Exhibitions, Mimi and Peter Haas Fund, Brett and Daniel Sundheim, Franz Wassmer, Karen and Gary Winnick, and Oya and Bülent Eczacıbaşı.

MoMA Audio is supported by Bloomberg Philanthropies.

Produced by the Department of Publications, The Museum of Modern Art, New York

Christopher Hudson, Publisher

Don McMahon, Editorial Director

Marc Sapir, Production Director

Edited by Sarah Resnick

Designed by Joseph Logan and Katy Nelson, assisted by Erica Getto

Production by Matthew Pimm

Printed and bound by Ofset Yapimevi, Istanbul

This book is typeset in Superclarendon, Janson, and Berthold Akzidenz Grotesk.

Printed on Cyclus Offset and Creator Star

Published by The Museum of Modern Art
11 West 53 Street
New York, NY 10019-5497
www.moma.org

Library of Congress Control Number: 2018945654
ISBN: 978-1-63345-063-9

Distributed in the United States and Canada by
ARTBOOK | D.A.P.
75 Broad Street
Suite 630
New York, NY 10004

www.artbook.com

Distributed outside the United States and Canada by
Thames & Hudson Ltd
181A High Holborn
London WC1V 7QX
www.thamesandhudson.com

Cover image: Peter Moore's photograph of Yvonne Rainer, Alex Hay, David Lee, and Deborah Hay (from left) in Deborah Hay's *They Will* (then titled *Would They or Wouldn't They?*), 1963. Performed at Concert of Dance #13, Judson Memorial Church, November 20, 1963. Back cover: Al Giese's contact sheet with images of Carolee Schneemann's *Newspaper Event*, 1963. Performed at Concert of Dance #3, Judson Memorial Church, January 29, 1963. Frontispiece: Program for Concert of Dance #3 (see pages 90–99). Pages 2–4: Program for Concert of Dance #13 (see pages 100–11). Page 5: Program for the concert Motorcycle (see pages 164–65). Pages 6–8: Programs for Concerts of Dance #14, #15, and #16

Printed and bound in Turkey